STAGING THE TABLE
in Europe 1500–1800

STAGING THE TABLE

Bard Graduate Center
New York City

Deborah L. Krohn

This catalogue is published in conjunction with the exhibition *Staging the Table in Europe 1500–1800* held at Bard Graduate Center Gallery, New York, from February 17 to July 9, 2023.

DIRECTOR OF FOCUS PROJECT EXHIBITIONS Nina Stritzler-Levine
EXHIBITION CURATOR Deborah L. Krohn
BOOK DESIGNER Jocelyn Lau
DIRECTOR OF PUBLISHING Daniel Lee
MANAGING EDITOR Katherine Atkins
COPY EDITOR Florence Grant
MANAGER OF PHOTOGRAPHIC RIGHTS AND REPRODUCTIONS Alexis Mucha

Published by Bard Graduate Center, New York, and distributed by the University of Chicago Press.

Copyright © 2023 Bard Graduate Center. All rights reserved. This book may not be reproduced in whole or in part, in any form (beyond that copying permitted in Sections 107 and 108 of the U.S. Copyright Law and except by reviewers for the public press), without written permission from the publisher.

TYPEFACES ED Daffodil, Jager, Joseleen, and Signifier

PRODUCTION BookLabs, United Kingdom

PRINTER Artron Art Group, China

Library of Congress Control Number: 2022950891
ISBN: 978-1-941792-36-0
A catalogue record for this book is available from the British Library.

10 9 8 7 6 5 4 3 2 1

COVER Pierre Petit, frontispiece, from *L'Art de trancher la viande, & toutes sortes de fruits / nouvellement a la françois par Pierre Petit eicuyer trenchant* ([Lyon?], [1647?]). Engraving. Special Collections, Regenstein Library, University of Chicago, TX885.P480 1600z c.1. Cat. 38.
SPINE AND BARCODE Giovanni Francesco Colle, carving tools, from *Refugio overo ammonitorio de gentilhuomo* (1532), A2v–3r. Woodcut. Special Collections, Regenstein Library, University of Chicago, TX885 C650 1532. Cat. 2.
INTERIOR COVERS Antonio Latini (author), Francisco de Grado (engraver), fruits, from *Lo Scalco alla Moderna* (Naples: Domenico Antonio Parrino and Michele Luigi Mutti, 1694). Engraving. The Metropolitan Museum of Art, New York, The Elisha Whittelsey Collection, The Elisha Whittelsey Fund, 1949, 49.42.3. Cat. 41.
BACK COVER Georg Philip Harsdörffer, "Der Capaun," from *Vollständig vermehrtes Trincir-Buch* . . . (Nuremberg: Paul Fürst, 1652), page 31. Engraving. Herzog August Bibliothek, Wolfenbüttel.

Generous support for *Staging the Table in Europe 1500–1800* has been provided by The Gladys Krieble Delmas Foundation, Joseph S. Piropato, The Cafaro Foundation, The Roy and Niuta Titus Foundation, Suzanne Slesin and Michael Steinberg, and other donors to Bard Graduate Center.

· For Livia and Sammy ·

Meanwhile, to ensure no cause for resentment is lacking, watch the carver prancing about,
with *brandissements* of his flying knife, and carrying out each last one
of his master's instructions: no small matter to make a nice
distinction between the proper gestures
for the carving of hares
and hens!

—Juvenal, *The Sixteen Satires*

.

Structorem interea, ne qua indignatio desit, saltantem spectes et
chironomunta uolanti cultello, donec peragat dictata
magistri omnia; nec minimo sane discrimine
refert quo gestu lepores, et quo
gallina secetur.

—Juvenal, *Saturae*

.

And it is also as necessary for him to know how to fold, pleat and pinch his Linnen
into all manner of forms both of Fish, Beasts, and Birds, as well as Fruits,
which is the greatest curiosity in the covering of a Table well,
for many have gone farther to see a Table neatly
covered, than they would have done for
to have eaten a good meal
at the same Table.

—Giles Rose, *A Perfect School of Instructions for the Officers of the Mouth*

Table of Contents

XII Director's Foreword
SUSAN WEBER

XVI Focus Project Director's Foreword
NINA STRITZLER-LEVINE

XVIII Acknowledgments
DEBORAH L. KROHN

1 ✦ **INTRODUCTION** Setting the Stage

25 ✤ **CHAPTER I** Courtesy and Carving: Manuscript to Print

39 ✦ **CHAPTER II** The Rise of the *Trinciante*: Carving by the Book

61 ✤ **CHAPTER III** Carving and Folding Visualized: Mattia Giegher's *Tre Trattati*

115 ✿ **CHAPTER IV** "Nach Italienischer Manier": Edible Geometry and Sleight of Hand

155 ✱ **CHAPTER V** From *L'écuyer tranchant* to Genteel Housekeeper

189 Selected Checklist of the Exhibition

202 Selected Bibliography

212 Index

215 Photographic Credits

Director's Foreword

SUSAN WEBER

CURATING AND EXHIBITION MAKING ARE AT THE CENTER OF ACADEMIC LIFE AT Bard Graduate Center, New York. The institution's Focus Projects—exhibitions and publications that are dedicated to the highly diverse research interests of our faculty—are a direct outcome of that commitment. The curatorial thinking behind these projects often begins in the classroom, where faculty and graduate students refine the exhibition's concept and realize its various interpretation strategies. At Bard Graduate Center, the faculty member who works on a Focus Project is given the title of professor-curator. The intention of constructing this identity is to assert the intertwined dual roles and engender the professional stature that curating affords in our community.

Deborah L. Krohn, a professor at Bard Graduate Center and author of this publication, was already an established curator in our gallery when she began working on this project, having previously organized two exhibitions with colleagues and students: *Dutch New York Between East and West: The World of Margrieta van Varick* (2009–10) and *Salvaging the Past: Georges Hoentschel and French Decorative Arts from the Metropolitan Museum of Art* (2013). However, *Staging the Table in Europe 1500–1800* is her first Focus Project as well as her first single-author contribution to the gallery's booklist. I am immensely proud of Krohn's work on this exceptionally researched book, which reflects her position as a pioneer in the scholarly studies of dining culture. She has been teaching courses related to the history of food and the culture of dining for many years, garnering respectability within the field for this area of research. *Staging the Table in Europe 1500–1800* is a culminating moment of such work, but, like many of the finest research endeavors, it is also a point of departure into new areas of investigation. I trust that you, as the reader, will easily become engrossed in the discussion of

manuals and other published sources about the ritual of dining and examination of items like cutlery and table linens in the chapters that follow.

Since this project examines books and related materials that have received little attention in the history of early modern Europe, Krohn relied heavily on the lenders to the exhibition that accompanies this volume, to whom we owe a tremendous debt of thanks. *Staging the Table in Europe 1500–1800* received generous support from the Metropolitan Museum of Art, New York, particularly from the Department of European Sculpture and Decorative Arts, Department of Medieval Art, and Antonio Ratti Textile Center. We are grateful to the Conjuring Arts Research Center, New York; Cooper Hewitt, Smithsonian Design Museum, New York; Lilly Library, Indiana University, Bloomington; New York Public Library; Rare Book & Manuscript Library, Butler Library, Columbia University; University of Chicago Library; and Wadsworth Atheneum Museum of Art, Hartford, Connecticut. Ivan Day, Michele Beiny Harkins, Ben Kinmont, and Joan Sallas also graciously loaned items that enhanced the exhibition's checklist.

Focus Projects are a team effort involving colleagues from many departments at Bard Graduate Center. Their shared work ethic and professionalism is a source of great pride. As director of Focus Project exhibitions, Nina Stritzler-Levine oversees this team. This book would not have been possible without the guidance of Daniel Lee, director of publishing, with support from Katherine Atkins, who is the highly skilled and tireless managing editor, and Alexis Mucha, who sourced and secured the many illustrations featured in this book as associate director of sales, marketing, and rights for publications. As copy editor, Florence Grant astutely prepared the manuscripts for publication. Echoing the format and essence of its source material, this book was realized through a collaborative process between Krohn and designer Jocelyn Lau. Ian Sullivan also worked closely with Krohn to capture the whimsical and intriguing nature of the subject matter for the design of the exhibition, and was joined by Lau on graphics. Jesse Merandy, director of digital humanities and exhibitions, assisted by Julie Fuller, digital humanities educational technologist, collaborated with Krohn and her students on the wonderful digital components of the exhibition. Helen Polson, assistant professor, shared her editorial insight on the exhibition's various interpretive materials. Eric Edler, exhibitions registrar, managed the loans, exhibition assembly, and dispersal, as well

as directed the talented installation crew with Alexander Gruen, chief preparator. Amy Estes, director of marketing and communications, Maggie Walter, content manager, and Ema Furusho, coordinator of marketing and communications, worked together on outreach initiatives for press and social media. I want to express appreciation for Benjamin Krevolin, chief advancement officer, who led the highly successful fundraising initiative with Ruth Epstein, Minna Lee, and Daniel Zimmer in the development office. Andrew Kircher and Laura Minsky, respectively director and associate director of the newly established public humanities and research department, with Nadia Rivers, department coordinator, created the imaginative outreach programs that further enliven the exhibition.

I greatly appreciate the entire faculty, under dean Peter N. Miller, and staff at Bard Graduate Center for their dedication and incredible work. In particular, I want to thank Izabella Mujica, my multitalented executive assistant, as well as the operations and administrative staff led by Janet Ozarchuk, chief operating officer, inclusive of Mohammed Alam, Samantha Baron, Miao Chen, James Congregane, Rita Niyazova, Chandler Small, and the facilities and security teams, who bring the utmost professionalism to critical daily functions of the institution.

Finally, I want to acknowledge the generous support for *Staging the Table in Europe 1500–1800* that has been provided by the Gladys Krieble Delmas Foundation, Joseph S. Piropato, the Cafaro Foundation, the Roy and Niuta Titus Foundation, Suzanne Slesin and Michael Steinberg, and other donors to Bard Graduate Center.

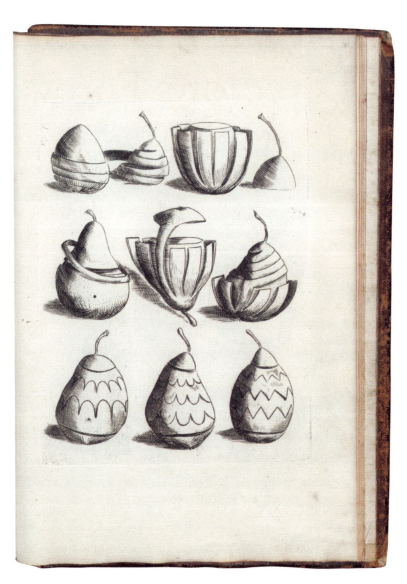

Pierre Petit, spiral pears #31, from *L'Art de trancher la viande, & toutes sortes de fruits / nouvellement a la françois par Pierre Petit eìcuyer trenchant* ([Lyon?], [1647?]). Engraving. Special Collections, Regenstein Library, University of Chicago, TX885.P480 1600z c.1.

Focus Project
Director's Foreword

NINA STRITZLER-LEVINE

> An exhibition isn't only the sum of its artworks, but also the
> relationships created between them, the dramaturgy
> around them, and the discourse
> that frames them.
>
> —Elena Filipovic, "What Is an Exhibition"

WHAT DOES IT MEAN FOR A CURATOR TO EVOKE A THEATRICAL PERFORMANCE WHEN making an exhibition? How do we understand the performative dimension of curatorial thinking? One way of answering these questions is to consider Elena Filipovic's argument that an exhibition can be a staging of things in space and the framing of those things as a discourse. "Implicit in the question," argues Filipovic, "is thus not so much what the meaning of the exhibition is as a category/genre/object, but what it *does*, which is to say, how exhibitions function and matter, and how they participate in the construction and administration of the experience of the items they present." An exhibition can be about what happens—what meaning is produced—when things are placed side-by-side, when they are juxtaposed. An exhibition can be about the adjacencies, the interstices, the dialogues that a curator can create between things.

This dramaturgical line of inquiry is what grounds *Staging the Table in Europe 1500–1800*, an exhibition and publication by Deborah L. Krohn. Surprising, humorous, and thought-provoking, the book transports us to a particular moment of experiential dining with tremendous visual power. The discursive idea of "staging" takes shape through the relationship between the writer's words and accompanying illustrations of bound volumes and pamphlets at the center of discussion. Krohn describes a multisensory experience of the table, both stationary in space and active in the mind. Drawing attention to forks and knives, as well as elaborately folded linens and expertly carved fruits and meats, she encourages us to reimagine past culinary delights.

"LE POULET DINDE – LE FAISAN," from *De Sectione Mensaria*, 17th century. Woodcut. Special Collections, Regenstein Library, University of Chicago, TX635.D4 1600z c.1.

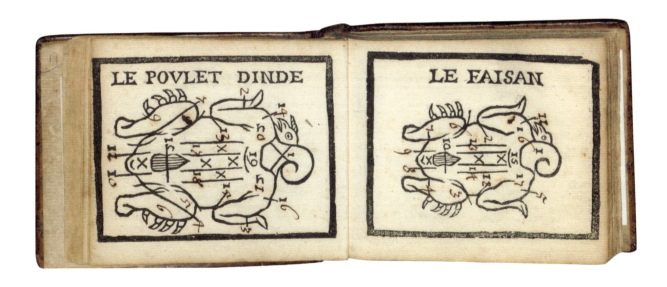

Acknowledgments

DEBORAH L. KROHN

ALTHOUGH MY NAME IS ON THE COVER, RESEARCHING AND ORGANIZING AN exhibition is a profoundly collaborative process. With that in mind, it is a great privilege to thank the people who have been part of the creation of both book and exhibition.

Colleagues at the Metropolitan Museum of Art, New York, have gone above and beyond to provide support. My thanks to Max Hollein, Andrea Bayer, and Sarah Lawrence for their great generosity with both loans and access. Denny Stone has facilitated numerous visits for me and for our students to the European Sculpture and Decorative Arts collection, enabling close looking and discovery. At the Antonio Ratti Textile Center, Cristina Carr, Giulia Chiostrini, Elizabeth Cleland, Eva DeAngelis-Glasser, Elena Kanagy-Loux, Eva Labson, and Janina Poskrobko have hosted students in several classes, helping us think out loud about table linens and their mysteries. In the Medieval Department, Christine Brennan and Melanie Holcomb helped identify relevant pieces. Thanks also to Daniële Kisluk-Grosheide, Wolfram Koeppe, Griffith Mann, Nadine Orenstein, Amelia Peck, Ken Soehner, Femke Speelberg, and Pierre Terjanian.

At the New York Academy of Medicine, Arlene Shaner has supported this project from its inception, sharing the riches of the library with numerous classes over the years. Ben Kinmont has generously provided two exceptional loans. I am also grateful to Emily Orr at Cooper Hewitt, Smithsonian Design Museum, New York, for key loans of cutlery; to Joel Silver at the Lilly Library, Indiana University, Bloomington; to Patti Gibbons at the University of Chicago Library; to Deborah Straussman the New York Public Library; to William Kalush at the Conjuring Arts Research Center, New York; to Jennifer Lee, at the Rare Book & Manuscript Library, Butler Library, Columbia University, New York; to

Martina D'Amato and Titi Halle at Cora Ginsburg LLC; and to Thomas J. Loughman at the Wadsworth Atheneum Museum of Art, Hartford, Connecticut.

Many thanks to Joan Sallas for generosity with his understanding of the history of folding and the creation of folded objects, and to Ivan Day for long-term enlightenment, inspiration, and for sharing his prodigious knowledge of the material culture of food in the early modern period. Melissa Calaresu provided a number of stimulating opportunities for presentation and workshopping of earlier iterations of this material, and with Vicky Avery, invited me to participate in the *Feast and Fast* exhibition in 2019–20 at the Fitzwilliam Museum, Cambridge, which enabled travel and research on books and objects. Allen Grieco opened his files and shared his unique perspectives, helping me to see a path forward in the larger field of the cultural history of food. Bernie Hermann has been inspirational as a writer and food thinker. The readers of the manuscript provided invaluable comments: immense thanks to Evelyn Lincoln and Molly Taylor-Poleskey.

Numerous people at Bard Graduate Center, New York, have worked tirelessly alongside me to bring this project to light. Daniel Lee, director of publishing, and Katherine Atkins, managing editor, have been patient, compassionate, and responsive as the book came to life. Florence Grant has expertly edited the texts enclosed, and Helen Polson has helped shape the interpretive materials for the exhibition with sensitivity and acuity. Alexis Mucha, FileMaker queen, has done much more than request permissions and update the database. Thanks also to Eric Edler, Alexander Gruen, and the exhibition team. In the press office, Amy Estes and her squad have helped frame the exhibition for the larger public. Heather Topcik and her library staff, especially Anna Helgeson and Sebastian Moya, have eagerly chased down obscure research materials. Keith Condon, director of admissions and student affairs, has helped navigate many an administrative squall with grace and skill, enabling me to focus on the book and exhibition. Benjamin Krevolin, Ruth Epstein, and Minna Lee have made invaluable contributions to help bring the exhibition and publication to fruition. Andrew Kircher has brought a much-needed spirit of experimentation to public programs. Laura Minsky has helped make these programs a reality.

It has been a gift to work with designer Jocelyn Lau, whose sensitivity to the historical materials as well as to my notions about how things should look has made the process

of creating this book truly a pleasure. I am fortunate to have had the chance to work with Laura Grey and especially with exhibition designer Ian Sullivan, once again, whose vision and ability to listen, to respond, and to improve cannot be quantified. Peter N. Miller has supported the Focus Project since its inception, providing a unique opportunity for faculty to shape their research and teaching in unconventional ways. Susan Weber stands behind it all, providing generous support, vision, and encouragement and ensuring that Bard Graduate Center can remain a creative and innovative institution.

A group of gifted and dedicated students in a series of seminars I taught at Bard Graduate Center between 2019 and 2022 have contributed research, spirit, and technical knowledge. I would like to thank them all for their good humor and creativity in the face of closed libraries, Zoom classes, and other frustrations. Their work is embedded in the project in various ways: Bridget Bartal, Adam Brandow, Elliot Camarra, Madison Clyburn, Christina de Cola, Noah Dubay, Jacqueline Mazzone, Ishai Mishory, Natalie de Quarto, Jeremy Reeves, Geoffrey Ripert, Pim Supavarasuwat, and Cynthia Volk. Mackensie Griffin, both student and communications assistant, has helped translate the project for a broader audience. A highly engaged and talented group have helped conceive and execute the exhibition's digital interactive feature with a deck of seventeenth-century playing cards under the supervision of Jesse Merandy with Julie Fuller: Irène Berthezène, Angela Crenshaw, Allison Donoghue, Bob Hewis, Louise Lui, Isabella Margi, Caroline Montague, and especially Talia Perry, who developed the wire-frame structure for its implementation.

In the end, words are inadequate to properly acknowledge the contributions and support of friends and family at Bard Graduate Center and beyond. I am fortunate to count among my close colleagues Jeffrey L. Collins, Ivan Gaskell, Aaron Glass, and Andrew Morrall, with whom I have shared many productive conversations as the project took shape. And warm thanks as well to Christopher Gibbs, Helena Gibbs, Lisa Krohn, Lauren McGrath, and Michael Wise for camaraderie and companionship across countless tables.

Knife and fork, Italy, 17th century. Steel, brass. The Metropolitan Museum of Art, New York, Gift of R. Stuyvesant, 1893, 93.13.19, .20. Cat. 18.

♦ INTRODUCTION ♦

Setting the Stage

I N THE ILLUMINATION FOR THE MONTH OF JANUARY IN THE *TRÈS RICHES Heures* of the duc de Berry, from about 1413, beautifully dressed courtiers crowd around a table groaning with gold and silver vessels (fig. 3.1). The duke, wearing a voluminous cloak of royal blue patterned with stylized pomegranates, sits behind the table, seemingly in conversation with a courtier to his right. In the foreground a man dressed in green stands facing the duke. With his right hand, he suspends a knife over what appears to be a platter of fowl or songbirds. Over his left shoulder is draped a white cloth, while a black bag slung from his waist carries another knife and other tools. This man is likely the carver, an essential officer at feasts and banquets such as the one this image depicts. Carvers were highly skilled courtiers carefully groomed for service, whose performance at festive meals demonstrated wealth and prestige. Their role is delineated in an array of manuals and handbooks from the late Middle Ages through the nineteenth century and beyond. This study examines these traditions of service and spectacle over time, focusing on a group of illustrated books published between 1500 and the late eighteenth century across Europe.

Conceived to accompany an exhibition that explores the culture of the table between 1500 and 1800, this book shares the same mission with the many books that are its primary subject: to document a group of practices and the objects through which they were enacted on tables and in kitchens across Europe. Closely related to and sometimes overlapping with cookbooks and recipe collections, the books provide instructions for several activities connected with food service. Many also illustrate inedible sculptural elements crafted from sugar, textiles, and other materials that were only slightly less ephemeral than the foods with which they shared the table.

As with so many areas of knowledge, the increasing diffusion of printed books in early modern Europe created both the means to deploy the information and a market for its consumption. Among the intriguing printed illustrations found in the pages of these handbooks are diagrams that demonstrate how to fold linen napkins into elaborate shapes; how to carve meats, fishes, and fruits before diners in a form of tableside theater that enhanced the spectacle of dining; and maps that lay out how to arrange the variety of dishes on the table.

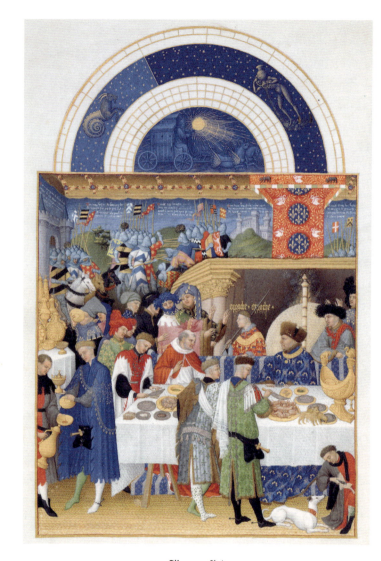

Figure. 3.1
Limbourg brothers (Herman, Paul, and Jean de Limbourg), January, from *Les Très Riches Heures du duc de Berry*, 1413–89. Ink on vellum. © RMN-Grand Palais / Art Resource, NY.

The table maps, though fewer in number than other kinds of images, provide an insight into the motivations of those who created and consumed these books. Though there is no way to know with certainty who the buyers and readers were, these cartographic table diagrams that appear first in the early seventeenth century evoke the massive enterprise of global mapping that facilitated travel and trade in both the Atlantic and Pacific arenas and suggest a degree of what has been called "map consciousness."[1] They also parallel the proliferation of architectural plans and elevations that enabled architects and their clients to visualize three-dimensional space in two dimensions.[2] Readers of a broad range of illustrated vernacular books were likely to be armchair travelers and aspirational builders—that is to say, upwardly mobile consumers whose interest in lavish and performative table settings went hand in glove with other forms of virtual experience.[3] Though the tabletop was hardly *terra incognita*, table maps can be seen as a microcosmic manifestation of the larger enterprise of making accessible a kind of knowledge heretofore limited to a small cohort of elites, as well as an attempt to impose order onto the potentially chaotic experience of conviviality.[4] Around the table, that experience often involved sharp tools, extreme heat, and elevated desires.

The early modern manuals and handbooks examined here are just one subset of a genre of didactic texts that addressed courtesy, etiquette, and behavior for children, the clergy, domestic servants, and their noble or aristocratic employers and supervisors, and can also be considered under the broader rubric of the history of education. This study

traces the evolution of these prescriptive texts from a group of manuscripts from the fifteenth century to printed books that were brought out all over Europe, in many languages, well into the eighteenth century. Though court archives likely hold information about specific stewards, carvers, and their working conditions, these sources, where they exist, have been little studied.[5] Many of the practices described extend backward into antiquity and persist to the present in a variety of formal dining settings. Manuals and handbooks for entertaining, as well as cookbooks and recipes, remain a lively sector of the publishing industry, as a visit to any large bookstore will confirm, and have proliferated on a variety of websites and social media platforms in recent years.

Though some of the carving and folding books have been cited in broader histories of courtesy, manners, and domestic service, such as that of Norbert Elias, to be discussed here, they have not been adequately explored for what they reveal about the material history of the table, dining room, and kitchen. The texts describe in words, and sometimes with pictures, the tools and materials used to carry out elaborate rituals and customs. Behind the succinct language of the cooks, carvers, stewards, and other domestic officers whose skills are explicated in the books lies the creation and maintenance of the tools that shaped the raw materials and served as theatrical props deployed for tableside performances. These objects include precision knives and forks of different sizes and shapes that had to be kept clean and sharp, and large supplies of white linens that had to be spun, woven, bleached, pressed, and shaped in order to play their roles properly.

The arresting images and diagrams featured in many of the printed sources have a history and a life of their own, but they cannot be studied without building out the larger material and intellectual contexts in which they were created and consumed. The cardinals in Rome and the electors in Germany, to name some of the presumed readers of the genre, were also great collectors who amassed vast *Kunst- und Wunderkammern*, or chambers of arts and curiosities, including ancient gems and cameos, paintings, books and manuscripts, scientific instruments, ceramics, precious metal plate, shells, and living and preserved plants and animals. The contents of many of these early modern collections have made their way into museums around the world, some accompanied by period catalogues that enable us to appreciate the extent of the collections despite many losses and dispersions.[6]

Parts of these collections were sometimes placed on view in proximity to the dining table or in the kitchen, on stepped buffets or *credenze*, what might be called a sideboard now. The Italian name, from the verb *credere* (to believe or to trust), indicates that this piece of furniture once served as a stand for foods that were to be tasted to make sure they were free of poison before being served to important diners. The credenza and the dining table, examined together, held both permanent and ephemeral objects: edible pyramids of meats, fruits, and vegetables; sumptuous offerings artfully carved and sliced before the diners with finely honed precision tools; and shape-shifting textiles that could be activated with the flourish of a highly practiced gesture. While the *Kunstkammer* was a static space for display and contemplation, the table and credenza were dynamic, adapting and changing over the course of a meal as the choreography of service was played out.

Credenze can be seen in images of mythological feasts, as in Giulio Romano's 1527–30 fresco of the marriage banquet of Cupid and Psyche from the Palazzo Te in Mantua (fig. 3.2), as well as contemporary kitchen genre scenes such as Vincenzo Campi's *Kitchen* of 1580 (fig. 3.3), where two credenze are visible: one in the kitchen and a second, in proximity to the dining table, in the background. In some representations, the credenza, called a *buffet* in French, functioned as a stand where impressive objects of human facture stood alongside spectacular products of nature, as in Alexandre-François Desportes's 1726 *Still Life with Silver* (fig. 3.4). Credenze are also visible in drawings and prints recording official banquets, where the display of plate helped emphasize

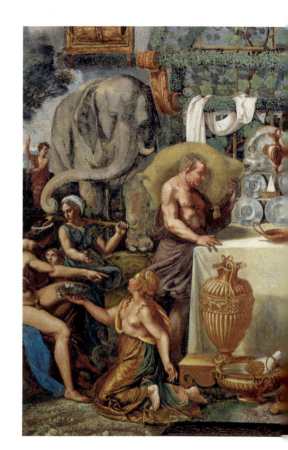

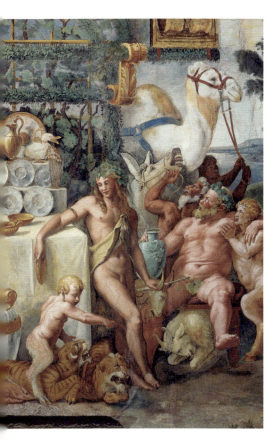

Figure. I.2

Giulio Romano, *Wedding Feast of Cupid and Psyche*, south wall featuring Apollo, Bacchus, and Silenus at a wedding banquet, 1527–30. Fresco. Palazzo Te, Mantua, Italy.

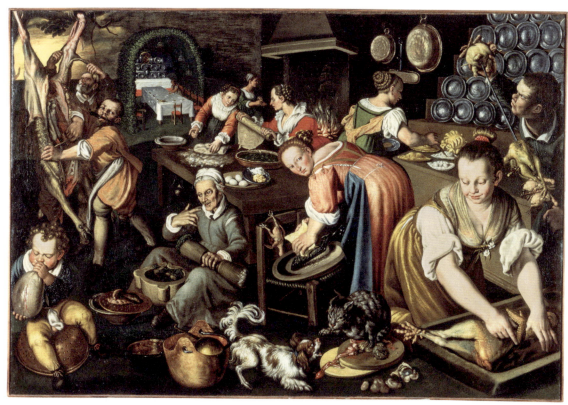

Figure. I.3

Vincenzo Campi, *Kitchen*, ca. 1580. Oil on canvas. Scala / Art Resource, NY.

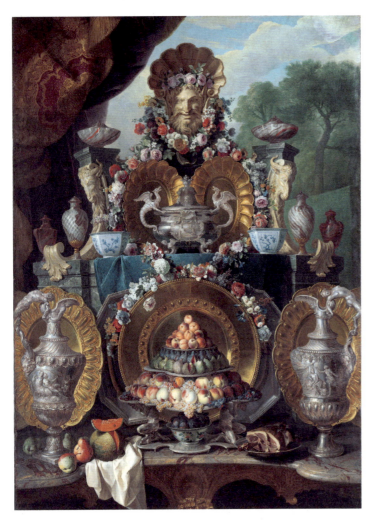

Figure. 3.4
Alexandre-François Desportes, *Still Life with Silver*, ca. 1726. Oil on canvas. The Metropolitan Museum of Art, New York, Purchase, Mary Wetmore Shively Bequest, in memory of her husband, Henry L. Shively, M.D., 1964.

the status of the host family, as in an illustration from an album now in Warsaw depicting the wedding of Alessandro Farnese to Maria of Portugal in Brussels in 1565 (fig. 3.5).[7] On the right, a cup bearer dressed in black hands a goblet to another servant across a wooden barrier that encloses the stepped credenza laden with golden chargers, covered cups, and ewers. A procession of servers winds from right to left bearing what appear to be sugar sculptures in the form of unicorns and stags, swan and peacock pies, and a boar's head. An extended description of the wedding festivities that unfolded over a couple of months, written by Alessandro De Marchi and published in Bologna in 1566, is one of many rich accounts of celebrations that took place all over Europe starting in the late fifteenth century and corroborates the vividly colored images in the Warsaw album.[8] The De Marchi account of the banquets that were part of the wedding includes enumeration of the number and kind of vessels on display, along with details of clothing, jewelry, and music, among other information deemed necessary to communicate the importance of the event. The text provides evidence of the propagandistic force these celebrations were designed to command, amplified by images such as those in the Warsaw album.[9] Many festival booklets, which may be considered early forms of journalism, were accompanied by prints that provided visual evidence alongside verbal description.[10] Accounts of important banquets were also incorporated into some of the carving and folding manuals under examination here, reinforcing their theatrical dimension.

Any attempt to discuss texts dealing with domestic service in the late Middle Ages and early modern period in

3.5 ▶

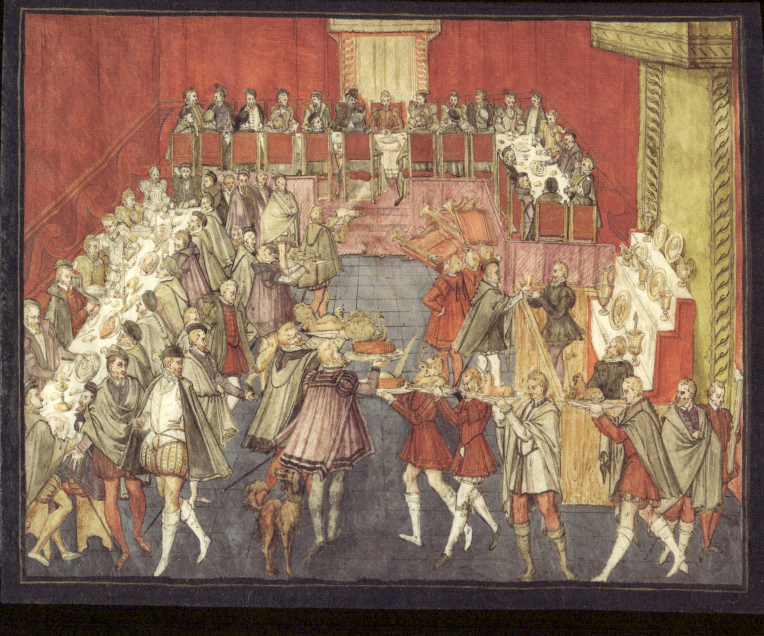

Figure. 3.5

(PREVIOUS PAGE)
Frans Floris, "Banquet at the Brussels Town Hall on 4 December 1565," from *Album Brukselki*, ca. 1565. Pen, iron-gall ink, brush, wash, watercolor, gouache, tempera, and deerskin parchment primed with chalk and gum arabic. The Print Room of the University of Warsaw Library, inw.zb.d.10258.

Europe must acknowledge the complexities of trying to parse the categories of apprenticeship and servitude.[11] Many such texts are explicitly didactic, taking the form of a dialogue between master and pupil. Servants who worked close to the dining table were elevated in relation to those who were in the kitchens or other less visible areas of food service. Many of the books to be discussed in the chapters that follow make the claim that they are instructing household staff in skills appropriate to their status as carver, steward, or cook, outlining appropriate clothing, grooming, and other ways that would enable the officer to meet social expectations. In some cases, an interlocutor announces that he is conveying the substance of his teachings on paper, framing these texts, in prefaces or dedications, as the record of a live pedagogical relationship. Generally speaking, the underlying assumption is that the reader or pupil is eager to soak up whatever information is being provided.

There were many kinds of service in the early modern period, including that of a child toward a parent, a reminder that the term "family" and its cognates in other languages comes from the Latin *famuli*, a group of servants who worked for the same master.[12] Domestic service represented a major channel for the transmission of knowledge and expertise from one generation to the next. Highly trained domestic workers such as carvers, stewards, or cooks may have come up through the ranks as unpaid apprentices but would eventually receive payment, perhaps in the form of food, clothing, lodging, or other in-kind benefits. Whether or not the texts and their illustrations under examination here were conceived to take the place of formal hands-on training for "officers of the mouth," as they were called, is an ongoing question. Going back to the Middle Ages, instruction for table service was often included as part of more comprehensive household management texts that addressed a broad variety of tasks, but by the end of the sixteenth century, individual skills—such as carving meats or folding linens—appeared in highly specialized dedicated publications such as those of Vincenzo Cervio and Mattia Giegher.[13] In many ways, the business of printing and publishing created a market for illustrated treatises that helped nurture the emergence of a professional cohort of food service officers whose practice was commodified between the covers of a book.

This study builds on my examination of Bartolomeo Scappi's 1570 *Opera del arte del cucinare*, which I believe to be the first illustrated cookbook.[14] Initially intrigued with its twenty-seven engraved images that feature kitchen spaces, cooking vessels and implements,

and the mechanics of catering for a papal conclave, I sought to situate this work within the context of culinary history, book history, and print culture in late Renaissance Rome. Scappi, cook to cardinals and popes and a papal chef at the time the book appeared, emerged from the ranks of voiceless servants as an author, probably with the explicit backing and encouragement of brothers Francesco and Michele Tramezzino, who ran a successful publishing house with branches in Rome and Venice. Recipes make up the majority of the volume, accompanied by menus detailing both fictive and actual meals. Later editions of the book, which was reprinted at least eleven times before 1643, were bundled together with additional texts dealing with other aspects of food service, including an illustrated carving manual written by Vincenzo Cervio, who was *trinciante*, or carver, to Cardinal Alessandro Farnese.[15] An exploration of the world of these *trincianti* led me to look backward for precedents and forward to the legacies of this highly specialized form of culinary performance. The kinds of issues I'd like to raise now, looking at the trajectory of carving and napkin folding books all over Europe between the late fifteenth and the end of the eighteenth century, follow directly from the many unanswered questions that remained once that book went to press.

History of the Genre
BEFORE DELVING INTO THE PARTICULARS OF THE BOOKS and their illustrations, a consideration of the genre, and its genealogy, is in order. As I hope to demonstrate, the manuals for carving and folding under examination here emerged from a body of texts dealing with what has been called "courtesy" or "conduct" literature that flourished in the High Middle Ages. Courts across Europe functioned as schools where children, generally boys, were trained in skills deemed essential to becoming successful members of elite society, which included food service. The many shared precepts in the prescriptive sources surveyed here suggest that behavior around the dining table was among the most problematic in a social environment, in need of clearly articulated guidelines. Late medieval texts form the subsoil for the more focused guides to carving and serving that emerged in the early sixteenth century and are the starting point for the current project.

A fundamental touchstone for the history of European court culture in the late Middle Ages and early modern period remains the pioneering work of Norbert Elias. *The Civilizing Process* first appeared in 1939 and provides a fascinating survey of prescriptive texts from

roughly 1300 to 1800.[16] The evidence marshaled by Elias charts evolving behaviors and attitudes around the dining table, among other aspects of social life. Though subsequent historians have formulated significant and convincing critical objections to the model presented by Elias, it remains an important starting point, enabling readers to conceptualize changes over time.[17]

Elias's main story line concerns the development of "the increasing inhibition of impulse."[18] The appearance of regulations governing behavior around the dining table concerning food and the bodily responses it engenders is fundamental to Elias's narrative, but also incidental to the larger structures he is tracing. In brief, Elias argues that a major shift took place between medieval and early modern codes of behavior, marked by the publication and rapid dissemination across Europe of Erasmus's *De Civilitate Morum Puerilium* in 1530 and concomitant standards of polite behavior. However, critics argue that the terms *civil* and *civilitas*, to mean "refined" and "to have good taste," were available to English readers in Latin texts long before they were diffused by Erasmus to the Italian and French authors of early modern courtesy books.[19] Among these early texts are the third-century CE *Distichs of Cato*, which John Gillingham terms "a work of practical morality in the Stoic tradition."[20] The twelfth-century courtesy poem known as *Facetus* was read in English schools from around 1300 to the early sixteenth century and included table manners, as did the *Disciplina clericalis* of Petrus Alfonsi, which promised to reward those who lived "in a more civilised style, dress with more elegance, and eat with more refinement" with tax rebates.[21] Another important early text was the *Liber Urbani* (the book of the civilized man), which also dates to the twelfth century and is, according to Gillingham, the "most substantial courtesy poem in any language." Like many later texts, it contains information on health and nutrition in the tradition of the *regimen*, with recipes included, and instructions for controlling the body and concealing emotions.[22]

Related sources beyond England that dealt with courtesy and conduct, and therefore table manners, include Thomasin von Zirclaere's *Der Welsche Gast*, the oldest surviving didactic text written in vernacular German. Elias includes snippets of *De quinquaginta curitalitatibus ad mensam* by Bonvesin de la Riva (ca. 1240–ca. 1315), a didactic poem written in Milanese Italian dialect (despite its Latin title) that outlines fifty "courtesies," including many precepts that reflect a dining situation where sharing of cups and bowls was the norm. Apparently diners might have their own spoon, and a personal knife that would be transported in a sheath.

Diners were entreated not to drink with a full mouth, lean on the table, create a disturbance, call attention to a fly in the victuals, touch the rim of a shared cup, lick the fingers clean, or pet cats and dogs during the meal.[23] These proscriptions attest to aspects of the material circumstances of the time, when spoons and knives were the only personal utensils (no forks yet), drinking vessels were shared between diners, and household pets were underfoot, as many visual sources confirm.

While it is not my intention to sidestep the conceptual frameworks touched upon by Elias—from the historiography of sacrifice and hunting to that of courtesy and manners—my focus is rather on the ways in which these texts might open windows into the material and social worlds of their authors, publishers, readers, and users. Though Elias engaged with the larger issues of the complex evolution of "civility" from "courtesy," I delve into the weeds and look closely at the texts, images, and objects to understand how they mediated the highly formalized dining rituals that figure as evidence. As the instructions for behavior at the table became more specific and focused in the later sixteenth and seventeenth centuries, texts and images were clearly aimed at a readership not only of boys learning how to become men in a court society, but of women and servants as well, perhaps even predominantly.

Handbooks and Manuals THE EMERGENCE OF SPECIALIZED HANDBOOKS AND manuals dealing with meat slicing and carving, napkin folding, and other visual components of elite dining must also be considered in the context of the codification and dissemination of craft knowledge that began in the late Middle Ages, discussed by Pamela O. Long and others.[24] Pamela H. Smith locates the beginning of the transformation from orality to text with an explosion of vernacular European technical writing beginning around 1400. Many well-known artists and architects wrote treatises, but "many more less-prominent craftspeople also began to write accounts of their trades: gunpowder makers, gunners, fortification experts, navigators, and, even more surprisingly, a galley oarsman in the service of the Venetian navy."[25] The volume of artisanal voices increased dramatically starting in the 1460s with the new medium of print. Cookbooks and other recipe books were among the earliest of vernacular texts to reach broad audiences, as the numbers of printings and the issuing of new editions of the same or minimally amended texts demonstrate.[26]

The carving and folding manuals from the late sixteenth through the eighteenth century under examination here should be seen as prescriptive or didactic texts that recorded a set of instructions and described specialized skills addressed to both practitioners and their elite patrons. Yet they must also have had entertainment value for readers who were neither planning lavish banquets nor instructing their personal chefs or stewards. The carving of meat and the laying of the table were practices that reflected the status of both host and guest. The larger history of conduct and of domestic service looms behind any account of these practices. Though the texts are often grouped under the umbrella category of courtesy and etiquette that address more interpersonal and social behaviors, they also delineate a constellation of highly specialized crafts that demanded specific tools and embodied skill to carry out properly.

While it is often difficult to presume the readership for early modern books, the range of knowledge in the corpus suggests that many had their origins in manuscripts created to transmit specific technical information. Carving manuals and related texts are certainly, at least in part, a form of technical writing, instructing readers of the text and those attentive to the images how to perform a variety of skills including, but not limited to, carving different kinds of meats, fish, and fruit as well as folding linens and creating eye-catching centerpieces. As Pamela Smith has written, "The appearance of these technical guides has been associated with the growth of urban culture and the cities' increased population of a 'middling sort,' who in their social mobility were more isolated from familial sources of technical knowledge and more desirous of new information that might be useful in their emulation of their social betters."[27] Carving manuals fall squarely within this ambit, as higher-level servants and others who needed to know how to manage a large, affluent household, or at least emulate one, made up at least one potential audience for the books. All the texts under consideration here are in the vernacular, suggesting a primarily lay, secular readership rather than a learned or professional one.

It is worth raising the question of whether the appearance of didactic manuals marks the erosion of apprenticeship as the primary means of education for skills pertaining to food service. By the end of the early modern period that Sarah Pennell and Natasha Glaisyer encompass in their survey of several forms of instructional or didactic literature in England, "the decline of guild controls over certain trades, and the slow decrease in absolute numbers

of apprentices across the long eighteenth century provided one of the information 'gaps' into which a didactic text might be introduced as a substitute for oral, face-to-face educative relationships."[28] It is likely that there may be an inverse relationship between the rise of illustrations in technical manuals for table service and the decline of personal training, though this also echoes the increasing prevalence of printed and illustrated books in general so must remain in the realm of speculation.

Among the lenses through which the carving and folding manuals must be considered is that of the history of the book. More expansively referred to as the study of print culture, this term signals the interdisciplinary approach needed to understand these sources—significant as texts as well as objects of visual and material interest, through their illustrations as well as their overall design. The disparate elements of each book may not be examined in isolation. Book history, now a well-established field of study which arguably began with Lucien Febvre and Henri-Jean Martin's *L'apparition du livre* in 1958, remains largely concerned with "important" texts rather than practical or how-to books, dismissing the more pedestrian "popular" printed record, in which handbooks, manuals, and how-to books figure, though this is certainly changing.[29] Scholars have studied parallel genres of early modern books, such as prayer books, playbooks, and manuals for hunting, fencing, horsemanship, penmanship, embroidery, and tailoring, to name a few, but books such as those under study here, part courtesy and etiquette manual, part servant's handbook, and part cookbook, have not generally been examined from this standpoint.[30]

Ancient Origins MANY ANCIENT CULTURES HAD RITUALLY INFORMED PRACTICES around eating meat, but it is in reference to Judeo-Christian traditions that medieval and early modern European court societies ultimately trace their lineage in this, as in many other areas. Early modern texts allude to ancient origins for the role of the carver, suggesting that, as in other realms of expertise, claiming a link with antiquity demonstrated sophistication. The books under study here affirm the persistent centrality of the joint or roast as a manifestation of prestige and power. The status of meat and fowl as the core elements in Western (European/classical) festive meals remains constant, crossing cultural and geographic borders. Among the larger structures that Elias spotlights is "the systematic abstractification

of 'meat' from 'animal.'"[31] Such broader structural assumptions underlie the enterprise of formal performativity associated with the serving of meat at the table.

Scholars of the ancient world and of religion focus on interpretation of both textual and archaeological sources that address the origins of killing and eating animals in the context of sacrifice to appease a deity or galvanize the community.[32] It is therefore surprising that, given the importance of apportioning an animal correctly, dividing up the parts between gods and men, ancient sources are scant on the technical aspects of both butchery and the carving of cooked meats, though their ritual significance is clear. An anthropological perspective on the preparation of meat for consumption is suggestive and allows a connection to be traced between the particularity of ancient sacrifice and the essentially secular customs that are detailed in the later carving manuals under study here.

In ancient epic such as the *Iliad*, knowledge of how to prepare the sacrifice, and which parts could be eaten following the ritual offering, was an important qualification for the narrative's heroic protagonists. In book 9, Achilles has Patroclus mix the wine and help him prepare the main course. He

<div align="center">

set the chopping-block in front of the fire,
and on it he laid the loin of a sheep, the loin also of
a goat, and the chine of a fat hog. Automedon held the
meat while Achilles chopped it; he then sliced the pieces
and put them on spits while the son of Menoetius made
the fire burn high. When the flame had died down,
he spread the embers, laid the spits on top of them,
lifting them up and setting them upon
the spit-racks; and he sprinkled
them with salt.[33]

</div>

Here, and in other similar passages that recount the preparation of celebratory meals, cooking skills—waiting for the embers to die down to achieve the right temperature, threading spits, and salting during the grilling—are placed on a par with knowledge of more traditional crafts of war such as metallurgy or healing. Both slaughter and the cleaning and preparation of the raw meat for consumption as well as carving, the presentation and serving of the cooked, are in play. As Marcel Detienne theorized, "in a ritual where the acts of cooking only extend those of killing and carving, the sacrificer is both butcher and cook."[34] In ancient Greece, the role of the cook evolved from that of the ritual butcher, the *mágeiros*, who helped the priest kill the sacrificial victim with a particular sacrificial knife called the *máchaira*, to a more familiar figure who became a comedic stock character associated with idleness and luxury in the humorous plays of Aristophanes and other writers.[35]

The meaning and method of sacrifice pervades the Hebrew Bible and subsequent rabbinic literature, which recounts regular priestly rituals including sacrifices of grain, animals, and money that were common until the destruction of the temple in Jerusalem in 70 CE, when, to make a long story short, sacrifices were replaced by prayer and study.[36] There is a vast scholarly literature on the topic of sacrifice and its absence in Judaism, but the material context, including the nature of the knives employed, is largely absent from the texts. It is particularly striking that the various terms for cutting tools, whether for agriculture, masonry, or butchery, remain obscure and difficult to interpret with reference to surviving archaeological evidence.[37] Though instructions for kosher slaughter of domestic animals were highly specific and historically defined in biblical and rabbinic texts, the function of illustrations before the modern period appears limited to establishing what kinds of defects in knife blades would disqualify them from use for the slaughter of animals intended to be certified as kosher.[38]

Just as sacrifice provides one historical frame for understanding the human relationship to animals as food, hunting provides another. In the late Middle Ages, the path to the banquet table might begin with the hunt or with the farm. Hunting for sport rather than necessity was, even in the fourteenth century, highly controlled and often limited to upper classes who had access to wild, uncultivated lands that would have been reserved solely for the purpose. The history of hunting is bound up with changing practices in land use and ownership all over Europe and is a large and unwieldy topic.[39]

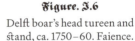

Figure. 3.6
Delft boar's head tureen and stand, ca. 1750–60. Faience. Courtesy Michele Beiny Harkins. Cat. 3.

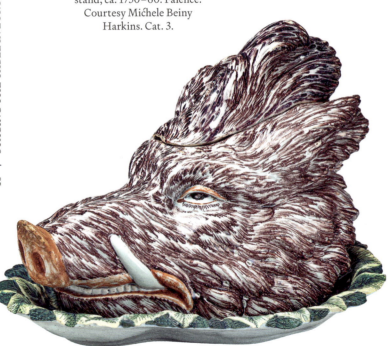

Mythological accounts of hunting and the deities who governed its outcome abound in ancient and medieval visual art and literature. Hunting was a demonstration of skill and cunning as well as dominion over the natural world, and could also symbolize the pursuit of romantic love in chivalric literature or the search for a deity. Hunting allowed the skills of war—weapons and the knowledge to outwit the prey—to be honed in peacetime. Triumphal cavalcades of returning armies could have inspired the processions of servants bearing trophies from the kitchen: savory pies topped by stuffed swans or peacocks, or the ubiquitous boar's head, as seen in many of the carving manuals illustrated here. A delft boar's head tureen, presumably made to serve one of the many recipes for this popular meat, suggests the delight that diners might have taken from its appearance on the table (**fig. 3.6**).

The well-known series of tapestries depicting the hunt for the unicorn at the Cloisters of the Metropolitan Museum of Art have been interpreted on several levels, though scholars do not agree on their meaning, nor even that they are a set.[40] The story that plays out across the seven tapestry panels, probably woven in Brussels in the last years of the fifteenth century, follows a band of aristocratic hunters in pursuit of the unicorn, a mythic creature with a single, twisted horn whose whiteness signified purity and was therefore seen as a symbol of Christ. The hunters carry out their task "by force of hounds," a hunting practice described in detail in the ubiquitous *Livre de Chasse*, written by Gaston de Foix between 1387 and 1389, which is considered to be the standard text on late medieval hunting practices.[41] Once captured, the mythical creature rests comfortably within an enclosure, leading art

historians to interpret it as a Christological allegory, whereby the unicorn represents faith. A panel from the Unicorn Tapestries depicting the return of the hunters to the castle bearing their prey captures the lavish material culture of hunting at its idealistic best, with large spears, gleaming swords, and bejeweled collars for the hounds (**fig. 3.7**).

The *Livre de Chasse* was translated into English in the early fifteenth century as *The Master of the Game* and circulated in many manuscript versions before the advent of printing later in the fifteenth century.[42] The book describes strategies for stalking and killing a variety of game animals, from hares to harts, but the preparation of the meat for consumption occupies

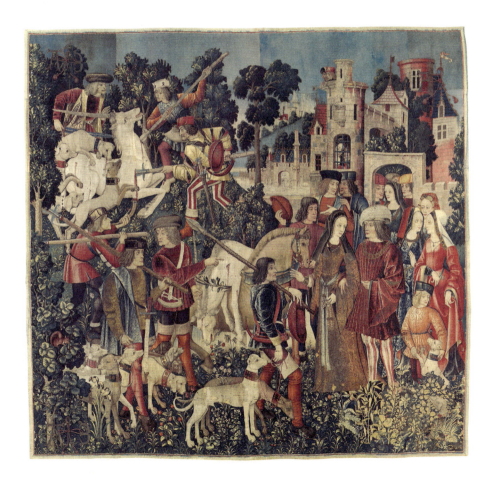

Figure. 3.7
"The Hunters Return to the Castle," from the Unicorn Tapestries, 1495–1505. Wool warp with wool, silk, silver, and gilt wefts. The Metropolitan Museum of Art, New York, Gift of John D. Rockefeller Jr., 1937, 37.80.5.

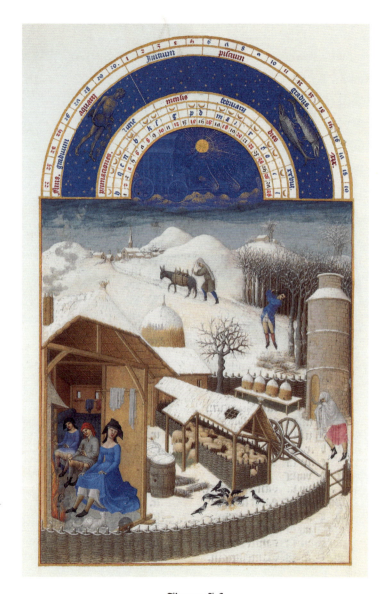

Figure. 3.8
Limbourg brothers (Herman, Paul and Jean de Limbourg), February, from *Les Très Riches Heures du duc de Berry*, 1413–89. Ink on vellum. © RMN-Grand Palais / Art Resource, NY.

only a few paragraphs at the end of the treatise, indicating that butchery was not part of the skill set required by the aristocratic hunters but was likely carried out by professionals.[43]

The aura of the hunt and the prestige value that the serving and presentation of meat retained into the period under study here surely harks back to the idealization of both sacrifice and hunting and its literary and artistic legacy. But the journey of the meat, from hoof to high table, did not always begin with the hunt. Most meat probably came from domesticated animals that were important also in the economy for other products such as horn and hide.[44] Wild fowl and fish as well as small mammals were sold by tradespeople at markets, as can be seen in visual depictions of markets in Italy and the Low Countries.[45]

Farming, like hunting, featured prominently in the cultural imagination of the period. They appear side by side in many iterations of the Labors of the Months. Starting in late antiquity, from allegorical depictions of Greek and Roman gods and goddesses who supervised the seasonality of food production in their earthly realms, to books of hours and cathedral façades, these cyclical activities made manifest the interdependency of natural forces, humans, and animals. Among the most well-known depictions of the Labors of the Months are those in the *Très Riches Heures* of the duc de Berry. The month of August features gaily dressed courtiers, men and women, out hunting with hawks and hounds. The month of February (fig. 3.8) illustrates several agricultural details, including a herd of sheep sheltering in a snow-covered shed, beehives coated in snow, and a person chopping wood to stoke the hearth that warms the laborers in their cottage.

The technical illustrations on the carving of meats that proliferated in the manuals under consideration here, though very different from the colorful illuminations of luxury manuscripts like the *Très Riches Heures*, must be seen in light of the importance that meat retained in the hierarchy of the meal. Knowledge of the seasonality of all foods, and how to choose the best products, was also part of the toolkit of people who sourced or prepared meals, including some of the authors of carving and folding manuals to be examined here.

The next chapter focuses on three texts from the fifteenth century that bridge the late Middle Ages and the more expansive, courtly arena radiating outward from Italy starting in the sixteenth century. Italian texts from 1520 to around 1600, including those of Francesco Colle, Cristoforo di Messisbugo, Bartolomeo Scappi, and Vincenzo Cervio, are the subject of chapter 2. It is in this period that the custom of carving *in aria*, "in the air," becomes associated with Italian courts such as that of the Este in Ferrara, and the many wealthy cardinalate households in Rome. Many of these texts document the refined and cosmopolitan nature of the Italian kitchen and table. Chapter 3 is largely a discussion of Mattia Giegher's *Tre Trattati*, which was the urtext for many of the later carving and folding manuals that feature in chapter 4, such as a group of German books that build on the foundations of the Italian sources, adapting them to local historical events. The final chapter surveys the persistence of the visual and textual traditions in France and elsewhere, returning finally to London, where a set of playing cards was printed in the late seventeenth century using schematic carving images harking back to the Italian treatises, bringing carving skills once the exclusive province of highly trained household staff to the "genteel house-keeper," advertised on the wrapper that contained the deck of cards.

Unless otherwise noted, all translations are my own.

1. "Cartographic historians generally agree on a significant rise in 'map consciousness' in the period, the ability to conceive of one's own place in the world in relation to the spaces surrounding it as visualised through cartographic representation." Bernhard Klein, "Maps and Material Culture," in *The Routledge Handbook of Material Culture in Early Modern Europe*, ed. Catherine Richardson, Tara Hamling, and David Gaimster (Abingdon: Routledge, 2016), 65.

2. As formulated by David Woodward and J. B. Harley, "Maps are graphic representations that facilitate a spatial understanding of things, concepts, conditions, processes, or events in the human world." J. B. Harley and David Woodward, eds., *The History of Cartography, vol. 1, Cartography in Prehistoric, Ancient and Medieval Europe and the Mediterranean* (Chicago: University of Chicago Press, 1987), xvi. See also David Woodward, "Maps and the Rationalization of Geographic Space," in *Circa 1492: Art in the Age of Exploration, ed. Jay A. Levenson* (New Haven, CT: Yale University Press, 1991), 83–87.

3. On architectural plans, see James Ackerman, "The Conventions and Rhetoric of Architectural Drawing," in *Origins, Imitation, Convention* (Cambridge, MA: MIT Press, 2002), 294–317.

4. On the divulging of restricted knowledge through print, see William Eamon, *Science and the Secrets of Nature: Books of Secrets in Medieval and Early Modern Culture* (Princeton, NJ: Princeton University Press, 1994). See also Elizabeth L. Eisenstein, *The Printing Press as an Agent of Change* (Cambridge and New York: Cambridge University Press, 1979), and its critical reception as discussed in Sabrina Alcorn Baron, Eric N. Lindquist, and Eleanor F. Shevlin, eds., *Agent of Change: Print Culture Studies after Elizabeth L. Eisenstein* (Amherst: University of Massachusetts Press, 2007).

5. Among publications that explore account books and other documentary sources to understand the workings of food service in the Italian Renaissance courts are Bruno Laurioux, "Le Registre de cuisine de Jean de Bockenheim, cuisinier du pape Martin V," in *Mélanges de l'École française de Rome—Moyen Âge: Temps modernes* 100, no. 2 (1988): 709–60; Allen J. Grieco, "Conviviality in a Renaissance Court: The Ordine et Officij and the Court of Urbino," in *Ordine et Officij de Casa de lo Illustrissimo Signor Duca de Urbino*, ed. Sabine Eiche (Urbino: Accademia Rafaello, 1999), 37–44; Guido Guerzoni, "Servicing the Casa," in *At Home in Renaissance Italy*, ed. Marta Ajmar-Wollheim and Flora Dennis (London: V&A Publications, 2006), 146–51; and Guido Guerzoni, *Le corti estensi e la devoluzione di Ferrara del 1598* (Carpi: Nuovagrafica, 2000).

6. On the phenomenon of the *Kunstkammer*, see, among many others, the foundational essays in Oliver Impey and Arthur MacGregor, *The Origins of Museums: The Cabinet of Curiosities in Sixteenth and Seventeenth Century Europe* (London: House of Stratus, 2001); and John Elsner and Roger Cardinal, eds., *The Cultures of Collecting* (Cambridge, MA: Harvard University Press, 1994).

7. For a discussion of the buffet and credenza, see Thierry Crépin-Leblond, *Le dressoir du prince*, exh. cat. (Écouen: Musée national de la Renaissance; Paris: Réunion des musées nationaux, 1995), 26–29. See also Allen Grieco, "Meals," in *At Home in Renaissance Italy*, ed. Marta Ajmar-Wollheim and Flora Dennis (London: V&A Publications, 2006), 250.

8. On the manuscript miniatures, now in the University Library, Warsaw, and the rare published account by De Marchi, see Giuseppe Bertini, *Le nozze di Alessandro Farnese: Feste alle corti di Lisbona e Bruxelles* (Milan: Skira, 1997).

9. For a survey of the genre of both print and manuscript festival books, see Bonner Mitchell, "Notes for a History of the Printed Festival Book in Renaissance Italy," *Daphnis* 32, no. 1–2 (2003): 41–56.

10. On this, see, for example, James M. Saslow, *The Medici Wedding of 1589* (New Haven, CT: Yale University Press, 1996), 4. Saslow indicates that fifteen souvenir accounts of the wedding were published.

11. Rafaella Sarti, "Who Are Servants? Defining Domestic Service in Western Europe (16th–21st Centuries)," in *Proceedings of the Servant Project*, 5 vols., ed. S. Pasleau and I. Schopp with R. Sarti (Liège: Éditions de l'Université de Liège, 2005), 2:2.

12. Sarti, "Who Are Servants?," 2:3ff.

13. For example, Vincenzo Cervio, *Il Trinciante di M. Vincenzo Cervio; Ampliato, et ridotto a perfettione dal*

cavalier Reale Fusoritto de Narni, *Trinciante dell'Illustrissimo e Reverendissimo Signor Cardinal Farnese* (Venice: Appresso gli heredi di Francesco Tramezini, 1581); and Mattia Giegher, *Li Tre Trattati di Messer Mattia Giegher Bavaro di Mosburc* (Padua: Guaresco Guareschi al Pozzo Dipinto, 1629).

14. Deborah L. Krohn, *Food and Knowledge in Renaissance Italy: Bartolomeo Scappi's Paper Kitchens* (Farnham and Burlington, VT: Ashgate, 2015).

15. First edition: Cervio, *Il Trinciante* (1581).

16. Norbert Elias, *The Civilizing Process* (1939; Cambridge, MA: Blackwell, 1994), esp. 52–92.

17. Among the critiques of Elias are John Gillingham, "From Civilitas to Civility: Codes of Manners in Medieval and Early Modern England," *Transactions of the Royal Historical Society* 12 (2002): 270–72; and Anna Bryson, *From Courtesy to Civility: Changing Codes of Conduct in Early Modern England* (Oxford: Oxford University Press, 1998).

18. Bryson makes the provocative connection between Elias's text and Freud's *Civilization and Its Discontents*, which appeared a few years before Elias's book, in 1930. Bryson, *From Courtesy to Civility*, 10.

19. Gillingham, "From Civilitas to Civility," 281. See also C. Stephen Jaeger, *The Origins of Courtliness: Civilizing Trends and the Formation of Courtly Ideals 939–1210* (Philadelphia: University of Pennsylvania Press, 2010), 113–17.

20. Gillingham, "From Civilitas to Civility," 279.

21. Gillingham, "From Civilitas to Civility," 272, citing C. Burnett, "The Works of Petrus Alfonsi," *Medium Aevum* 66 (1997): 44.

22. Gillingham, "From Civilitas to Civility," 272–75.

23. Gianfranco Contini, *Le opere volgari di Bonvesin della Riva*, vol. 1, *Testi* (Rome: Società filologica romana, 1941). See also Bonvesin della Riva, *Le cinquanta cortesie da tavola*, ed. Mario Cantella and Donatella Magrassi (Milan: Libreria Meravigli Editrice, 1985).

24. Pamela O. Long, *Openness, Secrecy, Authorship: Technical Arts and the Culture of Knowledge from Antiquity to the Renaissance* (Baltimore and London: Johns Hopkins University Press, 2001), 102ff.

25. Pamela H. Smith, "In the Workshop of History: Making, Writing, and Meaning," *West 86th: A Journal of Decorative Arts, Design History, and Material Culture* 19, no. 1 (2012): 9.

26. Krohn, *Food and Knowledge*, 26–36.

27. Smith, "In the Workshop of History," 9.

28. Natasha Glaisyer and Sara Pennell, *Didactic Literature in England 1500–1800* (Farnham and Burlington, VT: Ashgate, 2003), 9.

29. Lucien Febvre and Henri-Jean Martin, *L'apparition du livre* (Paris: Éditions Albin Michel, 1958); Lucien Febvre and Henri-Jean Martin, *The Coming of the Book: The Impact of Printing 1450–1800*, trans. David Gerard, ed. Geoffrey Nowell Smith and David Wooton (London and Brooklyn: Verso, 1976). See also Adrian Johns, *The Nature of the Book: Print and Knowledge in the Making* (Chicago and London: University of Chicago Press, 1998); Sachiko Kusukawa, *Picturing the Book of Nature: Image, Text and Argument in Sixteenth-Century Human Anatomy and Medical Botany* (Chicago and London: University of Chicago Press, 2012); and Bradin Cormack and Carla Mazzio, Book Use, Book Theory 1500–1700 (Chicago: University of Chicago Library, 2005).

30. Exceptions include Evelyn Lincoln, "Mattia Giegher Living," in *The Renaissance: Revised, Expanded, Unexpurgated*, ed. D. Medina Lasansky (Pittsburgh: Periscope, 2014), 382–401; Glaisyer and Pennell, *Didactic Literature in England*; and *Rudolph M. Bell, How to Do It: Guides to Good Living for Renaissance Italians* (Chicago: University of Chicago Press, 1999).

31. Annette Yoshiko Reed, "From Sacrifice to the Slaughterhouse: Ancient and Modern Approaches to Meat, Animals and Civilization," *Method and Theory in the Study of Religion* 26 (2014): 115.

32. For example, Stefan Schorn, "On Eating Meat and Human Sacrifice: Anthropology in Asclepiades of Cyprus and Theophrastus of Eresus," in *Studies in the History of the Eastern Mediterranean (4th Century B.C.–5th Century A.D.)*, ed. Peter Van Nuffelen (Leuven, Paris, and Walpole, MA: Peeters, 2009), 11–48. The author examines a story from Asclepiades that recounts a priest in Cyprus who touched a piece of burnt meat, put his hand in his mouth to staunch the pain, and liked the taste, sharing it with his wife before being thrown into a chasm for breaking the rules. Eventually, as explained, the eating of roasted meat becomes customary.

33. *The Iliad of Homer*, trans. Samuel Butler (1898), bk. 9, Project Gutenberg, released September 18, 1999, http://www.gutenberg.org/files/2199/2199-h/2199-h.htm.

34. Marcel Detienne and Jean-Pierre Vernant, *The Cuisine of Sacrifice among the Greeks*, trans. Paula Wissing (Chicago: University of Chicago Press, 1989), 11.

35. This evolution is traced by María José García Soler, "Les professionels de la cuisine dans la Grèce ancienne: De l'abatteur au chef," *Food and History* 15, no. 1–2 (2017): 25–43.

36. Mira Balberg, *Blood for Thought: The Reinvention of Sacrifice in Early Rabbinic Literature* (Oakland: University of California Press, 2017), 2–3. Balberg focuses on the Tannaitic sources, up to about the 3rd century CE.

37. Aaron J. Koller, *The Semantic Field of Cutting Tools in Biblical Hebrew: The Interface of Philological, Semantic, and Archaeological Evidence* (Washington, DC: Catholic Biblical Association of America, 2012), 200–217.

38. I would like to thank Joshua Teplitsky for his insights into early modern *shehita* manuals based on his forthcoming work on the topic as presented in a talk, "Books and Butchers: Manuals for Kosher Food Preparation in Early Modern Europe," presented at the Columbia University Material Text Colloquium in December 2019, as well as in personal correspondence.

39. See, for example, John Cummins, *The Art of Medieval Hunting: The Hound and the Hawk* (London: Weidenfeld and Nicolson, 1988).

40. For a summary of the various interpretations, see Adolfo Salvatore Cavallo, *The Unicorn Tapestries at The Metropolitan Museum of Art* (New York: Harry N. Abrams; New York: Metropolitan Museum of Art, 1998), 29–78.

41. On the *Livre de Chasse* and specifically on the use and care of hunting dogs, see Hannele Klemettilä, *Animals and Hunters in the Late Middle Ages: Evidence from BnF MS fr. 616 of the Livre de Chasse by Gaston Fébus* (New York and London: Routledge, 2015), 100–165. See also Cummins, *Art of Medieval Hunting*.

42. William A. Baillie-Grohman and Florence Baillie-Grohman, eds., *The Master of the Game by Edward, 2nd Duke of York: The Oldest English Book of Hunting* (London: Chatto and Windus, 1909).

43. On the history of butchery in medieval England, see Krish Seetah, "The Middle Ages on the Block: Guilds and Meat in the Medieval Period," in *Breaking and Shaping Beastly Bodies: Animals as Material Culture in the Middle Ages*, ed. Aleksander Pluskowski (Oxford: Oxbow Books, 2007), 18–31.

44. For a discussion of leather and horn in early modern England, see Lisa Yeomans, "The Shifting Use of Animal Carcasses in Medieval and Post-medieval London," in Pluskowski, *Breaking and Shaping Beastly Bodies*, 98–115.

45. Fish markets were important sources for natural history research as well, as discussed in Sachiko Kusukawa, "*Historia piscium* (1686) and Its Sources," in *Virtuoso by Nature: The Scientific Worlds of Francis Willughby (FRS)*, ed. Tim R. Birkhead (Leiden: Brill, 2016), 305–34.

✦ CHAPTER I ✦

Courtesy and Carving: Manuscript to Print

THOUGH CARVERS WERE CELEBRATED IN ANCIENT TEXTS SUCH AS JUVENAL'S *Satires*, no treatises that address carving from before the late Middle Ages are known today. This chapter focuses on three texts, two from the fifteenth century and one from the very early sixteenth, that provide written testimony of the already well-established traditions of food service that informed both written sources and practices for the following two centuries. The first, by a henchman at the Aragonese court, opens a window onto the cosmopolitan nature of court life in the early modern Mediterranean, suggesting connections between Castile and the Kingdom of the Two Sicilies, and therefore potentially between Spain and Italy.[1] Two closely related English texts demonstrate similar values and roles for a carver that echo in later Italian sources.

Villena THE EARLIEST TEXT TO ZERO IN EXCLUSIVELY ON CARVING IN Europe seems to be a manuscript treatise by Enrique de Villena known today as *Arte Cisoria*, of 1423. Villena, who died in 1434, was a courtier to his cousin, Alfonso I of Aragon, from 1414 to 1416.[2] Villena was more than a carver, however. In addition to the carving text, he translated Virgil from Latin and Dante from Italian into Castilian. His reputation as a magician or necromancer who communicated with the dead earned him a long afterlife in Spanish literature, including a story in which, in order to outwit the Devil, he "anticipated trouble by having himself cut up fine and placed in a large flask, so that when the Devil came to collect him, he found his intended victim out of circulation, quietly reassembling in preparation for another life."[3] A linkage of the arts of carving with magic, or sleight of hand, is made in several of the seventeenth- and eighteenth-century carving books discussed in chapter 5, pointing to the performative role played by the carver, as well as to the potential power embodied by a person wielding sharp tools in a highly formal and restrictive setting.

In what emerges as a common trope in many kinds of instructional texts from the late Middle Ages, Villena frames his manuscript in its preface as response to a request from a friend at court who expressed curiosity about the arts of

carving. And as in almost all the later carving manuals, there are elaborate instructions not only on the proper way to carve but on the personal comportment of the carver, including his clothing, the way his nails are to be cut, and the length of his beard. The carver was advised to maintain olfactory discipline by avoiding eating onions, garlic, leeks, and cilantro, and to keep clear of smoke, horses, and foundries—smells that would create an association with manual labor.[4] The text also details the variety of knives and forks he should have in his arsenal: five knives of iron and steel, each with specific dimensions and adapted for particular use, and two forks of gold and silver to spear the food and hold it in place while cutting.

Demonstrating a broad knowledge of customs across Europe, Villena reports that Italian, German, and English knife handles were often made of ivory inlaid with gold and silver, while the Moors used small knives since they ate stewed and boneless meats. In Castile, the knives were coarse and heavy, with gilded and fluted handles. Also of note is the role played by the carver as the first line of defense against the poisoning of the master, largely due to his proximity. He was to keep his tools locked so they could not be impregnated with poison, and wear rings with stones—such as rubies, emeralds, diamonds—that were believed to be apotropaic (to protect against the evil eye). Semiprecious materials considered to be antidotes might also be incorporated, such as coral or the horn of a unicorn (in reality more likely a narwhal).[5]

Villena's treatise on carving was not published until the eighteenth century, though Villena himself encouraged its copying in his own day.[6] There are two extant manuscripts; one contains several line drawings of the carver's tools that were adapted when it was first published in 1766 (**fig. 1.1**).[7] The extent to which *Arte Cisoria* prescribes a set of practices that echo in many later texts is striking testimony that it emerged from a culture in which the role of the carver was entrenched.

*The *Boke of Nurture* and the *Boke of Keruynge** THE FOLLOWING PAGES compare two related texts: John Russell's *Boke of Nurture* and the *Boke of Keruynge*. Though they are not the only sources from the fifteenth century that address table service, they have proven to be the most prominent, thanks to their diffusion through later texts. Roughly contemporary with Villena's treatise, Russell's *Boke of Nurture* is among the most detailed of fifteenth-century sources to address this topic. Russell's *Boke*, together with other assorted

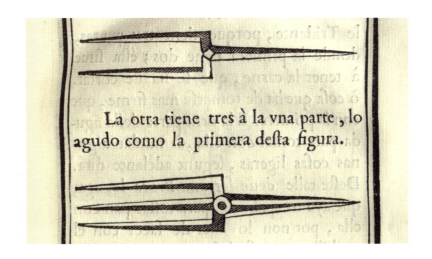

Figure. 1.1
Enrique de Aragón Villena, two forks, from *Arte cisoria, ó, Tratado del arte del cortar del cuchillo, que escrivió don Henrique de Aragon, marques de Villena,* . . . (Madrid: A. Marin, 1766), page 43. Woodcut. Courtesy the New York Academy of Medicine Library, RBS21. Cat. 22.

poems and prose works, were anthologized in a volume by Frederick J. Furnivall, which effectively established a canon for English instructional texts.[8] The *Boke* provides ample evidence for an elaborate system of manners that existed before it was recorded in the fifteenth century. It is the direct source for the first printed book in any European language that uses the term "carving" in its title: the *Boke of Keruynge* was printed in the early sixteenth century and is a prose adaptation of Russell's text.

Russell's *Boke of Nurture* survives in five manuscript versions, all of which were produced between the middle and the end of the fifteenth century.[9] Explicitly directed toward the education of a younger pupil by an older, more experienced teacher, it is framed as a dialogue between the two.[10] Russell, its purported author, identifies himself as an usher and marshal to Humphrey, Duke of Gloucester (1390–1447), though no other biographical details are known. The convention of communicating the information as a conversation or a dialogue is found in a variety of instructional as well as literary texts.[11] The didactic format reflects the educational system in which boys from noble families were trained as pages or squires in large households. The text begins as the usher-narrator comes upon a youth in the forest and proposes to instruct him:

Now, good son, if I will teach, will you learn?
Will you be a serving-man, a ploughman, a laborer,
a courtier, a clerk, a merchant, a mason,
or an artificer, a chamberlain,
a butler, a panter,
or a carver.[12]

The youth replies, "Teach me, sir, the duties of a butler, panter, or chamberlain, and especially, the cunning of a carver." The *Boke* contains vivid detail on the material aspects of the various service or trades roles listed here, as well as on the personal conduct of the servants in those positions.

The duties of the courtiers involved with food service—the server, carver, panter, or butler—were closely allied. They dealt with breads, meats, and drinks, as well as the various kinds of table linens that played a central role in the course of the meal. Service actually began long before the diners arrived, with the laying of the table, or "borde," as it was called. This word is a reminder that dining tables in this period were generally boards on trestles that would be erected for meals and then taken down afterward, rather than fixed pieces of furniture, as they eventually became in later periods.[13]

Following the introduction, the role of panter (elided with the butler) is outlined. Tools are mentioned first off: there should be three knives for the handling of bread—one to chop loaves into rolls, one to pare the rolls, and a third to smooth and square the trenchers. The particular blade profiles are not described, though presumably the different tasks required subtle morphological variations. Different vintages of bread coexisted on the table: for the lord, the bread was to be fresh, but for the others at the table it could be one day old, and for the household in general, three days. The trenchers, which functioned as plates, at the bottom of the hierarchy, were made of four-day old bread.[14] Salt was to be

white, fair, and dry, and a requisite salt-planer, a kind of flat scoop made of ivory, was to be used to level the salt in its receptacle. In a detail that suggests the precision with which these objects were expected to be handled, the lid of the saltcellar was not permitted to touch the salt itself.[15]

Detailed instructions in the *Boke of Nurture* on how to fold the various requisite table coverings foreshadow more elaborate folded textiles that are first recorded visually in the illustrated Italian manuals of the early seventeenth century, such as Mattia Giegher's *Li Tre Trattati*, to be discussed in chapter 3. Napery, including the "bordclothe, towelle, and napkyñ," was to be sweet (presumably alluding to smell), fair, and clean. The multiple layers of linens described in the *Boke* help to contextualize the large numbers of tablecloths, napkins, towels, and other textiles listed in household inventories across the social spectrum well into the eighteenth century.[16] At least two people were needed to carry out the protocols of laying the linens. After wiping the table clean, a cloth was laid, followed by a second and third. Next, the cupboard or the ewery, where the wines were placed at the ready to be served, was to be covered by a cloth. Linens also figured in the personal uniforms of the servants, such as the diapered cloth that was to be hung from the neck and draped over the left arm of the carver, "for that is curtesy, lay that one side of the towaile on thy lift arme manerly."[17] This is visible in the calendar illumination of January from the *Très Riches Heures* (see fig. 3.1).

3.1

Following the laying of the table, the loaves (or rolls) were to be trimmed and wrapped in a "towaile of Raynes," fine cloth spun in Rennes in France, with the ends twisted in order to form a wrapper that was to be unfolded in a flourish in front of the lord, called a "port-payne," or bread carrier. Following the laying of the cloths and preparation of the lord's place, the rest of the table was fitted out with trenchers, spoons, knives, and saltcellars. The sideboard was provisioned with silver and gilt vessels, the washing table with basins of hot and cold water, and plenty of cups and napkins. The *surnape*, a folded covering for the table to be used when the lord was washing, was prepared and put at the ready.

The table knife was to be brightly polished, and the spoon well washed.[18] In his annotated edition of the *Boke*, Furnivall provides references to three different kinds of knives, taken from contemporary inventories or vocabularies: "Kerving knives," "Kneyves in a schethe, the haftys of every (ivory) with naylys gilt," and a "trencher-knyfe."[19] The description of the

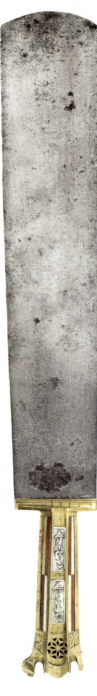

1.2

knife with an ivory haft and gilt nails suggests a luxury object that might have looked like a sixteenth-century Austrian serving knife (fig. 1.2), its brass handle inlaid with bone, walnut, and carved mother-of-pearl, or an Italian carving knife (fig. 1.3) with an ivory handle, though it is impossible to identify specific surviving knives that might correspond in type to these descriptions. The extent to which knives had different profiles and types of decoration based on their use suggests a highly specific design vocabulary that also informs illustrations of knives when they begin to appear in carving manuals in the sixteenth century.

The next section of the *Boke* concerns the service of wine from casks, which had to be drained using an arsenal of specialized tools. Along with how to serve various types of wine, instruction was provided on the selection of seasonal fruits and preserves, butter, cheeses, and comfits: foods that would have been served at room temperature from the credenza. Hot foods were served directly from the kitchen and therefore could not be laid out before the diners were seated. The distinction is made in many later printed recipe books, where suggested menus are organized on the basis of courses served cold from the credenza or hot from the *cucina*. Finally, there is a recommendation to keep cups and vessels clean, and not to give anyone stale drink.

Knowledge of the effects of food on the body was important to anyone in a position of cooking or serving. The narrator suggests, for example, that hard cheese is good for keeping the bowels open, while one should "Beware of saladis, grene metis, and frutes raw, for they make many a mañ have a feble maw."[20] Though the range of domestic knowledge described in Russell's *Boke* does not include medical advice, food and medicine were deeply intertwined in late medieval society, when the theory of dietetics held that good health could be maintained through diet. Galen of Pergamon, a doctor who lived in the second century CE, brought together a number of earlier philosophical and medical ideas. Galenic medicine, as it became known, posited the existence of four humors, or temperaments, that needed to be kept in balance to maintain physical and mental health: blood, yellow bile, black bile, and phlegm. Each "humor" was associated with a season and a set of characteristics that could be, in theory, manipulated by food, the environment, and personal habits. Functions such as sleep, exercise, sex, digestion, hygiene, and emotional well-being were thought to be influenced by the properties of foods and how they interacted with an individual's specific makeup.

Knowledge of the medicinal properties of plants, minerals, and animals filtered into the medieval pharmacopoeia by way of a text by Dioscurides, written in Greek around 65 CE. Known today by its Latin name, *De Materia Medica*, it covered the preparation, properties, and testing of drugs. It served as the basis of many medical recipes, by some accounts, until the nineteenth century.[21] Dietaries such as the *Tacuinum Sanitatis,* from the Arabic *Tarqwin al-Sihhah* (the maintenance of health), written by Ibn Butlan, an eleventh-century Christian doctor from Baghdad (d. 1066), circulated widely all over Europe starting in the middle of the fourteenth century, some in beautiful illustrated luxury manuscripts. Originally presented in tabular form, the *Tacuinum* is a concordance of dietary and environmental factors, both "natural" and "nonnatural," after Aristotle, and describes their effects on health, both salutary and destructive. The *Tacuinum* included information on many kinds of foods, including herbs, vegetables, fruits, grains, and products made from these raw ingredients such as wine, cheese, and bread. In addition, it describes edible animals as well as the seasons, clothing of wool and linen, and the winds.[22] The history of humoral medicine and its relationship to culinary texts is a vast topic that has been addressed by Ken Albala and David Gentilcore, among others.[23]

As a text that touched on a broad array of skills and information, the dietary advice found in the *Boke of Nurture* helps to situate it within an emerging body of culinary literature, though it has few actual recipes. One of these is for making Hypocras, a sweetened and spiced wine that was often served at the conclusion of a meal. Specific utensils are listed, such as pewter basins and straining bags, as well as ingredients: cinnamon, sugar, honey, long pepper, ginger, cardamom, grains of paradise, and *tornsole* (heliotrope, for color).

The section in Russell on the skills of the carver, in contrast to the panter or butler, starts with the couplet: "Son, thy knyfe must be bright, fayre, & clene, and thyne hands faire wasche, it wold the welle be sene." Instructions for how to grip the knife, with the haft in

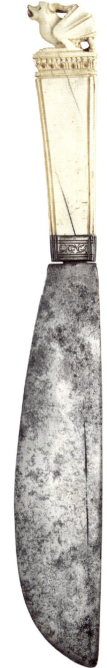

1.3

𝕱igure. 1.2
Attributed to Hans Sumersperger of Hall, serving knife, Austria, 15th–16th century. Steel, brass, wood, bone, and mother-of-pearl. The Metropolitan Museum of Art, New York, Rogers Fund, 1951, 51.118.3. Cat. 7.

𝕱igure. 1.3
Knife, Venice, 14th century. Ivory and steel. The Metropolitan Museum of Art, New York, Frederick C. Hewitt Fund, 1911, 11.137.4. Cat. 12.

the middle of the hand, follow, with an admonition to have only two fingers and a thumb on the knife so as not to get hurt.[24] The relationship between knife and hand would take visual form in the early seventeenth-century carving manuals. Hygiene, applied to knives but also to linens, to the hands of the carvers, and to their clothing, is a trope which runs through all the handbooks and manuals from the late Middle Ages through the eighteenth century.

All the carving manuals surveyed here presume both a visual and linguistic competence in reference to the kinds of animals that the carver might encounter. This parallels the humoral or dietetic knowledge contained in the section about wines and fruits—how the various foods might affect the eater. The carver had to know what the animals were called, and how to make connections between the words and the flesh. Since the text does not provide any information about where to procure the animals—such as how to track them in the wild or to hunt—the narrator presumed that a variety of meats and fowl were readily available and would be provided as directed or requested by the head of the household.

Though the text is introduced by the narrator of Russell's *Boke* as a guide for an uneducated and aimless young man who expressed the desire to learn the skills of courtesy, it is unlikely that poor, unconnected youths were the real audience. The various kinds of knowledge, tasks, and skills indicated in the *Boke* were brought together by someone, perhaps a man named Russell, though his identity has recently been thrown into question, and it is largely irrelevant whether or not Russell actually composed the rhyming couplets.[25] More significant is that this type of specialized knowledge—of tablecloths, knives, linens, and where to place trenchers and rolls and saltcellars—must have been fairly diffuse, and not solely the province of servants to the elite.

*The *Boke of Keruynge** IN DEMONSTRATION OF THIS LARGER AUDIENCE, RUS-sell's text had a long afterlife through a truncated version, the *Boke of Keruynge*, that was printed by Wynkyn de Worde in 1508 and 1513. This text survives in two unique copies, both in the Cambridge University Library. Looking at the relationship between John Russell's manuscript *Boke of Nurture* and the *Boke of Keruynge* printed in the early sixteenth century allows us to speculate on an evolving audience for carving and folding knowledge, and points to the popularity of printed books with this content in the later sixteenth and sev-

enteenth centuries. The *Boke of Keruynge* renders the playful, mnemonic rhymes of Russell's verse in a flatter, more straightforward style, conveying the information in prose without the poetic finesse of Russell's original couplets. The comparison suggests an emerging audience for instructional texts such as Russell's *Boke* that a publisher like Wynkyn de Worde sought to capitalize on and implies the presence of readers curious about how to carry out the tasks described, whether for practical use or simply for entertainment or social advancement. The readership, audience, or market for specialized knowledge of tasks involving the kitchen and table remains a subject for speculation. It is clear, however, that a published book would have reached a larger audience than a manuscript.

This raises a question that vexes any study of didactic or how-to books from the early modern era, and while it is impossible to answer definitively, it must be acknowledged. To what extent was Russell's manuscript or Worde's book intended to be followed as a guide to practice, as opposed to simply establishing a record of that practice? Carrie Griffin suggests that the shortened, more marketable version of the text printed by Worde points to different readers from those that a manuscript such as Russell's *Boke* might have had: a middle-class rather than elite audience.[26]

Though the range of skills touched on in Russell's *Boke* is much broader than that in the *Boke of Keruynge*, shortened to make it more economically viable as a printed book, the sections on draping the linens are largely the same. As one of several technical sections of the manuscript, where very detailed, step-by-step instructions were presented, the relationship of the narrator to the tasks being set forth deserves to be explored. Though individual details are clearly and authoritatively conveyed, including actual measurements in yards or ells, the difficulty for modern readers in following the order and the sequence suggests that the presumed author or narrator was not particularly skilled at communicating the tasks which he may have been very skilled at carrying out.

Only after going through the instructions for laying the table, the properties of foods, and guidelines for personal comportment of the servants, does Worde's text address the mechanics of carving. Though neither Russell nor Worde can be considered a cookbook (not yet an established genre in the early fifteenth century), they comprise a great deal of information on how food was prepared and served. This was the responsibility of the servers and

carvers—what we'd now call "front of the house." Cooks working in the kitchen would presumably be following their lead in terms of menus and presentation.

In keeping with its shortened length, the *Boke of Keruynge* begins with a straightforward description of its content, abandoning the introductory section where Russell is entreated to instruct the youth, thus framing the narrative. It starts with a simple statement: "Here begins the book of carving and sewing [serving] and all the feasts in the year for the service of a prince, or any other rank. You will find the duties of each service in this book."[27] The book then launches into the "Terms of a carver." This is taken directly from Russell. This highly specific vocabulary for serving up meats and fowl was clearly one of its primary purposes—that is, to catalogue appropriate terminology that was an important part of the carver's verbal arsenal. Each animal demanded a particular verb for its undoing: the carver must break a deer, rear a goose, lift a swan, spoil a hen, fruche a chicken, unbrace a mallard, unlace a coney, display a crane, disfigure a peacock, allay a pheasant, wing a partridge, mince a plover, thigh a pigeon, tyre an egg, splat a pike, splay a bream . . . and so on. The richness of this vocabulary speaks to long-term oral traditions that inform the codification of the phrases in print.

The job of the carver was to cut the meat into small enough pieces for the diners to eat with their hands, since personal forks were not routinely used until the seventeenth century in most of Europe, with Italians leading the trend.[28] The carver was also tasked with adding the proper condiments to the cooked meat or fowl as it was served up. To dismember a heron, for example, was done thus: "Take a heron and take off its legs and its wings like a crane, and sauce it with vinegar, mustard, powdered ginger, and salt." This included removing all the indigestible parts such as wings, sinews, skin, hair, and bones.

The only illustration in the *Boke of Keruynge* is the title page (**fig. 1.4**), reinforcing the idea that many skills would have been imparted through emulation or live instruction rather than through the images or diagrams that were to become more common in the course of the sixteenth century. The woodcut depicts an intimate meal with three diners and at least two servants. It helps to describe the book, advertising its content to prospective buyers, rather than providing supplementary information to interpret the text. The second printing of the *Boke of Keruynge* uses the same title page, with little or no change to the organization of the text within.

Figure. 1.4
Wynkyn de Worde, title page, from *Here begynneth the boke of keruynge* . . . (London: Wynkyn de Worde, 1508). Woodcut. Reproduced by kind permission of the Syndics of Cambridge University Library, Sel.5.19.

¶ Here begynneth the boke of keruynge.

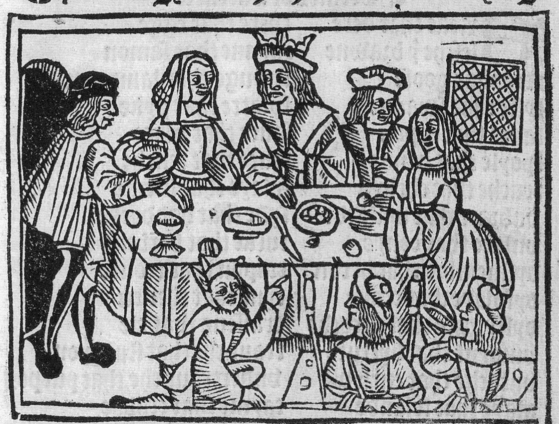

In the course of the sixteenth century, as printed books of many sorts become ubiquitous, books about food—how to cook and how to serve—increasingly incorporate images along with texts. In the following chapters, the emergence and diffusion of illustrated carving manuals demonstrates a lively market for food knowledge that crossed geographic and cultural borders.

Unless otherwise noted, all translations are my own.

1. On this connection, see Olivia Patrizot, "Un noble au service d'un art: L'ecuyer tranchant en Espagne et en Italie à la fin du Moyen Âge," in *La Table de la Renaissance: Le mythe italian*, ed. Florent Quellier and Pascal Brioist (Rennes: Presses Universitaires de Rennes; Tours: Presses Universitaires François-Rabelais de Tours, 2018), 131–50.

2. The definitive modern edition is *Arte Cisoria*, ed. Russell V. Brown, Biblioteca Humanitas de textos inéditos 3 (Barcelona: editorial Humanitas 1984). See also Olivia Patrizot, "En qué manera se deve servir el ofiçio del cortar: L'*Arte Cisora* d'Enrique de Villena (1423)," *Circé: Histoire, Savoirs, Sociétés*, no. 5 (2014): http://www.revue-circe.uvsq.fr/en-que-manera-se-deve-servir-el-oficio-del-cortar-larte-cisoria-denrique-de-villena-1423/.

3. Doris King Arjona, "Enrique de Villena and the *Arte Cisoria*," Hispania 43 (May 1960): 209, citing S. M. Waxman, "Chapters on Magic in Spanish Literature," *Revue Hispanique* 38 (1916): 287–348.

4. Sol Miguel-Prendes, "Chivalric Identity in Enrique de Villena's *Arte Cisoria*," *La corónica: A Journal of Medieval Hispanic Languages, Literatures, and Cultures* 32, no. 1 (2003): 307–42.

5. Joan Evans, *Magical Jewels of the Middle Ages and the Renaissance* (1922; New York: Dover, 1976).

6. Patrizot suggests this, based on the following quotation from Villena's text: "E eso mesmo para que lo comuniquedes a muchos por traslados, conplaziendo en ello a vuestros amigos, e asy en utilidat común redunde. E que tengades a cautela dél todavía dos oreginales, uno que de vos non partades, e otro para prestar, porque algunas vezes non tornan los libros prestados" (And this so that you may communicate it to many through copying, thus pleasing your friends, and so for common utility. And that you take care to have two originals, one of which you do not part with, and another to lend, because sometimes the lent books are not returned). Patrizot, "En qué manera se deve servir."

7. *Arte cisoria o tratado del arte del cortar del cuchillo / Que Escrivió Don Henrique de Aragon, Marques de Villena, la da a Luz [. . .] la Biblioteca Real de San Lorenzo del Escorial* (Madrid, 1766). On this edition, see Russel V. Brown, "El 'Arte Cisoria' de Enrique de Villena: Borrador de una desconocida edición del siglo XVIII," *Romance Notes* 18 (1978): 398–403. The illustrated manuscript is held by the Biblioteca de Menéndez Pelayo, Santander.

8. Rickert and Naylor, *Babees' Book*, 26. Rickert's edited prose translation draws on Furnivall's compilation.

9. Carrie Griffin profitably examines the other manuscripts with which the *Boke of Nurture* is now bound to conclude that "these range from volumes that reflect what we describe as the aspirational tendencies of a household to books that are more practical and that co-locate the *Boke of Nurture* with other kinds of utilitarian text." *Instructional Writing in English 1350–1650: Materiality and Meaning* (New York: Routledge, 2019), 39–40.

10. Virginia Cox discusses the form of the dialogue, albeit mainly from a later period, in *The Renaissance Dialogue: Literary Dialogue in Its Social and Political Contexts, Castiglione to Galileo* (Cambridge and New York: Cambridge University Press, 1992), esp. chap. 2.

11. Evelyn Lincoln discusses illustrated dialogues that were also didactic manuals in *Brilliant Discourse: Pictures and Readers in Early Modern Rome* (New Haven, CT: Yale University Press, 2014), 211–35.

12. Rickert and Naylor, *Babees' Book*, 26–27.

13. For a discussion of tables, including those with trestles, illustrated by images taken from period sources, see Peter Thornton, *The Italian Renaissance Interior, 1400–1600* (New York: H. N. Abrams, 1991), 205–20.

14. Frederick J. Furnivall, *Early English Meals and Manners* (London: Kegan, Paul, Trench, Trübner, 1868), 4.

15. For a modern definition, see William Dwight Whitney, ed., *The Century Dictionary: An Encyclopedic Lexicon of the English Language* (New York: Century, 1906), 4528.

16. On the large numbers of linens in inventories, see Sanny De Zoette, "Laying the Table," in *Class Distinctions: Dutch Painting in the Age of Rembrandt and Vermeer*, by Ronni Baer et al. (Boston: MFA Publications, 2015), 83n23.

17. Furnivall, *Early English Meals and Manners*, 13. I have modernized the spelling slightly, emending in this and the following citations Furnivall's transcription of the Middle English.

18. Furnivall, *Early English Meals and Manners*, 4.

19. Furnivall, *Early English Meals and Manners*, 4n1.

20. Furnivall, *Early English Meals and Manners*, 8.

21. See Paula De Vos, "European Materia Medica in Historical Texts: Longevity of a Tradition and Implications for Future Use," *Journal of Ethnopharmacology* 132, no. 1 (2010): 28–47.

22. On the illustrated versions of the *Tacuinum*, see Cathleen Hoeniger, "The Illuminated *Tacuinum sanitatis* Manuscripts from Northern Italy c. 1380–1400: Sources, Patrons, and the Creation of a New Pictorial Genre," in *Visualizing Medieval Medicine and Natural History, 1200–1550*, ed. Jean A. Givens, Karen Reeds, and Alain Touwaide (Aldershot and Burlington, VT: Ashgate, 2006), 51–81. See also Florence Moly, "Il *Tacuinum Sanitatis* alla corte dei Visconti: Un testo Arabo fra manuale medico e oggetto di curiostià," in *Islamic Artefacts in the Mediterranean World: Trade, Gift Exchange, and Artistic Transfer*, ed. Catarina Schmidt Arcangeli and Gerhard Wolf (Venice: Marsilio, 2010), 195–204; for a fascinating discussion of the representation of women, see Giulia Orofino, "Il pane e le rose: Donne e cereali nell'iconografia dei Tacuina sanitates," in *La civiltà del pane: Storia, techniche, e simboli dal Mediterraneo all'Atlantico*, ed. Gabriele Archetti (Milan: Centro studi longobardi, 2015), 1339–55.

23. Ken Albala, *Eating Right in the Renaissance* (Berkeley: University of California Press, 2002); and David Gentilcore, *Food and Health in Early Modern Europe: Diet, Medicine, and Society, 1450–1800* (London and New York: Bloomsbury Academic, 2016). On the history of humoral theory more generally, see Noga Arikha, *Passions and Tempers: A History of the Humours* (New York: HarperCollins, 2007).

24. Furnivall, *Early English Meals and Manners*, 21.

25. Carrie Griffin writes, "We cannot be certain whether John Russell was the author of the poem: he may be a fictional persona or he may have simply compiled a prologue and appended it to a pre-existing work." *Instructional Writing in English*, 48–49.

26. Griffin, *Instructional Writing in English*, 48–49.

27. Wynkyn de Worde, *The Boke of Keruynge*, ed. Peter Brears (Lewes: Southover Press, 2003), 26. I am citing Brears's translations.

28. For a summary of the history of the use of forks, see Barbra Ketcham Wheaton, *Savoring the Past: The French Kitchen and Table from 1300 to 1789* (Philadelphia: University of Pennsylvania Press, 1983), 54–55.

ARVING WAS WELL-ESTABLISHED AS A COURTLY SKILL WITH ITS OWN SET of very specific protocols, as outlined in the previous chapter, by the beginning of the sixteenth century. In what follows, I will survey the printed books, many of them illustrated, that were brought out in the course of the long sixteenth century in Italy.[1]

The first printed carving manual to be illustrated with the tools of the carver was Giovanni Francesco Colle's *Refugio de povero Gentilhuomo*, published in Ferrara in 1520.[2] It contains a single illustration of a suite of knives (fig. 2.1). The title, which could be translated as "A refuge for a poor gentleman," suggests that the book will provide useful information for a well-born but impecunious servant who could read it to acquire the skills to serve in an elite household. The author explains the title in his preface: "I call it a refuge, because the only refuge from derisible poverty is immortal and comforting virtue."[3] In keeping with other instructional texts ostensibly authored by practitioners asked to record their knowledge, Colle indicates that his employer, Alfonso d'Este, requested that he write "this simple and incongruous little work" about "skillful and courtly carving."[4]

The patronage of the Este family is signaled in the iconography of the book—this may very well have been a court-sponsored project. The Este coat of arms appears on the title page, surrounded by a border composed of classicizing elements: a frieze above and below, trophies, shells, and a pair of nudes reminiscent of Adam and Eve—notorious eaters by way of their tasting of the forbidden fruit, signifying knowledge. A border featuring religious imagery such as the Annunciation and prophets, housed within a similar architectonic framework, is found on the first page of the first signature of the text, following the unpaginated front matter. Extremely rare today, the slim quarto of about forty pages must have been printed in very small numbers.[5]

Following the introduction, the author gets down to business with instructions on how to clean knives and forks used for carving, using the *terra* or dust that was a by-product from the sharpening of the tools. This technical section

FRVTE

SMEMBRATORE

CARNE

CARNE

CARNE

TORTA

CARNE

FRVTE

precedes a more general discussion of terminology, a clue about the book's composition: it suggests that a set of notes penned by Colle himself was given to an editor who got things jumbled in the process of preparing the text for printing. The term he employs for the office is "courtly carver, what I call the name for the person who cuts, the name of whom is Trinciante in the Gallic language, and also in Spanish."[6] The fact that he indicates that the term "trinciante" comes from French and Spanish is noteworthy. This word, which is also used as a verb, *trinciare* (to carve), became the standard Italian term later in the sixteenth century and was in turn adopted in the German, Swedish, and Dutch texts well into the seventeenth and eighteenth centuries to indicate the Italian way of carving. The citation of other languages may be a reflection of the polyglot nature of the court and suggests that "courtly carving" was already recognized as a widespread and international phenomenon before the explosion of printed carving manuals in Italy later in the sixteenth century.

To demonstrate his knowledge of classical sources, Colle refers to a passage from Juvenal's *Satires* that must have been well-known in the Renaissance, one of two that appear in other carving texts as well.[7] The *Satires* recount a series of dinner parties, providing opportunities to discuss topics around food preparation and service. The context for this citation is a *cena* or dinner hosted by a patron, Virro. One of the guests is his client Trebio, who is progressively humiliated by being served rotten food and wine while watching his patron dine on delicacies. The presence of the carver, referred to by a Greek rather than Latin term (*Chironomunta*), brings the client's indignation to a fever pitch and drives home the author's condemnation of the immoral nature of Roman society:[8] "Meanwhile, to ensure no cause for resentment is lacking, watch the carver prancing about, with *brandissements* of his flying knife, and carrying out each last one of his master's instructions: no small matter to make a nice distinction between the proper gestures for the carving of hares and hens!"[9]

This lively evocation of the performative nature of the carver from Juvenal's fifth *Satire*, along with a second passage from the eleventh *Satire*, appears in a much earlier source as well: Michele Savonarola's treatise *De modo incidendi* (how to carve), written sometime in the first half of the fifteenth century. Savonarola (1385–1466), grandfather of the much better-known religious reformer Girolamo Savonarola, was a doctor who taught at the University of Padua until 1440, when he moved to Ferrara to serve as court physician to the Este until his death.

Figure. 2.1
Giovanni Francesco Colle, carving tools, from *Refugio overo ammonitorio de gentilhuomo* (1532), A2v–3r. Woodcut. Special Collections, Regenstein Library, University of Chicago, TX885 C650 1532. Cat. 2.

His work on carving fits into his larger oeuvre on medical topics, including dietetic writings. His most well-known work is the *Libreto de tutte le cosse che se manzano* (a small book about everything that one eats), written for Borso d'Este, Duke of Ferrara (1413–1471) in the mid-fifteenth century but not published until 1508, which provided guidance about how to eat well, following in the tradition of the late medieval dietaries.[10]

Savonarola's manuscript on carving, presumably written while he was at the Este court, was published in the 1534 *Schola Apiciana*, an anthology of ancient and late medieval writings on food, which was likely compiled by the German humanist Fichard (1513–1581) and brought out under the name of Polyonimo Syngrapheo.[11]

This same citation from Juvenal appears as an epigram in the 1766 edition of Villena's *Arte Cisoria*, presumably added by its editor, Padre Francisco Núñez, chief librarian of the Escorial at the time, who may have come across it in the *Schola Apiciana* or elsewhere. While Villena himself does not include the passage from the fifth *Satire*, he does refer to a passage from the eleventh *Satire* that recounts the way that elite carvers would practice their craft, using models made of elmwood.[12]

As we saw with John Russell's *Boke of Nurture* and Wynkyn de Worde's *Boke of Keruynge*, which both contained sections on "terms of a carver," providing the requisite vocabulary for the tasks at hand was a central function of the text. But Colle takes this a step further, adding representations of the knives as well as descriptions. The inclusion of an illustration of the tools of the carver is consonant with the text's material specificity. In a woodcut printed on a single sheet folded into the book, the knives appear in silhouette, dark, dense shapes labeled according to their function—fruit, meat, cake, and dismembering.[13] Missing from the rendering is anything beyond relative scale, which reinforces the notion that the representation was for purposes of identification or naming, rather than facture. The reversed *n* in the word *carne* (meat) in the three knives and one fork indicated for that purpose is clearly a mistake, but once the block was cut, it would not have been worth recutting the entire image. The book is divided into three chapters that address the way to carve a variety of meats, fowl, fish, and fruit.

Carving *in aria* COLLE'S TEXT ALSO CONTAINS THE FIRST MENTION OF WHAT became the trademark of Italian carvers, and of carving "in the Italian manner," a phrase that is commonly used in many of the seventeenth-century northern European adaptations, as I will discuss in further chapters. This is carving *in aria*; literally, "in the air." All the subsequent Italian texts provide instructions for carrying out this most performative of carving techniques, which demands that the carver suspend the piece of meat or fowl on the fork while slicing it neatly and cleanly into pieces that fall on a platter below. In the chapter on carving a roast or boiled hen, almost as an afterthought, he writes, "and of that part which you would like to carve in the air, place the fork in the shoulder, and don't remove it until the hen is cut as described above, and do the same with everything that you wish to carve in the air."[14] The offhand way in which the directive appears suggests that this method was already entrenched in the practice of carving. It was to become highly celebrated later in the sixteenth century.

Another text from the 1520s confirms the working hypothesis that there was an emerging readership for table service books, and one that was not composed solely of professional carvers or stewards, since the title explicitly states that it will instruct readers to do it *like* the professionals.[15] Signed by Eustachio Celebrino, its long descriptive title provides a summary of its contents: *A new work which instructs how to set a table for a banquet: & and also how to carve all kinds of meat at the table & to serve the foods following the order used by the stewards to honor foreigners. Called The Refettorio it includes related recipes for cooking and also for preserving meat and fruit for an extended period* [. . .].[16] A slim fifteen-page text that includes menus for meals of varying complexity, several editions were published between 1526 and in 1532.[17] The *Refettorio* was not the only publication signed by Celebrino (ca. 1490–1535). He authored a variety of other texts including a formulary for writing love letters, recipes for perfume "to make all women beautiful," and several salacious novellas. He also worked as an engraver of wooden blocks for handwriting manuals and pattern books, which makes it puzzling that the *Refettorio* does not contain illustrations beyond its title page.[18]

Perhaps the most celebrated Italian food text from the first half of the sixteenth century is Christoforo di Messisbugo's *Banchetti, composizioni di vivande e apparecchio generale*, published in Ferrara in 1549.[19] At least part of its fame can be attributed to the high profile of the context in which it arose—the Este court in Ferrara. Messisbugo served as a ducal administrator

(*provedditore ducale*) from 1515 until his death in 1548, first under Alfonso I d'Este and then under his successor Ercole II d'Este.[20] Along with recipes, the book comprises an extensive verbal catalogue of objects: pieces of furniture, various elements of bedding, many different types of lamp and candelabra, and vessels for the table. A hierarchy of materials prevails, with silver specified for a saltcellar and various basins to go on the "prima tavola," or the table of the lord, while those for other tables are nonspecific.

Messisbugo lists the various kinds of textiles needed for meal service, including "Tovaglie da acqua a mani et da vivande," meaning napkins for drying the hands after handwashing at the table and for dining, as well as coverings for the credenza, where cold foods were placed, and the *bottigliera,* or bottle rack. Cloths for swathing the knives are also listed, similar to those described in the *Boke of Nurture*. He also mentions two kinds of knives: "Coltelli con le sue forzine per trinzare, & Coltelli per le Tavole, e Cuchiare, e Pironi": knives with their forks, for carving, and table knives, with spoons and forks. It is notable that the word "Pironi" is used here to refer to forks for the table, as contrasted with "forzine" (*forchette* in standard Italian), which is specifically used to mean a carving fork, a fork "per trinzare" or *trinciare*.[21]

Following a lengthy catalogue of food and drink considered necessary to undertake entertainment on this scale, a list of officials follows. Given the exhaustive quality of the list, it is somewhat surprising that Messisbugo does not name the office of the carver as one of the service positions required to create the banquets referred to in the book's title, though it is probable that the overall managerial position of *scalco* or *schalco* (steward) included carving. The publication of Colle's 1520 book, devoted exclusively to carving and dedicated to Alfonso d'Este, as well as the fifteenth-century treatise by Michele Savonarola on carving, probably written while he was serving as the personal physician to Alfonso's predecessor Borso, suggests that carvers played an important role over several generations at the Este court.

After Messisbugo's introductory section establishing the ingredients and the *mise en place*, there is a series of menus from historic meals, including what was served, in what order, and to whom and then, finally, recipes. A clue to the readership of the book can be gleaned from the suggestions for less-grandiose meals: "if there is a middle-class gentleman [*Gentil'uomo mezzano*] who is giving a banquet, he could use a third less sweets and spices."[22] He also suggests when honey could be substituted for sugar, and when not, since honey was cheaper

but would discolor some of the dishes that needed to be pure white. Perhaps fearing he had overstated the cost-cutting tips, he explains that he is "not . . . instructing how to fry a tench or cook a pike on the grill, or other similar things that any simple woman knows how to make perfectly."[23] With this seemingly offhand remark, Messisbugo indicates an awareness of readers who might not be members of the upper crust, though it is clear that he is not going to go too far into the preparation of more ordinary meals. In any case, with this, he acknowledges that his readership might cross social and economic categories, as does Celebrino. The dishes described are presented as the products of highly skilled labor, but the recipes are also meant to be accessible to a more modest user. The healthy market for the book, which appeared in twenty editions through 1626, confirms that this strategy successfully stimulated a broad-based readership.[24]

Perhaps the first representation of a *trinciante* wielding his tools appears in Bartolomeo Scappi's *Opera*, a compendium containing recipes, menus, and information necessary for running a princely kitchen, published in 1570. In the image, a carver stands at a small table demonstrating the use of the fork to hold a joint aloft while carving it with a knife in his other hand (**fig. 2.2**). Blood or juice drips from the joint into a bowl beneath, as the carver holds the meat with his iconic tools: the knife and the fork that appear in many of the subsequent carving images. The caption reads, "smembratione" (dismembering or carving), echoing the caption on one of the knives represented in Colle's treatise of 1520. Though Scappi's book does not include diagrams for carving or other detailed instructions, the presence of carvers at the tables of his clients is indicated in the section of the book that lists menus. From the illustration here, these carvers were likely using the technique that Italian carvers were already famous for: carving *in aria*, with the meat suspended above a platter by a large, two-tined fork.

Scappi's *Opera* also contains an image of "various knives," many of which might be used by *trincianti* at table, among others that were used in food preparation (**fig. 2.3**). Included in this arsenal are highly specialized knives for sweeping the table, for oysters, cake, and pasta, a tool for shaping macaroni, a larding needle, and a small stake for a songbird—anything with a blade or a point. The group of knives is one of several copperplate illustrations in the book that function as visual inventories of the equipment needed to outfit a papal kitchen. Others show different varieties of pots and pans, as well as colanders, ladles, graters, and so on.

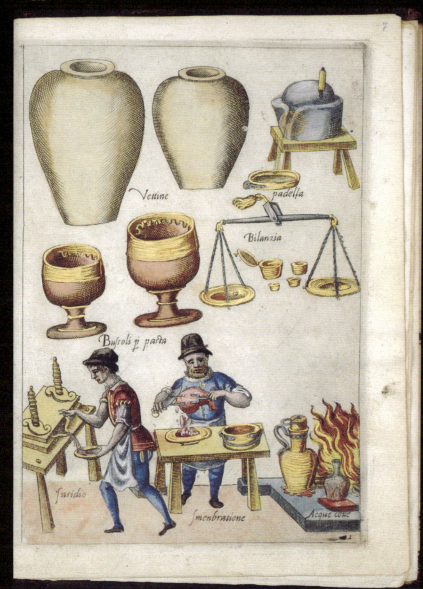

Figure. 2.2
Bartolomeo Scappi, "Vettine," from *Opera* . . . (Venice: Michele Tramezino, Venice, 1570), plate 12. Hand-colored engraving. Niedersächsische Staats- und Universitätsbibliothek Göttingen, Manuscripts and Rare Prints / University Archives 8 OEC I, 3660 RARA. Cat. 24.

Figure. 2.3
Bartolomeo Scappi, "Diversi Coltelli," from *Opera* . . . (Venice: Michele Tramezino, 1570), plate 13. Hand-colored engraving. Niedersächsische Staats- und Universitätsbibliothek Göttingen, Manuscripts and Rare Prints / University Archives 8 OEC I, 3660

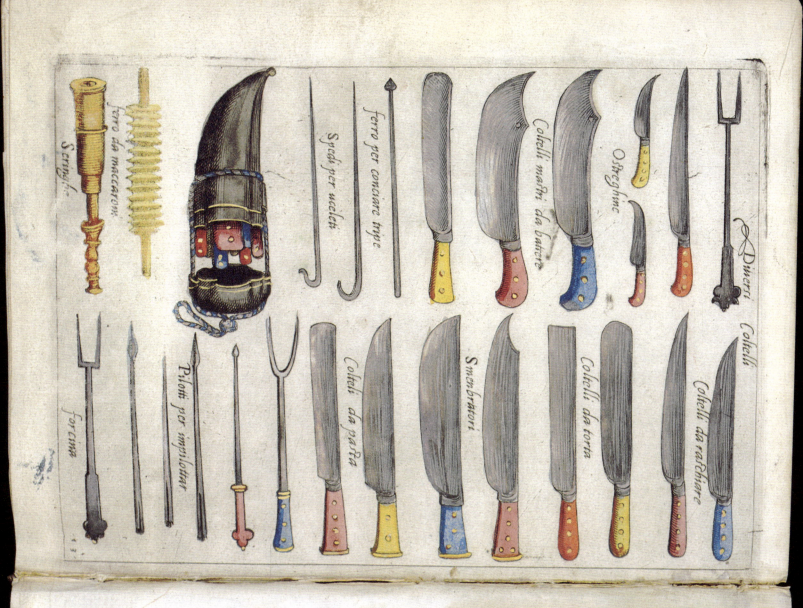

Earlier texts, such as Messisbugo's *Banchetti*, contained exhaustive lists of tools and equipment, but Scappi's book was first to present them in visual form.

Following the success of Scappi's *Opera*, Vincenzo Cervio's *Il Trinciante* was published in 1581 by the heirs of Francesco Tramezino—the same family that published the *Opera* (fig. 2.4). In the dedication to the book, the Cavalier Reale Fusoritto da Narni, *trinciante* to Cardinal Alessandro Farnese, explains that he took it upon himself to complete a manuscript left unfinished by his predecessor Cervio at his death.[25] A note to the readers, signed by publisher Venturino Tramezino, provides further information about the book's creation. "My ancestors the Tramezini always strove to bring new, useful and delightful things to the world," Venturino

Figure. 2.4
Vincenzo Cervio, title page, from *Il Trinciante . . . ampliato, et ridotto a perfettione dal cavalier Reale Fusoritto da Narni, Trinciante dell'Illustrissimo e Reverendissimo Signor Cardinal Farnese* (Venice: The Heirs of Francesco Tramezini, 1581). Woodcut. Courtesy the New York Academy of Medicine Library.

begins, adding that "Among the works they brought to light, and of no small estimation, [there was] *Il Panonto*, which both instructs how to recognize good foods, and shows how to cook them well; no less is the work of Bartolomeo Scappi, which teaches not only the goodness of foods and how a great cook cooks them, but also how a perfect steward should comport himself, and what kinds of foods aid the sick in convalescence." He then explains, "I wanted to complete those two works by adding one for someone who wants to know how to serve the written dishes, after they have been cooked and placed on the table, by carving them as befits a great Prince or a Lord . . . so a booklet about this came into my hands, written by Vincenzo Cervio, who was a great carver, much praised by all who knew him, and after showing it to experts, having found it worthy of accompanying the aforesaid Authors, I diligently printed it and I offer it to all those who delight in things noble."[26]

Venturino does not mention that the *Trinciante*, like Scappi's *Opera*, is also illustrated. It contains three fold-out woodcuts depicting tools and a pair of fowl. The first shows a serrated knife, a fruit fork, and a triangular fork that would enable the carver to secure a soft-boiled egg in its grip, slice its top off, and then season it with salt, sugar, cinnamon, or whatever the patron requested before serving it up, as described minutely in the text (**fig. 2.5**).[27] The second shows two birds—the turkey and the peacock with their parts labeled (**fig. 2.6**), as we learn from a second edition printed in 1593.[28] The turkey is called a "Gallo d'India"; literally, an Indian chicken, since Europeans first encountered turkeys in the early sixteenth century as an import from the

Figure. 2.5
Vincenzo Cervio, knife, fruit fork, and egg holder, from *Il Trinciante . . . ampliato, et ridotto a perfettione dal cavalier Reale Fusoritto da Narni* (Venice: The Heirs of Francesco Tramezini, 1581). Woodcut. Courtesy the New York Academy of Medicine Library.

2.6

East Indies.[29] The third, a fold-out, illustrates a graduated set of four knives and three two-tined forks (fig. 2.7). Like the images in Colle, they provide the requisite vocabulary and relational scale so the carver can identify his tools as he learns the techniques, and indeed the treatise is quite detailed in its description of the tools and their facture. Cervio provides a history of carving forks and knives, refining further the terminology and emphasizing his personal knowledge of the forms and materials most advantageous in getting the job done. In keeping with earlier texts by Messisbugo, Scappi, and others, he includes several detailed descriptions of the dishes served and the entertainments offered at a selection of historical banquets for illustrious patrons.

After a long disquisition on what a *trinciante* should *not* do, he explains the proper comportment and technique for the execution of the office. In addition to general qualities of virtue and obedience, he should place himself either directly in front of the patron, or at the head of table, so he can keep his eye on what is being eaten, and so the patron can see him in action as he carves: performance is key to the identity of the *trinciante*.[30] He goes on to explain that "the true *Trinciante* will slice everything with the fork raised above the

Figure. 2.6
Vincenzo Cervio, "Gallo d'India—Pavone," from *Il Trinciante . . . ampliato et a perfettione ridotto dal Cavalier Reale Fusoritto da Narni* (Rome: Gabbia, 1593). Woodcut. Rare Books Division, The New York Public Library, *KB 1593 (Cervio, V. Trinciante). Cat. 30.

Figure. 2.7
Vincenzo Cervio, carving forks and knives, from *Il Trinciante . . . ampliato, et ridotto a perfettione dal Cavalier Reale Fusoritto da Narni* (Venice: The Heirs of Francesco Tramezini, 1581). Woodcut. Courtesy the New York Academy of Medicine Library. Cat. 20.

2.7

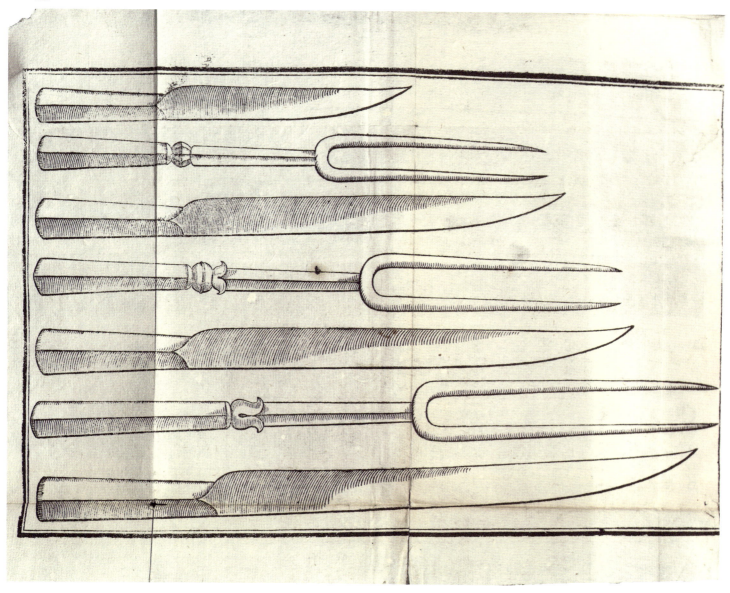

plate, which in Italy we are normally [*vulgarmente*] accustomed to calling carving in the air, and truthfully, among all the fashions of carving, it is impossible to carve more beautifully or more politely than this." He continues with an extended metaphor, comparing learning to carve properly with the acquisition of equestrian skills: "it is necessary for he who wants to learn to carve to first know how the forks and knives are made, and of what temper, and how they are cleaned and when to sharpen them, and how to hold them in the hands, and how to use them, and how to hold oneself while using them."[31]

Cervio continues, explaining that carvers in France and Germany use forks with long handles and short tines, and knives with long handles and long, blunt blades, so they have to carve on the plate rather than on high, sometimes even holding the food steady with their hands. He disapproves. In Spain and Naples, they use forks with short handles and long, heavy, thick tines and short-handled, long-bladed knives that bend at the front which could be used to carve in the Italian manner, but with these it was also easy to cut a finger. After further musings on various attempts to perfect carving forks and knives, he concludes that the ideal models are those he uses himself:

you will find them always useful and good . . .
and when you have impaled the thing that you want to carve,
and raised it up . . . you will have the thing farther away
from your hand and from your body, so that it will be
a pleasing sight, and you will be certain not to
touch the thing with your hand, and certain
also not to touch it with your fingers,
which you could not avoid
with short knives
and forks.

Believe me, since I have had this experience many times, when using short forks and knives. Thus, for the reasons laid out above I conclude that you will not find a more beautiful or more useful style than this, which style of forms and knives you will see drawn [disegnata] on the following pages.[32]

He also goes into great detail describing the materials for the forks and knives: forks of iron, burnished and polished to seem like silver, and knives of carefully tempered steel so as not to melt with the heat of the meat, or bend too much.[33]

Two subsequent editions of *Il Trinciante* were published in 1593, one in Rome and the other in Venice. The Roman version contains two additional texts by Fusoritto da Narni, including a dialogue with his student and nephew Giovanni Battista Fusoritto and a second dialogue between Fusoritto, described here as *trinciante* to the Cardinal Montalto, and Cesare Pandini, major domo ("Mastro di Casa") of Signor Cardinal Farnese, both wealthy and famous patrons. Though carving was the primary activity of the *trinciante*, his role was closely tied to that of the *scalco*, or steward, called also the *maestro di casa*, who oversaw many different tasks and workers in a large household, including the kitchen staff.

The later editions of Cervio's *Trinciante* contain additional illustrations, suggesting an expanded role for the carver. They depict two tablescapes: one with a central fishpond that would enable diners to fish for their supper, and a second edged with greenery, both suggestions for tabletop entertainment in the tradition of the medieval *entremet* or the English *soteltie* (**figs. 2.8 & 2.9**). The foods themselves might be skillfully carved and served up by

2.8 2.9

Figure. 2.8
Vincenzo Cervio, table setting with fishpond, from *Il Trinciante... ampliato et ridotto a perfettione dal Cavalier Reale Fusoritto da Narni* (Venice: The Heirs of Giouanni Varisco, 1593). Woodcut. Archive.org, Getty Research Institute, Los Angeles. Cat. 48.

Figure. 2.9
Vincenzo Cervio, table setting with greenery, from *Il Trinciante... ampliato et a perfettione ridotto dal cavalier Reale Fusoritto da Narni* (Rome: Gabbia, 1593). Woodcut. The Metropolitan Museum of Art, New York, Harris Brisbane Dick Fund, 1935, 35.10.13.

the *trincianti*, but linens and tabletop sculptures of various materials were equally important as supporting characters in the performance. The illustrations are slightly different in the two distinct 1593 editions of *Il Trinciante*. Though the variations are minor, they suggest that the printers recut the matrices for their editions, making small changes along the way, allowing for the wide dissemination of closely related but not identical images across time and space.

In 1605 (and again in 1610) Venetian printer Alessandro Vecchi reissued Scappi's *Opera* with a new title page announcing the inclusion of *Il Trinciante* by Cervio and the two additional texts published in the 1593 editions (fig. 2.10). Like Venturino Tramezino, who positioned *Il Trinciante* within the context of his family's earlier publications, the publishers and booksellers who collaborated to bring out subsequent Scappi editions of 1610, 1622, and 1643 continued to include the additional texts on carving and household management, suggesting that the projected readership for a book of recipes and menus would be rounded out or completed by this information. They also dispensed with the printer's device that appeared on the title page of earlier Scappi books, replacing it with a more marketing-informed double illustration that gave potential buyers a taste of the book's contents. The right-hand panel depicts a kitchen with an elaborate clockwork rotisserie on which three spits turn, threaded with roasting viands.

In the left panel, a carver stands before a table laid for a meal. Demonstrating his skill, he brandishes a bird on a fork *in aria* with his left hand, holding a knife in his right hand, as instructed in the manuals. These two implements, the two-tined fork to hold the piece of meat and the corresponding knife to slice it, are the signature tools of the Italian carver in many of the subsequent depictions. A credenza stocked with dishes can be seen in the upper right, completing the picture of a meal properly served. The bundling of texts addressing various aspects of food service seems to have been a successful strategy among publishers of manuals or handbooks in both Italian and German markets.

A closely related text that emerges from the same milieu in Rome is Cesare Evitascandolo's *Dialogo del Maestro di Casa*. A detailed manual in the popular form of a dialogue for all-around domestic service, it was first published in 1598, but based on manuscripts that had been in circulation from the 1570s, according to the text itself.[34] It includes discussion not only of the responsibilities of the carver but also of his ideal age and comportment and the proper care of his tools—namely, his knives: there should be five of them, of different sizes with their matching forks, and a sixth, for the sole purpose of opening oysters. It is best that the carver should clean his own knives, before sharpening, polishing, and placing them in a box filled with bran. The interlocutor remarks that he thought it best to place them in mortar, or *calcina*, but the response is that bran is better for the handles of the knives, which are usually of bone. If the carver is not going to use the knives for a while, he should rub them with a salve made of deer marrow mixed with powdered sugar to

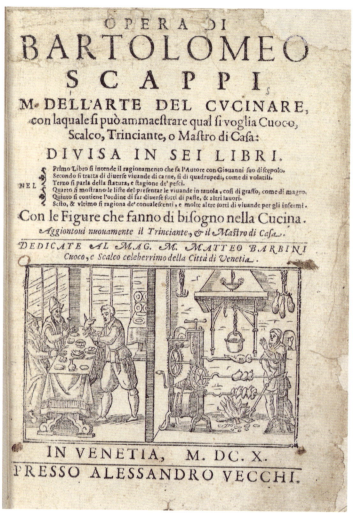

Figure. 2.10
Bartolomeo Scappi, title page, from *Opera*... (Alessandro Vecchi, 1610). Woodcut. Rare Books Division, The New York Public Library, *KB 1610 (Scappi, B. Opera). Cat. 37.

prevent them from rusting. He adds that this "secret" (*secreto*), meaning recipe, can also be used for swords, cuirasses, and other armor. From the matter-of-fact tone with which these substances are mentioned, they must have been readily available.

This text is also concerned with the carver's need to keep his linens clean, not using his hand towel to wipe the knives so as to make sure it doesn't get too greasy for wiping his hands. These linens could be used for a variety of tasks during the meal service, including makeshift bandages when the carver slices his finger and contrives to keep it covered until the end of the service so as not to reveal his clumsiness to the patrons. Although not illustrated, Evitascandolo's text vividly evokes the material world of the carver, who must maintain composure amid the greasy foods and sharp blades of his trade.

While these texts—Savonarola, Colle, Celebrino, Scappi, Cervio, and Evitascandolo—address the office of the carver and his training, they do not anatomize or represent the tasks graphically in the detail that is found in the early seventeenth-century sources that are the subject of the following chapters. They were nevertheless significant precedents for the particular constellation of knowledge that is brought together in the Italian and German carving and folding manuals of the seventeenth century.

Unless otherwise noted, all translations are my own.

1. There were undoubtedly earlier texts that were not published, such as a manuscript from 1466 called *Taiare de cortello*, written in Venetian dialect. Olivia Patrizot, "Un noble au service d'un art: L'ecuyer tranchant en Espagne et en Italie à la fin du Moyen Âge," in *La table de la Renaissance: Le mythe italian*, ed. Florent Quellier and Pascal Brioist (Rennes: Presses Universitaires de Rennes; Tours: Presses Universitaires François-Rabelais de Tours, 2018), 132n4.

2. The colophon reads, "Stampato in Ferrara per Magistro Laurentio di Russi da Valentia. A di XX di

Zugno M.D.X." There was also a second edition in 1532: Giovanni Francesco Colle, *Refugio Ouer Ammonitorio De Gentilhuomo*, with no place of publication indicated. The 1532 edition has a more elaborate title page without the modifier "povero," or the dedication to Giuliano de' Medici.

3. "Dico refugio perche l'ultimo refugio de la irisa povertade e la imortal e consolatoria virtute." Colle, *Refugio*, n.p.

4. "maxime ne gli passati giorni che del artificioso e cortegiano tagliar componer cosa alcuna io dovesse, la qual benigna commisione non sapendo e non volendo e non potendo scusare, feci questa inornata e incongrua operetta." Colle, *Refugio*, n.p.

5. There are eight copies in public collections: Ferrara, London (2), Madrid, Rome, Bloomington, Indiana (Lilly Library), and University of Chicago.

6. "cortegiano tagliare, che io dico el nome di quello che taglia, el nome del quale, se dice nel Gallico idioma, Trinciante, e nello Hispanico anchora." Colle, *Refugio*, 1v.

7. The *Satires* often figured in humanist educational curricula. See Eva Matthews Sanford, "Renaissance Commentaries on Juvenal," *Transactions and Proceedings of the American Philological Association* 79 (1948): 92–112.

8. For an in-depth study of this *Satire*, see Mark Morford, "Juvenal's Fifth Satire," *American Journal of Philology* 98, no. 3 (1977): 219–45.

9. Juvenal, *The Sixteen Satires*, trans. Peter Green (London: Penguin Books, 2004), 32. The Latin reads, "Structorem interea, ne qua indignatio desit, saltantem spectes et chironomunta uolanti cultello, donec peragat dictata magistri omnia; nec minimo sane discrimine refert quo gestu lepores, et quo gallina secetur." Juvenal et al., *A. Persii Flacci, D. Ivnii Ivvenalis, Svlpiciae Satvrae*, 3rd ed., recognovit Otto Iahn, ed. Franciscus Buecheler (Berlin: Weidmannos, 1893), 107–8, *Satire* 5, lines 120–24.

10. Michele Savonarola, *Libreto di tute le cosse che se manzano* (Venice: Simone de Lucre, 1508). See also Massimo Alberini and Michele Savonarola, *Breve storia di Michele Savonarola: Seguita da un compedio del suo Libreto de tutte le cosse che se manzano* (Padua: Editoriale Programma, 1991).

11. The full title is *Schola Apiciana: Ex optimis quibusdam authoribus diligenter constructa; qua continentur officia Coniuatoris, Cultus & Habitus boni Co[n]uiuij, Qualitates &*

Regulae Opsoniorum, Rationes secandi uel Scrutandi in mensa, Sermones conuiuales, Quaestiones conuiuales iucundisimae, & alia item plura (Frankfurt: Christian Egenolff, 1534).

12. This passage from Juvenal is also cited and translated into German by Georg Philip Harsdörffer. See chapter 4.

13. There are visual affinities with the technique of blackwork printing, used by jewelers and metalworkers, though that technique was generally created with metal plates through engraving rather than the woodcuts here, and did not appear until later in the sixteenth century. Femke Speelberg, "Blackwork: A New Technique in the Field of Ornament Prints (ca. 1585–1635)," in *Heilbrunn Timeline of Art History* (New York: Metropolitan Museum of Art, 2000–), http://www.metmuseum.org/toah/hd/blak/hd_blak.htm. I am grateful to Evelyn Lincoln for pointing out the parallel with blackwork.

14. "e de quella parte che vorai tagliare nelaria/ meterai la forcina nelle spalle / e non la mouerai fina che sia tagliata la galina del modo sopradetto/e cosi farai de tutte quelle / che nellaria tagliare vorai." Colle, *Refugio*, Biii.

15. This point is made by Allen Grieco, "Meals," in *At Home in Renaissance Italy*, ed. Marta Ajmar-Wollheim and Flora Dennis (London: V&A Publications, 2006), 247.

16. *Opera noua che insegna a parecchiar una mensa a vno conuito: & etiam a tagliar in tauola de ogni sorte carne & dar li cibi secondo l'ordine che vsano gli scalchi per far honore a forestieri. Intitulata Refettorio appresso aggiontoui alcuni secreti apertinenti al cucinare & etiam a conseruar carne e frutti longo tempo* [...].

17. Venice, 1526; Cesena, before 1530; Brescia, 1532. For the Venice copy, see Claudio Benporat, "A Discovery at the Vatican—the First Italian Treatise on the Art of the Scalco (Head Steward)," in *Petits propos culinaires*, November 1988, 41–45. There is also a related text unsigned and without date, at the University of Chicago Library, as mentioned by Benporat.

18. Evelyn Lincoln, "Mattia Giegher Living," in *The Renaissance: Revised, Expanded, Unexpurgated*, ed. D. Medina Lasansky (Pittsburgh: Periscope, 2014), 392. Alessandro Giacomello, "Il "Refettorio" di Eustachio Celebrino: Edizioni sconosciute e rare di un testo sulla tavola nel primo '500," in *Il Friuli e le cucine della memoria fra Quattro e Cinquecento: Per un contributo alla cultura dell'alimen-*

tazione (Udine: Forum, 1997), 23–49; and Luigi Servolini, "Eustachio Celebrino da Udine intagliatore, calligrafo, poligrafo ed editore del sec. XVI," *Gutenberg Jahrbuch* 19–24 (1944–49): 179–89.

19. Christoforo di Messisbugo, *Banchetti, Compositioni di Vivande, et Aparecchio Generale* (Ferrara: Giovanni de Bulghat and Antonio Hucher Compagni, 1549).

20. For a summary of his biography, see Luciano Chiappini, *La Corte Estense alla metà del Cinquecento: I compendi di Cristorforo di Messisbugo* (Ferrara: Stabilimento Artistico Tipografico Editoriale, 1984), 39–50.

21. Messisbugo, *Banchetti*, iii. According to historical dictionaries, *pironi* appears to be Venetian for "fork," from the Greek πιρούνι (πιρούνια), but can also be used to mean a nail or some kind of stake. The connection to Greek is intriguing, since some sources trace first use of the fork in the West to the Byzantine court in Venice. For the definition, see WordSense Online Dictionary, s.v. "πιρούνι," https://www.wordsense.eu/πιρούνι/.

22. "Dove é da sapere che se fosse alcuno Gintil'huomo mezzano, che facesse il convito, potrebbe egli fare col Terzo meno de Zucchari e spitiarie." Messisbugo, *Banchetti*, n.p.

23. "questo solo e da sapere ch'io no[n] spendero Tempo, o fatica in descrivere diverse minestre d'hortami, o legumi, e in insignare di frigere una Tencha, o cuocere un Luzzo su la gratella, o simili altre cose, che da qualunque vile feminuccia ottimamente si sapriano fare." Messisbugo, *Banchetti*, n.p.

24. Henry Notaker, *Printed Cookbooks in Europe, 1470–1700* (New Castle, DE: Oak Knoll Press; Houten, Netherlands: Hes & De Graaf, 2010), 298–305.

25. "Essendomi capitata alle mani questa operetta di M. Vincentio Cervio, gia Trinciante . . . e ritrovandola imperfetta in molte parte, per la morte sopragiunta all'Autore." Vincenzo Cervio, *Il Trinciante di M. Vincenzo Cervio; Ampliato, et ridotto a perfettione dal cavalier Reale Fusoritto de Narni, Trinciante dell'Illustrissimo e Reverendissimo Signor Cardinal Farnese* (Venice: Appresso gli heredi di Francesco Tramezini, 1581), [iii].

26. Cervio, *Il Trinciante*, [iv–v].

27. Cervio, *Il Trinciante*, 41r.

28. Vincenzo Cervio, *Il Trinciante: Ampliato et ridotto a perfettione ridotto dal caualier Reale Fusoritto* (Rome: Ad istanza di Giulio Burchioni, nella Stampa di Gabbia, 1593).

29. Sabine Eiche, *Presenting the Turkey* (Citta di Castello: Petruzzi Stampa, 2004), 16.

30. Cervio, *Il Trinciante*, 3r.

31. Cervio, *Il Trinciante*, 3v.

32. Cervio, *Il Trinciante*, 5r–v.

33. Cervio, *Il Trinciante*, 5r–v.

34. Cesare Evitascandolo, *Dialogo del Maestro di Casa* (Rome, 1598.) See Laurie Nussdorfer's discussion of Evitascandolo in "Managing Cardinals' Households for Dummies," in *For the Sake of Learning: Essays in Honor of Anthony Grafton*, 2 vols., ed. Ann Blair and Anja-Silvia Goeing (Leiden and Boston: Brill, 2016), 173–94.

✦ CHAPTER III ✦

Carving and Folding Visualized: Mattia Giegher's *Tre Trattati*

THIS CHAPTER WILL EXAMINE IN DETAIL MATTIA GIEGHER'S *LI TRE TRATTATI* (the three treatises), published in 1629, arguably the most influential of the carving and folding books thanks to its much-imitated illustrations.[1] The proliferation of illustrated handbooks and manuals for table service, including the performative skills of carving *in aria*, across Europe in the seventeenth century suggests that knowledge and skills once reserved for elite households had become more widely desirable, or at least a reasonable market risk for publishers. Previous chapters have traced the persistence of these practices through a group of texts with a smattering of illustrations, but the potential to impart the particulars of these courtly arts was not fully harnessed until the seventeenth century.

The forty-eight copperplate illustrations for carving meat, fowl, fish, and fruit, and folding napkins and other linen table decorations in Giegher's *Tre Trattati* inspired copies and adaptations in related publications into the nineteenth century. These illustrations established a visual language for the representation of the arts of carving and folding, though their designer and engraver remain anonymous. Giegher's book is notably in the format of an oblong quarto, somewhat unusual for the period. Other books published in this format include musical scores, tailor's patterns, and handwriting manuals—books that worked best opened out in a landscape fashion. Since books were generally bound in paper or vellum in flexible bindings, the weight of the pages opening in a landscape format, with the bound edge the shorter of the rectangle, would enable the book to rest comfortably in an opened state, useful for consultation even with both hands occupied with a task such as playing an instrument, writing with a quill, or folding and carving. Many of the subsequent didactic manuals retained this format well into the eighteenth century.

Earlier illustrated books, such those of Colle and Cervio, depicted the carver's utensils such as forks and knives, and even a knife-sharpening machine and a carver at work in the kitchen, as in Scappi. Giegher's works push this genre of illustrated technical manual to a new level by showing not only the tools of the trade but the tools activated in the hands of the artisan wielding them, in what

Figure. 3.1

Mattia Giegher, *Li Tre Trattati* (Padua: Guaresco Guareschi al Pozzo dipinto, 1629), plate 1. Engraving. Universitätsbibliothek Basel, AP V 31a.

seems almost stop-action detail (**fig. 3.1**). The presence of these eerily disembodied hands is one of the elements that makes the folding and carving diagrams so powerful. Similarly isolated hands of the folder or the carver appear across the range of these books into the modern period. They demonstrate the proper way to hold tools and materials, thus bridging the gap between reader and user, serving as virtual proxy.

Mattia Giegher was born Matthias Jäger in Moosburg, Bavaria, around 1589, and was teaching his linen-folding skills in Padua from around 1616, according to historian and artist Joan Sallas.[2] Limited biographical information exists for Giegher, much of it coming directly from the text of his books. Sallas has been able to verify Giegher's identity through the three hunting horns that appear as his personal coat of arms next to his portrait in the book, and which are also found on the tomb of a bishop with the same name in the Johanniskirche in Moosburg.

Giegher first appears in the historical record in 1621, with the publication of a pamphlet called *Il Trinciante,* clearly following in the tradition of earlier carving manuals, even borrowing the title of Cervio's 1581 book.[3] A second pamphlet was published in 1623, *Lo scalco* (the steward), also bearing a title that was used by several authors, including Evitascandolo (1609), Lancellotti (1623), and others.[4] In 1629 *Li Tre Trattati* appeared, with its own title page, where the author explained that the volume included the two previous publications, *Lo scalco* and *Il Trinciante*, with the addition of a third which promised to "show with great ease the way to fold any kind of linen fabrics, that is, napkins and tablecloths, and how to set a table, with certain other gallantries worth knowing." He continued to say that they are all "rappresentate in figure di rame"—that is, depicted in copper-plate engravings—and that they are "a totally new invention by the author, never seen before."[5]

By the early 1620s, similar engraved images in carving manuals by other authors were already circulating, but the folding images are new.[6] The folding treatise is the first of the three books in the volume, with the *Scalco* and the *Trinciante* following. Giegher also mentions the copperplate engravings for these, claiming that the *Trinciante* has been refreshed and enlarged, as was common in re-editions. Giegher himself dedicates this volume of his collected works to Burcardo Ranzovio (Burkhardt Rantzau), from Sassdorf in Bavaria, who was the councilor of the German Nation at the law school of the University of Padua, claiming, with the false modesty that is typical of many books of this genre, that as the faithful servant of this body,

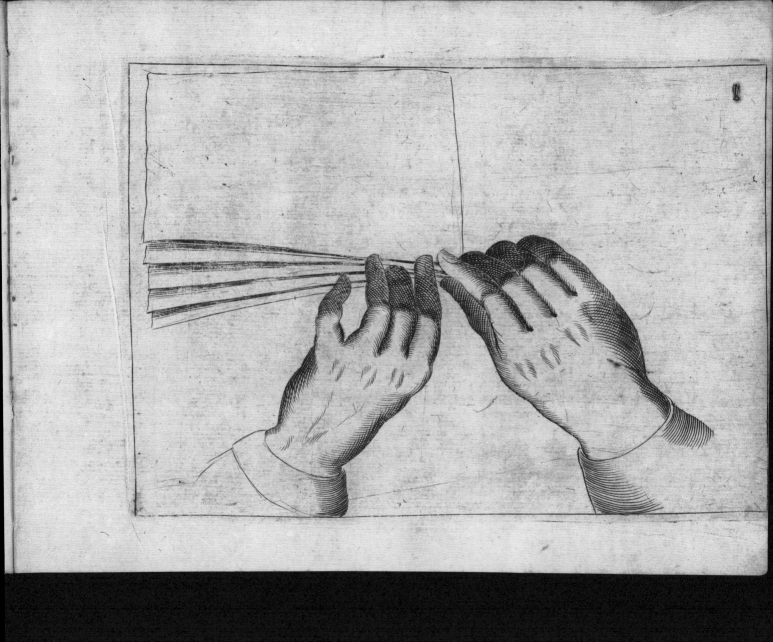

he wanted to demonstrate that he did not live like a useless, unproductive drone.[7] The first edition of the *Trinciante*, dated 1621, is also dedicated to the councilor of the German Nation at the law school, Federigo di Polenz, suggesting the Giegher had a long-standing association with this body.

Following the dedication, Giegher includes an introduction to the *Trattato delle Piegature* (treatise on folding) that lays out the rationale for republishing the two previous books (fig. 3.2). Claiming once again that he has been asked repeatedly to "complete" the set, he adds that he has enlarged them with new figures of carved citrus fruits and has "had engraved in copper various ways to fold tablecloths or napkins with a brief and succinct explanation, to better understand them, and also to prompt the memory of people who had learned this skill from me."[8] This is a clear statement that he was engaged in teaching the art of folding and suggests that the diagrams and instructions supply only some of the information needed to carry out the tasks indicated. He explains that the folding treatise is first, since the napkins are the first things that go on the table. In second place is the *Scalco*, since it is the steward who places the food on the table. Last place goes to the *Trinciante*, who "seals" the table with his presence, "carving with politesse and grace the foods that the Scalco placed on the table."[9]

Figure. 3.2

Mattia Giegher, *Trattato delle Piegature*, from *Li Tre Trattati* (Padua: Guaresco Guareschi al Pozzo dipinto, 1629). Engraving. Universitätsbibliothek Basel, AP V 31a.

Internal evidence tells us that the copperplates may very well have belonged to Giegher, since he commissioned them himself. A second edition of the book was brought out in 1639 by a different printer, Paolo Frambotto, who added a letter to the reader that contextualizes the first edition of ten years earlier. Frambotto recounts that Giegher was well-known for his skill and that the book is notable not only for the quantity of pages but also for the quality of the subject. He alludes to another version of the book, "cert'altra Operetta," which "may have fallen into your hands, pretty badly produced, completely lifted from his Original." Frambotto continues to explain that he is restoring Giegher's work to glory, which is known to the whole city. He recounts a story: by chance, during the last epidemic, he came upon the doctor who stole the manuscript from Giegher on his deathbed, and even the copperplates (*i rami*) so that he was able to purchase them from this doctor and bring them to light.[10] This is very likely an elaborate ruse to explain why he is reprinting the earlier edition of 1629 after the death of its author, perhaps justifying what would otherwise appear to be an act of piracy. The fact that he goes to great lengths to explain that he acquired the actual plates from Giegher's thieving physician indicates clearly that Giegher, rather than his previous publisher, was in possession of the plates.

The question of the facture of the engraved images is illuminating. Examination of a copy of a 1621 edition of the *Trinciante* now in Vienna sheds light on how the book was used.[11] Among the anomalies of this stand-alone publication is the spelling of Giegher's name: Gieger, without the *h* that appears in the subsequent editions. More interesting than the variation in his name, which was common in the period, is the existence of handwritten captions on the engraved images. In addition to the names of the beasts, there are hand-drawn marks and lines on the images to indicate where the cuts should be made. Sallas has documented another copy of the 1621 edition (on the market in 2010) that includes some handwritten captions for the carving images that are even closer in terms of hand to those printed in 1629, leading him to suggest it may be an author's proof for the version with printed labels and captions.[12] This evidence adds up to suggest that sets of engravings were printed and distributed to students, who then may have marked them up on the basis of the in-person lessons, eventually binding them together with the text pages. The existence of two different marked-up 1621 editions suggests that different individuals did the marking.

It is tempting to conclude that the engraved images in the book simply followed didactic materials which Giegher had on hand as teaching aides. This same phenomenon occurs in several copies of carving books from later in the century: a group associated with a French-Swiss carver called Vontet dated between 1647 and 1669, as well as in another French manual, *De Sectione Mensaria*, from the 1650s. Like the Giegher, these volumes also have handwritten notes or numbers added to printed carving diagrams, as if students were taking notes on a class handout.[13] I will return to these books in chapter 5. That there is a reciprocal relationship between manuscript and print is not surprising in the case of didactic or technical materials and helps to reinforce the actual purpose of the illustrations. In light of these manuscript interventions, the treatises appear as frozen moments of pedagogy, providing a fleeting glimpse of the method of personal instruction that is otherwise lost to time and that survives only by dint of its having been fixed in print.

Padua and *Trincianti* TEXTS ABOUT TABLE SERVICE, INCLUDING THE RESPON-sibilities of the stewards and carvers, emerged from a variety of court centers on the Italian peninsula, including Ferrara, Florence, and Rome, where the convergence of wealthy ducal, papal, and cardinalate *famigilie* with an avid and growing publishing industry spawned a burst of related books. Padua also appears to have been very important for the diffusion of table arts, and carving in particular. At least two of the early seventeenth-century carving manuals were published there. As the second-oldest university in Italy (after Bologna), and one of the oldest in the world, it attracted students from all over Europe who were organized into groups based on their place of origin and were called "nations," as indicated in Giegher's dedication.[14] In addition to the faculties of law, liberal arts, and theology, the University of Padua was also well-known for its medical school and anatomical theater, where medical students and scientists could watch dissections of human cadavers starting in 1595.[15] Though any argument tying the emergence of illustrated carving manuals to the medical culture of Padua must remain circumstantial, there may well have been a relationship between the teaching of medicine and surgery through anatomy and dissection, and the diagrams illus-trating the carving of cooked animals for the table.

Giegher's primacy as author of the first book illustrating napkin folding is unchallenged, but the question of the origins of the related diagrams for meat carving is less straightforward. Giacomo Procacchi's *Trincier Oder Vorlege-Buch*, first published in Leipzig in 1620, raises some questions. Signed by engraver Andreas Bretschneider (1578–1640), who created all the book's illustrations, the title page features the book's long title surrounded by a strapwork frame crowned by a plated goose or other fowl, and flanked by grotesque elements with fish, quadrupeds, and fruits, signaling the content of the book. The title page for the second edition of 1624, illustrated here, includes highlights in contrasting red ink, perhaps an upgrade from the first edition, which does not include any color: rubrication added to production costs, as the title page had to be run through the press twice.[16]

The title page features a banquet scene, with several guests seated at a long table. A credenza opposite exhibits a selection of tall *pokals*, double cups, and glasses. Several attendants stand at the ready, including a carver who brandishes a two-tined fork with his left hand in the foreground **(fig. 3.3)**. The Italian origin of the book is signaled graphically through the eclectic use of typefaces, whereby words with Latin or Romance roots are printed in Italic or Roman fonts, while German words are printed in Fraktur. This is visible on the title page and throughout the text, and is a consistent feature in many contemporary German-language texts. On the title page, the term "Trincier" is a Teutonized version of *trinciare*, the Italian verb for the what the *trinciante* does. But it is printed together with the German name for the book, *Vorleg-Buch*, which might be translated as "presentation

Figure. 3.3

Andreas Brettschneider, title page, from Giacomo Procacchi, *Trincier Oder Vorlege-Buch* (Leipzig: Henning Goss the Younger, 1624). Engraving. Special Collections, Regenstein Library, University of Chicago, TX885.P96 1624. Cat. 4.

book." The title page also explains that the book was "written in the Italian Language" then "faithfully translated into high German."[17]

Though the author's preface in the book is dated 1601 in Rome, no Italian original has come to light, perhaps because it was never published, but remained in manuscript until its German incarnation.[18] It is also possible that the existence of an Italian original was simply claimed as a way to increase the prestige value of the book. By around 1600, there were several Italian carvers and stewards who had published their works, including Colle, Cervio, and Evitascandolo, discussed in the previous chapter. Procacchi's book contains seventeen illustrations, including three of the knives and forks suitable for carving, but there are fewer than in Giegher's 1621 book. However, they actually precede it in terms of publication date. If we take the preface at face value, sometime between 1601, the supposed date of the composition of Procacchi's text in Italian, and its 1620 publication in Leipzig, it was translated and prepared for publication for a German–speaking audience. Perhaps it was Giegher himself, a native speaker of German, who translated the text and provided the German publisher with the illustrations that were adapted by Bretschneider, whose initials appear on many of the images.[19] Though Procacchi was originally from Ancona, according to the preface of his book, he could very well have been one of Giegher's pupils in Padua, beating his master to the press. In fact, in Giegher's 1629 publication, the first that bundles the three texts, he states in the preface that he was adding the one on folding to the two previous ones (on carving and on the job of the *scalco*) "that had already been adapted for print various times some years ago."[20] The wording of this phrase, "adapted for print," suggests that they were worked up from manuscript drawings.

Based on the similarities between illustrations in Procacchi's 1620 Leipzig book and Giegher's of 1621, it is likely that Giegher's working drawings, or perhaps even prints, were circulating and served as models for the engravings published in Procacchi's book, just as they served as aides-mémoire for those learning the arts of carving at the hand of the master, as he states in the text. Giegher's drawings may have traveled to Leipzig with one of the members of the German Nation in Padua, with whom Giegher was associated, where they could have been redrawn for engraving by Andreas Bretschneider, who illustrated several model books also published by Gross in Leipzig.[21]

A third closely related book that also bears the title of *Il Trinciante*, signed by Mattio Molinari, was published in Padua in 1636, with a second edition appearing in 1655.[22] Like Giegher, it takes the form of an oblong quarto. The illustrations in Molinari hew closely to those in Giegher. Neither Procacchi nor Molinari include descriptions or diagrams about folded napkins or centerpieces—they are solely carving manuals. Molinari's book was published after Giegher's 1629 compilation of the three treatises but before the 1639 second edition, brought out by a different printer. In his letter to the reader, this printer, Paolo Frambotto, recounts the story of how he came to have access to the copperplates. He mentions an earlier edition, a "badly produced operetta" that may very well refer to Molinari's 1636 *Trinciante*, implying that this book did not have the "original" plates from Giegher's earlier editions. In fact, Molinari's thirty-three illustrations are not the same as those in Giegher, but they are much closer than those signed by Bretschneider in Procacchi. Though there are variations, and in some instances the image is reversed, the timing and the textual evidence suggest that the illustrations in Molinari were largely copied.

Though the exact relationship between these three books, by Giegher, Procacchi, and Molinari, can only be surmised, it is indicative of the strength of the market for this kind of information in early seventeenth-century Europe. All three went into multiple editions. That the authors and publishers of these "trachtätleins," as Procacchi's publisher Hennig Gross calls them, were targeting a broad readership, is indicated in Gross's preface to the *Trincier Oder Vorleg-Buch*, where he explains that he sees the publication as way to make available "carving on the fork, not only for the courts of princes and lords, but also for nobles and non-nobles."[23] The projected readership is not the artisans themselves, but the patrons at whose tables these carvers would be plying their trade, and those for whom carving in the Italian style might be aspirational rather than simply informational—the "Unadel," or bourgeoisie.

All three manuals for instructing how to be a *trinciante* also include images of knife sets, and information on cleaning and sharpening them, following the tradition that dates back to the earliest carving manuals from the fifteenth century. Giegher includes two fold-out illustrations. One depicts five implements, including a broad knife sometimes called a *presentoire*, which he says could be used to sweep crumbs from the table, or to present pieces of cooked fish, cakes, or other things (**fig. 3.4**).[24]

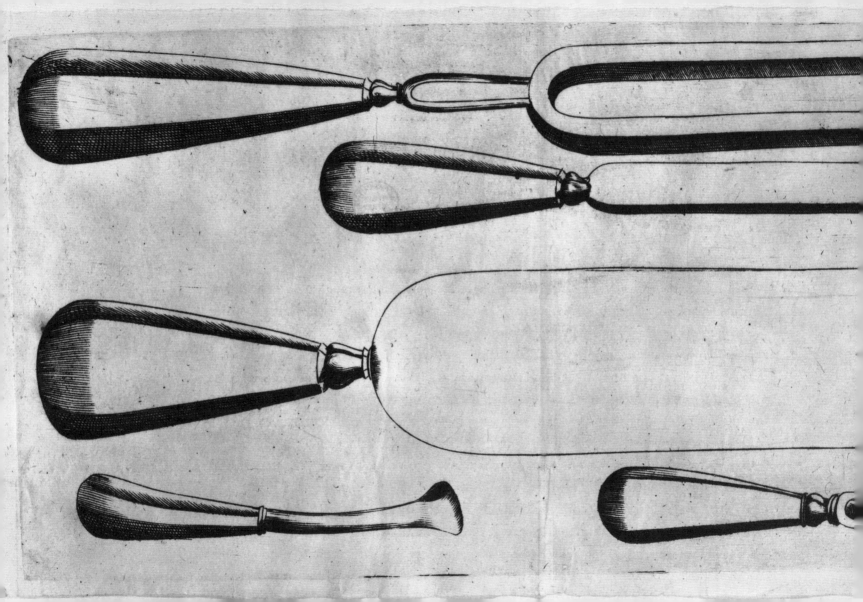

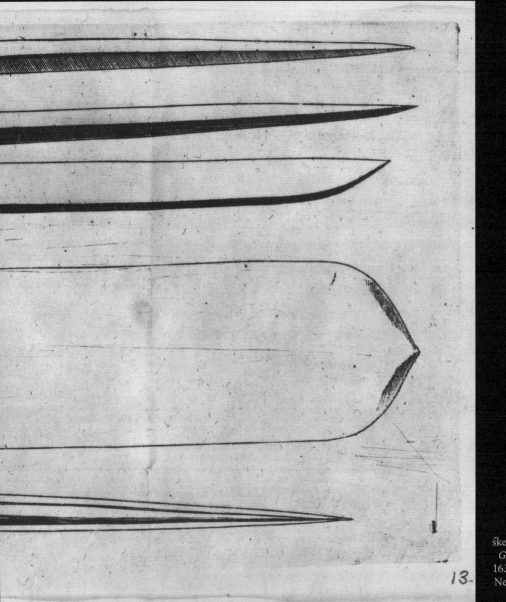

Figure. 3.4
Mattia Giegher, knife, presentation knife, fork, skewer, and scoop, from *Li tre trattati di Messer. Mattia Giegher bavaro di Mosbvrg* (Padua: Paolo Frambotto, 1639). Engraving. The Metropolitan Museum of Art, New York, Harris Brisbane Dick Fund, 1940, 40.84.

Figure. 3.5

Mattia Giegher, knives and forks, from *Li tre trattati di Messer. Mattia Giegher bavaro di Mosbvrg* (Padua: Paolo Frambotto, 1639). Engraving. The Metropolitan Museum of Art, New York, Harris Brisbane Dick Fund, 1940, 40.84.

A second image, also a fold-out, shows a suite of forks and knives. Giegher explains what sorts of meats, fish, or fruit each one is best suited for, including forks that can be used to impale small birds such as quails "ten at a time" for serving more quickly (**fig. 3.5**). Instructions for cleaning and de-rusting the implements are also part of the treatise, including the way to tell if a knife is sharp enough: one makes a cut on thumbnail of the "mano stanca," that is to say, the nondominant hand (in case there is an accident?), and if it leaves a mark, it is sufficiently sharpened.[25] He also discusses the degree of tempering and the proportions of iron and steel in the implements. Although cutlery was fabricated by specialized artisans rather than by the carvers themselves, an intimate knowledge of the ways materials acted in the conditions in which they were deployed was also part of the training. The material specificity with which Giegher lays out the care and use of his tools leaves no doubt that this was part of the constellation of knowledge expected for a carver.

As in most of the carving treatises, the comportment of the officer is described in detail. He must be well-born, discrete, and self-effacing; he must have good judgment and know how to impale and apportion the foods for carving. He must arrange his tools on the table before the lord enters the dining area, covering them with a cloth which he removes and drapes over his left shoulder before revealing what he will carve from beneath its covering. He should move with grace, without contorting his mouth or other parts of the body. Above all, he must make sure that nothing falls from the fork or flies under the table as he is carving it, to avoid becoming the object of laughter or blushing, thereby harming his reputation. If such a thing should happen, he must not lose his composure but should cover up the mistake in some lighthearted way and continue the performance. The interaction between the body of the carver, the various textiles, and the knives was carefully choreographed.

Many of the illustrations in the carving section of the *Tre Trattati* are essentially diagrams that indicate where to cut the already cooked piece of meat or bird in order to divide it for serving up to the diners. A legacy from the late Middle Ages, when individual diners did not have their own forks and would instead spear bite-sized nuggets on the point of a knife, it was the carver's job to cut the food down to edible proportions. By the middle of the seventeenth century, it is likely that many elite diners did have knives and forks, at least in Italy, so could in fact do some of their own cutting once the morsel arrived on their plates,

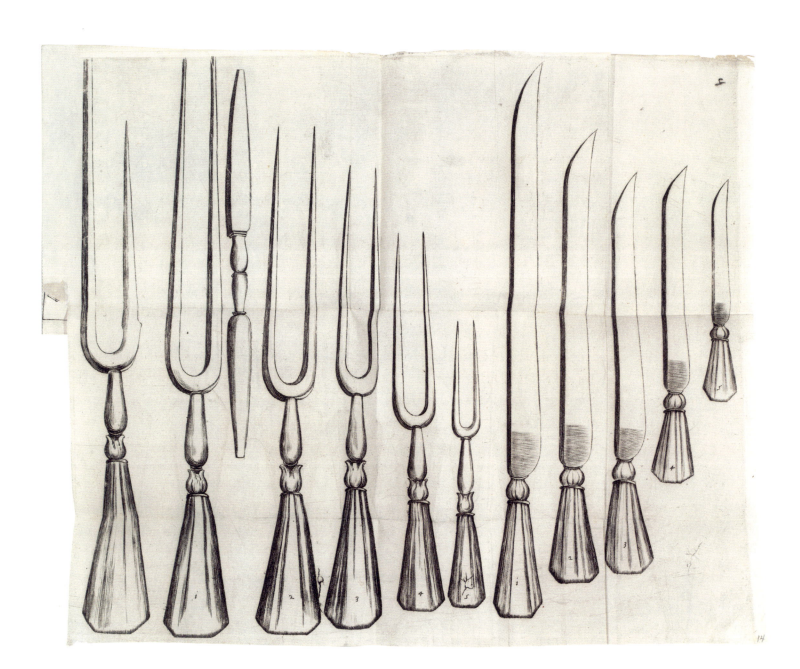

but the tradition of having it done by a servant persisted, hence the longevity of the genre of illustrated carving books. Cervio's *Il Trinciante*, first published in 1581, has exhaustive verbal instructions as well as a couple of images of large birds indicating how to carve them up (see fig. 2.6), but the volume of visual information in Giegher is of another order.

2.6

Il Trinciante—The Carver THE FOLLOWING SECTION PRESENTS A SELECTION OF

carving diagrams from Giegher's book that form a basis for comparisons with related images from other carving manuals discussed in subsequent chapters. Given the number of images, and the small but telling variations across the genre, this is but a taste of the complexities that these kinds of visual records present.

The first image in the section on carving fowl is the only carving diagram that includes both the hands of the artisan and the thing being sliced (fig. 3.6). The left hand holds a two-tined fork on which a small bird is impaled, with the other hand holding a long, thin knife. The perspective is that of the carver himself rather than what a diner might see, with considerable attention to how the tools are held. The images of hands holding tools are related to the representation of the hands of the folder, this one the second of three in Giegher (fig. 3.7). The caption for the image, located in the index of the images at the end of the book, reads, "Come si tenga in man la forcina, e'l coltello" (how one holds the fork and the knife in the hand).[26]

The images depicting where to cut and how to serve all kinds of winged creatures are the most numerous in Giegher's treatise, with eighteen engraved diagrams devoted to fowl, as opposed to the twelve for quadrupeds, four for fruits, and two for fish. There is also a list titled "The names of the joints of fowl," which provides the required vocabulary reminiscent of the terms of the carver that appeared in John Russell's *Boke of Nurture* from the fifteenth century. Since there is neither corresponding text nor images to go with this list, it is not clear what its purpose was, other than to familiarize the student of carving with the terminology that they might encounter in the lessons.

Before discussing each carving task in detail, Giegher provides a series of general guidelines for different food groups. The first is for beef, "la carne Vaccina." He cautions the carver to impale it properly if one intends to "trinciare in aria" (to carve in the air), and to place

Figure. 3.6

Mattia Giegher, "Come si tenga in man la forcina, e'l coltello," from *Li Tre Trattati* (Padua: Guaresco Guareschi al Pozzo dipinto, 1629). Engraving. Universitätsbibliothek Basel, AP V 31a.

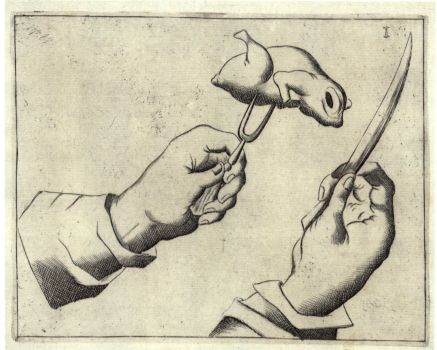

Figure. 3.7

Mattia Giegher, *Li Tre Trattati* (Padua: Guaresco Guareschi al Pozzo dipinto, 1629), plate 2. Engraving. Universitätsbibliothek Basel, AP V 31a.

Figure. 3.8
Mattia Giegher, "Lonza di Vitello," from *Li Tre Trattati* (Padua: Guaresco Guareschi al Pozzo dipinto, 1629), plate 8. Engraving. Universitätsbibliothek Basel, AP V 31a.

three or four thin slices on each plate with a little bit of fat and marrow, especially for the person at the head of the table.[27] An example from this category might be the *Lonza di Vitello*, or veal loin (**fig. 3.8**). The engraving shows the carver where to impale (*imbroccare*) the piece of meat with the fork in order to hold it securely so it can be sliced with the knife, *in aria*, as suggested. This is the basic principle of carving *in aria*: if one inserts the fork properly, the rest of the sequence can follow without incident. It is this emphasis on the fork, rather than the knife, that explains the German term in Procacchi, cited above, "carving on the fork." The lines and numbers at the bottom of the engraving indicate how to create portions from the loin—essentially, the knife should separate out the individual ribs. Written instructions in the section of the text on the veal loin repeat the suggestion that each piece should be served with a little of the fat.

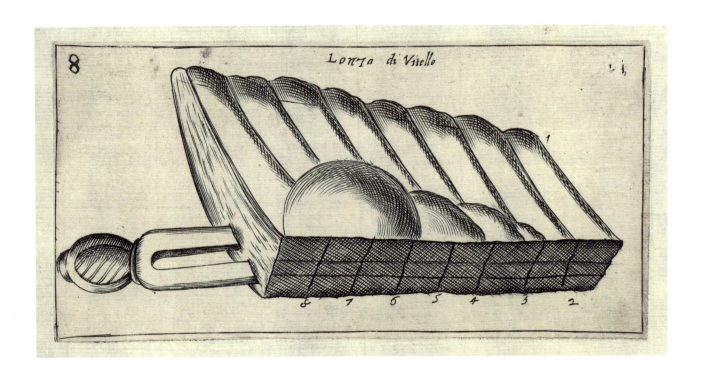

Following the suggestions for serving beef and veal, Giegher discusses what he calls *potaggi*. These are different kinds of meats seasoned by the cook, and could be whole or in parts. The carver is to place them on the plate, then add the juices or gravy using a silver spoon, as well as salt from the rim of each plate that must be placed there in advance—not just for *potaggi*, but in general. Instructions for the capon are next. Capons, castrated roosters that were often fattened for eating, are also the first of the fowl discussed and were, Giegher claims, standard fare at ordinary meals. Giegher suggests skewering them in the kidneys and carving them "according to the order indicated by the numbers in the figure" (fig. 3.9).[28] He suggests holding capons *in mezza aria* because if held too high, the grease will drip onto the fork and make it difficult to hold, resulting in the bird falling off the fork and embarrassing the carver. Served first is the fleshy tailbone (*codrione*), considered a delicacy, sometimes with a wing, followed by the breast and lastly the thighs, considered less desirable. The numbers on the image correspond to this order of attack. The basic sequence may be followed for other larger birds, Giegher explains.

Another image that travels through the generations of texts that follow is the wild boar, distinguished by its characteristic snout and tusks (fig. 3.10). A prized quarry of the hunt and a standard offering at celebratory feasts from antiquity up to the present, wild boar was valued for the difficulty of its capture—it is a powerful animal with large, sharp teeth—and the tastiness of its flesh. Recipes for wild boar appear in most early modern cookbooks, in many cases in several different preparations.[29] Giegher includes a couple

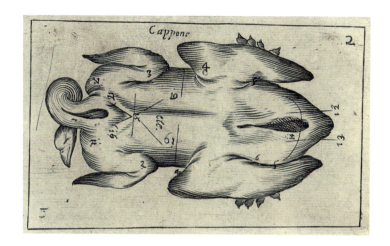

Figure. 3.9

Mattia Giegher, "Cappone," from *Li Tre Trattati* (Padua: Guaresco Guareschi al Pozzo dipinto, 1629), plate 2. Engraving. Universitätsbibliothek Basel, AP V 31a.

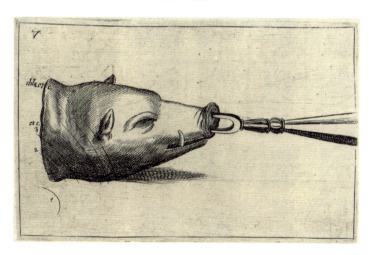

Figure. 3.10

Mattia Giegher, wild boar, from *Li Tre Trattati* (Padua: Guaresco Guareschi al Pozzo dipinto, 1629), plate 7. Engraving. Universitätsbibliothek Basel, AP V 31a.

of different ways to serve boar, including in a stew. A paragraph on "how to cook and carve a head of a *cinghiale, o porco salvatico*," explains that it should be that of a young animal and include a couple of finger-widths of the neck and the throat, which is the best part. It should be boiled in wine, vinegar, rosemary, sage and salt, and can be served cold. The text provides a detailed narrative on how to carve the head, "as one is able to see in the picture": piercing the boar's nose with the tines of the fork, one removes the rind, then starting with the cheeks, makes thin slices until one reaches the jawbone, and if the ear looks nice and tender, slice that too.[30] As in many of the meat images, the fork is depicted, but the knives are signaled only through the inscribed lines that represent the path the knife should follow to carve the flesh. This reinforces the static nature of the fork—it simply holds the objects steady, in contrast with the dynamic knife that enacts the carving. Some of the diagrams are labeled with the name of the animal, but the text on the wild boar consists only of instructions: "di la etc.": from here, etc. This same formulation is used in other images as well.

Giegher's illustration of the fish also functions as a template for subsequent images (**fig. 3.11**). The caption, "Pesce," is generic, suggesting that there is only one basic method for carving and serving a whole fish. Also included are instructions for carving and serving marzipan and other confections, as well as fruits. There are no illustrations of these sweets, but the four images depicting various carved fruits are among the most delightful of the book.

Giegher informs the reader that he didn't want to add more than thirteen *disegni* of fruits, since that would be enough to serve memory, nor did he want to describe in great detail how to carve them since he trusts the memory of those who will have learned from him (**fig. 3.12**).[31] In addition to apples and pears, which are peeled and sliced in various shapes, he includes instructions on how to carve citrons, lemons, and oranges, either simply for decoration, or to accompany roasts or antipasti. The citrons are beautifully drawn, appearing in the form of stylized plants, birds, fish, and a double-headed eagle, seemingly constructed from the fruits, scored and shaped, with additional plant elements serving as stems (**fig. 3.13**). Another image depicts citrons in the form of reptiles and shellfish: a turtle, a crab, a sloth, and a crawfish (**fig. 3.14**), echoing the vogue for so-called *style rustique* (rustic style) that informed the work of ceramicist Bernard Palissy or metalsmith Wenzel Jamnitzer in the sixteenth century. The final engraving depicts eight oranges carved in ingenious patterns that

Figure. 3.11
Mattia Giegher, "Pesce," from *Li Tre Trattati* (Padua: Guaresco Guareschi al Pozzo dipinto, 1629), plate 19. Engraving. Universitätsbibliothek Basel, AP V 31a.

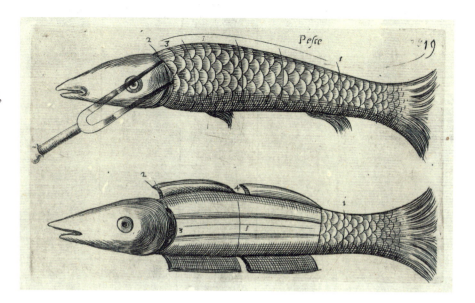

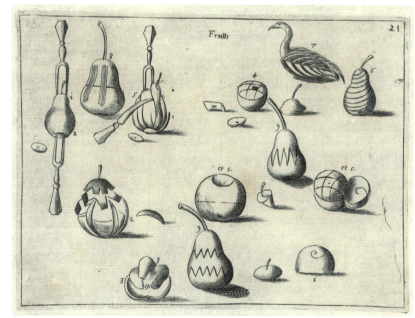

Figure. 3.12
Mattia Giegher, "Frutti," from *Li Tre Trattati* (Padua: Guaresco Guareschi al Pozzo dipinto, 1629), plate 21. Engraving. Universitätsbibliothek Basel, AP V 31a.

Figure. 3.13

(PREVIOUS SPREAD)
Mattia Giegher, "Cedri,"
from *Li Tre Trattati* (Padua:
Guaresco Guareschi al
Pozzo dipinto, 1629),
plate. 22. Engraving.
Universitätsbibliothek Basel,
AP V 31a.

Figure. 3.14

(PREVIOUS SPREAD)
Mattia Giegher, "Cedri,"
from *Li Tre Trattati* (Padua:
Guaresco Guareschi al
Pozzo dipinto, 1629),
plate 23. Engraving.
Universitätsbibliothek Basel,
AP V 31a.

Figure. 3.15

Mattia Giegher, "Melarance,"
from *Li Tre Trattati* (Padua:
Guaresco Guareschi al
Pozzo dipinto, 1629),
plate 24. Engraving.
Universitätsbibliothek Basel,
AP V 31a.

in turn emphasize, in turn obscure, the globular forms of the fruits, demonstrating a taste for surface pattern but also for the geometry that can be inscribed upon imperfect natural forms, a thread that will carry through to the images of napkin folding and carved fruits in the German texts discussed in the next chapter (**fig. 3.15**). The citron and orange images, created for the 1629 edition and among the most compelling of the book, are not part of the 1621 stand-alone version and are not accompanied by instructions on how to execute them but are instead presented as masterpieces, designed to impress rather than educate.

It is notable that none of the written instructions are located next to the images, so that a potential user could not be reading and carving "by the numbers" at the same time. To a certain extent, the disjunction between text and image is a consequence of the printing process. The images were printed from engraved copperplates, on a different press than that for the letterpress text. Though the plates are numbered, they are not part of the numeration of the book, which is in the form of signatures. The signatures, which map out how the pages were to be folded, enabled the printer to put the book together in the proper order, but do not actually provide a useful framework for referencing the book by a reader since the images were not part of this system. As a result, the engraved plates are not always located in the same place in each individual copy today. Many books from this era have been rebound, but without obvious page numbers, pages were placed out of order or bound originally according to individual users' choices. In any case, a lack of coordination between the author and printer suggests that the book was not explicitly designed to be used as a ready reference in the field, but rather as a source to study before taking up the tools, or a guide for aspiring stewards and others responsible for setting the table. Though the many claims made in the book for its role as a memory aid imply readers who were reviewing their practical training, it seems that this was largely a rhetorical stance, or even false humility within which the author attempted to cloak his mastery and skill.

Lo scalco—The Steward ALSO PART OF THE *TRE TRATTATI*, GIEGHER'S *LO SCALCO* (the steward) appeared as a stand-alone book in 1623, two years after the *Trinciante*. It begins with a brief note from the author that lays out the content: some information about *Schalcheria*, stewardship, which included knowledge of how to build a menu for a banquet and how to set

a beautiful table, among other things. The relationship between the roles of the steward and the carver was somewhat fluid, with the carver often taking on responsibility for the table setting and placement of both food and decorations, as Giegher explains.[32] While the treatise literature does distinguish between the two, in practice, many smaller households may not have had both positions staffed.

Lo scalco begins with listings of what foods are best to eat in what season, followed by menus and four illustrations. Seasonality was traditionally part of food-service books, with similar sections commonly included in sources dating to the late Middle Ages, as discussed in chapter 1. The expectation that a steward would construct menus based on the effects that various foods might have on the physiology of the diners goes back to the earliest cookbooks that gradually emerged from medieval regimen literature. An expectation of knowledge of the agricultural calendar, as well as the taxonomy of animals and plants, lay behind this.

Menus and Maps THE PRESENCE OF MENUS IN COOKBOOKS IS NOT UNUSUAL. Menus, whether they document actual meals (or claim to do so) or merely suggest possible combinations of dishes, were an important component of recipe collections and household books starting in the fifteenth century.[33] The presence of menus alongside recipes suggests an evolving audience for comprehensive sources that encompass many areas of domestic knowledge and which, over the course of the early modern period, came to dominate the genre.

Beliefs about the healthfulness and suitability and potential humoral impacts of various foods played an important role in establishing the order of the meal. Not all recipe collections include menus, but only books that are geared toward more general household management. At least in printed books, the presence of menus signals a potential audience: people who are planning meals, such as stewards. The first cookbook in print, *De honesta voluptate et valetudine*, published in Rome about 1470 and in Venice in 1475, combined dietetics compiled from Latin sources by Bartolomeo Sacchi, a papal humanist who published under the name of Platina, with recipes from a professional cook, Maestro Martino de'Rossi, but no menus.[34]

Among the first printed books to feature menus was Christoforo da Messisbugo's 1549 *Banchetti, composizioni di vivande e apparecchio generale*, discussed in chapter 2, which contains recipes as well as instructions for stewards on how to set the table. The fourteen menus

included are all occasional, with the author explaining for whom the event was staged and when it took place. Most of his menus are more blow-by-blow descriptions of multimedia spectacles, where the food is just one of many objects of consumption that were put on display to celebrate the Este family, with the publication serving to create a lasting record of the otherwise ephemeral events.

Domenico Romoli's 1560 *Singolare dottrina*, like Messisbugo's *Banchetti*, was much more than a collection of recipes as well, containing information on all aspects of stewardship including descriptions of the various offices involved in food service. Book 4 of his compendium features a year's worth of menus, with the title "Del mangiare ordinario di di in di"; that is, "On ordinary eating, day by day." Bartolomeo Scappi's *Opera*, published in 1570, contains 112 menus (in addition to the 500 or so recipes) for meals throughout the year. As Scappi explains, the section containing menus is explicitly addressed to the cook who desires to plan meals with the expertise of a steward, suggesting that the roles might sometimes overlap, like those of the steward and the carver.

Giegher, too, provides information that might prove useful for a steward or carver in training to learn how to select the choicest provisions as well as to plan menus. He starts off with "The seasons of domestic and wild quadrupeds," followed by "The seasons of domestic and wild fowl." Fish are divided into two categories: fresh- and saltwater, and *pesci armati, o senza sangue*; that is, shellfish. And then there are the seasons for "fruits of the earth."[35] The recommendations are quite general, though many different species of meats, fowl, fish, vegetables, and fruits get their own paragraphs. Some of the fish are frequently called one thing but given an alternate name as well: "as they call it in Venice." Though Venice is just twenty-five miles from Padua, Venetians had their own dialect of Italian. It is understandable that Giegher would know, and feel compelled to provide, the Venetian names for fish, since Venice was probably the source for saltwater fish eaten in Padua.

Giegher concludes this section with a humorous disclaimer. He explains that he didn't want to get into too much detail, meaning that he didn't want to deal with the humoral or dietetic qualities of the foods mentioned, thus distancing himself from the tradition of dietetics. Explaining why he was not providing information on how food affected the body, his rationale was "in part not to meddle [literally, not to put my hands in other people's

pasta] since no doctor, but *trinciante* am I," and because lots of others have dealt with this in their own books, which one can read with pleasure.[36] Giegher's offhand comment alludes to a shift in the ways that people thought about the relationship of food and the body, from one based in ancient and medieval humoral theory to a more scientific perspective informed by empirical knowledge that was emerging in the late sixteenth century.[37]

Giegher nevertheless addresses the theme of seasonality with a series of menus that are appropriate for each of the four seasons, each with four courses. He also provides sample menus for different types of meals: a fasting meal, a meaty meal, and finally an *oglia putrida*, literally "rotten pot," a fashionable Spanish stew made with a variety of meats, fowl, and vegetables cooked together and placed in the middle of the table on a large plate, a kind of extravaganza that apparently required its own choreography on the table. He illustrates this dish in an engraving where the various kinds of meats are indicated in a numbered list that is keyed to an octagonal table seen in plan (fig. 3.16).

Figure. 3.16

Mattia Giegher, "Oglia putrida," from *Li Tre Trattati* (Padua: Guaresco Guareschi al Pozzo dipinto, 1629), page 58. Engraving. Universitätsbibliothek Basel, AP V 31a.

Two additional table maps are included in Giegher's *Lo scalco*. Since meals were served "family style," with a number of dishes set out at the same time, followed by subsequent courses also consisting of multiple dishes, the combination and choice of placement fell to the steward. Diners would probably partake of the dishes closest to them, though they may also have asked to taste dishes that were out of reach. The text explains that a *piatto ordinario* was to be set on a table that measured six palms in length by four in width. There should be four people per *piatto*, so the size of the table would be adjusted according to the number of diners. For eight people, a *piatto doppio* was required, while for twenty, three *piatti* were required. He explains that the copperplate engravings show where to place foods and confections on the table in three distinct ways. In the engraving titled "Piatto Doppio" (**fig. 3.17**), the proper placement of the saltcellars is indicated by the letter *S* for *saliera* in two locations on the table. The letters *S* are also visible on in the image of the *oglia putrida*.

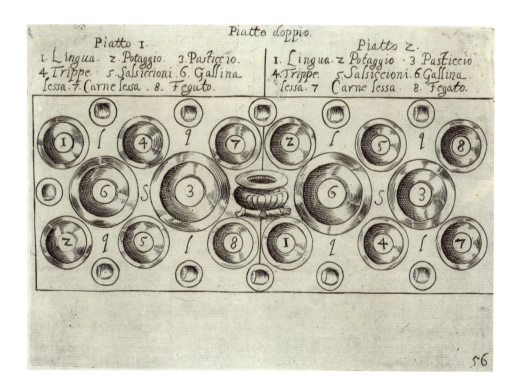

Figure. 3.17
Mattia Giegher, "Piatto doppio," from *Li Tre Trattati* (Padua: Guaresco Guareschi al Pozzo dipinto, 1629), page 56. Engraving. Universitätsbibliothek Basel, AP V 31a.

Figure. 3.18

Mattia Giegher, "a Carte 55," from *Li Tre Trattati* (Padua: Guaresco Guareschi al Pozzo dipinto, 1629), page 55. Engraving. Universitätsbibliothek Basel, AP V 31a.

Another engraving in this section, titled "a Carte 55," which appears to be an indication for the printer where to place the image that somehow became engraved onto the plate by mistake (it is in fact on page 55), shows how to alternate different kinds of decorative elements on the table as well on the credenza: vases, folded napkins, sugar paste sculpture (**fig. 3.18**). Additional engravings instruct where to place various ornaments on the table and how to organize a banquet with multiple courses of multiple dishes.

Although the description of such banquets and the presentation of menus for the meals was not a new phenomenon in the 1620s, the cartographic representation of the table, with the dishes indicated on the page in the form of a schematic plan, was an innovation that would appear in countless culinary texts across Europe in the seventeenth and eighteenth centuries.

In this same section where the table maps are found, Giegher also describes what sounds very much like an English banqueting course: a *collation*, or supper, for ladies (*per le Dame*), consisting of various kinds of candied or preserved fruits and vegetables.[38] The Italian word *banchetto* (probably from *banco*, or "bench"), from which the English term "banquet," in the sense of a specific dessert course, derives, is here used to mean a festive meal rather than an exclusively sweet course, however. Listed are candied pears, peaches, citrons, and lemons, but also artichokes, borage, and radicchio. He groups the fruits into categories of those to be served dry and those to be served in syrup, suggesting the English distinction between consuming wet and dry suckets, which were often part of the banqueting course in sixteenth- and seventeenth-century England.[39]

Before access to Caribbean sources brought the price of sugar in Europe down, it was generally sold by an apothecary alongside drugs, spices, cordials, and candles. In a well-documented example, sugar was bought by Florentine merchants from Portuguese traders and refined in Italy, allowing price variations based on the degree of refinement.[40] Whether as foodstuff or sculptural medium, sugar was an essential element on the table by the early seventeenth century. European demand for sugar was fueled by the Spanish and Portuguese colonial plantations in the Caribbean and Brazil that were developed starting the fifteenth century and thrived thanks to the employment of slave labor.[41] By the early seventeenth century, sugar was no longer used primarily medicinally or as a seasoning, but increasingly as

a Carte 35

the main ingredient in sweet dishes. The presence of sculptural elements made of sugar paste, in which sugar is a material rather than a foodstuff, cannot be mentioned without reference to the dark history of sugar as a commodity.

Trionfi: "Un ricordo per adornar con varie figure la tavola" UNDER THE heading "Un ricordo per adornar con varie figure la tavola" (a reminder for how to decorate the table with various figures), Giegher discusses different sorts of decorative elements that could be deployed for this purpose. The creation of elaborate, ephemeral sculpture for display on the table on special occasions was, by the early seventeenth century, an entrenched practice at most European courts, both secular and ecclesiastical. Called *trionfi* in Italian, they are related to edible decorations known as *entremets*, *sotelties*, *Schauessen*, or *Schaugerichte*, among other terms used across Europe. Giegher instructs that one should place some figures *fatte di cera, o di pasta, o di tovagliuoli*: wax, sugar paste, or folded napkins, in part to ornament the table and to mark the importance of the banquet, but also to articulate the spacing of the plates. He lists the many shapes these sculptural figures might take: pyramids, castles, eagles, lions, stags, dragons, a Satyr, a Mars, a Hercules, a Europa on the bull with her hands on its horns, a clothed Trojan Helen with golden hair, and various nudes: Venus, Pallas, and Juno.[42] These sculptural elements were not generally edible, though they might be made of foodstuffs such as butter or sugar paste, or of textiles or wax. Though none survive, unlike the automata and table fountains of precious materials that made their way into *Kunst- und Wunderkammern* and eventually to museums, they can be glimpsed through different kinds of documentation starting in the fifteenth century.[43]

Piegature—Folds and Folded Things GIEGHER'S BOOK IS NOTABLE AS THE first text to provide instructions on how to create *piegature*, table centerpieces constructed from sheets of starched linen that have been folded or pleated into intricate shapes.[44] From antiquity, letters were folded as a way to maintain secrecy in a practice known as letterlocking.[45] Folding techniques used for table linens are closely related to traditional Japanese paper folding, called origami.[46] The folding of napkins is also reminiscent of Troublewit, a type of magical performance carried out with paper folded accordion-style that was manipulated to

form different shapes in front of an audience, first documented in the seventeenth century.[47] Ruffs, ubiquitous fashion accessories made of starched linen, are another parallel form. The connections between paper and textiles are close: folding for the table was apparently taught in the classroom through practice with stiffened paper before moving on to starched linen, which was more complicated and more expensive to prepare.

Giegher was likely not the first person to practice the craft of napkin folding, but he was certainly the first to document it in print. He explains how to arrange groups of table sculpture:

> *It is to be noted that at first one places a seahorse and other animals made of sugar, with three other statues of sugar three palms high . . . for example the Wild Boar of Meleager with an arrow in its breast; a Moorish King sitting astride a camel; an elephant bearing a castle on its back, filled with men at arms holding bows, arrows and stones.*[48]

In reference to one of the table maps (see fig. 3.17), he explains that where there is a vase that appears to be a *saliera* one could place a figure of wax or of *piegature*, or even a vase with flowers, in order to divide one plate from another.[49] The specific materials of which the centerpieces could be fashioned are interchangeable: wax, linen, or even a flower arrangement.

Giegher does not indicate where the wax or sugar figures might be procured, nor does he provide instruction on how to make them. Though prescriptive texts like Messibugo, Cervio, or Giegher do not specify the artisans who might provide these figures, other kinds of sources

3.17

indicate that sculptors, rather than officers of the table such as stewards or *trincianti*, would have provided the designs for these elements and would probably have fabricated them in their studios or had them produced by casters or carvers in their workshops.[50]

Documentation of several hundred sugar sculptures created for celebrations staged for Henri III of France and Poland in 1574 in Venice provides copious evidence for the involvement of Venetian sculptor Jacopo Sansovino (1486–1570) in the creation of the *trionfi*.[51] Another example is provided by a pamphlet published on the occasion of the wedding of Maria de' Medici to Henry IV of France, which took place in Florence on October 5, 1600. Written by Michelangelo Buonarotti the Younger, son of the famous artist, it includes vivid descriptions of table decorations made of both sugar paste and *piegature*.[52] According to documentary evidence in the form of purchase receipts, the sugar sculptures were created under the supervision of Giambologna (1529–1608). The Flemish–born artist worked frequently for the Medici and others in Florence, and used the bronzes which he created for these same granducal patrons as models for sugar sculptures.[53] Payments to other sculptors in his workshop, such as Pietro Tacca, for figures made of "pasta di zucchero" (sugar paste) and for gilding for these same figures, indicate that there were a number of artisans involved in supplying sugar-paste figures for this event.[54]

In any case, it is clear that Giegher was not a sculptor and was not in a position to provide instruction on how to make figures from materials other than textiles or food itself, if one considers the elaborately peeled fruits and carved meats to be comestible sculpture. The text of Buonarotti's *Descrizione* suggests that for the guests at the wedding in 1600, the figures fashioned of sugar paste associated with recognized sculptors, some with gilded bases that mimicked metalwork supports, held both prestige and visual appeal through their association with more permanent sculptural works. These texts are silent on the subject of who provided the linens.

Giegher's treatise on folding can be seen as a corrective to the relative anonymity of the artisans who created the *piegature*. In Giegher, the complexity and bravura of the craft of folding linen achieved a level of recognition that launched a graphic tradition in print, as well as the proliferation of illustrated texts aimed at instructing others. Subsequent chapters will examine Giegher's legacy across Europe in the later seventeenth and eighteenth centuries.

So, while Giegher's book does not include information on how to make *trionfi* of sugar paste, wax, or butter, he does detail the creation of centerpieces made of linen. Giegher's *Trattato delle Piegature* was written sometime between the publication of *Lo scalco* in 1623 and 1629, when it was published bundled together with the two previous books. While the general content of the *Trinciante* and the *Scalco* was not particularly original, but rather illustrated and codified knowledge that was already available in previous treatises, its engraved images made it highly influential. The book, in both editions, was probably collected from an early period by clients or patrons who employed the stewards, rather than the artisans themselves, to judge from the library collections where it is held today.[55]

In the preface to the folding treatise, as in the general introduction to the *Tre Trattati*, Giegher reiterates that he wants the book "to help preserve the memory of people who have learned from me."[56] He explains that he placed the folding treatise first in the volume because the napkins are the first elements to be placed on the table—before the food arrives. Giegher appeals to potentially different readerships when claiming that the treatise provides elementary instruction for the uninitiated but also serves as a reminder for pupils who had studied with him in person. Presumably the suggested link between the author and actual pupils would help to establish credibility for the majority of readers, who were neither past nor future students.

In comparison with the large number of carving images, there are only six for the folding treatise: three showing how to carry out the basic techniques and three that provide a catalogue of forms that could be made as a result. As we will see, additional folding images were created for later German texts, though there were a limited number of basic techniques.

The first image "of the hands," as Giegher writes, shows how to make the first folds with the sheet of linen. Note that he refers to them as "the hands," not "my hands" or "your hands," suggesting a kind of formal distance (see fig. 3.1) These are the basic "long folds" translated as *Langfalten* in German. The second image (incorrectly numbered 3 in the book) shows how to begin to make the *spinapesce*, the fish-scale or herringbone fold, which is the basic unit used to shape many of the forms (see fig. 3.7). The third shows proper finger technique (fig. 3.19). These engravings are simple and straightforward, with the representational focus on the disembodied hands of the artisan. The perspective is that of the person carrying out

3.1

3.7

3.19

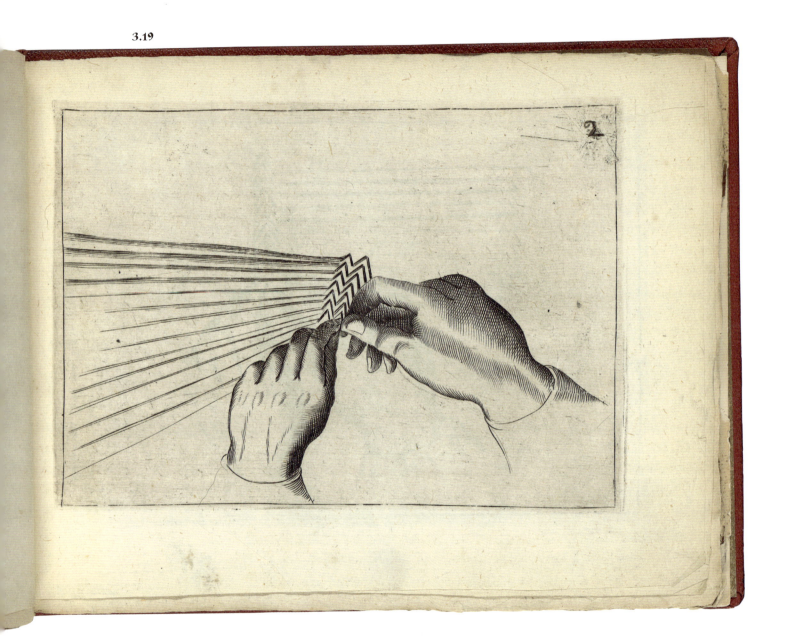

the action, enabling readers to imagine their hands following the motions described by the lines. Confronting images of hands working, estranged from the bodies to which they are attached, is arresting for readers who are, in essence, carrying out intellectual work rather than physical labor, in the reading of the text.

The hands appear to be male, reinforcing the gender identity of the folder. There is no mention of whether Giegher's actual students were male or female, but the assumption is that all were male. While women may very well have worked in kitchens as cooks, at least in nonecclesiastical households, people who interacted with the diners beyond the kitchen such as stewards or carvers were all male, to judge by the prescriptive sources and surviving documentary evidence. Women often appear in paintings or prints from continental Europe depicting banquets or feasting, but they are generally seen in distant kitchens in the backgrounds rather than closer to the diners, unless the image is specifically set in a kitchen, as in Vincenzo Campi's well-known *Kitchen*, where the presence of women signals the visceral qualities of food, among other things (see fig. 3.3).

In addition to these three pages that zoom in on the basic hand motions for folding, there are three pages depicting the various forms that could be made from sheets of linen. The first, numbered page 4 in the upper left corner (fig. 3.20), includes a ship, a castle, a fan, and a fish, among other elements. A small human figure, perhaps a courtier carrying a sword, stands mysteriously dwarfed in the center of the page. Page 6 goes together with page 4 and features more abstract shapes and the characteristic "monti" (mountains). Pages 4 and 6 must be seen as a unit (fig. 3.21). Some of the images show the sequence of steps for creating a particular form, indicated through the presence of the number on more than one shape. Some of these forms appear on two of the pages, while the sequential stages are not presented in a way that makes it possible to move through the process. An example of this is the group of forms numbered 3 that demonstrate the fan and a crown, as well as a shape referred to as "S.S." Shapes marked with the number 3 are distributed between pages 4 and 6. Another example is the group numbered 2, also distributed between these two pages, labeled "leaves for making organs, lilies, and mountains."

The list found at the beginning of the *Trattato delle Piegature* that promises to provide "the names of the figures, or the designs in the present work" describes the forms on pages

Figure. 3.19
Mattia Giegher, *Li Tre Trattati* (Padua: Paolo Frambotto, Padua, 1639), plate 3. Engraving. Rare Books Division, The New York Public Library, *KB 1639. Cat. 56.

3.3

3.20

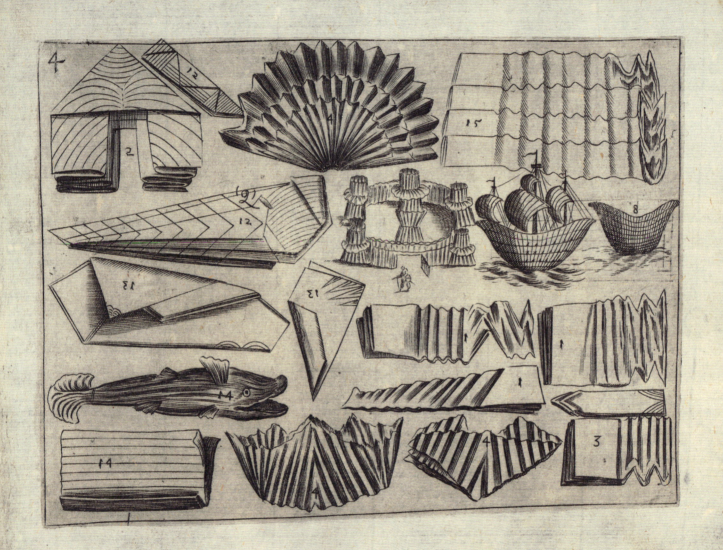

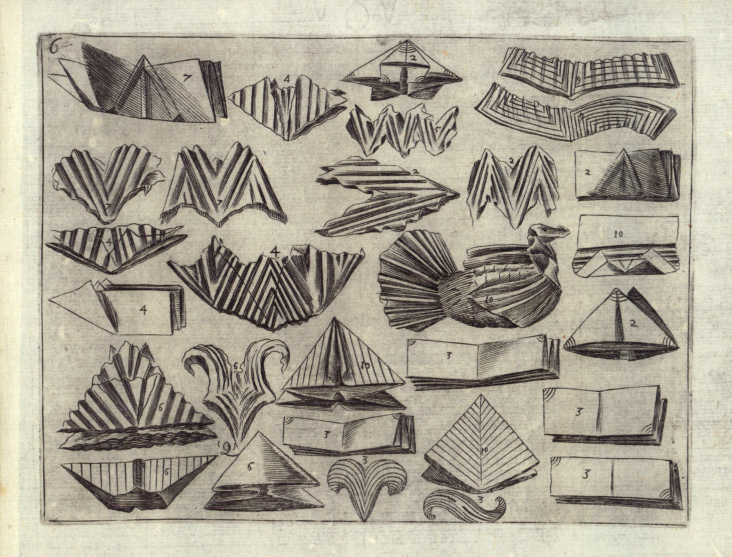

Figure. 3.20
(PREVIOUS SPREAD)
Mattia Giegher, *Li Tre Trattati* (Padua: Guaresco Guareschi al Pozzo dipinto, 1629), plate 4. Engraving. Universitätsbibliothek Basel, AP V 31a.

Figure. 3.21
(PREVIOUS SPREAD)
Mattia Giegher, "Per fare animali di spinapesce," from *Li Tre Trattati* (Padua: Guaresco Guareschi al Pozzo dipinto, 1629), plate 6. Engraving. Universitätsbibliothek Basel, AP V 31a.

Figure. 3.22
Mattia Giegher, *Li Tre Trattati* (Padua: Guaresco Guareschi al Pozzo dipinto, 1629), plate 5. Engraving. Universitätsbibliothek Basel, AP V 31a.

4 and 6, while the images on page 5 are described under a subheading: "Per fare animali di spinapesce" (**fig. 3.22**). This third page of folded forms, numbered out of order like the three disembodied folding hand pages, features a herringbone menagerie of real and imaginary creatures, including a double-headed eagle, a dog, a lion, a beaver (actually a dog with a fish tail), a turtle, a bear, a pelican, a salamander, a phoenix, a crab, a peacock, a rooster and hen, the lion of Saint Mark, and a dolphin. Some of these are reminiscent of the monsters that lurked in the margins of contemporary maps or were illustrated in natural history texts by Ulisse Aldrovandi or Athanasius Kircher—more than a coincidence, and suggestive of a shared interest in the variety of animal species whose collection and cataloguing and were

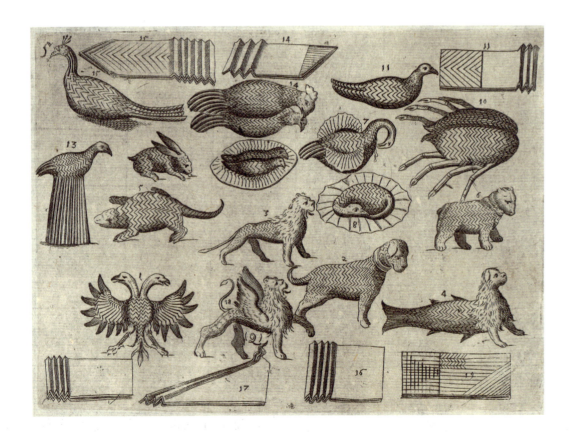

essential for the emerging field of natural history, as well as to adorn a well-dressed table.[57] They also may have been inspired by contemporary pattern books. Rather than being in some kind of logical order, Gieghers's pleated animals crowd onto the page, seemingly arranged in the most efficient way to load the allotted space with the panoply of representational shapes that might be fashioned using the techniques outlined in the first three images.

Though the individual shapes are provided with numbers that are loosely keyed to the text, they are hard to follow and are thus what might be called *performatively didactic*. They appear to instruct, but do not in fact provide enough information to create the forms depicted. Without a live teacher, it would be quite challenging to use these diagrams to do so. It is tempting to suggest that the printer or compositor may have inadvertently numbered these pages out of order, but why would Giegher not have made sure the order of the pages followed his text? Both the 1629 edition, published while Giegher was living, and the second 1639 edition, published posthumously, use the same plates in the same state, and the same descriptions, suggesting that Giegher was not intimately involved even in the first edition of the book. It seems plausible that Giegher may have supplied the diagrams that he used for teaching to the printer, who passed them along to be adapted by an engraver who did not follow the text closely. This process parallels the relationship between Giegher's presumed manuscript handouts for carving students that were formalized in the process of being engraved for the printed book. Though of limited practical use as step-by-step guides to create *trionfi* of folded linens, the images were suggestions of what could be created using the basic techniques, intriguing enough to be copied in many subsequent books, in various sizes, alongside texts in different languages. It is also possible that the pleated forms inspired *trionfi* of other materials.

Sculpted linens may be visible in visual records of banquets such the well-known drawings by Pierre Paul Sevin (1650–1710), a French artist who spent time at the French Academy in Rome in the 1660s. Sevin recorded long tables laden with characteristic Baroque pyramids of fruit, vases of cut flowers, and a great variety of sculptural forms that may have been made of sugar paste, possibly gilded or bronzed, or more permanent materials. One drawing of what was probably a banquet celebrating Leopoldo de' Medici's investiture as cardinal in December of 1667 depicts *piegature* that are very close to some of the forms depicted in Giegher's treatise (**fig. 3.23**). The table sculptures borrow Medici iconography with a diminutive version of

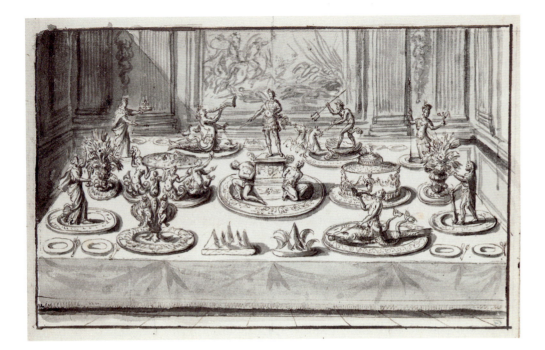

Figure. 3.23

Pierre Paul Sevin, *Banquet Table with Trionfi for Cardinal Leopoldo de' Medici's Investiture*, [1667?]. Pencil and brown ink, layering in gray on paper. Nationalmuseum, Stockholm, NMH THC 3612.

the sculpture of Ferdinando I de' Medici by Giovanni Bandini in Livorno, flanked by figures of bound slaves by Pietro Tacca. Four standing figures at the corners of the table personify Medici power.[58] The marine theme, including Neptune and his horses, tritons blowing horns and riding fish, and what appears to be a terrine surrounded by nereids and mermaids, suggest that the banquet was held on a fish day, when the Catholic calendar forbade the eating of meat. All the figure groups stand on dishes, suggesting that they are fashioned of edible media. The *piegature* in the forefront occupy two of the six places on front side of the table, signaling diners ranked more highly than those who were provided with forks and spoons but no napkins. Sevin might have had a chance to sketch these festive displays before the event, since laid tables would be made accessible to visitors for a few days before the actual banquet.

A description of a series of Roman banquets attended by the English ambassador to Rome, the Earl of Castelmaine, in 1685 records this custom:

THIS large Table, having (as is said) these adornments in the middle, had between them, and the Napkins (which were also most artificially folded) two Rows of Assiets, or Intermesses, on either side, fill'd with all sorts of relishing bits, whether salt, sweet, or soure; as Pickles, Butter, slices of delicate Bacon, Bologna-Sauciges, Taratufoli, Composts, &c. all which, stood in the above said Order, for two whole days, (according to the Roman way) that every ones curiosity might have some share in the Entertainment.[59]

Many of these foods were cured or preserved, like bacon, sausage, or pickles, so they would not have spoiled during the period of viewing.

Sugar-paste sculptures might be given away to guests or stored for another event, but *piegature* would likely not survive, since they were used by the diners during the meal. An example of this is recounted by Wright: "The breadth of the said Table was eight foot (which might easily be allow'd, the Room being 24 wide) and thro' the middle of it, from one end to the other, ran a Range of Historical Figures (some almost half as big as the Life) which the Italians, call Trionfi: They are made of a kind of Sugar-Paste, but modelled, to the utmost skill of a Statuary; So that they are afterwards, sent as Presents to the greatest Ladies."[60] Not all sugar sculptures became party favors, however: a plan of the Vatican kitchens from the period apparently includes a room labeled as "the room of the trionfi," suggesting that they were kept there in storage.[61]

Another visual record of seventeenth-century *piegature* in situ is found in a painting by Flemish painter Louis de Caullery (ca. 1580–1621) (fig. 3.24). It captures a moment that is not often chosen by artists: a large table set for a banquet, with guests gathering upon arrival, presumably about to take their seats. Folded linens are placed at the table settings, while several swans, perhaps pies or sugar-paste sculptures, punctuate the large, U-shaped table. Once diners take their places, the napkins will be unfurled and will lose their shape. A credenza loaded with glittering gold and silver plate is visible on the right. A servant enters the hall from the kitchen, bearing what appears to be a peacock pie.

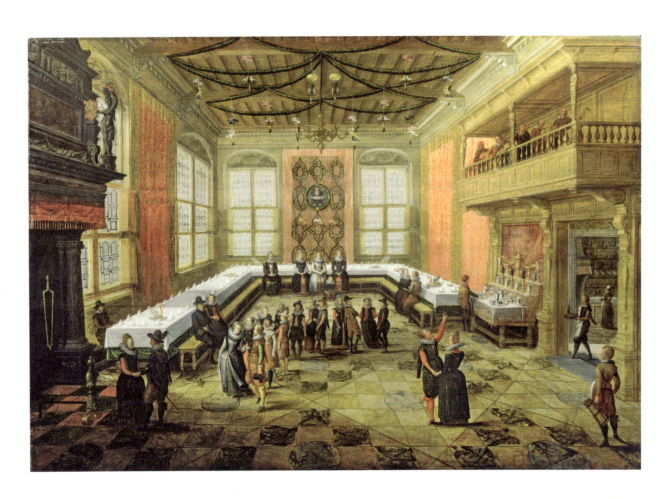

Figure. 3.24
Louis de Caullery, *Elegant Figures Congregating in a Banqueting Hall*, before 1621. Oil on panel. Private collection, Rafael Valls Gallery London, Bridgeman Images.

Though these sorts of detailed paintings or drawings of folded napkins in the fleeting moments before they are disassembled are rare, Joan Sallas has re-created similar shapes following the models in the treatises for contemporary viewers (figs. 3.25–29). Sallas's reconstructions, beautifully crisp and precise, have been featured in several museum exhibitions.[62] Although no documents survive to confirm their use, Sallas, on the basis of his own reconstructions, believes that support and shaping for the figures was provided by the use of a needle, thread, and scissors, and that bread was used as ballast to anchor and provide volume for the forms. Techniques for napkin folding would have paralleled the handling of folds in clothing, where additional tools were used.[63] Furthermore, the linen would have been heavily starched to help maintain the intricate forms, then moistened to help shape it as it was pleated. The fashion for ruffs, cuffs, and other sartorial embellishments made of white, starched linen reached a high point during the seventeenth century, as their ubiquitous appearance in countless paintings suggests.[64] Ruffs, like the elaborate folded linen centerpieces pictured

Figure. 3.25
Joan Sallas, "Il granciporo, e granchio di mare" (Crab, and sea crab), after Mattia Giegher, *Li Tre Trattati* (Padua: Guaresco Guareschi al Pozzo dipinto, 1629), 2010(?). Starched linen napkin with herringbone folds, pleated, and cut legs. The Metropolitan Museum of Art, New York. Cat. 57.

Figure. 3.26
Joan Sallas, "Funff Berge" (Mountains), after Georg Philip Harsdörffer, *Vollständig vermerhtes Trincir-Buch* (Nuremberg, 1652), 2010. Starched linen napkin. The Metropolitan Museum of Art, New York. Cat. 58.

Figure. 3.27
Joan Sallas, "Ein Welscher Han" (Turkey), after Andreas Klett, *Neues Trenchir-und Plicatur-Büchlein* (Nuremberg: Leonhard Loschge, 1677), 2010. Two starched linen napkins. The Metropolitan Museum of Art, New York. Cat. 59.

Figure. 3.28
Joan Sallas, "Aquila" (Eagle), after Mattia Giegher, *Li Tre Trattati* (Padua: Guaresco Guareschi al Pozzo dipinto, 1629), 2022. Starched linen napkin. PADORE - Archive for Documentation and Research of Historical Folding Art. Cat. 5.

Figure. 3.29
Joan Sallas, "Fisch mit Floss-Federn" (Fish with feather-rafts, likely a pike), after Andreas Klett, *Neues Trenchir-und Plicatur-Büchlein* (Nuremberg: Leonhard Loschge, 1677), 2010. Starched linen napkin. The Metropolitan Museum of Art, New York. Cat. 60.

in Giegher and subsequent books, signaled wealth and status through the labor and complex processing that were implicit in their desired qualities of whiteness and stiffness.

Linen, widely cultivated all over Europe from the Middle Ages, was subject to elaborate preparations prior to its deployment into precisely modeled forms that would hold their shape over days, if not months. Different varieties of flax, from which linen is woven, were spun locally in many areas for domestic use as undergarments, as well as for furnishing the table. Fine linens were generally woven with either a small geometric repeated pattern, called diaper, or figurative patterns with larger repeats that were known as damasks. Damasks of linen, rather than silk, were first produced by weavers in the Southern Netherlands in the fifteenth century, but many of these skilled artisans left Flanders in 1585 with the fall of Antwerp and moved to Holland.[65] The linen that Giegher and his clients desired for their tablecloths and napkins would likely have been "toiles de Hollande" imported from Holland, which was the leading processor of fine linens from the late sixteenth century.[66] Some of the folded objects may even have been created using damask-woven linens. By the early seventeenth century, Haarlem, favored by plentiful water sources, grassy fields for drying the linens, and an ample supply of buttermilk from local dairies, had become the European hub for the bleaching of linens. The labor-intensive bleaching process involved soaking and washing the linen with soap and water, then boiling it in an alkaline substance for two days. Following this, it was spread on fields in the sun for up to two days, after which the process was repeated, but with an added step—that of soaking the linen in buttermilk, which enhanced the bleaching through its acidity.[67] Haarlem's bleaching fields were a favorite subject for Dutch painters, who depicted the vast expanses of verdant fields under bright sunlight and big skies in works such as Jacob van Ruisdael's *View of the Dunes Near Bloemendael with Bleaching Fields* (**fig. 3.30**).

The starching and ironing of linens was also an important and labor-intensive element of their preparation for display in a variety of contexts, not limited to table centerpieces. Like the labor of spinning, weaving, and bleaching the linen, these necessary tasks that underlay the practice of folding napkins and centerpieces are not mentioned in the treatise literature surveyed here. This lacuna is somewhat puzzling, since the care and storage of knives was included in many of the carving manuals from the earliest period. This suggests that the folders did not have the same relationship to their tools or basic materials as the carvers, who had to

be knowledgeable about the nature of the foods they were serving up, as well as the maintenance of their knives, as evidenced by the inclusion of seasonality and precise nomenclature in carving manuals throughout the early modern period. While carving already had a long history in the seventeenth century, folding and pleating were new, so there was presumably not even a verbal tradition to commit to print.

 Giegher's *Tre Trattati* proved to be a foundational text. Starting in the 1640s, a series of adaptations appeared in Germany, Holland, Sweden, Norway, France, and England. Perhaps

Figure. 3.30
Jacob van Ruisdael, *View of the Dunes Near Bloemandael with Bleaching Fields*, ca. 1670–75. Oil on canvas. Wadsworth Atheneum Museum of Art, Hartford, Connecticut, The Ella Gallup Sumner and Mary Catlin Sumner Collection Fund, 1950.498. Cat. 42.

its long afterlife might be explained by the notion of the fold or pleat as a central trope of the Baroque, as developed by Gilles Deleuze in his 1988 book *The Fold: Leibniz and the Baroque*.[68] In Deleuze's text, the fold becomes a polysemous metaphor that serves to explicate space and time: "A flexible or an elastic body still has cohering parts that form a fold, such that they are not separated into parts of parts but are rather divided to infinity in smaller and smaller folds that always retain a certain cohesion." This passage could describe some of the intricate folded forms that Giegher's engraved images depict, figures forged of soft materials that tease the eye as they seem to conceal underlying structures, but that, at least in some instances, were deconstructed in seconds by diners as they sat down to eat and drink, part of the theater of the meal, metamorphosing back into simple pieces of cloth. For Deleuze, channeling Leibniz, "The model for the sciences of matter is the 'origami,' as the Japanese philosopher might say, or the art of folding paper."[69] The next chapters survey the many echoes of Giegher's illustrations and examine how they were translated and transformed in later sources.

Unless otherwise noted, all translations are my own.

1. Mattia Giegher, *Li Tre Trattati di Messer Mattia Gigeher Bavaro di Mosburc* (Padua: Guaresco Guareschi al Pozzo Dipinto, 1629).

2. Joan Sallas, "Mattia Giegher and the First Work Published on Folded Centerpieces," *Datatèxtil* 40 (2020): 26–34. Sallas's work, including highly accurate reconstructions of early modern folded napkins and centerpieces, has been featured in several exhibitions in historic houses and museums. More on Sallas below.

3. Mattia Giegher, *Il trinciante di Messer Mattia Gieger Bavaro di Mosburc* (Padoua: Per il Martini Stampator Camerale, 1621).

4. Laurie Nussdorfer, "Managing Cardinals' Households for Dummies," in *For the Sake of Learning: Essays in Honor of Anthony Grafton*, 2 vols., ed. Ann Blair and Anja-Silvia Goeing (Leiden and Boston: Brill, 2016), 173–94.

5. "Nel primo si mostra con facilità grande il modo di piegare ogni sorte di panni lini, cioè, salviette, e tovaglie, e d'apparecchiare una tavola, con certe altre galanterie degne d'esser sapute." Giegher, *Li Tre Trattati* (1629), A1.

6. "rinovata, e di molte cose ascresciuta." Giegher, *Li Tre Trattati* (1629), A1.

7. Giegher, *Li Tre Trattati* (1629), n.p.

8. Giegher, *Li Tre Trattati* (1629), n.p.

9. Giegher, *Li Tre Trattati* (1629), n.p.

10. Giegher, *Li Tre Trattati* (1629), n.p.

11. Gieger, *Il trinciante* (1621), *44.H.66 ALT PRUNK, Austrian National Library, Vienna. The title page bears the inscription "Ex libris Petri Lambecii Hamburgensis," identifying the book as having once belonged to historian Peter Lambeck (1628–80), who traveled in Italy and lived in Rome for several years before moving permanently to Vienna, where he became librarian to Leopold I, Holy Roman emperor.

12. Personal correspondence with Joan Sallas, August 2022.

13. Please see the bibliography for a list of these sources.

14. For more context on the Germans in Padua, see Peter J. van Kessel, "The Denominational Pluriformity of the German Nations at Padua and the Problem of Intolerance in the 16th Century," *Archiv für Reformationsgeschichte* 75 (1984): 256–76.

15. The medical school in Padua was one of the oldest in Europe, training doctors and surgeons from the Middle Ages. For the history of medical education with useful bibliography, see Nancy G. Siraisi, *Medieval and Early Renaissance Medicine: An Introduction of Knowledge and Practice* (Chicago and London: University of Chicago Press, 1990), 48ff.

16. This second edition also contains additional engravings on fruit carving that are not included in the 1620 first issue or 1621 second issue of the first edition.

17. *Trincier Oder Vorleg-Buch: Darinnen berichtet wird Wie man allerhand gebratene und gesottene Speisen so auff Fürstliche und andere Taffeln getragen werden mögen Nach Italianischer und vornemlich Romanischer Arth anschneiden und auff der Gabel zierlich zerlegen soll Vor dessen Von Giacomo Procacchi. In Italianischer Sprach beschrieben. An jetzo aber In das hochdeutsche trewlichen versetzet / und mit den signirten Kupfferstichen auffs best und fleissigste gezieret [. . .]* (Leipzig: Hennig Gross the Younger, 1620). There is a second issue from 1621 and a second edition from 1624, illustrated here.

A Dutch version was brought out in 1639: Giacomo Procacchi, *Voorlegh-boeck ofte maniere om verscheyden soorten van spyse [. . .] voor te snyden [. . .] eerst uit Italiaensch beschreven* (Leyden: Jacob Roels, 1639).

18. Presumably, the author's name would be Procacci in Italian, without the *h*, but may have been Teutonized by the German translator or publisher, reflecting the potential German pronunciation. It is "corrected" in most library catalogues.

19. Many of the illustrations are signed "AB" in the lower left corner. He signs the title page with his whole name.

20. "già alquanti anni addietro in diversi tempi adatti alla Stampa." Giegher, *Li Tre Trattati* (1629), A3.

21. Andreas Bretschneider the Younger worked with Gross in Leipzig, who published, among other books, his *New Modelbüch* (Leipzig, 1615). Arthur Lotz, *Bibliographie der Modelbücher: Beschreibendes Verzeichnis der Stick und Spitzenmusterbücher des 16. und 17. Jahrhunderts* (Stuttgart: A. Hiersemann, 1963), cat. no. 55, 102–4.

22. Mattio Molinari, *Il Trinciante* (Padua: Livio Pasquati, 1636; 2nd ed., Padua: Livio Pasquati, 1655).

23. "zumal weil dessen Contenta / als das Vorschneiden an der Gabel / nicht allein an Fürsten und Herren Höfen/sondern auch bei Adel und Unadel." Procacchi, *Trincier Oder Vorleg-Buch* (1620), ii.

24. "Il coltello largo, cioè, da credenza, serve non solo a racorre, e tor su le brice, e i minuzzoli rimasi sopra la mensa; ma eziandio a presentare il pesce cotto in pezzi, item torte, e certe alter cose." Giegher, *Li Tre Trattati* (1629), chap. 18, n.p.

25. Giegher, *Li Tre Trattati* (1629), chap. 19, n.p. Cervio also includes this way to test the blade. Vincenzo Cervio, *Il Trinciante di M. Vincenzo Cervio; Ampliato, et ridotto a perfettione dal cavalier Reale Fusoritto de Narni, Trinciante dell'Illustrissimo e Reverendissimo Signor Cardinal Farnese* (Venice: Appresso gli heredi di Francesco Tramezini, 1581), 7r.

26. Giegher, *Li Tre Trattati* (1629), n.p.

27. Giegher, *Li Tre Trattati* (1629), chap. 4, n.p.

28. "si trincia secondo l'ordine mostrato per li numeri della sua figura." Giegher, *Li Tre Trattati* (1629), chap. 6, n.p.

29. Ken Albala enumerates many of these in "Wild Food: The Call of the Domestic," in *Wild Food: Proceedings of the Oxford Symposium on Food and Cooking* (Devon: Prospect Books, 2006), 9–19.

30. Giegher, *Li Tre Trattati* (1629), chap. 10, n.p.

31. "poichè mi fido della memoria di ciascuno, che quelle da me avrà imparate." Giegher, *Li Tre Trattati* (1629), chap. 17, n.p.

32. "egli è ben vero, ch'all'usanza del nostro paese, tocca ancora al Trinciante di far l'ufficio dello Scalco nel metter le vivande in tavola." Giegher, *Li Tre Trattati* (1629), n.p.

33. Studies that address menus and meal order include Jean Louis Flandrin, "Structure des menus français et anglais aux XIV° et XV° siècles," in *Du manuscrit à la table: Essais sur le cuisine au Moyen Âge*, ed. Carole Lambert (Montréal and Paris: Presses de l'Université de Paris, 1992), 173–92; Bruno Laurioux, "Les menus des banquets dans les livres de cuisine de la fine du Moyen Âge," in *La sociabilité à la table: Commensalité et convivialité à travers les âges; Actes du colloque de Rouen (14–17 Novembre 1990)*, ed. Martin Aurell, Olivier Dumoulin, and Françoise Thélemon (Rouen: Publications de l'Université de Rouen, 1992), 273–80; Jean Louis Flandrin, *L'ordre des mets* (Paris: Odile Jacob, 2002); and Gilly Lehmann, "The Late-Medieval Menu in England—a Reappraisal," *Food and History* 1, no. 1 (2003): 49–84.

34. See the critical edition: Platina, *De Honesta Voluptate et Valetudine: On Right Pleasure and Good Health*, ed. and trans. Mary Ella Milham (Tempe, AZ: Medieval and Renaissance Texts and Studies, 1998). The first manuscript, which Milham endeavors to establish in her edition, is dated about 1465 (59). There is a modern translation: Maestro Martino, *The Art of Cooking: The First Modern Cookery Book*, ed. Luigi Ballerini (Berkeley: University of California Press, 2005).

35. Giegher, *Li Tre Trattati* (1629), 2. This section of the 1629 publication has pagination.

36. "parte per non metter le mani nella pasta d'altri; poiche non fisico, ma trinciante io mi sono." Giegher, *Li Tre Trattati* (1629), 24.

37. To begin to explore this large topic, see Harold J. Cook, "The History of Medicine and the Scientific Revolution," *Isis* 102, no. 1 (March 2011): 102–8; and Katharine Park and Lorraine Daston, eds., *Early Modern Science* (Cambridge: Cambridge University Press, 2006), among many other perspectives.

38. Scappi, in his *Opera* (1570), includes several collations in his list of menus, including one staged to celebrate the birth of the French Dauphin, discussed in Deborah L. Krohn, "Le livre de cuisine de la Reine: Un exemplaire de l'*Opera* de Scappi dans la collection de Catherine de Médicis," in *Culture de table: Échanges entre l'Italie e la France 15e-mi-17e siècle; Actes du colloque international de Blois, 13–14 Septembre 2012*, ed. Florent Quellier (Tours: Presses Universitaires François-Rabelais; Rennes: Presses Universitaires de Rennes, 2018), 151–63. See also Barbara Ketcham Wheaton, *Savoring the Past: The French Kitchen and Table from 1300 to 1789* (Philadelphia: University of Pennsylvania Press, 1983), 51ff.

39. For a summary of recipe books dealing with banqueting, see C. Anne Wilson, *Banquetting Stuffe: The Fare and Social Background of the Tudor and Stuart Banquet* (Edinburgh: Edinburgh University Press, 1991).

40. James Shaw and Evelyn Welch, *Making and Marketing Medicine in Renaissance Florence* (Amsterdam and New York: Rodopi, 2011), 191ff.

41. See the now-classic text on this topic: Sidney W. Mintz, *Sweetness and Power: The Place of Sugar in Modern History* (New York: Viking, 1985).

42. "Si può ancora mettere in tavola insieme con l'antipasto, parte per ornamento d'essa tavola, e grandezza del convito, e parte per poter scompartir giustamente, e con facilità i piatti, certe figure fatte di cera, o di pasta, o di tovagliuoli, come son piramidi, castelli, pagoni, aquile, igni, struzzoli, leoni, cervi, dragoni; statue di varie sorti, verbigratia, un Satiro, un Marte, Un Ercole, che sbrana la bocca al lione. Un Europa sul toro con le mani alle corna. Un Elena Troiana adornata di veste, e capelli d'oro. Una Venere, Una Pallade, Una Giunone, ignuda, etc." Giegher, *Li Tre Trattati* (1629), 51.

43. There is a vast bibliography on objects such as automata created as table centerpieces. For example, Christina Normore discusses a fourteenth-century French table fountain at the Cleveland Museum of Art in *A Feast for the Eyes: Art, Performance and the Late Medieval Banquet*

(Chicago: University of Chicago Press, 2015), 21–43; and Wolfram Koeppe includes many such pieces in *Making Marvels: Science and Splendor at the Courts of Europe*, exh. cat. (New York: Metropolitan Museum of Art, 2019). Also on table fountains, see Evelyn Lincoln, who publishes a Roman *avviso* from 1615 describing "a little gilded silver boat in the middle of the table for a fountain that spouted water through two dragons at its head, and centred at the feet was an eagle." "The Studio Inventory of Camillo Graffico, Engraver and Fountaineer," *Print Quarterly* 29, no. 3 (2012): 263.

44. For a history of folding as an ornamental technique with textiles, see Joan Sallas, *Gefaltete Schönheit: Die Kunst des Serviettenbrechens* (Freiberg im Breisgau, Germany, and Vienna: Joan Sallas, 2010), 14–22.

45. On this practice, including further bibliography, see Jana Dambrogio et al., "The Spiral-Locked Letters of Elizabeth I and Mary, Queen of Scots," *British Electronic Library Journal* (2021): https://www.bl.uk/eblj/2021articles/pdf/ebljarticle112021.pdf.

46. On the history of origami, see Nick Robinson, "Origami," in *Encyclopaedia Britannica*, published December 3, 2014, https://www.britannica.com/art/origami.

47. For the first European mention of Troublewit, see [James Moxon], *Sports and pastimes: or, Sport for the city and pastimes for the country; with a touch of hocus pocus, or leger-demain, fitted for the delight and recreation of youth, by J[ames] M[oxon]. Printed by H.B. for John Clark* (1676), 38–40.

48. "Egli è da notare, che prima si mette in tavola un cavalluccio, ed altri animali fatti di zucchero, con tre altre statue di zucchero alte tre palmi di canna, verbigratia il Cinghiale di Meleagro con freccia nel petto; un cammello con un Re Moro sopra; un'Elefante con un Castello su la schiena pieno d'huomini armati, con archi, frezze, e sassi in mano." Giegher, *Li Tre Trattati* (1629), 53.

49. Giegher, *Li Tre Trattati* (1629), 53.

50. Katharine J. Watson, "Sugar Sculpture for Grand Ducal Weddings from the Giambologna Workshop," *Connoisseur* 199, no. 799 (September 1978): 20–26; Jennifer Montague, *Roman Baroque Sculpture: The Industry of Art* (New Haven, CT: Yale University Press, 1989), 190–97; Ivan Day, *Royal Sugar Sculpture: 600 Years of Splendour*

(Barnard Castle, County Durham: Bowes Museum, 2002); and Joseph Imorde, "Edible Prestige," in *The Edible Monument: The Art of Food for Festivals*, ed. Marcia Reed (Los Angeles: Getty Research Institute, 2015), 101–23.

51. On this, see Ewa Kociszewska, "Displays of Sugar Sculpture and the Collection of Antiquities in Late Renaissance Venice," *Renaissance Quarterly* 73 (2020): 441–88.

52. Michelangelo Buonarotti, *Descrizione delle Felicissime Nozze della Cristianissima Maestà di Madama Maria Medici Regina di Francia e di Navarra* (Florence: Giorgio Marescotti, 1600), transcribed in *Dolci trionfi e finissime piegature*, exh. cat., ed. Giovanna Giusti and Riccardo Spinelli (Florence: Palazzo Pitti Galleria Palatina; Livorno: Sillabe, 2015), 73–77.

53. Riccardo Spinelli, "La mensa di Maria de'Medici e il suo 'dolce apparato': Sculture in zucchero e altro per il matrimonio fiorentino della regina di Francia," in Giusti and Spinelli, *Dolci trionfi e finissime piegature*, 15.

54. Giusti and Spinelli, *Dolci trionfi e finissime piegature*, 130. Besides Giambologna and Tacca, the sculptors Michele Caccini, Giovanni di Santi Penni, Francesco di Girolamo della Bella, and others appear in the payments that are now in the Guardaroba Medicea, Archivio di Stato, Florence.

55. Copies of the *Tre Trattati* are held by a number of the European national libraries, as well as several American libraries. In Europe, the provenance of many early modern books is traceable to monastic or princely owners through ex-libris stamps and signatures. No comprehensive survey of the provenance of culinary books exists.

56. "e per aiutare in parte la memoria di coloro, che da me quest'arte auranno appresa." Giegher, *Li Tre Trattati* (1629), n.p.

57. On Aldrovandi, Kircher, and Renaissance naturalism, see Paula Findlen, *Possessing Nature: Museums, Collecting, and Scientific Culture in Early Modern Italy* (Berkeley: University of California Press, 1994). See also Biancastella Antonino, ed., *Animali e creature mostruose di Ulisse Aldrovandi* (Milan: Motta, 2004); and Giuselle Olmi and Fulvio Simoni, eds., *Ulisse Aldrovandi: Libri e immagini di storia naturale nelle prima età moderna* (Bologna: Bononia University Press, 2018).

58. Per Bjurström, *Feast and Theatre in Queen Christina's Rome* (Stockholm: Bengstons litografiska, 1966), 58–62.

59. *An account of His Excellence, Roger Earl of Castlemaine's embassy from His Sacred Majesty James IId, King of England, Scotland, France, and Ireland, &c. to His Holiness Innocent XI published formerly in the Italian tongue by Mr. Michael Wright [. . .] and now made English; with several amendments and additions* (London: Printed by Tho. Snowden for the Author, 1688), 67.

60. *Account of His Excellence*, 55.

61. Montague, *Roman Baroque Sculpture*, 219n94.

62. Sallas has also reconstructed a series of folded centerpieces for exhibitions in Freiburg im Breisgau and Salzburg (*Tischlein deck dich. Ursprung und Entwicklung des Serviettenbrechens*, Salzburg Baroque Museum, 2008), in New York (*Vienna Circa 1780: An Imperial Silver Service Rediscovered*, Metropolitan Museum of Art, 2010), and in Buckinghamshire, United Kingdom (*Folded Beauty: Masterpieces in Linen by Joan Sallas*, Waddesdon Manor, 2013), among others. See also Charlotte Birnbaum, ed., *The Beauty of the Fold: A Conversation with Joan Sallas* (Berlin: Sternberg Press, 2012).

63. Sallas, *Gefaltete Schönheit*, 55.

64. On starching, see Natasha Korda and Eleanor Lowe, "In Praise of Clean Linen: Laundering Humours on the Early Modern English Stage," in *The Routledge Handbook of Material Culture in Early Modern Europe*, ed. Catherine Richardson, Tara Hamling, and David Gaimster (New York: Routledge, 2017), 306–21.

65. David Mitchell, "Linen Damask Production: Technology Transfer and Design, 1580–1760," in *The European Linen Industry in Historical Perspective, ed. Brenda Collins and Philip Ollerenshaw* (Oxford and New York: Oxford University Press, 2003), 61ff.

66. Linda Stone-Ferrier, "Views of Haarlem: A Reconsideration of Ruisdael and Rembrandt," *Art Bulletin* 67, no. 3 (September 1985): 418.

67. Stone-Ferrier, "Views of Haarlem," 425.

68. Gilles Deleuze, *Le pli: Leibniz et le Baroque* (Paris: Éditions de Minuit, 1988).

69. For a lucid treatment of Deleuze's interpretation of Leibniz, see Gilles Deleuze, *The Fold: Leibniz and the Baroque*, foreword and trans. Tom Conley (Minneapolis: University of Minnesota Press, 1993), 6.

CHAPTER IV

"Nach Italienischer Manier": Edible Geometry and Sleight of Hand

ATTIA GIEGHER'S *TRE TRATTATI* WAS NOT THE EARLIEST TEXT THAT codified and provided illustrations for a set of practices that had been part of European table culture for centuries before his 1629 publication, but it was certainly the most copious and influential. Throughout the rest of the seventeenth century and well into the eighteenth, echoes of Giegher's book saturated the print culture of the German lands and beyond, with examples in Dutch, Swedish, and Norwegian, in addition to French and English. This chapter focuses on the German adaptations. However, it is oversimplifying matters to posit a unidirectional south-to-north flow in the realm of culinary culture. While this model might be useful for other media such as music or visual arts during the early modern period, where the narrative follows the convention of tracing German emulation of Italian ideas and forms, the situation is more nuanced when it comes to food.

Giegher himself was Bavarian, a native German speaker. It is also worth recalling (as was discussed in the previous chapter) that a carving manual from the very early years of the seventeenth century by an otherwise unknown carver from Ancona, Giacomo Procacchi, was translated from the Italian (so its introduction claims) and published in Leipzig in 1620.[1] Whether or not Giegher was somehow involved in the translation of the Italian text into German, he may have (wittingly or not) provided the illustrations that accompanied it, which are very close to his own. Though Giegher was employed by the German "Nation" in Padua, he must also have had students and a following among Italians. There is no indication anywhere in the *Tre Trattati* that it was translated from German, which was likely spoken widely in the city. A highly international city at the foot of the Alps, it was a mecca for students from all over Europe, who were attracted by its stellar reputation due to famous professors such as Vesalius and Galileo. Judging by his text, Giegher himself was probably bilingual (at least—he may have spoken Venetian as well) and would have been in an ideal position to provide German equivalents for the specialized Italian terms that were his stock and trade.

It is against this backdrop that the German editions should be considered. At least thirty German adaptations of Giegher's *Tre Trattati*, comprising both text and illustrations, were published in various German–speaking cities between 1635 and 1677.[2] Many are associated with Georg Philip Harsdörffer, a literary figure, about whom more below, and are oblong quartos, following Giegher's precedent, though their trim size varies. That an earlier German translation of an Italian carving manual (Procacchi) appeared in 1620 in Leipzig (with two subsequent editions in 1621 and 1624), one year before Giegher's stand-alone *Trinciante* dated 1621, suggests that the fame of Italian carvers preceded Giegher north of the Alps. While some evidence exists in rare surviving book catalogues from the Frankfurt book fair, as well as in other sources, that Italian culinary texts were circulating beyond the Italian peninsula during the later sixteenth century, none of the Italian books discussed in previous chapters containing table-setting or carving information, such as Messisbugo, Cervio, Scappi, or Romoli, were directly translated into other languages.[3]

Leipzig, where Procacchi's book was published, was also the location of the printing of the first German translation of Giegher's *Trinciante*, in the 1630s, between the first and second Padua editions of the book. At least two distinct editions are extant. One, in the Bavarian State Library in Munich, is attributed to Georg Philip Harsdörffer in the catalogue and given a provisional date of 1635, though Harsdörffer's name is absent from this edition, which is undated.[4] The format follows Giegher's carving book, with the text and images in proximity.

Another volume, printed in Danzig, includes the date of 1639 on the title page. This must have been based either on the 1629 first edition of Giegher (since the second edition was not published until 1639) or on Procacchi.[5] Though neither Giegher nor Procacchi is given credit as author, the book establishes authority by claiming that it will teach the reader to carve "after the Italian Manner," echoing the long title of Procacchi's 1620 book. The title page features corner vignettes of the four kinds of foods treated inside the book: fish, fowl, fruit, and quadrupeds, a kind of iconographic shorthand for the content (**fig. 4.1**). A second section, with its own internal title page announcing that it was "first printed in Padua in Italian," provides the text to explain the carving images (**fig. 4.2**). A related edition uses a very similar template for the title page but replaces the date of 1639 with 1642 and gives the place of publication as Königsberg. The internal title page, in both 1639 and 1642 editions, also includes

the signature "Conradt Götke schulp," indicating that Götke engraved the plates, presumably adapted from Giegher.[6] If these editions were in fact translated by Harsdörffer, there is no internal evidence to suggest that. It may be that bibliographers in libraries came to associate all German carving manuals with Harsdörffer without being attentive to internal evidence within the books themselves. It is notable that none of the diagrams for folding napkins are included in these editions, as they would be in later books.

Leaving aside the tangled lineage and parsing of editions, both text and images were freely copied, adapted, recut, reversed, and reused. There were ways to protect intellectual property through privileges, but pattern books, which share many characteristics with the carving and folding books, did not generally carry these protections since they were, in fact, meant to be copied. Of course it was theoretically possible to take someone to court for publishing your work, but in practice the boundaries were very fluid and unenforceable.[7] It is clear that the German texts lift a great deal of material from Giegher and other Italian books, but to see this as anything other than business as usual is to impose modern sensibilities. Rather, "Harsdörffer's" engagement with the carving and folding books provides a platform for opening up a discussion of what is actually being transmitted in these texts, beyond the mechanical instructions on how to carve and fold.

Who was Harsdörffer? A prominent author and literary figure whose multifaceted writings are the subject of scholarship by students of German linguistics, literature, aesthetics, and history, the carving and table-setting books to which he contributed content and, most importantly, his name, are

Figure. 4.1
Title page, from *Trincier Büchlein Das ist Eine Anweisung...* (Danzig: Peter Händel, 1639). Engraving. Staats-und Universitätsbibliothek Dresden.

Figure. 4.2
Inner title page, from *Trincier Büchlein Das ist Eine Anweisung...* (Danzig: Peter Händel, 1639). Engraving. Staats-und Universitätsbibliothek Dresden.

the least known or studied of his considerable oeuvre.[8] Harsdörffer (1607–58) was a founding member of the Pegnitzschäfer, a literary society based on the Tuscan Accademia della Crusca, devoted to bucolic, pastoral poetry that recalled classical genres, and belonged to another society in Nuremberg, the Fruchtbringende Gesellschaft. He published about fifty volumes of poetry and prose, and authored the first opera libretto in German, in 1644, for a work scored by composer Sigmund Theophil Staden. Although it may seem incongruous for a literary figure of Harsdörffer's stature to be involved in publishing handbooks on the arts of the table, there are multiple points of convergence between his elaboration of the Italian carving and folding manuals that reached German readers during the first half of the seventeenth century and his other pursuits.

Among Harsdörffer's most important works are a series of dialogues, the *Frauenzimmer Gesprächspiele* (women's conversation games) published between 1641 and 1657. These are notable for their explicit acknowledgment of women as active participants in the world of letters, and have been studied for the wealth of information they provide on a range of early modern themes.[9] He was also active in the field of mathematics, publishing two volumes, *Deliciae physico-mathematicae oder mathematische und philosophische Erquickstunden* (physical-mathematical delights or mathematical and philosophical recreational hours) in 1651 and 1653.[10] Harsdörffer traveled widely around Europe, including to Italy, and was likely inspired by Italian works such as Castiglione's *Il Cortegiano*, in which women are participants in literary and philosophical discussions. Though he is not credited on any of the title pages of any of the editions of the carving books until after his death, his association with them indicates the desire of the publisher to situate these essentially practical handbooks within a more elevated literary or humanist genre, thus lifting them out of the practical service culture in which they originated in Italy. This may explain why so many of the metadata records in German libraries, even today, credit Harsdörffer as author of books in which a substantial portion of both text and images was adapted from Italian sources and perhaps even translated before his interventions.

As part of his literary activity, Harsdörffer was engaged with performance in various guises, including music and theater, but also in the production of official celebrations that included banqueting and feasting in the high Baroque style characteristic of the era. It is

therefore not surprising that his career was entwined with important historical events in Nuremberg, and thus that he supplied texts choreographing theatrical spectacle along with ornamental dishes at the table: *Schauessen* and *Schaugerichte*. The Baroque banquet was a dynamic arena that provided a temporary stage for a *Gesamtkunstwerk*, a total work of art, layering visual, aural, intellectual, gustatory, and olfactory stimuli. Harsdörffer's interventions in the Italian treatises must have shifted the projected readership from stewards or other officers of the table in upper-class homes or palaces, presumably interested in learning how to carve or fold, to a larger audience of literary consumers.

Harsdörffer's association with the carving and folding texts probably began in fact with a 1642 book published by Paul Fürst in Nuremberg. This publisher would bring out at least five subsequent editions, each progressively enlarged.[11] Just to confuse things, unsigned versions were published in 1648 and 1650 in Rinteln with some variations, including new title pages and titles.[12] In 1649 an expanded version of the 1642 book was brought out by Fürst in Nuremberg and signed by Harsdörffer.[13] This volume was the first of several closely related editions published in 1652, 1654, 1657, and 1665 (this last was posthumous) and successively enlarged, that would eventually include not only the carving and folding sections, but also other kinds of information, harking back to earlier Italian books such as Messisbugo's *Banchetti, Compositioni di Vivande, et Apparecchio Generale* (Ferrara 1549, first edition) or Cervio's *Trinciante* (Rome 1581, first edition). Like these Italian books that included detailed accounts of historic meals, including foods served, decoration, and entertainments, and similar also to more journalistic reports of official celebrations such as weddings and coronations that were published as broadsheets or pamphlets, the editions after 1652 also included detailed descriptions of banquets.

A letter to the reader was added in 1649, which set the learned tone for the book, citing biblical and classical precedents for the topic of carving and table setting, including citations of the same passages from Juvenal's *Satires* mentioned by Michele Savonarola in the fifteenth century and Colle in the sixteenth century. Harsdörffer gives the reader the Latin passages in Roman type, following these with rhyming verse translations into German. The first passage, from the fifth *Satire*, is previously discussed in chapter 2. It describes the dancelike gestures of the carver, a servant at the table of a wealthy Roman lawyer who is the subject of this *Satire*.

The second passage is from the eleventh *Satire* and is notable for the way it sets up a comparison between a professional carver, Trypherus, and an unschooled hack who does a passable job even without formal training using the noisy wooden models employed by Trypherus, though Harsdörffer includes only the section describing the professional:

Nor will you find a carver to whom the whole kitchen staff has to defer, a pupil of the maestro, Trypherus, in whose classroom, a splendid banquet—sow's paunch, pheasant, boar, antelope, hare, gazelle, not to mention the tall flamingo—is mock-carved with blunt knives upon elmwood dummies, making a clatter that loudly resounds throughout the neighborhood.[14]

In incorporating these citations that constitute a kind of canon of classical sources for carving and making them available to his German readers, Harsdörffer is framing the more technical parts of the text in a literary context in keeping with his own interests. At the end of this letter to the reader, Harsdörffer acknowledges his sources for the more mechanical portions of the book: the works of carving masters Procacchi, whose now-missing Italian text was published in German, and Giegher, who was Bavarian but wrote in Italian. This edition includes the carving and folding sections after Giegher. The letter ends with a poem and is signed with the initials "GPH," for Georg Philip Harsdörffer, marking the first time his authorship is documented. In subsequent editions, Harsdörffer expanded this letter, indicating that a section of the book had been added to supplement the table-setting, carving, and seasonality sections: this is titled "Von den Schauessen und Schaugerichten." Both words have as their

root the verb *schauen* (to behold or watch), suggesting the performative or theatrical nature of these multimedia creations.

This 1649 edition also includes a section on seasonality that is carried over into the subsequent Harsdörffer-Fürst editions. This is the *Kuchenkalender*—what foods to serve in which seasons, a topic that appears in various forms in many early modern culinary texts. In addition, there is a play: *Der Götter Blumen-Mahl* (the flower-feast of the gods), with its own title page depicting a group of ancient deities such as Flora, Jupiter, and others, who are featured in the play. They are gathered around a table strewn with flowers, illustrating the title of the drama (fig. 4.3).

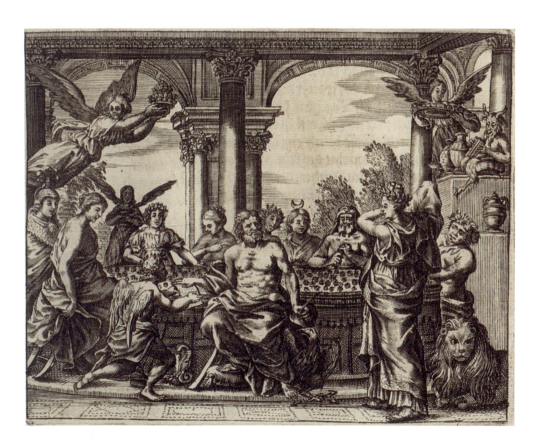

Figure. 4.3
Georg Philipp Harsdörffer, *Der Götter Blumen-Mahl*, from *Vollständig vermehrtes Trincir-Buch*... (Nuremberg: Paul Fürst, 1652), page 225. Engraving. Herzog August Bibliothek, Wolfenbüttel.

It seems likely that Harsdörffer and his publisher were inspired to bring out a new edition, following the success of the 1649 book, by historical events that took place in Nuremberg between 1649 and 1650 in conjunction with the Peace of Westphalia, the accord that effectively ended the Thirty Years' War that had ravaged Europe.[15] The 1652 edition (identical to a 1654 imprint) includes narratives of two lavish banquets that were held as part of the celebrations. One, the Nuremberg Friedensmahl, or Peace Banquet, was organized by Count Palatinate Carl Gustav von Zweibrücken, the Swedish representative who would later become king of Sweden, and held with great flourish in the Nuremberg town hall in September of 1649. Harsdörffer was the mastermind behind the event and was directly involved in providing the learned program for the celebration, which was a summa of Baroque spectacle, combining texts, images, music, and food.[16] Other Nuremberg poets and composers, including Sigmund von Birken (1626–1681), Johann Erasmus Kinderman (1616–1655), and Johann Klaj (1616–1656), also members of the Nuremberg Pegnesischer Blumenorden with Harsdörffer, composed music and poetry for these banquet entertainments. A second, even more lavish banquet took place the following year, hosted by Ottavio Piccolomini, Duke of Amalfi, just outside Nuremberg, and was also memorialized in the 1652 *Trincir-Buch*.[17]

While Giegher's treatises were ostensibly manuals for carvers and stewards who were in training to set tables and organize banquets, these editions from the 1650s, with the considerable interventions of Harsdörffer, were hybrid texts, melding practical manual with humanist literary treatise comprising dialogue, poetry, and natural history, as well as descriptions of *Schauessen* and *Schaugerichten*—ornamental dishes and table decorations, parallel to Italian *trionfi*.

In his account of the Nuremberg Friedensmahl, Harsdörffer, slipping into quasi-reportage, explained that three special kitchens were set up for the event, and twelve cooks were engaged to prepare six courses, each with multiple dishes: first including soups and *oglia putrida*, roasts and game of various kinds; then fish and savory pies; next fruits in silver chargers and on live trees. Following this, sugar-coated flower petals were strewn on the table, and finally the sixth course was brought in, consisting of sugarworks and sweets served in marzipan bowls.

This same 1652 edition also included many allegorical and symbolic mottoes that were incorporated into the *Schaugerichten*, served in successive courses. There were architectural or figural sculptures made of various foods—sugar paste, pastry, or baskets filled with fruit—upon which were placed brief mottoes in both Latin and German on the theme of peace and concord, in keeping with the overall objective of the banquets: to celebrate the resolution of the Thirty Years' War. The mottoes were interspersed with notes on what they were to be made of, such as pleats, *plicaturen*, or butter.[18] Each figure was described in German, followed by the Latin motto, and then a German verse, as in "7. Pallas die Kunstgöttin. NUNC CEDAT LAUREA OLIVO. Lorbeeren weichet die Oliven, last gelehrte Zungen triefen."[19]

Harsdörffer's literary flourishes did not stop with the elaborate *Schaugerichten* and accompanying mottoes. In the Erasmian tradition, he added a section titled "Gast- oder Tischfragen" (literally, "Guest or table questions"), which included a menu for conversation with twenty-four talking points that were to be initiated with leading questions such as "Question 2: How many times a day should one eat?" or "Question 6: Whether man can more easily suffer hunger or thirst."

It is likely that these sections were added not simply to record the historical events, since there were other published accounts in circulation, but to attract potential readers aiming to emulate what were probably the most elaborate and spectacular banquets of the era, with ornamental dishes in various media, including sugar, butter, marzipan, and folded linen, and thus to participate in an international and cosmopolitan milieu.

One of several other visual records of this event is a print based on a monumental painting by Joachim von Sandrart in 1650 that now hangs in the Nuremberg City Museum. It depicts a phalanx of servants entering the town hall where the banquet took place, carrying what looks like an entire aviary of exotic birds such as swans and peacocks, stuffed and placed as decorative flourishes on the tops of pies (**fig. 4.4**). Led by the head steward with a sword and a baton, the parade snakes back and disappears in the upper right, a profusion of necks and feathers. The distinguished guests at the event are seated around two vast rectangular tables, with the most important at the short end of the table with their backs to the viewer. Many of the dignitaries present are named in a key which is included at the bottom of the print. The table is laid with individual plates as well as a couple of stray

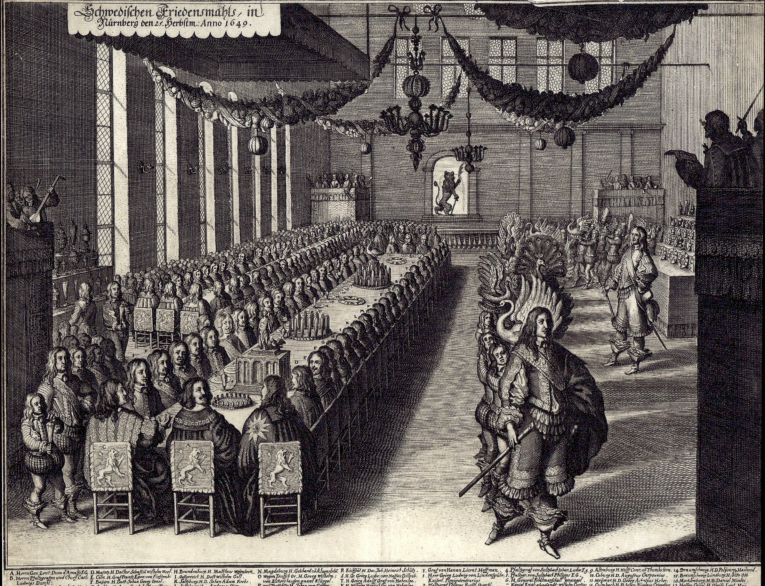

◀ 4.4 swans and several *Schaugerichten* including a classicizing temple possibly made of sugar paste, reminiscent of an illustration in Harsdörffer that functions as an inner title page for the section (fig. 4.5).

Also visible on the print are two credenze or stepped buffets, one with pokals and other vessels of precious plate, some of which are held by servants about to fill the glasses of the diners, and the other with dishes. Musicians located in four raised galleries in the corners of the hall who reportedly played antiphonal, or mirroring compositions, provide visual testimony that the banquet was a feast for the ears as well as for the palate.[20]

4.5

Figure. 4.4
After Joachim von Sandrart, *Schwedischen Friedensmahls in Nürnberg den 25. Herbstm: Anno 1649*, ca. 1650. Etching and engraving. © The Trustees of the British Museum, 1871, 1209.1402.

Figure. 4.5
Georg Philip Harsdörffer, title page for the fourth section, "Von den Schauessen und Schaugerichten," from *Vollständig vermehrtes Trincir-Buch* . . . (Nuremberg: Paul Fürst, 1652), page 131. Engraving. Herzog August Bibliothek, Wolfenbüttel.

3.9

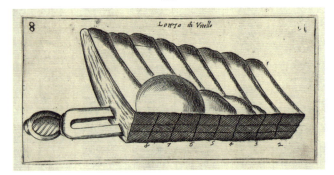

3.8

Comparison of several of the Giegher carving diagrams from 1629 with those in the 1652 imprint of Harsdörffer demonstrates how faithful the recut German engravings are to the Italian originals. Unlike notions of originality and authorship that govern contemporary copyright law, following general conceptions of fair play and fair use, book illustrations in this period were not easily controlled by formal regulation, as discussed in chapter 3. Close perusal exposes subtle but clear differences. Harsdörffer's *Capaun* (fig. 4.6) indicates the same numbered order for making cuts as in Giegher's *Cappone* (see fig. 3.9), but they are more schematic in their representation. While the bird's head is facing in the opposite direction on the later image, indicating a simple reversal, other variations in detail suggest that the engraving was completely recut for the German text. Similar observations follow from comparisons between Giegher's 1629 *Lonza di Vitello* (see fig. 3.8) and Harsdörffer's *Nieren Braten* (fig. 4.7). The German image is more detailed, especially the fork, but the numbers are identical. Giegher's *Testa di Cinghiale, o Porco Salvatico* (see fig. 3.10) is more carefully detailed than Harsdörffer's *Wild Schweins Kopff* (fig. 4.8), which has much less depth and crosshatching, and a stockier shape. Harsdörffer's *Forellen und andere fisch* (fig. 4.9) is quite similar to Giegher's *Pesce* (see fig. 3.11) but includes additional numbers to indicate the order of attack for the carver.

Generally speaking, the German images are more elaborate, with frames around the figures, titles for each page, and an indication of where the corresponding text is found—in which chapter of the book. An exhaustive comparison

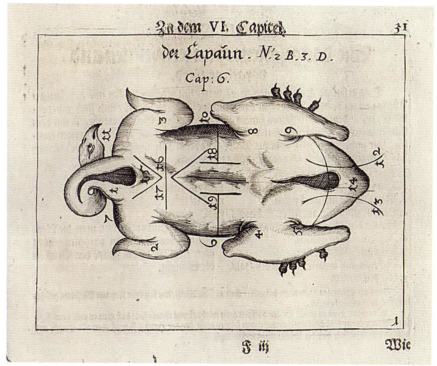

Figure. 4.6
Georg Philip Harsdörffer, "Der Capaun," from *Vollständig vermehrtes Trincir-Buch...* (Nuremberg: Paul Fürst, 1652), page 31. Engraving. Herzog August Bibliothek, Wolfenbüttel.

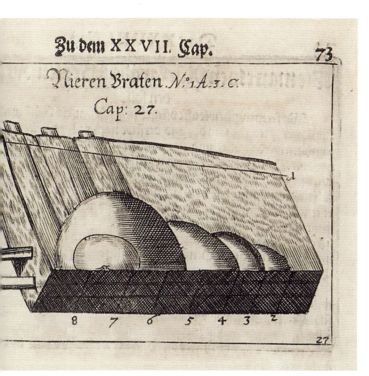

Figure. 4.7
Georg Philip Harsdörffer, "Nieren Braten," from *Vollständig vermehrtes Trincir-Buch...* (Nuremberg: Paul Fürst, 1652), page 73. Engraving. Herzog August Bibliothek, Wolfenbüttel.

4.8

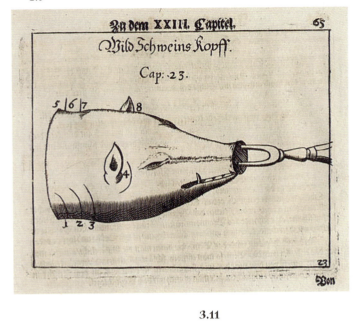

3.10

3.11

4.9

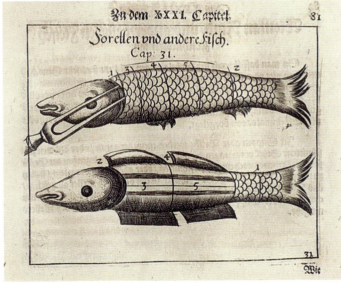

across all carving manuals, from Procacchi (1620) through the end of the eighteenth century, image by image, would likely reveal a number of subtle variations, allowing for changes in paper size and texture or quality, the skill of the engravers, and the location of the image within the book. While the Giegher images have minimal captions on the page, recalling their probable origins as working diagrams for Giegher's pupils in Padua, the Harsdörffer images require a greater level of explication since they are further removed from the practical, didactic context. The encyclopedic nature of the Harsdörffer volumes published in 1652, 1654, and 1657, as well as the posthumous 1665 edition and many other derivatives, to be addressed below, meant that they were probably consumed by readers who might have understood them as instructional texts, literary entertainments, and historical accounts at one and the same time.

Harsdörffer and the Visualization of Mathematics AMONG THE MOST

arresting images in the German books associated with Harsdörffer and others are those that elaborate on the folding diagrams first published by Giegher in 1629. While Giegher's methods were not explicitly mathematical, geometrical reasoning was necessary to fold the linen napkins into various shapes, so it was on some level a mathematical exercise.[21] The situating of books about folding and carving under the larger umbrella of etiquette and culinary service, as discussed in previous chapters, is very much in keeping with the widespread visual representation of emerging fields of knowledge, encouraged by the growing market for illustrated books during the early modern period. But by the middle of the seventeenth century books about carving and folding intersect with another phenomenon: the deployment of mathematics for both informal education and play.[22] There are two distinct avenues by which the practice of paper folding was integrated into recreational mathematics during the seventeenth century: through the creation of elaborate table centerpieces, as documented in the Italian and German texts, and through the tradition of geometric thinking going back at least to Dürer's *Underweysung der Messung*, published in 1525.[23]

Though Harsdörffer was connected with the carving and folding manuals already in the 1640s, probably through his publisher, Paul Fürst, he may have initially been exposed to them through his interest in geometry or mathematical education. Following the earlier

Figure. 4.8
Georg Philip Harsdörffer, "Wild Schweins Kopf," from *Vollständig vermehrtes Trincir-Buch* . . . (Nuremberg: Paul Fürst, 1652), page 65. Engraving. Herzog August Bibliothek, Wolfenbüttel.

Figure. 4.9
Georg Philip Harsdörffer, "Forellen und andere fisch," from *Vollständig vermehrtes Trincir-Buch* . . . (Nuremberg: Paul Fürst, 1652), page 81. Engraving. Herzog August Bibliothek, Wolfenbüttel.

3.1

German adaptations of Giegher, Harsdörffer's books present the folding diagrams in a smaller, though still oblong, format (**fig. 4.10**). But Harsdörffer goes beyond simply replicating the images of disembodied hands demonstrating the basic folding techniques (**see fig. 3.1**). He elaborates on the accompanying text, which is minimal in the Italian sources as well as earlier German versions such as Procacchi. Though Harsdörffer was not trained as a folder, he must somehow have come to possess knowledge of the practices he is discussing, perhaps through recreational mathematical exercises.

Figure. 4.10
Georg Philip Harsdörffer, "Die I Figur," from *Vollständig vermehrtes Trincir-Buch* ... (Nuremberg: Paul Fürst, 1652). Engraving. Herzog August Bibliothek, Wolfenbüttel.

He explains that the folds called *spinapesce* in Italian (fish scales or herringbone) may be translated into German as *Schuppelfalten*, and that it is easier to practice with a sheet of paper, on which mistakes can be more easily corrected, than with starched linen.[24] He also stresses that the folds must be perfectly uniform, or the finished shape will be uneven. He adds that small fingers of young women are better than large farmer's hands for making

the folds. While the folding images and captions that originated with Giegher are published in the first section of the book, which deals with table settings, an additional section added on at the end of the book presents text and images original to Harsdörffer.[25]

It is in this section that the pivot between Harsdörffer's carving manuals and the mathematical works is found. Harsdörffer's 1653 volume, the *Deliciae physico-mathematicae*, contains a brief chapter on how geometric principles can be demonstrated through folding. This section is in fact a condensed version of what appears in the previously published in the 1652 edition of the *Trincir-Buch*. In the 1653 mathematical text, he illustrates two tables, round and square, covered with riotously pleated tablecloths folded into jagged peaks that rise and fall like tabletop mountain ranges.[26] These same images are also found in the 1652 *Trincir-Buch*, so were presumably "borrowed" for the subsequent publication, although the two books do not share a publisher (**fig. 4.11**). Harsdörffer describes the tablescapes as waves or flames, explaining that they would level out once platters, plates, and candelabra were placed upon them.[27]

The beginning of this same chapter presents a series of diagrams of folded napkins that are clearly informed by mathematics (**fig. 4.12**). Harsdörffer explains that these form the basic foundation, or *Grundlegung*, for all the complex compositions:

<div style="text-align:center">

Many sayings can be seen but not painted;
many things can be painted but not expressed in words;
many things can be articulated neither in paintings
nor words. Among these is this handiwork
with pleating; and the first figures
show how the foundation and
first steps 1, 2, 3, 4,
are made.[28]

</div>

4.11

4.12

Figure. 4.11
Georg Philip Harsdörffer, "Rund Tafel," from *Vollständig vermehrtes Trincir-Buch* . . . (Nuremberg: Paul Fürst, 1654), page 325. Engraving. Rare Books Division, The New York Public Library, *KU 99-262. Cat. 47.

Figure. 4.12
Georg Philip Harsdörffer, "Die I Figur.," from *Vollständig vermehrtes Trincir-Buch* . . . (Nuremberg: Paul Fürst, 1652), page 307. Engraving. Herzog August Bibliothek, Wolfenbüttel.

The premise is that an understanding of geometry can be transmitted through practical activity such as folding, rather than through formulae, or even by simply looking at images or diagrams.[29] This focus on haptic or experiential knowledge points to the influence of Francis Bacon, who argued in his 1620 *Novum Organum* that laws of nature could be derived through the experience of engagement with materials.[30]

Fruits THE PAGES ON THE ART OF CARVING FRUITS IN BOTH ITALIAN AND GERMAN texts, while not as clearly linked to practical geometric exercises as the napkin-folding images, share a delight in the power of artisanal skill to transform haphazard products of nature—pears, apples, oranges, peaches, citrons—into regular forms that defy their material properties. Giegher includes several diagrams with elaborately peeled and shaped fruits—mainly apples and pears—as well as citrus fruits, as discussed in the previous chapter (*see figs. 3.12-15*). These use a decorative vocabulary that draws on spirals, grids, and the creation of negative and positive space.

But the German texts offer much more detailed instructions on fruit presentation. Harsdörffer's 1649 *Vollständiges Trincir-Büchlein* includes several chapters on different kinds of fruits: melons, bitter oranges, apples, pears, and peaches, with corresponding images inspired by, but not identical to, those in Giegher. Among noteworthy additions are instructions on how to slice an apple or a pear from the inside and then sew the pieces together with fine thread, so that the skin remains intact. Once served, the instructions specify, it falls into perfect pieces. He explains that this is a good joke for the women's dining room, but not for a table of men. His rationale reveals a gender bias: the trick is not so complicated, but for those who don't understand how it is done, it appears "wonderous and strange" (*wundersams und seltzams*).[31] The skill required for fruit carving was also mentioned in chapter 34 of Molinari's *Il Trinciante*, in which the author explains that the art of carving fruits must demonstrate subtlety and grace. The fruit must be sliced quickly without falling from the fork, with the hands barely touching it, more like a "giocatore di mano," a conjurer, than a *trinciante*.[32]

3.12

3.13

3.14

3.15

Antonio Latini's encyclopedic two-volume book, *Lo Scalco alla Moderna*, also includes a lengthy section on the preparation of whole fruits for presentation at the table. Using the same techniques outlined by Molinari and others, Latini details instructions for pre-slicing and sewing together pears and apples in their own peel with a needle and thread, so that diners who pick them up will find them miraculously carved into pieces ready to eat, "which will result in great praise for the Trinciante."[33] The language deployed suggests sleight of hand and underlines the role of the carver in delivering tableside theater. The invocation of wonder and skill confirms the status of the table as a locus for spectacle, a dynamic parallel to the more static *Kunst- und Wunderkammer*.

Some of these techniques are conveyed in a dazzling fold-out engraving in Latini (fig. 4.13). The fruits, many of which are impaled on the two-tined forks favored by professional carvers, are labeled with letters that correspond to a key inserted into a cartouche on the page. For *A*, the key reads, "Pear cut in four parts without breaking the skin." A needle and thread are conspicuously inserted into the body of the pear. The fruit labeled *I*, placed in the center of the page, depicts "The last cut that one gives for fruit that is carved 'in aria,'" suggesting that fruits, like flesh and fowl, might be sliced in real time in front of the diners. Also included is an iron tool, *T*, that is presumably used for scooping out the insides of the

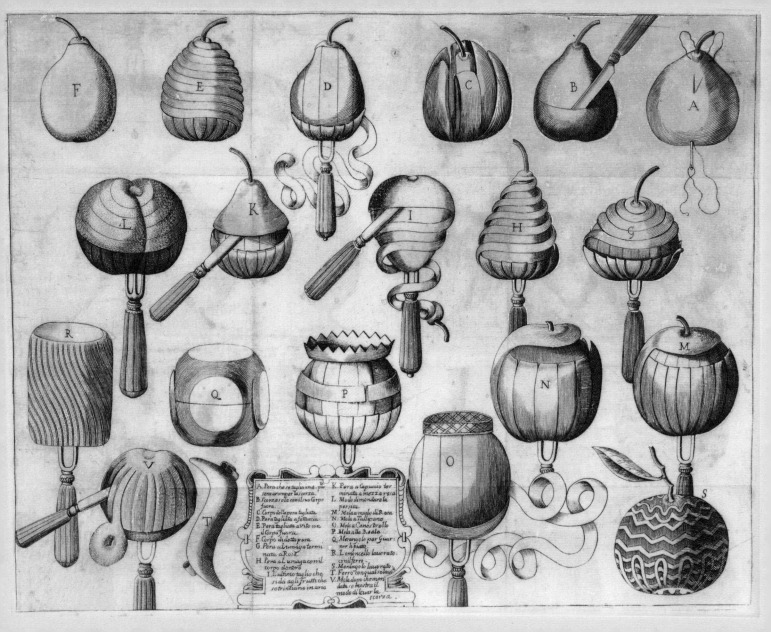

◀ 4.13 fruits. This same tool is also visible in Harsdörffer.³⁴ With their spiraling peels that dance off the page, they parallel contemporary paintings by Dutch artists such as Jan Davidszoon de Heem (1606–1684), in which lemons are often painted partially peeled, their rinds coiling provocatively in a state of perpetual potential. The painter's attempt to capture the ephemeral nature of fruits and flowers may be compared with the carver's performative peeling, turning ordinary citrus and other fruits into props for live entertainment, still lifes no longer still.³⁵

Images and instructions for the presentation of fruit are included in most of the books under study, but the connection to geometric knowledge is much more explicitly brought out in the first posthumous edition of Harsdörffer, also published by Fürst, in 1665. The section on fruit is introduced by a special inner title page that features an image of a dais of solid rectangular blocks that anchors a stout column draped with bouquets of skillfully carved fruits (**fig. 4.14**). Atop the column is a structure that mirrors the base, formed of blocks, on which rest two matched pairs of fruits—an apple and a pear—carving tools, and an open book. The caption reads, "Appendix to the other section of the Trincir-Buch, on the slicing of fruit."³⁶

Figure. 4.13
Antonio Latini (author), Francisco de Grado (engraver), fruits, from *Lo Scalco alla Moderna* (Naples: Domenico Antonio Parrino and Michele Luigi Mutti, 1694). Engraving. The Metropolitan Museum of Art, New York, The Elisha Whittelsey Collection, The Elisha Whittelsey Fund, 1949, 49.42.3. Cat. 41.

Figure. 4.14
Georg Philip Harsdörffer, "Anhang zu dem Andern theil . . . ," from *Vollständiges und von neuem vermehrtes Trincir-Buch . . .* (Nuremberg: Paul Fürst, 1665). Engraving. Rare Book & Manuscript Library, Columbia University, B641 H25. Cat. 39.

4.14

Figure. 4.15
Georg Philip Harsdörffer, "Ungrade Zerschneidung einer Birn," from *Vollständiges und von neuem vermehrtes Trincir-Buch* . . . (Nuremberg: Paul Fürst, 1665). Engraving. Rare Book & Manuscript Library, Columbia University, B641 H25.

Figure. 4.16
Georg Philip Harsdörffer, "Arth und weis sternen und figuren in früchte zuschneiden," from *Vollständiges und von neuem vermehrtes Trincir-Buch* . . . (Nuremberg: Paul Fürst, 1665). Engraving. Rare Book & Manuscript Library, Columbia University, B641 H25.

This is an emblematic image, its meaning at least nominally revealed by a rhyming verse on the following page that explains that the knife is there to slice the fruit, not the hand nor the truth, since lies should melt into the air without effect and would not therefore need a knife.[37] The verb used here is *schneiden* (to slice or carve), rather than the Italianate *trenchiren*, which is used in the introduction to this section, and many other places with variant spellings, printed in Roman type to signal its etymological heritage. Several pages of introductory text follow, in which the author gives credit to "Mathematischer Wissenschaften" (mathematical sciences) as the wellspring of knowledge on how to slice and present the fruits.

The carver is instructed in word and image to slice a pear, for example, into a kind of duck with a body made of a three-dimensional cross (**fig. 4.15**). Another page from this book depicts four geometric patterns with the caption "Arth und weis sternen und figuren in früchte zuschneiden," which could be translated as "The way to carve stars and figures of fruits" (**fig. 4.16**). The implication is that both knowledge (*weis*)—here perhaps geometric or mathematical knowledge—and technical manual skill or dexterity (*arth*) are needed to carry out the carving and slicing of fruit as well as the folding of napkins.

4.15
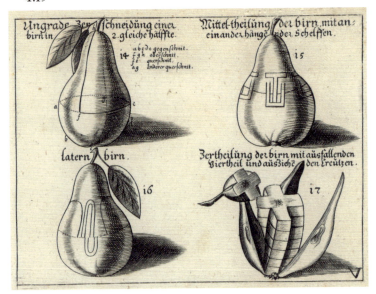

4.16

Title Pages of Carving and Folding Books

THE GENRE OF CARVING AND folding manuals first published in sixteenth-century Italy flourished in Germany, central Europe, the Low Countries, and Scandinavia during the seventeenth century, clearly a profitable gambit for publishers, who brought out edition after edition of books with related content, both illustrations and text. As we have seen in the case of Harsdörffer, these books also functioned as a base upon which other kinds of content could be layered. As they evolved, their title pages, which served as important advertising in the absence of book jackets (which were not used in this period), also changed. A survey of these, many of which display unique and informative imagery, yields a greater sense of the market. Their persistence and their evolution suggest that there was strong demand, as a variety of printers considered them to be a good business venture.

2.10

The earliest illustrated title page with a carver was created for an early seventeenth-century edition of Scappi's *Opera* (see fig. 2.10). The image is derived from one of the full-page engravings in the book (see fig. 2.2), in which a carver holds a joint on a fork in a kitchen or work area.[38] This is in fact the earliest image of a carver at work, as I discuss in chapter 2. The carver on the title page of the 1610 edition has moved out of the kitchen and carries out his craft tableside, reflecting the bundling of Vincenzo Cervio's *Il Trinciante* with Scappi's book, which was originally published without instructions for carvers in 1570. This change reflects the rising popularity of the genre of handbooks for stewards and carvers in the last quarter of the sixteenth century.

2.2

The title page for Procacchi's 1620 *Trincier Oder Vorleg-Buch* (see fig. 3.3) includes a carver at work at a banquet, one of several men appearing in service roles, announcing that the book contains instructions for table setting as well as carving, as also reflected in the title. The implication is that the book will provide the know-how to create similar events. Another edition, undated but published in Leipzig, possibly in 1635, features one of the most graphic depictions of a carver (fig. 4.17). Following a brief introduction, a full-page image depicts a tall, smiling, well-groomed carver dressed in livery brandishing a specimen aloft on a fork in his right hand, with his left holding a long knife poised to slice. He stands before a draped table with exaggerated curlicue feet, upon which rest several other dishes waiting to be carved. These are the foods that can be found in the diagrams that follow. The lack of context—in

3.3

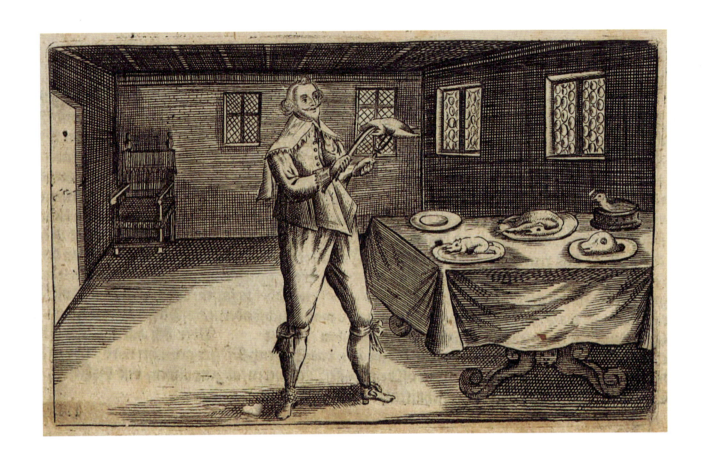

Figure. 4.17
George Philip Harsdörffer, carver, from *Trincir oder Vorleg-Büchlein* . . . (ca. 1635), folio 3r. Engraving. Bayerisches Staatsbibliothek, Munich, Oecon. 1722 p.

the form of diners, other servants, or other foods—suggests that these are not actual cooked dishes, but wooden demonstration models that were used to train students, as described in several manuals from the period as well as in Juvenal's eleventh *Satire*.[39] Though the carving diagrams in this book are very close to the Italian original, the proud carver is unique to this edition, adding what can only be described as "human interest" to the otherwise technical manual and suggesting a bridge between live instruction and its echo in the text.

It will not come as a surprise that the first edition definitively signed by Harsdörffer, published most likely in 1649, had a new frontispiece that was reused for the editions of 1652,

1654, 1657, and 1665 (**fig. 4.18**). The image features a dozen well-dressed people, both male and female, seated at a table in the midst of a festive meal. At the head of the table we see a woman from the back, wearing a large lace collar and an elaborate coiffure consisting of long locks emerging from a snood. In her right hand, she holds a two-tined fork. To her right stands what appears to be a carver, a *trinciante*, holding more carving tools, a cloth draped over his left arm. He looks expectantly at the woman holding the fork, as if he is politely requesting that she return the fork so he can proceed with the task at hand. Just behind him stands a page, holding a stack of plates awaiting their charge. The table is set with a linen tablecloth that bears the crisp folds that signal the back-of-house attention to the care of fine linens that was a mark of status.

The diners have plates before them on the table, and several are holding tall *façon de Venise* glasses with long stems and funnel-shaped flutes. A sideboard loaded with additional lidded vessels and some foods is visible to the left. The floor is paved with marbled tiles in a checkerboard pattern. In the left foreground, a small table holds an ewer and basin for hand-washing. The room is airy, with a roaring fire in the fireplace in the right foreground, and a window of round bottle glass open to a village landscape with a house visible in the distance. The scene conveys a convivial celebration in a bourgeois German home. This suggests a wider readership than the professional carver or a steward who was ostensibly the audience for the first illustrated manuals published in Italy. That this same image was used in subsequent editions, with the date appearing in the 1652 or second edition and then changed for later ones, suggests that it must have been a successful promotional strategy.

It is notable that a woman is seated at the head of the table, and that she holds a carving fork. Though Harsdörffer was arguably open-minded about the potential of women to engage in sophisticated discourse, as suggested by the multivolume work *Frauenzimmer Gesprächspiele*, published between 1641 and 1657, he also disparaged the "Frauenzimmer" as a place where the crafty carver might delight the more gullible gender with his fruity trickery, as discussed above. The image appears to be adapted from a print by the French artist Abraham Bosse, dated 1636 with the engaging title *Wives at Table during the Absence of Their Husbands* (**fig. 4.19**).[40] The verses beneath the scene express the women's pleasure at indulging themselves in food and drink, behavior that was evidently not possible with their husbands around.[41] Details such as

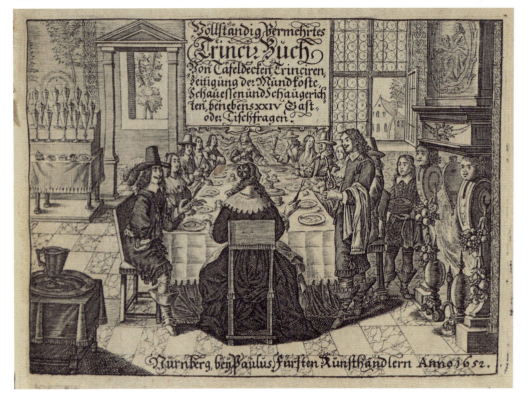

Figure. 4.18
Georg Philip Harsdörffer, title page, from *Vollständig vermehrtes Trincir-Büchlein...* (Nuremberg: Paul Fürst, 1652). Engraving. Courtesy the New York Academy of Medicine Library, RB. Cat. 46.

Figure. 4.19
Abraham Bosse, *Wives at the Table during the Absence of their Husbands*, published by Jean I Leblond, ca. 1636. Engraving. The Metropolitan Museum of Art, New York, Harris Brisbane Dick Fund, 1926, 26.49.63. Cat. 43.

the woman seated at the head of the table with her back to the viewer, and the large hearth to her right, are very similar, though the room itself has been transformed from a bedchamber with table to a more formal setting. The Crucifixion over the mantel in the Bosse print is replaced by a more generic scene, not unexpected in a Protestant country, and the pets and children appropriate to a gathering of women have been banished from the mixed company of the German frontispiece. The Harsdörffer adaptation appears conventional, retaining none of the playfulness and subversive qualities in Bosse's original. It is impossible to know whether most German readers of Harsdörffer's books were aware of the quotation of the Bosse print, but it is a useful reminder of the mobility of print culture.

4.19 ▶

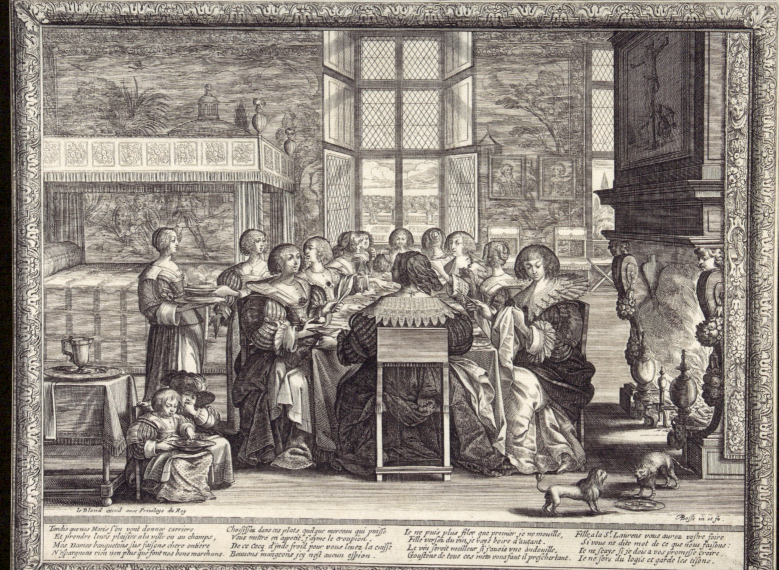

Tandis que nos Maris s'en vont donner carriere, Choisissez dans ces plats quelque morceau qui puisse Ie ne puis plus filer que premier ie ne mouille, Fille, a St. Laurens vous aurez vostre foire
Et prendre leurs plaisirs a la ville ou au champs, Vous mettre en apetit, j'ayme le croupion. Fille versez du vin, ie vays boire d'autant. Si vous ne dite mot de ce que nous faisons:
Mes Dames banquetons sus faisons chere entiere De ce Cocq d'jnde froid pour vous leuez la cuisse Le vin seroit meilleur si s'auois vne andouille, Ie ne sçays si ie dois a vos promesse croire,
N'espargnons rien non plus que font nos bons marchans. Beuuons mangeons icy n'est aucun espion. Goustons de tous ces mets vous faut il prescher tant. Ie ne sors du logis et garde les tisons.

Figure. 4.20

Johann Georg Pasch, frontispiece, from *Neu vermehrtes vollständiges Trincier-Büch...* (Naumburg: Martin Müller, 1665), page 2. Engraving. Courtesy the New York Academy of Medicine Library, RB. Cat. 21.

By the middle of the seventeenth century, carving books were clearly good business and were published all over the German–speaking lands. The frontispiece for Johann Georg Pasch's *Neu vermehrtes Trinchir-Büch*, published in Naumburg in 1665 (fig. 4.20), depicts an intimate meal in an airy home with a view to a landscape and a kitchen. The diners are seated at a round table upon which rests a swan-topped pie. A carver brandishes a fork before the seated guests.

A series of carving and folding books signed by Andreas Klett and published between 1657 and the first quarter of the eighteenth century feature a number of unique frontispieces

that place the carver in a slightly different light. While Harsdörffer and his publisher sought to situate carving and folding manuals in a broader literary context, Klett was apparently a carving teacher, an artisan like Giegher rather than a writer. The first edition of Klett's *Neues Trenchir-Büchlein*, dated 1657, features a title page depicting male and female diners around a large table in the midst of a meal. Several platters of food are discernible, including fish, a veal loin, and an animal's head, perhaps that of a wild boar. Three servants, one of whom may be a *trinciante*, enter from the right. One carries a swan pie. Two additional servants stand before the credenza, one pouring liquid from an ewer into a glass **(fig. 4.21)**.

Figure. 4.21
Andreas Klett, frontispiece, from *Neues Trenchir-Büchlein* (Jehna: Casparus Freyschmied, 1657). Engraving. Rare Book & Manuscript Library, Columbia University, B641 K679.

The preface explains that Klett was entreated to write down what he had taught in the "Collegium Trenchitorium" in Jena for two years before departing for another city, a familiar rationale for committing artisanal knowledge to print in early modern texts. Another edition with the same frontispiece was brought out in 1660. In 1662, Klett published the *Neu Verbessertes Trenchir-Büchlein,* with an ornamental title page featuring an auricular cartouche in which two figures nestle, derived from Michelangelo's oft-quoted reclining nudes from the New Sacristy in the church of San Lorenzo in Florence. Fowl in feather including a turkey as well as cuts of pork, fish, and the head of a wild boar with a two-tined fork in its nose populate the undulating banderoles (fig. 4.22).

Klett is associated with several additional carving books, some with folding instructions as well, that appeared into the first quarter of the eighteenth century. The frontispiece of his 1665 *Neü-erfundenes Trenchir-Büch* depicts two couples seated at a table in a pastoral landscape, though this is a rather formal picnic, with a generous tablecloth and a *trinciante* in full costume who stands before the table holding a joint of beef or a fowl aloft on a fork, his knife poised to slice *in aria*. A shepherd can be seen holding a crook in the background, while his sheep graze placidly (fig. 4.23). The frontispiece of an edition published in Munich in 1671 depicts a *trinciante* in the middle of a lesson. He holds what appears to be the lower half of a hare on the two-tined fork, brandishing the knife in his right hand while a student looks on. Information on the frontispiece lists Klett as "exercise master" in Ingolstatt, where he presumably moved from Jena, suggesting

Figure. 4.23
Andreas Klett, frontispiece, from *Neu-Erfundenes Trenchir-Buch* (1665). Engraving. Bayerische Staatsbibliothek, Munich.

Figure. 4.22

Andreas Klett, frontispiece from *Neu Verbessertes Trenchir-Büchlein* (Wittenberg: Mattaeus Henckel, 1662). Engraving. Staatsbibliothek zu Berlin – Preußischer Kulturbesitz.

Figure. 4.24

Andreas Klett, frontispiece, from *New Erfundenes und vollständiges Trenchir-Büchlein* (Munich: Lucas Straub, 1671). Engraving. Bayerische Staatsbibliothek, Munich, Oecon. 986/ BV001500323.

Figure. 4.25
Andreas Klett, frontispiece, from *Neues Trenchir-und Plicatur Büchlein* (Nuremberg: Leonhard Loschge, 1677), page 5. Engraving. Staats- und Univeritätsbibliothek Dresden, 2007 8 037757.

that carving masters were itinerant, or at least peripatetic (fig. 4.24). Yet another frontispiece, this from the 1677 *Neues Trenchir-und Plicatur-Büchlein*, portrays a carver standing at a table that has been set up on a platform under a tree in a formal garden (fig. 4.25). In the foreground, a large metal basin keeps beverages cool, while a fountain plays to the left. This engraving is signed by Peter Troschel, a Nuremberg artist who created engraved images for Harsdörffer's *Frauenzimmer Gesprächspiele* and also produced a large-format engraving of the fireworks set off to celebrate the Peace of Westphalia in Nuremberg in 1650, thus linking him to Harsdörffer. This copy of the manual also includes a section on folding, as indicated in its title. The illustrations for the folding section are adapted from the Harsdörffer editions discussed above, while the carving images do not hew as closely to the earlier models. The cloth on the table is based on the image of the mountainous table from Harsdörffer (see fig. 4.11).

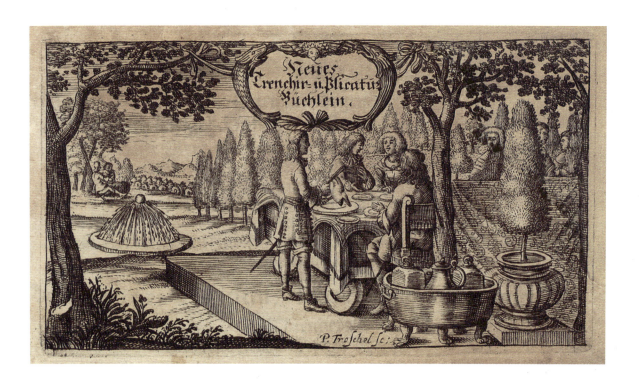

A final example from a Klett book published in Nuremberg in 1724 will suffice to demonstrate the persistence of the carver even as dining customs evolved. Though the carver's services are still being advertised as a selling point for the book, the setting reflects contemporary trends in architecture and landscape design (fig. 4.26). A party of six, mixed company, is seated around a table before a classicizing garden pavilion. The *trinciante* stands at one end of the table in the foreground of the print, holding a fowl pierced by the fork, with his right hand holding the knife. To the right of the diners, where empty dishes await the carver's charge, an elaborate table holds a drinks cooler. A large and exuberant fountain sits in the center of a low basin, while in the background, a damask-patterned garden parterre can be seen.

Figure. 4.26

Andreas Klett, frontispiece, from *Wohl-informirter Tafel-Decker und Trenchant . . .* (Nuremberg: Buggel und Seitz, 1724). Engraving. Staatsbibliothek zu Berlin – Preußischer Kulturbesitz, 50 MA 10701.

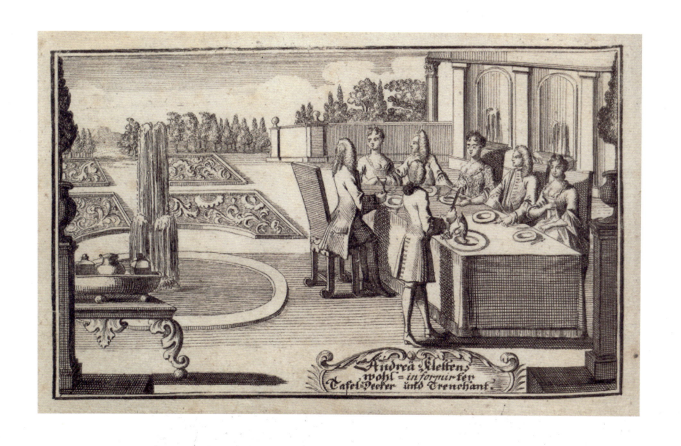

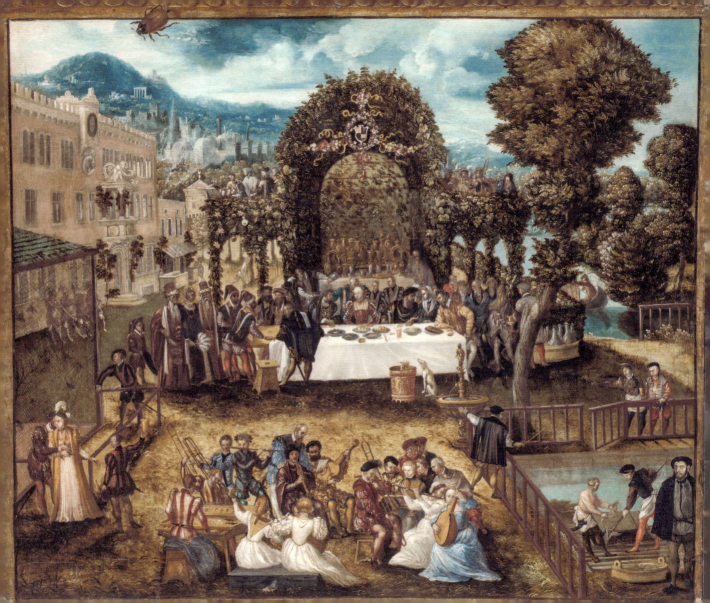

Taken as a group, the frontispieces document varying dining practices, from large, elaborate banquets to intimate outdoor suppers. All require the services of a *trinciante*, naturally. Some of these illustrations are echoed in a lively painting depicting an *al fresco* banquet by Hans Mielich (1516–1573), signed and dated 1548 (fig. 4.27). In the garden of an Italianate villa, a group of diners are seated at a table set before a credenza laden with gold and silver vessels. The stepped structure is framed by an arbor decorated with flowers and greenery, with raised musicians' galleries on either side. A steward or carver stands before the table with his back to the viewer, a white cloth draped over his right shoulder. He appears to be pulling back the tablecloth to reveal the board beneath it, perhaps signaling that this is the final course. To the right, large flasks stand cooling in a basin very similar to that in figure 4.25. The foreground is dominated by a group of musicians who are serenading the feast, while a servant stands at a fishpond, directing the catching of fish bound for the table. In its vivid color and profusion of detail, the painting provides a lively counterpoint to the sober monochromes of the frontispieces surveyed here.

While this perusal does not exhaust the carving and folding manuals published in Germany, it is sufficient to chronicle the enduring and adaptive marketability of a didactic text over more than a hundred years. These black-and-white diagrams, seemingly dry and clinical, provide systematic instructions for a vast array of convivial practices that unfolded across Europe in myriad settings. The final chapter follows these same themes in illustrated carving manuals from France, Holland, Scandinavia, and England.

Figure. 4.27
Hans Mielich, *Outdoor Banquet*, 1548. Oil on panel. Wadsworth Atheneum Museum of Art, Hartford, Connecticut, The Ella Gallup Sumner and Mary Caitlin Sumner Collection Fund, 1949.199. Cat. 45.

Unless otherwise noted, all translations are my own.

1. Giacomo Procacchi, *Trincier Oder Vorleg-Buch: Darinnen berichtet wird Wie man allerhand gebratene und gesottene Speisen so auff Fürstliche und andere Taffelngetragen werden mögen Nach Italiänischer und vornemlich Romanischer Arth anschneiden und auff der Gabel zierlich zerlegen soll Vor dessen Von Giacomo Procacchi. In Italienischer Sprach beschrieben. An jetzo aber In das hochdeutsche trewlichen versetzet / und mit den signirten Kupfferstichen auffs best und fleissigste gezieret [...]* (Leipzig: Hennig Gross the Younger, 1620).

2. The most comprehensive survey of German carving manuals is Uwe Frenzel, *Deutschsprachige Tranchierbücher des Barock (1620–1724)* (Hamburg: self published, 2012).

3. On Scappi and other Italian books at the Frankfurt book fair, see Deborah L. Krohn, *Food and Knowledge in Renaissance Italy: Bartolomeo Scappi's Paper Kitchens* (Farnham and Burlington, VT: Ashgate, 2015), 40–43. For a discussion of translations of Platina's *De honesta voluptate et valetudine*, see Timothy J. Tomasik, "Translating Taste in the Vernacular Editions of Platina's *De honesta voluptate et valetudine*," in *At the Table: Metaphorical and Material Cultures of Food in Medieval and Early Modern Europe*, ed. Tomasik and Juliann Vitullo (Turnhout, Belgium: Brepols, 2007), 189–210. Giovanni Roselli's *Epulario* was translated at the end of the sixteenth century. Giovanne de Roselli, *Epulario, or The Italian Banquet [...] Translated out of Italian into English* (London: Printed by A[dam] I[slip] for William Barley, and are to bee sold at his shop in Gratious street, neere Leaden-hall, 1598).

4. *Trincier oder Vorleg Büchlein: Wie man allerhand Speisen, nach Italiänischer Art, anschneiden Vnd auff der Gabel Zierlich Zerlegen soll* (Leipzig: Johann Leipnitz, [1635]). This book is, however, not listed in the standard bibliography of Harsdörffer. Gerhard Dünnhaupt, *Personalbibliographien zu den Drucken des Barock*, 6 vols. (Stuttgart: Hiersemann, 1990–93).

5. *Trincier Büchlein Das ist Eine Anweisung, wie man nach Italienischer manier allerhand Speisen zerschneiden vnd vorlegen kan* (Danzig, 1639). Here too Harsdörffer is listed as the author, though his signature is absent.

6. Harsdörffer, *Trincier Büchlein* (1642), 42. On Götke, see Jolita Liškevičienė, "Conradt Götke—En-

graver of the First Half of the 17th Century," *Knygotyra* 55 (2010): 54–79. Götke was active in book arts of Lithuania (Vilnius) and Poland in the first half of the seventeenth century. The article cited includes a digest of his oeuvre but does not include his engravings for this book.

7. Evelyn Lincoln has written on questions of privilege and invention in prints authored by artists, but the inventors of the imagery for the carving books are usually not named. It is assumed that they are the authors of both text and images, the owners of the knowledge they contain, which is what is being sold, not the images themselves, as is the case with prints by, say, Albrecht Dürer or Marcantonio, about whom she writes. "Invention and Authorship in Early Modern Italian Visual Culture," *De Paul Law Review* 52 (2003): 1093–120. See also Jane Ginsberg, "Proto-property in Literary and Artistic Works: Sixteenth Century Papal Printing Privileges," *Columbia Journal of Law and the Arts* 36 (2013): 345–458.

8. His influence on the arts is addressed in Doris Gerstl, *Georg Phillip Harsdörffer und die Künste* (Nuremberg: Fachverlag Hans Carl 2005). For a general sense of his writings and critical scholarship, see Hans-Joachim Jakob and Hermann Korte, eds., *Harsdörffer-Studien: Mit einer Bibliografie der Forschungsliteratur von 1847 bis 2005* (Frankfurt: Peter Lang, 2006).

9. Mara R. Wade, "From Reading to Writing: Women Authors and Book Collectors at the Wolfenbüttel Court—a Case Study of Georg Philip Harsdörffer's *Frauenzimmer Gesprächspiele*," *German Life and Letters* 67, no. 4 (October 2014): 481–95. It is notable that these books were also printed in the oblong quarto format.

10. A first volume was published by Daniel Schwenter in 1636, before Harsdörffer's collaboration. Michael Friedman and Lisa Rougetet, "Folding in Recreational Mathematics during the 17th–18th Centuries: Between Geometry and Entertainment," *Acta Baltica Historiae et Philosophiae Scientiarum* 5, no. 2 (Autumn 2017): 14.

11. Georg Philip Harsdörffer, *Newes Trincir Büchlein. Wie man nach rechter Italienischer Art und Manier allerhand Speisen zierlich zerschneiden un höflich verlgen soll* (Nuremberg: Paulus Fürst, 1642). Internal linguistic evidence suggests it is likely that Harsdörffer was not involved in the other 1642 edition that came out in Königsberg, nor does his name

appear in it, though he likely did intervene in the Nuremberg edition that came out in the same year. Jean Daniel Krebs, "Quand les Allemands apprenaient a trancher," *Études Germaniques* 41, no. 1 (1986): 11.

12. *New Vermehrtes Trincier-Büchlein: Wie mann nach rechter Jtalienischer auch jtziger Art und Manier allerhand Speisen zierlich zerschneiden und höflich fürlegen soll: Alles mit zugehörigen newen Kupfferstücken gezieret* (Rinteln: Lucius, 1648). Joan Sallas has noted a related volume also from 1648, associated with Georg Greflinger: *Newes Complementir und Trincir Büchlein* (Rinteln: Lucius, 1648), cited in Joan Sallas, "Mattia Giegher and the First Work on Folded Centerpieces," *Datatèxtil* 40 (2020): 33. The title pages are reproduced in Frenzel, *Deutschsprachige Tranchierbücher des Barock (1620–1724)* (2012), 29–31.

13. Some secondary sources argue that Harsdörffer's first interventions were in an undated edition of 1640, but it is more likely that a second Harsdörffer edition, enlarged with topical content, was published in 1649 and that there was no edition printed in 1640. Werner Wilhelm Schnabel contradicts the 1640 dating suggested by Gerhard Dünnhaupt; see Werner Wilhelm Schnabel, "Vorschneidekunst und Tafelfreuden: Georg Philip Harsdörffer und sein 'Trincierbuch,'" in *Georg Philipp Harsdörffer und die Künste*, ed. Doris Gerstl (Nuremberg: Schriftenreihe der Akademie der Bildenden Künste in Nürnberg, 2005), 158–74; Dünnhaupt, *Personalbibliographien*, 1975. For the so-called 1640 edition in the Herzog August Library, Wolfenbüttel, see Harsdörffer, *Vollständiges Trincir-Büchlein* (Nuremberg: Paulus Fürst, [1640]), http://diglib.hab.de/drucke/135-10-pol-2/start.htm.

14. Juvenal, *The Sixteen Satires*, trans. Peter Green (London: Penguin Books, 2004), 90–91. The original Latin reads, "Non tamen his ulla umquam obsonia fiunt rancidula aut ideo peior gallina secatur. sed nec structor erit cui cedere debeat omnis pergula, discipulus Trypheri doctoris, apud quem sumine cum magno lepus atque aper et pygargus et Scythicae volucres et phoenicopterus ingens et Gaetulus oryx hebeti lautissima ferro caeditur et tota sonat ulmea cena Subura." Juvenal, et al., *A. Persii Flacci, D. Ivnii Ivvenalis, Svlpiciae Satvrae*, 3rd ed., recognovit Otto Iahn, ed. Franciscus Buecheler (Berlin: Weidmannos, 1893), 192, *Satire* 11, lines 136–41.

15. There is a vast bibliography on the many events that marked the peace all over Germany and central Europe. It was also the subject of a large exhibition staged by the 26th Council of Europe, *1648—Krieg und Frieden in Europa / War and Peace in Europe* (October 25, 1998–January 17, 1999), with accompanying catalogue. Klaus Bussman and Heinz Schilling, eds., *War and Peace in Europe* (Münster: Westfälisches Landesmuseum für Kunst und Kulturgeschichte, 1998).

16. For bibliography on the event generally and Harsdörffer's role in detail, see Andrea M. Kluxen, "Harsdörffer und das Schauessen beim Nürnberger Friedensmahl," in *Georg Philipp Harsdörffer und die Künste*, ed. Doris Gerstl (Nuremberg: Schriftenreihe der Akademie der Bildenden Künste in Nürnberg, 2005), 89–103.

17. For a detailed history of the musical accompaniments to the events that celebrated the peace, see Alexander J. Fisher, "Musicalische Friedens-Freud: the Westphalian Peace and Music in Protestant Nuremberg," in *Rethinking Europe: War and Peace in the Early Modern German Lands*, ed. Gerhild Scholz Williams, Sigrun Haude, and Christian Schneider (Leiden: Brill-Rodopi, 2019), 277–99.

18. Georg Philip Harsdörffer, *Vollständig vermehrtes Trincir-Buch* (Nürnberg: Fürst, 1652), 207.

19. Roughly translated, "Pallas, Goddess of Useful Arts/Skill. Now the laurel gives way to the olive. The laurel yields to the olive, learned tongues are loosened." Harsdörffer, *Trincir-Buch* (1652), 207.

20. Fisher, "Musicalische Friedens-Freud," 282.

21. Friedman and Rougetet, "Folding in Recreational Mathematics," 10.

22. This practice has a long afterlife: Jeffrey Saletnik traces the origins of Josef Albers's pedagogic use of folded paper, and of folding as an important haptic method in design education, to seventeenth-century folding treatises such as Giegher and Harsdörffer in *Josef Albers, Late Modernism, and Pedagogic Form* (Chicago: University of Chicago Press, 2022), 104–9.

23. Friedman and Rougetet, "Folding in Recreational Mathematics," 12.

24. Harsdörffer, *Trincir-Buch* (1652), 2.

25. Harsdörffer, *Trincir-Buch* (1652), 306.

26. Georg Philip Harsdörffer, Deliciae physico-

mathematicae oder mathematische und philosophische Erquickstunden (Nuremberg: Endter, 1653), 189–91.

27. Harsdörffer, *Trincir-Buch* (1652), 324–27.

28. "Viel Sagen lassen sich sehen und nicht mahlen. Viel lassen sich bilden und nicht sagen. Viel können mit dem Gemähl und mit den worten nicht ausgedruckt werden. Darunter auch dieser arbeit mit Plicaturen und ist in dieser erst figuren zu sehen wie der Anfang und der Grundlegung Darunter auch dieser arbeit mit Plicaturen und ist in dieser erst figuren zu sehen wie der Anfang und der Grundlegung 1, 2, 3, 4 gemachet wird, allermassen auch auf den 7 Blat angedeutet worden." Harsdörffer, *Trincir-Buch* (1652), 306.

29. Friedman and Rougetet, "Folding in Recreational Mathematics," 20.

30. Friedman and Rougetet, "Folding in Recreational Mathematics," 21.

31. "Dieses und hervorgehendes dienet zu Scherz, bei Frauenzimmer; aber keines wegs an grosser Herrn Tafel, und ist auch die Kunst nicht gross, dem aber der es nicht weis, und den Apfel oder Pyren schelen wil, etwas wundersams und seltsams." Harsdörffer, *Trincir-Büchlein* (164[9]), 98.

32. "e procurando, che il frutto non isfugga il ferro, ò che cada, e tagliandolo con ogni prestezza senza tenerlo molto nelle mani, dove si deve sempre haver davanti gli'occhi, il dovuto decoro sfuggendo i tiri, che hanno più tosto del giocatore di mano, che di Trinciante." Mattio Molinari, *Il Trinciante* (Padua: Livio Pasquati, 1636), n.p.

33. Antonio Latini, *Lo Scalco alla Moderna*, 2 vols. (Naples: Domenico Antonio Parrino e Michele Luigi Muzzi, 1692), 1:71. For background on Latini, see Tommaso Astarita, *The Italian Baroque Table: Cooking and Entertaining from the Golden Age of Naples* (Tempe: Arizona Center for Medieval and Renaissance Studies, 2014).

34. Georg Philip Harsdörffer, *Vollständiges und von neuem vermehrtes Trincir-Buch* (Nuremberg: Paul Fürst, 1665), 139.

35. On the history and significance of the lemon in 17th-century Dutch art and culture, see Julie Hochstrasser, *Still Life and Trade in the Dutch Golden Age* (New Haven, CT: Yale University Press, 2007), 78. Hochstrasser explains that the presence of lemons signified class since only the elite could grow or import them. See also Mariët Westermann, "The Emergence of the Lemon Twist in Dutch Still

Life," public lecture, NYU Abu Dhabi Institute, January 29, 2020, YouTube, https://www.youtube.com/watch?v=9nuo9a68wgM.

36. "Anhang zü dem Andern theil des Trincir-Büchs, von früchten schneiden." Harsdörffer, *Trincir-Buch* (1665), aiiv.

37. "Sehet doppel- früchte Paar! neben diesem Büchlein liegen, Sehet auch den Werckzeug hier, damit Grobheit zu besiegen. Zwar das Messer liegt dabei, nur damit die Frücht zu schneiden, Nicht die Wahrheit, noch die hand; keinem ist es Noth von beiden; Sonders, weil der Lügen Schnitt, ohne messer kan geschehen, Muss er einem Lufft-Schnitt gleich, Wirckungs-loss im Lufft zergehen." Harsdörffer, *Trincir-Buch* (1665), n.p.

38. This is from a hand-colored edition of Scappi now held at the University Library, Göttingen.

39. Harsdörffer, *Trincir-Büchlein* [1640/1649], 21. The assignment of a date of 1640 for this copy by Dünnhaupt in the HAB catalogue is disputed. Krebs, "Quand les Allemands apprenaient a trancher," 12. Later editions also mention the use of wooden models. For the Juvenal reference, see above.

40. See the description of the print in Sophie Join-Lambert and Maxime Préaud, *Abraham Bosse, savant graveur (Tours 1604–1676 Paris)*, exh. cat. (Paris: Bibliothèque national de France; Tours: Musée de Beaux-Arts de Tours, 2004), 174.

41. "Tandis que nos Maris s'en vont donner carriere / Et prendre leurs plaisirs a la ville ou au champs, / Mes Dames banquetons sus faisons chere entiere / N'espargnons rien non plus que font nos bons marchans. / Choisissez dans ces plats quelque morceau qui puisse / Vous mettre en appetit, j'ayme le croupion, / De ce Cocq d'inde froid pour vous leuez la cuisse / Beuuons mangeons icy nest aucun espion. / Ie ne puis plus filer que premier je ne mouille, / Fille versez du vin, je vays boire d'autant. / Le vin seroit meilleur si j'auois une andouille / Goustons de tous ces metz vous faut il prescher tant. / Fille, a la St. Laurens vous aurez vostre foire / Si vous ne dite mot de ce que nous faisons : / Ie ne scays si je dois a vos promesse croire, / Ie ne sors du logis et garde les tisons."

CHAPTER V

From *L'écuyer tranchant* to Genteel Housekeeper

THE PROLIFERATION OF HANDBOOKS OR TREATISES WRITTEN BY OR FOR stewards and carvers during the early modern period suggests that the staging of the table was becoming increasingly professionalized. As with other kinds of precise skills, the transition from apprenticeship to learning through textual or visual sources unfolded in conjunction with the emergence of print culture and the rise in literacy. By the seventeenth century, carvers and stewards like Giegher in Italy or Klett in Germany established schools to teach their skills to whomever had interest or means, regardless of social standing. In France also, texts documenting the training of carvers appear in the course of the seventeenth century, though the practice was clearly much older.

Écuyer tranchant THE OFFICE OF *ÉCUYER TRANCHANT* (SQUIRE-carver) dates back at least to the fourteenth century. Mentioned by Olivier de la Marche (1425–1502), courtier and chief steward at the Burgundian court during the second half of the fifteenth century, carvers appear in visual sources such as the month of January from the *Trés Riches Heures* (see fig. 3.1).[1] As in England or Spain, which also had hereditary aristocracies, the carver was supposed to be of noble birth, since he would be in close proximity to the lord at the table.

3.1

Evidence for a Francophone practice of carving parallel to that in Spanish, Italian, and German sources comes in the form of a small number of surviving hybrid texts, some of which are associated with Jacques Vontet, a Swiss professional from Fribourg who traveled through Europe teaching carving before eventually settling in Lyon, according to the texts themselves.

This group of books features very similar engraved images of cooked meats and fowl on platters, ready to be carved, along with diagrams of how to slice fruits. The text that accompanies the printed images is in manuscript, and many of the engravings are overlaid with manuscript notation. The title pages, when they survive, vary slightly, with two copies in Kraków, and one in Paris, titled *L'Art de trancher la viande et toutte(s) sorte(s) de fruit(s) à la mode italienne et nouvellement à la Françoise.*[2] Two copies on the antiquarian book market are missing their

front matter, but provide opportunities to compare details that suggest how these books were made and used: *La methode de trancher aloüetes Bequefis, et ortolans avec toute sorte d'autres petits oyseaux* and *Au Lecteur Ce n'est pas sans Raison que les plus grands personnages de L'Europe se servent d'Escuyer trenchant.*[3]

In *Au Lecteur* and *La methode*, the engraved sheets with images, unnumbered and without text, are bound in varying order and sometimes in a different orientation, upside down or sideways. The engraved images are almost identical, but the dimensions of the plates (clearly visible), and the figures themselves, differ in small increments, likely due to varying degrees of shrinkage of the paper during the printing process, as the images themselves are too close to suggest that they were re-engraved. The manuscript text is very similar, though not identical; the hands are different, as are the line breaks and sizes of majuscule letters, confirming that they are unique copies. Manuscript notations on the printed images mark off the places where the cuts are to be made, sometimes with numbers clearly indicating the order of attack, in a similar manner to the annotations in the Giegher copy examined on the art market, discussed in chapter 3. A related book in Chicago with a title page attributing the text to Pierre Petit, *écuyer tranchant*, is undated, and contains only engraved images, without text.[4] Later French carving manuals rely heavily on Vontet's text and illustrations, though this may not be the only source.[5]

This group of texts presents a unique opportunity to speculate on the working methods of a carving master like Klett or Vontet, and several hypotheses are possible. The most likely is that students were taking live dictation from the master. Small variations in the text, and the use of different hands, suggest that there was a common source—either textual or verbal. The text was copied onto loose sheets, while engraved images were distributed as handouts, and the lot was bound at a later date. There are no sheets with both printed images and printed text—the images are the only printed material in the books. It is impossible to know whether these manuscripts were created at the same time and place, in a classroom or school setting, or in different locations asynchronously. Perhaps Vontet himself provided a master copy, while his pupils made notes on the engraved images and copied the explanations. The title of one of the copies in Kraków is reminiscent of the German translations of Giegher's carving manual, which announce their debt to Italy on the title page: "The art of carving meat and all kinds of

fruits in the Italian manner and newly in French" (**fig. 5.1**). The scribe, perhaps the master himself, signs the page "Jacques Vontet, Ecuyer Tranchant." The penmanship, florid and striking, with calligraphic swirls and exaggerated majuscules, continues throughout, alternating with more simple script. One image appears in the front matter of several of the surviving copies: it is the hands of the carver, demonstrating the Italian method of carving in the air, with a small larded bird held on a fork by the left hand, and a knife at the ready on the right. The cuffs of the carver are meant to represent pleated linen trimmed with lace (**fig. 5.2**). In the upper left corner, a pierced sphere with a crown of fleur-de-lis hints at another skill that is covered in the books: it is a finished version of one of the geometrically sliced fruits, for which both plans (**fig. 5.3**) and elevations (**fig. 5.4**) are provided.

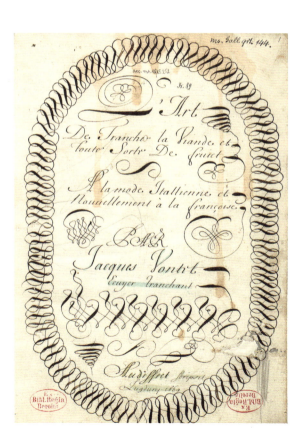

Figure. 5.1

Jacques Vontet, *L'Art de trancher la viande et toutte(s) sorte(s) de fruit(s) à la mode italienne et nouvellement à la françoise* (Lyon, 1669). Manuscript. Biblioteka Jagiellońska, Krakow, Berol. Ms. Gall. Qu. 144.

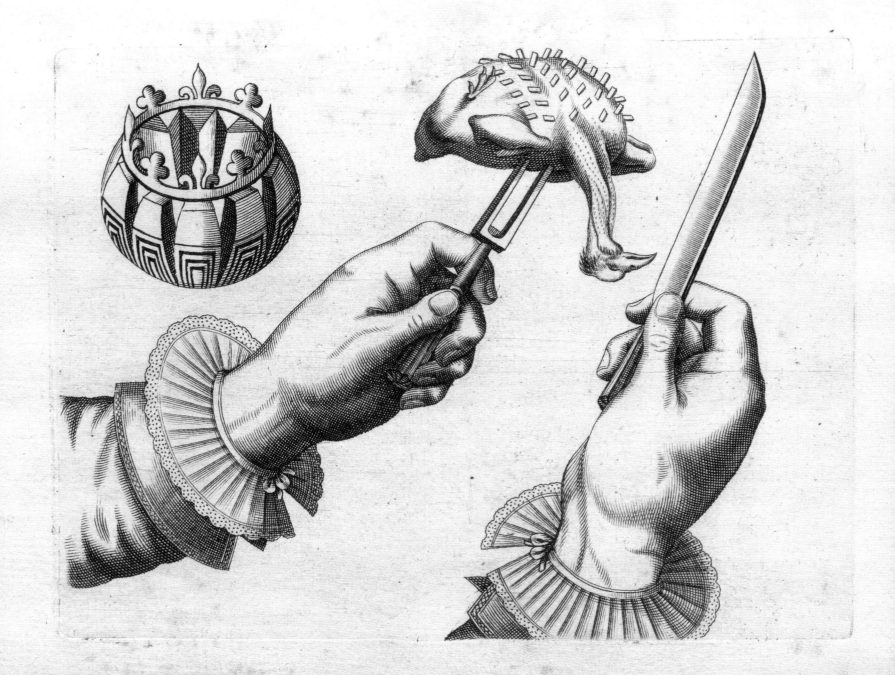

 Figure. 5.2
Pierre Petit, frontispiece, from *L'Art de trancher la viande, & toutes sortes de fruits / nouvellement a la françois par Pierre Petit eicuyer trenchant* ([Lyon?], [1647?]). Engraving. Special Collections, Regenstein Library, University of Chicago, TX885.P480 1600z c.1. Cat. 38.

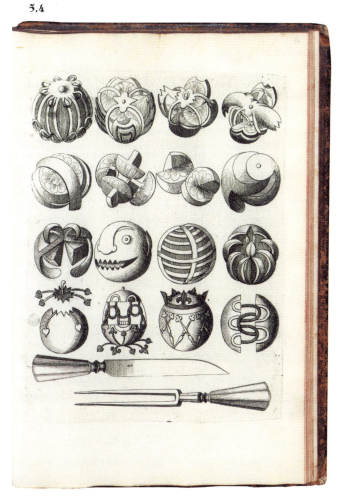

Figure. 5.3

(PREVIOUS PAGE)
Pierre Petit, geometric fruits #27, from *L'Art de trancher la viande, & toutes sortes de fruits / nouvellement a la françois par Pierre Petit eicuyer trenchant* ([Lyon?], [1647?]). Engraving. Special Collections, Regenstein Library, University of Chicago, TX885.P480 1600z c.1.

Figure. 5.4

(PREVIOUS PAGE)
Pierre Petit, fruits #26, from *L'Art de trancher la viande, & toutes sortes de fruits / nouvellement a la françois par Pierre Petit eicuyer trenchant* ([Lyon?], [1647?]). Engraving. Special Collections, Regenstein Library, University of Chicago, TX885.P480 1600z c.1.

Figure. 5.5

[Jacques Vontet], *La Methode de trancher aloüetes Bequefis, et ortolans avex toute sorte d'autres petits oyseaux* . . . (Lyon or Paris, 1647–50). Iron-gall ink on paper. PY Rare Books. Cat. 34.

Figure. 5.6

[Jacques Vontet], *No. 1 Au Lecteur Ce n'est pas sans Raison que les plus grands personnages de L'Europe se servent d'Escuyer trenchant* (Lyon or Paris, 1647–50). Manuscript. Ben Kinmont Bookseller. Cat. 35.

A comparison of pages from the copies held by Ben Kinmont Bookseller and PY Rare Books illustrates the unique status of these books. Each consists of a text page, with small variations in spelling and word choice, and the corresponding engraving. Under the heading "La maniere de trancher la poule Bouillie ou chapon rosty" (the manner of carving a boiled chicken or a roast capon), the following instructions are provided: "The boiled chicken has a very good taste and provides excellent nourishment more suited to young people than the capon due to the fact that it does not transmit as much heat as the capon. One carves it in two ways: in the air, or if it is too well-done, on the plate. It is done in the same way as the capon and it is carved according to the figure, according to which one may also carve the roast capon."

The hand in the PY Rare Books copy is much bolder, with greater losses due to the pooling, corrosive ink, and there are notations on the engraving of the plated fowl (fig. 5.5). The hand in other copy is less elaborate, and there are no notations on the identical engraved image (fig. 5.6). The fowl in both looks like the capon, with the small nail-like extrusions indicating that it has been threaded with lard to improve the flavor by providing moisture as it roasts. The mention of the relative heat of boiled and roasted chicken echoes humoral sources, where foods are credited with inherent qualities that make them more or less desirable for different people. Regimen literature recalling the humoral basis of the *Taccuinum Sanitatis* is echoed even

5.5

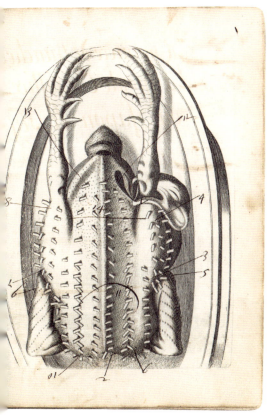

La maniere
De trancher la poule Boulie,
ou chapon roty.

La poule Boulie est de tres bonne saueur
et de fort bonne nourriture, plus propre pour les jeunes
Gens que le chapon a cause quelle ne communique pas
tant de chaleur, on la tranche de deux façons en lait
si elle est trop cuitte dans le plat, on la sert de mesme
façon que le chapon, et on la tranche selon que
montre la figure, selon laquelle on peut aussy
trancher un chapon roty.

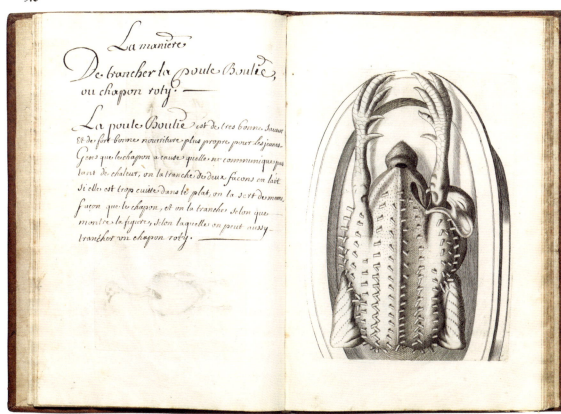

more directly in another example. The page for the hare reads, "Its season is from the month of December until March, its flesh being hot and dry in the second degree that engenders melancholy from which comes that it is not good for the old, nor for the young since it is difficult to digest and makes one become thin."[6]

Together with the humors, a knowledge of seasonality, or when foods are at their best, was also traditionally the responsibility of the carver or the steward, as discussed in the introduction. This is clear from the text that accompanies the images for duck, wild and domestic, in both copies: "Du canard sauvage, et domestique" (**figs. 5.7 & 5.8**). The text reads, "The season of the large ducks is from the month of October to the end of February. Their best sauce is made from their own blood, or from the juice that comes from their own substance." Detailed instructions on how to carve the animal follow, and are noted on the accompanying engraving. As in the comparison of the pages for the capon or chicken, the same engravings are used in both copies, one marked up, the other clean.

However these manuscripts were created, multiple readers and users decided along the way to preserve the records of these didactic sessions as commonplace books, which were eventually bound as they made their way into library collections or onto the antiquarian book market. Leather bindings and bookplates in the copies in Kraków, as well as the Kinmont copy, demonstrate their cladding in the trappings of luxury books. The PY Rare Books copy is in a more modest vellum wrapper, though the multiple repairs to individual sheets and other interventions aimed at preservation suggest the effort that was taken to assure its survival.

The introductory sections in some of the exempla contain a first-person description of the qualities that a carver should have, familiar from the Italian and German treatises, followed by a brief catalogue of the author's professional accomplishments. According to these texts, Vontet served as squire-carver to the Duke of Toralda in Spain. In Rome, Siena, and Padua, he taught his art publicly to the "highest ranked nobles, both foreign and local," as well as in other Italian cities. He claims to have learned his craft while touring and practicing with the "best squires in Europe" as well as reading their books, none of which he cites by name. He concludes the introductory note, which survives in the Beaux-Arts and Kraków copies, with this caveat: "Certainly the figures in my book provide a great deal of enlightenment in this skill. Nevertheless, one cannot learn well without the voice and the precepts of the Master."[7]

Figure. 5.7

[Jacques Vontet], "Du Canard Sauvauge & domestique," from *Au Lecteur Ce n'est pas sans Raison que les plus grands personnages de L'Europe se servent d'Escuyer trenchant* (Lyon or Paris, 1647–50). Iron-gall ink on paper. PY Rare Books. Cat. 34.

Figure. 5.8

[Jacques Vontet], "Du canard sauvauge et domestique," from *La Methode de trancher aloüetes Beqeufis, et ortolans avex toute sorte d'autres petits oyseaux* (Lyon or Paris, 1647–50). Manuscript. Ben Kinmont Bookseller. Cat. 35.

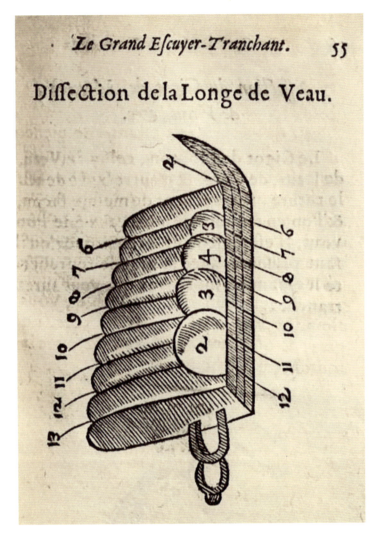

Figure. 5.9
"Longe de Veau," from *L'Escole Parfaite Des Officiers de Bouche: Contenant Le vray Maistre d'Hostel, Le grand Escuyer-Tranchant, Le Sommelier Royal, Le Confiturier Royal, Le Cuisinier Royal, Et le Patissier Royal* (Paris: Ribou, 1662). Engraving. National Library of the Czech Republic.

An amateur reader is able to acquire a few skills from the professional through the book, but embodied knowledge is best taught in person.

Several other French texts bear mention in the context of the continuing diffusion of the Italian carving and folding traditions. First published in 1662 in Paris, *L'Escole parfaite des officiers de bouche, contenant le vray maistre-d'hostel, le grand escuyer-tranchant, le sommelier royal, le confiturier royal, le cuisinier royal, et le pastissier royal* includes a variety of cooking, serving, and presentation skills, as described in the title. It appeared in many subsequent editions, with attendant changes, through the first quarter of the eighteenth century. The term "officers of the mouth" refers to all the various and sundry tasks associated with food and dining, comprising the steward, carver, and pastry chef. The bundling of several different food-related skills between two covers is in keeping with the encyclopedic volumes printed in other parts of Europe, where different texts, often from several authors, were bound together to appeal to a greater variety of reader-consumers. A good example of this is Scappi's *Opera*, discussed in chapter 2.

In *L'Escole parfaite*, illustrations providing instructions on carving and slicing fruits, with reduced and simplified versions of the images in Giegher's *Tre Trattati*, are included in the section devoted to the squire-carver, such as "Longe de Veau," or veal loin (fig. 5.9), or the "Oranges" (fig. 5.10). The section on napkin folding uses some of the same terminology originally found in the Italian sources, translated into French, though no images are included. There are three maps in the section for the "Maitre d'Hostel," indicating, for example, how to serve nine dishes on a round table (fig. 5.11).

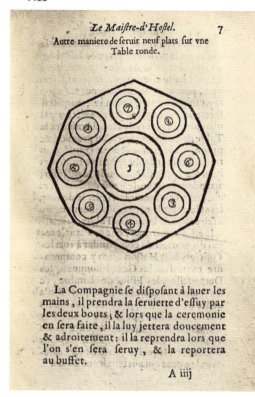

Figure. 5.10

Oranges, from *L'Escole Parfaite Des Officiers de Bouche: Contenant Le vray Maistre d'Hostel, Le grand Escuyer-Tranchant, Le Sommelier Royal, Le Confiturier Royal, Le Cuisinier Royal, Et le Patissier Royal* (Paris: Ribou, 1662). Engraving. National Library of the Czech Republic.

Figure. 5.11

Table map, from *L'Escole Parfaite Des Officiers de Bouche: Contenant Le vray Maistre d'Hostel, Le grand Escuyer-Tranchant, Le Sommelier Royal, Le Confiturier Royal, Le Cuisinier Royal, Et le Patissier Royal* (Paris: Ribou, 1662). Engraving. National Library of the Czech Republic.

This book was brought out by two printers, Jean Ribou and a woman, identified simply as "la Veuve Pierre David," at different addresses but both on the quai des Augustins in Paris, without an author specified.[8] A preface from the bookseller to the reader, "Le Libraire au lecteur," explains that the idea of the book was to bring together in a smaller size everything regarding table service at the grand houses as well as more modest ones, to make it more convenient and portable.[9] No longer an oblong quarto, the first edition of 1662 is a smaller octavo, and later eighteenth-century editions shrink even further to a diminutive duodecimo size, suggesting that the text was used more as a reference book or a souvenir than as a step-by-step guide to carving. The book's title, the "Perfect school . . . " suggests that the

realm of knowledge was being diffused across the social spectrum—making previously elite skills more accessible. This makes the repetitive epithet of "royal," almost ironic, a sales pitch, since users of this book would likely have been anything but royal. The book's smaller size, its broad subject matter, and its longevity suggest an avid readership among the bourgeoisie rather than a professional cadre of cooks, stewards, or carvers. Indeed, the preface from the bookseller acknowledges this, suggesting also that no privileges are needed other than those of its readers, in concluding,

> *For the rest, I dedicate this*
> *to no one other than you, the reader,*
> *because it is for your use if you want to make use*
> *of it, and I don't need any other protection than yours,*
> *if you have a taste for it, and if you find it agreeable.*
> *And thus if you will allow me, I hope you will*
> *enjoy it for a long time indeed, and in practice,*
> *not only for reading. Farewell.*[10]

The reference to readers who are *only* reading, rather than using the book as a practical or how-to book, is striking, and may explain its large readership, as implied by the number of editions.

The mention of the book's lack of official privileges comes into focus once it becomes clear, through reading the text, that much of the content is borrowed from one of the most important cookbooks of the period, *Le cuisinier français, enseignant la maniere de bien apprester & assaisonner toutes sortes de Viandes grasses & maigres, Legumes, Patisseries, & autres mets qui se servent tant sur les Tables des Grands que dans des particuliers*, first published in 1651. The identity of the author of this book, who is indicated on the title page as "le Sieur de LA VARENNE,

Escuyer de Cuisine de Monsieur le Marquis d'UXELLES," is disputed in the great volume of scholarship on his writings, which may or may not include a number of other contemporary cookery texts.[11] La Varenne is considered to be the first book to record a new kind of French cooking, marking the emergence from late medieval ingredients, combinations, and methods, through the creation of sauces, bouillons, and other techniques.[12] That the anonymous *L'Escole parfaite* combines the innovative content of *Le cuisinier français* with technical illustrations and descriptions for carving meats and folding napkins that hark back to late sixteenth-century Italy reflects the market forces outlined above.

It is also significant that the publisher of the 1651 edition of La Varenne, and many subsequent ones, was Pierre David, whose widow—"la Vve P. David"—is listed as copublisher of *L'Escole parfaite*. It seems likely, therefore, that Ribou was able to acquire the assets of Pierre David and thus incorporate the material from La Varenne, which went into some thirty-four editions between 1651 and 1680, with another sixteen appearing before 1700. By the 1680s, editions of La Varenne appear with Ribou as the sole publisher.[13]

Related carving books appeared in other languages as well. Roughly contemporary with the emergence of French cookbooks incorporating images and text reminiscent of Giegher's *Tre Trattati*, a book was published in Amsterdam with the title *De Cierlijcke Voorsnydinge Aller Tafel Gerechten* (the courteous carving of all dishes for the table).[14] Unlike the *Escole parfaite*, multiple editions of which were published in more conventional smaller octavo and duodecimo sizes, this book adopted the model pioneered by Giegher's oblong quarto format. Its first edition in 1664 was followed by at least one subsequent one, from 1670. The title page features a single male diner seated a square table, draped with a cloth which serves as a support for the title. The table is covered with various small dishes, and one large pie garnished with a flower. A carver to his left holds some kind of winged roast on a fork, his knife poised to slice it *in aria* so it falls onto a charger on the table below (**fig. 5.12**). While much of the content, in both text and image, is very close to Giegher, it also includes some original images. A tart very similar to that depicted on the title page is shown from above, with indications on where it should be sliced, and in which order. Two smaller heart-shaped tarts flank the central one. No similar images are found in the Italian or German books, demonstrating the merging of local culinary traditions with the Italian models (**fig. 5.13**).

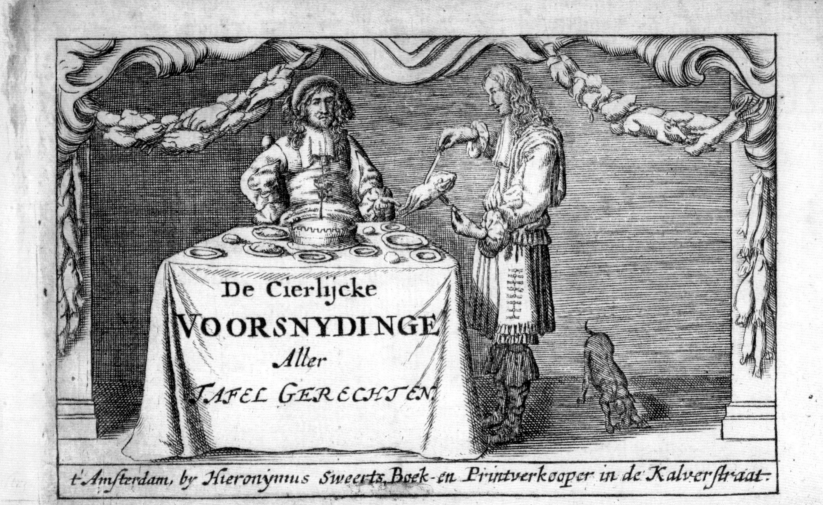

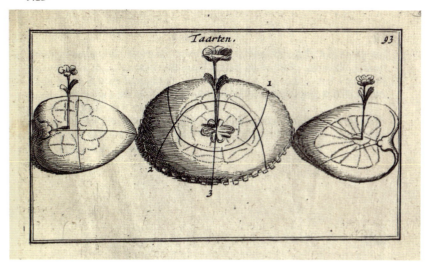

Figure. 5.12
Title page, from *De Cierlijcke Voorsnydinge Aller Tafel Gerechten* . . . (Amsterdam: Hieronymous Sweerts, ca. 1660). Engraving. Courtesy the New York Academy of Medicine Library, RB. Cat. 36.

Figure. 5.13
"Taarten," from *De Cierlijcke Voorsnydinge Aller Tafel Gerechten* . . . (Amsterdam: Hieronymous Sweerts, ca. 1660), page 93. Engraving. Courtesy the New York Academy of Medicine Library, RB.

Table Magic THE SPECIAL SKILLS OF THE *TRINCIANTE*, THE *ÉCUYER TRANCHANT*, or the master carver in manipulating both edible and decorative materials for the table were undeniably a form of *trompe l'oeil*, the performance of a visual deception for the edification of spectators. This is nowhere more in evidence than in a group of books from northern Germany and Sweden dating from the late seventeenth and eighteenth centuries. Published in Stockholm in 1696, *Ny alamodisk åg mykket nyttig trenchier-bok* was the first book on carving and serving food in Swedish.[15] Several subsequent editions with slightly different titles were published in Stockholm and Västerås in the course of the eighteenth century. These books are an unusual size, thin and tall, and small enough to fit into a pocket or to hide between the folds of a skirt—all the better since they include information on how to deceive that might best remain hidden.

Probably adapted from German sources, they include carving diagrams for meats, fish, fowl, and fruit that closely follow those found in related books all over Europe, originally Giegher's *Tre Trattati*, such as the capon **(see fig. 3.9)**. The title page, which folds out to reach a more conventional size, depicts an intimate dining room into which a servant is entering,

5.14

carrying a large charger (**fig. 5.14**). Four men are seated around a table laid with a cloth, some plates, and two large pokals or covered cups, suggesting a wealthy household. Another fold-out depicts the carver's arsenal in vivid red ink, continuing the custom of showing the different-sized knives required to guarantee proper execution of the various techniques for different foods, including an egg holder, oyster knife, and a marrow scoop (**fig. 5.15**).

Along with instructions and illustrations for carving meats and peeling or slicing fruit, these books contain poems to be recited at the table, a section with chemical recipes, including some for invisible inks, and a chapter with ninety-seven magic tricks. Examples of these tricks include how to make a candle that lights itself, how to make a playing card move around the table using a hair attached with wax, and how to make a roast chicken jump off a dish and run around when someone begins to carve it. Also included are cheats, such as turning coins into stones, that cannot then be reversed, fleecing the gullible donor of the coins.[16] The kind of knowledge offered up hovers between superstition and vernacular science, recalling the books of secrets which circulated in many languages all over Europe during the early modern period.[17]

Figure. 5.14
Title page, from *En mycket nyttig och förbättrad trenchier-bok . . .* (Västerås: Johann Laurens Horrn, 1766). Engraving. Umeå University Library. Cat. 25.

Figure. 5.15 ▶
Fold-out of knives, from *En mycket nyttig och förbättrad trenchier-bok . . .* (Västerås: Johann Laurens Horrn, 1766). Engraving. Umeå University Library. Cat. 26.

10. Ostron-Knifwen.
9. Märg-Skeden.

Tredens-Knifwen, hwar med Fisk uti Säppa liggande, eller Brödsmolor utaf bordet uptagas.

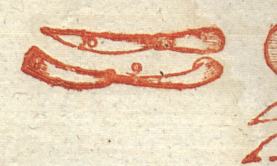

8. Märg-Prylen.

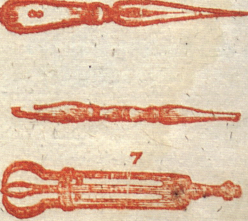

7. Ägghållaren.

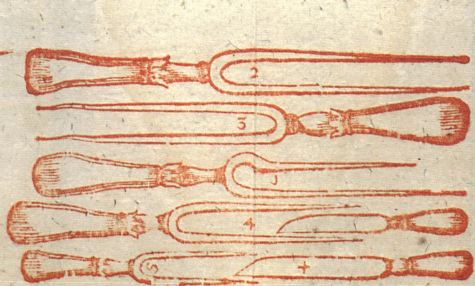

5.16

Though the magic tricks are not illustrated in these Swedish books, several editions feature a striking image of a magic lantern accompanied by the caption "A magic lantern, or black art." Progenitor of the movies, the magic lantern was invented in the middle of the seventeenth century, probably by Christiaan Huygens (1695–81). According to media historian Deac Rossell, a series of ten sketches of skeletons in one of Huygens's manuscripts is accompanied by the caption "For representation by means of convex glasses in a lantern" (fig. 5.16).[18] The figures are drawn in a variety of poses, some with an arc implying range of movement, as might be achieved through projection. The depiction of the skeleton in the carving and folding books is similar to Huygens's sketches, suggesting that the publishers, and perhaps also Huygens, were drawing on a common visual source for the skeleton, such as Hans Holbein's *Totentanz* prints.[19] The device functioned by means of a concave mirror behind a light source that would direct the light through a small sheet of glass with the image painted on it. The resulting projection would be magically enlarged, and the flickering candle would make it appear to be moving, inspiring wonder and awe in the viewer.

One of several optical machines that captured the imagination of both scientists and the general public during the seventeenth century, magic lanterns were manufactured and sold from the 1660s and show up all over Europe, including in Pepys's London.[20] The earliest traveling show to make use of a magic lantern was put on by Thomas Rasmussen Walgensten, a physician and architect who may have known Huygens, with performances recorded in Paris, Rome, Lyon,

and Copenhagen. A performance for King Frederik III in Copenhagen was apparently met with wonder from the king but horror from his courtiers, who found the animated representation of death terrifying.[21]

The image in the carving manuals, repeated without variation in several editions, depicts the inner workings of the apparatus rather than its effects, suggesting that readers might construct their own version, much as they might carve a capon or peel a pear using the instructions contained in the book. The nature of the depiction implies that readers would already know, at least by reputation, what the device could do, and would be interested in creating the experience for themselves. Though by the early eighteenth century the magic lantern was no longer a novelty, and was even considered a trifling form of diversion, its deployment as a device to entertain diners at a banquet marks its domestication.

A German carving and folding book published in Hamburg around 1700, also very small in size but using the familiar oblong quarto format, includes a very similar image of the magic lantern (fig. 5.17). It is possible that this book was the inspiration for the Swedish versions, since the magic lantern does not appear in the first edition of the Swedish carving book from 1696. Like those of many similar publications, its long descriptive title is a kind of table of contents:

Figure. 5.16
Christiaan Huygens, "Pour des representations par le moyen de verres," 1658–60. Ink on paper. Leiden University Library, Special collections (HUG 10) MS. HUG 10, folio 76v.

Figure. 5.17 ▶
Magic lantern, from *En mycket nyttig och förbättrad trenchier-bok* ... (Västerås: Johann Laurens Horrn, 1766). Engraving. Umeå University Library. Cat. 27.

Neu A la modisch Nach itziger gebräuchlichen Arth eingerichtetes Complementir-Frisier-Trenchier- und Kunst-Buch. This book brings in a new kind of skill to the mix: it is also a hairdressing treatise. The hair section does not include illustrations, but smaller, condensed versions of the napkin-folding and fruit-slicing diagrams have been retained. Another version, the *Neu Vermehrt Nützliches Trenchier-Buch*, published around 1700, uses the same frontispiece image as the Swedish exemplars from the mid-seventeenth century but contains a whole section that provides dummy texts on how to write letters (*Send-Schreiben*) of many sorts and to people of different ranks: wedding invitations, wedding acceptances, thank-you notes, birth announcements, death announcements, and more—a how-to guide for letter writing that confirms the book's upwardly mobile readership. As late as 1747, a Danish translation of Klett's carving book was published in Copenhagen, including carving diagrams as well as a condensed selection of some of the fruit-slicing images.[22]

England MEANWHILE IN ENGLAND, LATE MEDIEVAL CARVING TRADITIONS PERsisted well into the seventeenth century. John Murrell's *New Booke of Carving and Sewing* of 1630 was largely lifted from Wynkyn de Worde's 1508 *Boke of Keruynge*, in turn based on Russell's *Boke of Nurture*, including the memorable "terms of a carver" with its highly specialized vocabulary of methods for deconstructing animals.[23] The technique of carving *in aria* disseminated by Italian treatises such as Giegher's *Tre Trattati*, which depended on spearing the prey on a two-tined fork and slicing with a sharp knife, did not translate to England. "Conservative resistance to the fork . . . meant that ostentatious Italian carving methods never caught on. . . . For many years, English carvers continued to secure their master's meat on the plate with the first two fingers and thumb of their hand while they sliced it according to art with the knife held in their right hand."[24] Consequently, illustrations were not included in Murrell's book.

The influence of Italian carving techniques eventually did appear in England by way of Giles Rose's *A Perfect School of Instructions for the Officers of the Mouth shewing the whole art of a master of the houshold, a master carver, a master butler, a master confectioner, a master cook, a pastryman [. . .]: adorned with pictures curiously ingraven, displaying the whole arts / by Giles Rose, one of the master cooks in His Majesties kitchen*, printed in London in 1682. Rose's book was in fact a translation

from the 1662 *L'Escole parfaite* (see fig. 5.18). The page illustrating "the dissection of a Capon after the Italian fashion" presents a schematic diagram with a series of numbers corresponding to cuts. The text explains, "The Italians cut a Capon into a great many pieces; and those pieces are very small." In the same chapter, Rose opines that "there is not a more delicate bit in all the whole Capon than the brawn of the breast, nor a more worthy to be presented to any person of quality."[25] Following the French model, the section called the "Royal Butler" lists the various furnishings that are to go on the table, after which are instructions for folding linens, the responsibility of the *sommelier royal*:

> And it is also
> as necessary for him to know
> how to fold, pleat and pinch his
> Linnen into all manner of forms both
> of Fish, Beasts, and Birds, as well as
> Fruits, which is the greatest
> curiosity in the covering
> of a Table well, for many have gone
> farther to see a Table neatly covered,
> than they would have done for
> to have eaten a good meal
> at the same Table.[26]

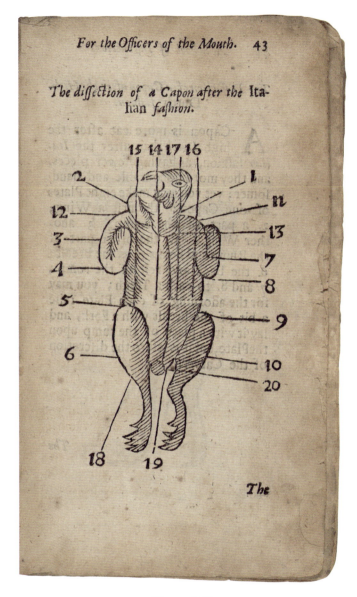

Figure. 5.18
Capon, from *A Perfect School of Instructions for Officers of the Mouth* . . . , translated by Giles Rose from an anonymous French work (London: R. Bentley and M. Magnes, 1682), page 43. Woodcut. Rare Books Division, New York Public Library, *KC 1682.

This implies that there were readers more interested in the appearance of the table than in the quality of the food. Not a word-for-word translation from the French, it is noteworthy that Rose refers to the pleated linens as "the greatest curiosity," invoking the wonder that these figures would still have inspired at the end of the seventeenth century. In a similar vein, the French text, *L'Escole parfaite*, uses the word *genie* (ingeniousness or ingenuity) to refer to the art of slicing fruits: "Because this skill is usually learned by watching someone do it, and by the ingenuity that one might have, there is no point in providing instruction here, rather only providing some images that might not be useless."[27] This acknowledges that the skill needed for the fruit slicing and carving was not something that most readers could aspire to, recalling Molinari's phrase from his 1636 treatise: more like a conjurer than a carver.[28]

Playing at Carving THOUGH GILES ROSE ESTABLISHES HIS CREDENTIALS AS "one of the Master cooks in His Majesties kitchen" in the long title to his 1682 *Perfect School of Instructions*, he also appeals to the broadest possible readership, in addressing "Ladies and Gentlewomen and all Persons whatsoever that are desirous to be acquainted with the most excellent ARTS of Carving, Cookery, Pastry, Preserving, and Laying a Cloth for Grand Entertainments." By the late seventeenth century, the stage was set for the transformation of the courtly art of carving to a more domestic and popular platform, where rising literacy created a booming business in cookbook writing and publishing. Skills such as carving were included in the growing number of cookbooks and related household manuals explicitly addressed to women, no longer found exclusively in texts addressed to male servants in courtly or aristocratic households.[29] Not only were more women reading cookbooks—they were also writing them, both unique manuscript "receipt books" and printed texts.[30]

A slim pamphlet that accompanies a deck of playing cards, printed in 1693 and now very rare, bears the title *The Genteel House-keepers Pastime, Or, The Mode of Carving at the Table Represented in a Pack of Playing Cards*.[31] While the gender of the "genteel house-keeper" is not specified, it most likely refers to women. Its long title is worth citing in its entirety, since it describes the purpose of the book. It continues: *By which, together with the Instructions in the Book, any ordinary Capacity may easily learn how to Cut up or Carve in Mode all the most usual Dishes of Flesh, Fish, Fowl and Baked Meats; and how to make the several services of the same at the Table;*

with the separate sawces and garnishes proper to each Dish of Meat. The cards and pamphlet were created by Joseph Moxon, a London printer and maker of maps and scientific instruments, likely in 1677, though no surviving copies bear that early date.

Some clues as to why a commercial printer might have had the idea to come out with a pack of cards sporting carving diagrams can be gleaned from a list of other products "made and sold by J. Moxon, at the Sign of the Atlas in Warwick Lane" that is found at the end of the pamphlet. This catalogue comprises globes, maps, mathematical instruments, books, pamphlets, and other packs of cards, with prices indicated. Son of a printer, Joseph Moxon lived in Holland as a youth and there trained as a globe- and mapmaker, returning to London to found his own press, the Atlas. As hydrographer to the king and purveyor of mathematical instruments and books, he was elected a Fellow of the Royal Society in 1678, unusual for a tradesman.[32] In addition to the carving cards, he published several additional decks that, taken as a whole, suggest the role that the popular press played in the dissemination of scientific knowledge of various kinds. Among these were the *Astronomical Playing-Cards*, depicting fifty-two constellations; *Geographical Cards*, with maps; and *Geometrical Playing-Cards*. Like the carving cards, these other packs brought specialized knowledge to a mass audience in a unique format, combining vernacular science, play, and entertainment. As Moxon writes in the introduction to the carving cards, "these Cards do not only perform the office of other Playing Cards, but the variety of Pictures of good Cheer on them, will doubtless oft prove the cause of adding Mirth and Jocularity to your sociable and harmless Recreation."[33]

Though the immediate purpose for this explanation of the advantages of good carving is that of the publisher marketing his product, it is nevertheless a clear indication of broad cultural valence of carving. Good carving, the narrator argues, also teaches its practitioners anatomy and math: "the Dissection of Parts, the Scituation of Joynts and Ligaments, and the true position of the (at least) eminent Muscles. Nor does it shut out the most excellent Sciences of Arithmetick and Geometry."[34] Given Moxon's profession and the fact that he sold scientific instruments in his shop, the linkage of carving with mathematics and geometry makes sense.

In fact, the pamphlet accompanying the geometrical cards was a translation by Moxon himself (so he claimed) of René Descartes's *Traité de la mecanique,* first published in 1618:

The Use of the Geometrical Playing-Cards, As also a Discourse of the Mechanick Powers. By Monsi. Des-Cartes. Translated from his own Manuscript Copy. Shewing What Great Things may be performed by Mechanick Engines in removing and raising Bodies of vast Weights with little Strength of Force.[35] These cards feature a series of diagrams that illustrate principles that are described in the pamphlet, and bear formal resemblance to some of the geometric diagrams for carving fruits in the German manuals. The image on the wrapper for the cards (**fig. 5.19**) suggests the kinds of "representations" contained therein.

Figure. 5.19
Joseph Moxon after René Descartes, wrapper, "Geometre and the Mechanick Powers." Printed and sold by J. Moxon, London, 1697. Engraving. Beinecke Rare Book and Manuscript Library, Yale University, UvL50 693G.

Though we do not know enough about the genesis of these packs of cards, their immediate context suggests that Moxon, and perhaps his audience, considered carving to be like other mechanical arts that required training, specialized knowledge, and manual dexterity, comparable to the recreational mathematics practiced by Harsdörffer and his readers and discussed in the previous chapter. It is also not impossible that Moxon was making a joke in his splitting of Descartes into two words: Des-Cartes, but this is a subject for another study.

The pamphlet accompanying the carving cards begins with a definition:

Carving at the Table is an orderly and methodical Cutting and Dividing any Dish of Meat, whether it be Flesh, Fish, Fowl, or Bak'd Meats, into so many Services as each dish of Meat will conveniently admit of: and doing this neatly and cleanlily, is worthily accounted a great Imbellishment to Man or Woman.[36]

The mention of a female carver is an indication of the projected readership for the pamphlet, and for the playing of cards. If good carving improves a dish, its opposite, the "disorderly mangling a Joynt or Dish of good meat, is not only an unthrifty wasting of it, but sometimes the cause of loathing, to a curious Observer or a weak stomack." The preface builds to further justify the purpose of the book: "Upon such considerations as these, hath the wisdom of the Grandees of former Ages of great antiquity elected Carvers at their Tables." The narrator invokes Moses, "who was instructed by God Almighty himself what parts to make choice of for his own Offerings and Services, what for the Levites, and what for the People." After Moses, there is a jump to fifteenth-century England, with the naming of a carver who served George Nevil, chancellor of England and archbishop of York.

Winding up, the narrator explains that the book will demonstrate carving "on curious engraven Cuts, accommodated to Playing Cards, since they are full as intelligible as if they were Printed in the Book, and more easie to peruse when you read upon each Card: because you may hold the Card in your hand while you are reading the Rules relating to it, though it may be for many leaves, without being troubled to turn backward or forward to the Figure."[37] This preoccupation with the functionality of the illustrated book may be in the service of advertising, but it is a fascinating commentary on the evolving dynamic between words and pictures that may be traced through the history of the book in early modern Europe. The individual cards are liberated from their prison between the pages of a bound volume, free to be manipulated according to the desires of the readers and users. This provides a unique take on the development of user interfaces that were devised in order to deal with the increasing volume of information made available via the new technology of the printed book.[38]

Following the introduction, there is a detailed verbal description of how to carve each kind of animal or pie represented on the fifty-two playing cards that were sold together with the pamphlet. A wrapper that enclosed the cards bears a printed image depicting a table around which eleven diners are seated on chairs or stools. The table is set with plates and several larger platters of food. Many of the diners hold goblets aloft, as if they were in the middle of a toast. To the left, a male carver stands in profile, holding a knife in his right hand and presumably a fork in his left. Though the book describes "the mode of carving at the table" as "the genteel housekeeper's pastime," suggesting a female domestic servant or head of the household, the carver pictured harks back to the many title-page illustrations that feature the *trinciante*, a male servant in his role as carver (**fig. 5.20**). The cards are straightforward, each with a carving diagram and the identifying marks of the suit. The diamonds are "fowl" such as goose, woodcock, pheasant, duck, and capon (**fig. 5.21**). The capon is reduced to its most basic outlines with just two numbers marking cutting lines, 5 and 8, that appear to be transferred from another image without any of the context that makes them useful. The text indicates how to carve the bird, and then what the sauce should be. For the capon, it is "Butter and vinegar beaten up thick, or Oranges. Its garnish is Oranges or Lemons, slic'd and laid about the brims of the Dish."[39] The "Loyne of Veal" (**fig. 5.22**), one of the "beasts" that are all given the suit of hearts, resembles more closely some of the earlier Italian and

Figure. 5.20
Wrapper, from *The Genteel House-Keepers Pastime, Or, The Mode of Carving at the Table Represented in a Pack of Playing Cards*. Printed and sold by J. Moxon, London, 1693. Engraving. Beinecke Rare Book and Manuscript Library, Yale University, UvL50 693G.

German diagrams illustrating this cut of meat, though the placement of the fork, as indicated in Giegher's version of the same cut, is missing (see fig. 3.8). The clubs are all different kinds of fish and seafood, such as the salmon, apportioned into eight sections, presided over by the queen (fig. 5.23). The boar's head "comes to the Table with its snout standing upward, and a sprig of Rosemary stuck in it" (fig. 5.24).[40]

Though local English foodways are evident in many contemporary recipe collections and receipt books, these carving cards stick mostly to the same cuts of meat and kinds of fowl featured in the continental carving books. The "bak'd meats" are all spades, architecturally shaped meat pies with fillings such as goose, tongue, or hare. The venison pasty (fig. 5.25)

3.8

182 ✳ STAGING THE TABLE IN EUROPE 1500–1800

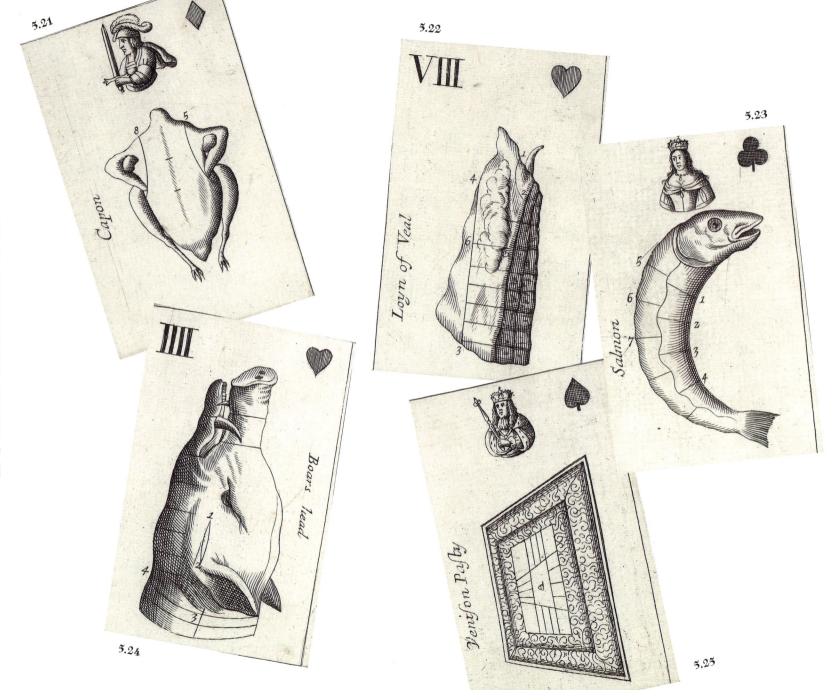

is perhaps the most elaborate of the pies, shaped like a garden parterre. The text does not explain this iconography but provides instruction on how to "read" an image drawn in perspective: "The Venison-Pasty, though it be here drawn with one end longer than the other, and the sides sloping away, because the representation of the raised crust may the better appear, yet they are made square, with its two opposite sides equal in length to each other."[41] Compared with similar images from the continental books such as Giegher's *Tre Trattati* or any of the German texts, they are more schematic and reductive. And though there are many similarities between the forms on the cards and the continental examples, they do not seem to be following any particular visual model exclusively.

∗ ∗ ∗ ∗ ∗ ∗ ∗

By the late seventeenth century, there was a plethora of illustrated carving manuals that might have been used as potential models for the carving cards, making a more specific genealogy difficult to establish. Representations of how to carve meats and fruits, and how to fold and pleat marvelous forms with table linens, were ubiquitous in printed books throughout Europe. Published in a variety of formats and in a myriad of languages, these books disseminated skills that were once the purview of elite courtiers to anyone who could buy them. While the fashion for carving and folding in the Italian manner appears to have waned by the end of the seventeenth century, Giegher's illustrations continued to serve as a model for similar images well into the eighteenth and beyond.

The outlines of a history of the carving and folding manual, from late medieval courtesy book to practical handbook for stewards and court officers, to humanist playbook for patrons of the carvers and stewards as they orchestrated celebratory banquets, to domestication in the form of a card game aimed to capture a middle-class and possibly female market, tells a familiar story in a language of black-and-white diagrams. The spread of Italian court culture northward can be tracked on many registers from the late sixteenth into the early eighteenth century, but the narrative resists a unidirectional interpretation. The story is not a simple one of model and imitation, and there is no clean endpoint, no moment when the tradition completely ceases.

Figure. 5.21-25
Jack of Diamonds, Eight of Hearts, Queen of Clubs, Four of Hearts, and King of Spades from *The Genteel House-Keepers Pastime, Or, The Mode of Carving at the Table Represented in a Pack of Playing Cards*. Printed and sold by J. Moxon, London, 1693. Engraving. Beinecke Rare Book and Manuscript Library, Yale University, UvL50 693G.

The staging of the table is enacted in contemporary restaurants and banquet halls around the world to this day, with delighted diners admiring the skills of highly trained artisans as they demonstrate mastery over edible materials. The fascinating array of images that accompanied the pedagogy and performance of carving and folding not only yields insights about elite practices and social mobility but also illuminates a fascinating network of engravers, printers, publishers, readers, and eaters across early modern Europe.

Unless otherwise noted, all translations are my own.

1. Olivier de la Marche, *Estat de la maison du duc Charles de Bourgoingne, dit le Hardy*, published together with *Memoires d'Olivier de la Marche, maître d'Hôtel et capitaine des gardes de Charles le Téméraire*, ed. Henri Beaune and Jules d'Arbaumont (Paris: Société de l'histoire de France, 1883–88), 4:1–94.

2. Two copies are held by the Biblioteka Jagiellońska, Kraków; both bear the date of 1669. A facsimile of a copy in the Bibliothèque des Beaux Arts, Paris, is given the date of about 1650, Lyon. *L'art de trancher la viande et toutes sortes de fruits* (Paris: École nationale supérieure des beaux-arts, 2013). A copy in the National Library of Medicine in Bethesda, MD, is dated 1646–49?. The Lilly Library, University of Indiana-Bloomington, has a copy that is dated 1650?.

3. For a detailed description, see Ben Kinmont, *Gastronomy* (Austin, TX: Antinomian Press, 2020), 54–62. There are forty-one engravings and twenty-seven pages of manuscript in *Au Lecteur*, and forty-eight engravings and twenty-four manuscript pages in *La methode*.

4. *L'art de trancher la viande, & toutes sortes de fruits / nouvellement a la françois par Pierre Petit écuyer trenchant* (n.p., n.d.). The Chicago library catalogue gives the book a provisional date of 1647, and links this Pierre Petit to a French astronomer and physicist (1598–1677) who was a member of the Royal Society. It is unclear whether this is in fact the same Pierre Petit.

5. A carving manual, supposedly "found" by Charles-Marie-Josephe Baconnière de Salverte in 1926 called *La vraye mettode de bien trencher les viandes* and allegedly the source for the most important nineteenth-century French work on carving, Alexandre Balthazar Grimod de la Reynière's *Traité de la dissection des viandes* in the *Manuel des Amphitryons* (1808), has been proven to be an early twentieth-century fake; it is likely that Grimod used a copy of Vontet as his source. On this, see Julia Abramson, "Deciphering *La vraye mettode de bien trencher les viandes* (1926)," in *Authenticity in the Kitchen: Proceedings of the Oxford Symposium on Food and Cookery*, ed. Richard Hosking (Totnes, UK: Prospect Books, 2006), 11–26.

6. "Sa saison et depuis le mois de decembre Jusqu'en

Mars sa chair estant chaude et seche au second degré elle engendre la melancolie d'ou vient quelle n'est pas bonne pour les veillards, ny trop pour les jeunes veu qu'encore elle est difficile a digerer et fait emmaigrie."

7. "Certainement les figures de mon livre donnent un grand éclairissment en cet art. Néanmoins, on ne le sauroit bien apprendre sans la voix et les préceptes du Maître."

8. *L'Escole parfaite des officiers de bouche; contenant le vray maistre-d'hostel, le grand escuyer tranchant, le sommelier royal, le confiturier royal, le cuisinier royal et le patissier royal* (Paris: chez la Vve P. David : J. Ribou, 1662). David was a prominent printer of many different kinds of books. His wife may have worked with him in the printing business but was invisible until she was widowed. Thanks to Evelyn Lincoln for this insight.

9. "joint que le faisant imprimer ie n'ay point eu d'autre dessein que de reduire en un seul Volume tout ce qui regarde les services de table, tant chez les Grands, que chez les personnes de moindre condition, & par ce moyen le render plus commode & plus portatif." *L'Escole parfaite*, n.p.

10. "Au reste ie ne le dédie à personne qu'à vous, LECTEUR, car il est pour vostre usage si vous voulez vous en servir, & n'a pas besoin d'autre protection que de la vostre, si vous y prenez goust, & s'il vous est agreable. Ce que si vous m'accordez, je souhaitte que vous en puissiez joüir long-temps, en effet & en pratique, nos pas en lecture seulement. Adieu." *L'Escole parfaite*, n.p.

11. For an authoritative summary of La Varenne, see *The French Cook*, introduction by Philip Hyman and Mary Hyman (Southover, Lewes, Sussex: Southover Press, 2001). See also François Pierre de La Varenne and Terence Scully, *La Varenne's Cookery: The French Cook; The French Pastry Chef; The French Confectioner* (Blackawton, Totnes, UK: Prospect Books, 2006).

12. On this transformation, see Ann Willan and Mark Cherniavsky, *The Cookbook Library: Four Centuries of the Cooks, Writers, and Recipes That Made the Modern Cookbook* (Oakland: University of California Press, 2012), 155ff.; T. Sarah Peterson, *The Cookbook that Changed the World: The Origins of Modern Cuisine* (Stroud: Tempus, 2006), 176.

13. For a census of editions of La Varenne, see Henry Notaker, *Printed Cookbooks in Europe, 1470–1700* (New Castle, DE: Oak Knoll Press, 2010), 161–77.

14. Amsterdam: Hieronymous Sweerts, ca. 1660.

15. *Ny alamodisk åg mykket nyttig trenchier-bok, hwar uti tillfinnandes är huruledes man effter nu för tiden brukelige art åg maner, allahanda rätter ordenteligen uppå bordet sättia, zirligen sönderskiära samt wäl åg tillbörligen föreläggia, såsom åg uti god ordning åter aftaga skal* (Stockholm: Nathanael Goldenau, 1696).

16. Topper Martyn, manuscript notes, consulted at the Center for Conjuring Arts, 2019. See also Richard du Rietz, *Gastronomisk Spegel* (Stockholm: Thulins Antikvariat, 1953).

17. On books of secrets, see the foundational book on the topic: William Eamon, *Science and the Secrets of Nature: Books of Secrets in Medieval and Early Modern Culture* (Princeton, NJ: Princeton University Press, 1994).

18. Christiaan Huygens, *Correspondence*, 4:102, cited by Deac Rossell, "Die Lanterna Magica," in *Ich Sehe was, was du nicht siehst! Sehmaschinen und Bilderwelten*, ed. Bodo von Dewitz and Werner Nekes (Cologne: Steidl, 2002), 134–45, https://www.academia.edu/345943/The_Magic_Lantern. See also Laurent Mannoni, Le grand art de la lumière et de l'ombre, archaéologie du cinema (Paris: Editions Nathan, 1994).

19. On this general iconographic phenomenon, see Elina Gertsman, *The Dance of Death in the Middle Ages: Image, Text, Performance* (Turnhout: Brepols, 2010).

20. Samuel Pepys recounts in his diary for August 19, 1666, that a London instrument maker by the name of Richard Reeves "brought a lanthorne with pictures in glasse, to make strange things appear on a wall, very pretty." *The Diary of Samuel Pepys*, ed. Henry B. Wheatley (1893), text via Project Gutenberg, https://www.pepysdiary.com/diary/1666/08/.

21. Rossell, "Magic Lantern."

22. Andreas Klett, *Ny Trencher-bog, hvorudi gives Anledning hvorledes man ret, maneerlig og som nu brugeligt er, adskillige Spise ordentlig skal paa Bordet sætte, de samme ziirligen forskiere og forelegge, ogsaa endeligen igien artelig optage, tilforne paa adskillige Stæder oplagt, nu nyligen med Fliid overseet, og med fornødne Figurer kommen til Lyset* (Copenhagen: Niels Hansen Møller, 1747).

23. Ivan Day, "From Murrell to Jarrin: Illustrations in British Cookery Books 1621–1820," in *The English Cookery*

Book, ed. Eileen White (Blackawton, Totnes, UK: Prospect Books, 2004), 123.

24. Day, "Murrell to Jarrin," 124.

25. Giles Rose, *A Perfect School of Instructions for the Officers of the Mouth shewing the whole art of a master of the houshold [sic], a master carver, a master butler, a master confectioner, a master cook, a pastryman [. . .]: adorned with pictures curiously ingraven, displaying the whole arts / by Giles Rose, one of the master cooks in His Majesties kitchen* (London: Printed for R. Bentley and M. Magnes, 1682), 60.

26. Rose, *Perfect School*, 94.

27. "Mais parce que cela ne s'apprend ordinairement que par voir faire & par le genie que l'on y peut avoir, ie n'en mets point icy d'instruction, mais seulement quelques certaines representations, qui pourront n'etre pas inutiles." *L'Escole parfaite*, 82.

28. See also chapter 4, note 32: Mattio Molinari, *Il Trinciante* (Padua: Livio Pasquati, 1636), n.p.

29. On this, see Wendy Wall, *Recipes for Thought: Knowledge and Taste in the Early Modern English Kitchen* (Philadelphia: University of Pennsylvania Press, 2016), 140. On literacy among women, see David Cressy, *Literacy and the Social Order: Reading and Writing in Tudor and Stuart England* (Cambridge and New York: Cambridge University Press, 1980).

30. On manuscript recipe books and women, see Kristine Kowalchuk, *Preserving on Paper: Seventeenth-Century Englishwomen's Receipt Books* (Toronto: University of Toronto Press, 2017); and Elaine Leong, *Recipes and Everyday Knowledge: Medicine, Science, and the Household in Early Modern England* (Chicago: University of Chicago Press, 2018).

31. James Moxon, *The Genteel House-keepers Pastime, Or, the Mode of Carving at the Table Represented in a Pack of Playing Cards [. . .]*, book, fifty-two cards, and wrapper (London: Printed for J. Moxon and sold at his shop at the Atlas in Warwick-Lane; and at the three Bells in Ludgate-Street, 1693). A set at the Beinecke Library, Yale University, includes all the elements complete. See also Virginia Wayland and Howard Wayland, *Of Carving, Cards & Cookery, or The Mode of Carving at the Table as Represented in a Pack of Playing Cards Originally Designed & Sold by Joseph & James Moxon, London 1676–7 together with Diverse Recipes for Excellent Dishes of Flesh, Fish, Fowl & Baked Meats Collected from 17th Century*

Masters at the Art of Cookery (Arcadia, CA: Raccoon Press, 1962).

32. On Moxon, see Jocelyn Hargrave, "Joseph Moxon: A Re-fashioned Appraisal," *Script & Print* 39, no. 3 (2015): 165–67.

33. Moxon, *Genteel House-keepers Pastime*, 6.

34. Moxon, *Genteel House-keepers Pastime*, 4.

35. René Descartes, *The Use of the Geometrical Playing-Cards, As also a Discourse of the Mechanick Powers [. . .]*, trans. Joseph Moxon (London: Printed and sold by J. Moxon, at the Atlas in Warwick-Lane, 1697).

36. Moxon, *Genteel House-keepers Pastime*, 1.

37. Moxon, *Genteel House-keepers Pastime*, 5–6.

38. On the rise of user interfaces such as tables of contents, indexes, and so on in learned books, see Ann Blair, *Too Much to Know: Managing Scholarly Information before the Modern Age* (New Haven, CT: Yale University Press, 2010).

39. Moxon, *Genteel House-keepers Pastime*, 28.

40. Moxon, *Genteel House-keepers Pastime*, 31.

41. Moxon, *Genteel House-keepers Pastime*, 44.

Selected Checklist of the Exhibition

Brief descriptions are provided for a selection of objects in the exhibition.

CAT. 1

Bartolomeo Scappi
Order and procedures for serving cardinals food and beverages, from *Opera . . .*
Venice or Rome: Michele Tramezzino, 1570
Engraving
8 ⅛ × 6 ¼ × 2 ⅛ in. (20.7 × 16 × 5.5 cm)
The Metropolitan Museum of Art, New York, The Elisha Whittelsey Collection, The Elisha Whittelsey Fund, 1952, 52.595.2

(CAT. 1)

The long title of Bartolomeo Scappi's *Opera* mentions the fact that he was the personal chef of Pope Pius V. One of the earliest illustrated recipe books in Europe, it features twenty-seven engravings that depict ideal kitchens, cooking implements such as pots and pans, and other objects associated with preparing and serving food. A double-page illustration depicting food service for the papal conclave of 1549 provides unique visual documentation of how food made its way from the kitchen to the table in a large household. In this situation, elaborate efforts were made to prevent contact between the sequestered cardinals in the process of electing the next pope and the outside world. Baskets with drawstring covers emblazoned with coats of arms, locked hampers, and bottle carriers are transported by a battalion of servants. Other items with locks reinforce the aura of secrecy and security that pervaded the conclave, with assayers poised to examine each and every morsel of food and drink before it passed through the revolving compartments to the hungry cardinals. In the detailed description that accompanies the image, Scappi reports that it was not permitted to bring in closed pies or whole chickens because they would be inspected, and presumably ruined, by the tasters.[1] One of the longest on record, the conclave lasted for seventy-two days and was, according to one papal historian, "unusual for the blatant disregard of the rules," which simply added to the deadlock.[2] This copy from the Department of Prints and Drawings at the Metropolitan Museum of Art may be an early proof copy of the first edition.

CAT. 2 (see fig. 2.1)

Giovanni Francesco Colle
Carving tools, from *Refugio over ammonitorio de gentilhuomo*, A2v–3r
1532
Woodcut
4 × 6 in. (10.2 × 15.2 cm)
Special Collections, Regenstein Library, University of Chicago, TX885 C650 1532

CAT. 3 (see fig. 1.6)

Delft boar's head tureen and stand
ca. 1750–60
Faience
Length: 15 ⅞ in. (40.3 cm)
Courtesy Michele Beiny Harkins

CAT. 4 (see fig. 3.3)

Giacomo Procacchi (author)
Andreas Brettschneider (engraver)
Title page, from *Trincier Oder Vorlege-Buch*
Leipzig: Henning Gross the Younger,

1624
Engraving
12 × 7 in. (30.5 × 17.8 cm)
Special Collections, Regenstein Library, University of Chicago, TX885.P96 1624

CAT. 5 (*see fig. 3.28*)
Joan Sallas
"Aquila" (Eagle), after Mattia Giegher, *Li Tre Trattati* (Padua: Guaresco Guareschi al Pozzo dipinto, 1629)
2022
Starched linen napkin, cut, with herringbone and closed folds
PADORE - Archive for Documentation and Research of Historical Folding Art

CAT. 6
Plate
Deruta or Siena, Italy
ca. 1510
Maiolica (tin-glazed earthenware)
1 × 8 ⅞ in. (2.5 × 22.1 cm)
The Metropolitan Museum of Art, New York, Gift of J. Pierpont Morgan, by exchange, 1965, 65.6.6

This intriguing maiolica plate features a central section depicting a large cleaver marked with the initial F. The utensil is held by a hand dressed with three distinct layers of clothing: a tight-fitting shirt in yellow, a looser

(CAT. 6)

white linen shift, and a frilled ruff-like top layer that suggests the person to whom the hand, and therefore the knife, belongs, is of high status. A series of geometrical borders encircle the central boss, consisting of blue slashes on white, entwined white ribbon on blue, orange scale pattern highlighted with yellow and divided into four compartments dotted in blue, and a leaf pattern of white on blue. On the reverse, a blue-and-orange pattern in "petal-back" style links it with related plates from Deruta.[3] A paraphed initial C painted on the foot is similar to works painted by the same hand with different initials, suggesting that it is not the mark of a painter or workshop.[4] The shape of the knife on the boss suggests a culinary use, similar to one of the knives portrayed by Bartolomeo Scappi in his 1570 cookbook. Might this have belonged to a *trinciante*?

CAT. 7 (*see fig. 1.2*)
Attributed to Hans Sumersperger
Two serving knives with trousse
Austria
15th–16th century
Steel, brass, wood, bone, mother-of-pearl, and leather

Knife (51.118.2; illustrated below):
17 ¼ × 2 ¾ × ⅝ in. (43.9 × 6.9 × 1.6 cm)
Knife (51.118.3; see fig. 1.2): 17 ⅜ × 2 ¾ × ⅝ in. (44.3 × 6.9 × 1.6 cm)
Trousse: 20 × 6 × 3 ⅞ in. (50.9 × 15.2 × 9.9 cm)
The Metropolitan Museum of Art, New York, Rogers Fund, 1951, 51.118.1–3

Broad, flat blades such as this are often called presentation or serving knives. Attributed to Hans Sumersperger (active 1492–98), knifesmith of Holy Roman Emperor Maximilian I (1459–1519), their brass handles are inlaid with strips of bone and walnut that frame central plaques of mother-of-pearl with incised images of the Virgin and Child, the Crucifixion, and saints.[5] They are related to Burgundian knife sets that became popular after Maximilian's marriage to Mary of Burgundy in 1477. Likely part of a set that included knives with sharper blades for slicing, they may have been used on the hunt or in the banquet hall to carve or convey meat to the trenchers or plates of the diners. One of the knives has been repaired.

(CAT. 7)

A tooled leather case, or trousse, for the knives also contains compartments for other implements now missing, perhaps skewers or a hone. Loops connecting the top and body of the case would have been threaded with a cord for convenient transportation.

A similar case carrying a knife can be seen suspended from the carver's belt in the miniature of January from the *Très Riches Heures* of the duc de Berry.

CAT. 8
Carving knife
Possibly Flanders
17th century
Steel
Length: 13 in. (33 cm)
The Metropolitan Museum of Art, New York, Gift of R. Stuyvesant, 1891, 91.16.82

(CAT. 8)

Though the shape of the steel blade recalls those in Scappi's illustration labeled "Coltelli mastri da battere" (master knives for striking or chopping; see cat. 24), this knife was probably not meant to be used in the kitchen, but may have been a carving knife for a huntsman.[6] The pistol-shaped silver handle is covered with a delicate floral pattern almost like a textile, providing a secure grip for potentially greasy hands, as well as a decorative flourish. A maker's mark can be seen on the blade.

CAT. 9
Knife
Portugal
16th century
Ivory and steel
Length: 11 ½ in. (29.2 cm)
The Metropolitan Museum of Art, New York, Gift of Irwin Untermyer, 1964, 64.101.1598

(CAT. 9)

The central roundel of the ivory hilt of this knife depicts a classicizing profile of a warrior, his corkscrew tendrils flowing out from a mask-like helmet. A putto stands above this, his outstretched arms grasping the legs of acrobats embracing the open maws of dragons, out of which more figures emerge. A female profile on the other side features similar serpentine locks. On the lower section of the handle, another putto balances atop an ovoid form, against a patterned background formed of small oculi. The curved and notched blade is engraved with a foliate pattern.

CAT. 10
Knife
Possibly Spain
ca. 1700
Steel, brass, and horn
11 ¾ × 1 ¼ in. (29.8 × 3.1 cm)
Cooper Hewitt, Smithsonian Design Museum, New York, The Robert L. Metzenberg Collection, Gift of Eleanor L. Metzenberg, 1985-103-14

The double-edged steel blade is engraved with a decorative border that calls attention to the serrations on its spine, designed for sawing through foods with thick or resistant surfaces. The serrations mark off the part of the knife meant to be sharpened. A brass panel is inlaid on the bolster. The handle is formed of undulating gadrooned bulbous forms made of horn alternating with horizontal stripes of brass.

It terminates in a finial that anchors the tang.

CAT. 11
Knife
Possibly Spain
16th century
Steel
10 ⅜ × 1 ½ in. (26.5 × 3.8 cm)
Cooper Hewitt, Smithsonian Design Museum, New York, The Robert L. Metzenberg Collection, Gift of Eleanor L. Metzenberg, 1985-103-15

Fashioned from a single piece of steel, the double-edged blade has serrations on the spine and engraved lozenge forms on the bolster. The deeply grooved spiral handle, large knob protruding from the bolster, and front quillon would have enabled a firm grip for the carving of greasy meats, anchoring thumb and forefinger.

CAT. 12 (*see fig. 1.3*)
Knife
Venice
14th century
Ivory and steel
11 ¼ × 1 ½ × ½ in. (28.5 × 3.8 × 1.2 cm)
The Metropolitan Museum of Art, New York, Frederick C. Hewitt Fund, 1911, 11.137.4

(CAT. 10 & 11) The large size and broad blade of this knife suggests it could have been used for carving or serving. The ivory hilt with pierced molding is capped by a winged mythological creature, perhaps a griffin. Similar

examples of ivory knives topped with lion or griffin figures are at the Cluny Museum, Paris, and the Deutsches Klingenmuseum, Solingen, as well as a private collection.[7] A gravoir, or hair-parting implement, at the Victoria and Albert Museum, London, with a very similar pierced molding of ivory, was made in Northern Italy and is dated to the late fourteenth century.[8]

CAT. 13
Carving knife
Possibly Flanders
First quarter of the 17th century
Ivory and steel
14 ⅛ × 1 ⅜ × 1 ¼ in. (35.9 × 3.5 × 3.2 cm)
The Metropolitan Museum of Art, New York, Gift of Mrs. Giles Whiting, 1962, 62.118.1

The ivory handle of this knife is in the form of a muscular male torso with an upturned face, scrolls replacing his arms.[9] The figure emerges from a foliate skirt that joins it to the shaft, reminiscent of architectural prints by the Flemish artist Hans Vredeman de Vries (1527–1604) that circulated widely during the sixteenth and seventeenth centuries, as in plate 9 from the *Artis Perspectiuae*, depicting similar armless herms supporting a canopy.[10] A piece of ivory appears to have fallen off the front of the figure, while the back is intact. The double-edged blade has an elegant scroll-like detail on the spine.

(CAT. 13)

CAT. 14
Fork
Possibly France
ca. 1650
Steel, horn, inlaid with mother-of-pearl, and brass
7 ⅛ × ⅞ in. (18 × 2.2 cm)
Cooper Hewitt, Smithsonian Design Museum, New York, The Robert L. Metzenberg Collection, Gift of Eleanor L. Metzenberg, 1985-103-59

Engraved brass bands alternate with inlaid mother-of-pearl notched wheels on the faceted horn handle of this fork. Its long tines suggest it may have been used for carving smaller birds or fruits, as in the illustrations from manuals by Mattia Giegher (fig. 3.12) or Antonio Latini.

CAT. 15
Fork
Mid- to late 18th century
Antler, steel, and silver
8 ¾ × 1 ⅜ in. (22.2 × 3.4 cm)
Cooper Hewitt, Smithsonian Design Museum, New York, The Robert L. Metzenberg Collection, Gift of Eleanor L. Metzenberg, 1985-103-155a

The handle of this long two-tined fork features the head of a male figure, whose beard and hair emerge directly from the craggy channels of the coronet of the antler, where it was once attached to the skull of the deer. A banded silver guard anchors the fork's tang. Reminiscent of Bartman or Bellarmine stoneware jugs with bearded male faces that were popular in seven-

(CAT. 14)

(CAT. 15)

teenth-century Germany, the fork may have once had a companion knife, like the set from the Metropolitan Museum of Art (cat. 28). With its sylvan associations, antler was a desirable material for implements that might help carve or serve the spoils of the hunt.

CAT. 16
Fork
Possibly Switzerland
Late 17th century
Steel and brass
Length: 8 in. (20.3 cm)
The Metropolitan Museum of Art, New York, Gift of R. Stuyvesant, 1891, 91.16.96

A German inscription etched into the brass hilt of this two-tined fork celebrates the pleasures of roasted wild meats. Additional motifs such as a deer and a female figure wearing a kerchief and an apron suggest a rustic context. The smaller size recalls the kinds of forks used by carvers in the illustrated manuals to spear smaller animals or fruit.

CAT. 17
Fork and knife
Germany
17th century
Steel, brass, horn, and bone
Fork: 12 ¾ × 1 ¾ in. (32.3 × 4.5 cm)
Knife: 11 ¾ × 1 ⅜ in. (30 × 4.3 cm)
Cooper Hewitt, Smithsonian Design Museum, The Robert L. Metzenberg

(CAT. 16)

Collection, gift of Eleanor L. Metzenberg, 1985-103-10, 11

Alternating bands of horn and bone form the lower portion of the handles of this imposing knife and fork, likely made for carving at table or on the hunt. Broad brass bolsters border punched brass panels in which steel rivets fastening the tang, which extends fully into the butt, are visible. The curved shape of the fork is very distinctive, recalling antlers or horns. (CAT. 17)

CAT. 18
Knife and fork
Italy
17th century
Steel and brass
Knife (.19) length: 8 ⅜ in. (21.3 cm)
Fork (.20) length: 8 ⅝ in. (21.9 cm)
The Metropolitan Museum of Art, New York, Gift of R. Stuyvesant, 1893, 93.13.19, 20

The design of the knife and fork handles has been attributed to the circle of Swiss goldsmith Hans Peter Oeri (1637–1692), on the basis of comparisons with similar objects.[11] The handles of twisted brass terminate in basilisk heads and were likely cast in two parts, then assembled and chased. A related set includes a matching honing steel in addition to a knife and fork.[12] The long twin prongs of the fork suggest that this set may have been used by a carver, perhaps for fruit or small birds. The saber-like steel blade, indented and waved, bears an inlaid maker's mark.

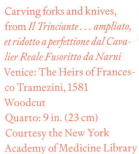

CAT. 19
Knife and fork
Italy
17th century
Steel, mother-of-pearl, stained horn, and brass
Fork (.50) length: 9 ¼ in. (23.5 cm)
Knife (.51) length: 10 ½ in. (26.7 cm)
The Metropolitan Museum of Art, New York, Gift of R. Stuyvesant, 1891, 91.16. 50, 51

This knife and fork are probably examples of Haban wares, made by Hutterites, a sect of Anabaptists who moved as a group between Germany, Austria, and Moravia in the sixteenth and seventeenth centuries. Though they practiced an ascetic lifestyle, cutlery, ceramics, shoes, and clocks crafted by the Hutterites in collective settings were highly regarded for their skill and quality.[13] The utensils' handles are secured to the tang by pins visible against the opalescent mother-of-pearl. Punched brass bands inlaid with stained horn mark a transition to feather-like pommels, also of mother-of-pearl.[14]

(CAT. 18)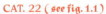

CAT. 20 (*see fig. 2.7*)
Vincenzo Cervio
Carving forks and knives, from *Il Trinciante . . . ampliato, et ridotto a perfettione dal Cavalier Reale Fusoritto da Narni*
Venice: The Heirs of Francesco Tramezini, 1581
Woodcut
Quarto: 9 in. (23 cm)
Courtesy the New York Academy of Medicine Library

CAT. 21 (*see also fig. 4.20*)
Johann Georg Pasch
Knives, from *Neu vermehrtes vollständiges Trincier-Büch . . .*
Naumburg: Martin Müller, 1665
Engraving
Unfolded: 16 × 12 ¾ in. (40.6 × 32.4 cm)
Courtesy the New York Academy of Medicine Library, RB/265717

CAT. 22 (*see fig. 1.1*)
Enrique de Aragón Villena
Two forks, from *Arte cisoria, ó, Tratado del arte del cortar del cuchillo, que escrivió don Henrique de Aragon, marques de Villena . . .*, page 43
Madrid: A. Marin, 1766
Woodcut
7 in. (18 cm)
Courtesy the New York Academy of Medicine Library, RBS21

CAT. 23
Danilo Leon Todeschini
Replica knives based on an illustration in Bartolomeo Scappi's *Opera . . .* (Venice:

(CAT. 19)

(CAT. 23)

Michele Tramezzino, 1570)
2016
Wood and steel
Private collection

CAT. 24
(see also fig. 2.3)
Bartolomeo Scappi
"Diversi Coltelli," from
Opera . . .
Venice: V. Pelagalo, 1596
Woodcut
8 ⅝ in. (22 cm)
Courtesy the New York
Academy of Medicine
Library, RB

CAT. 25
(see also fig. 5.14)
Title page, from
*En mycket nyttig och för-
bättrad trenchier-bok . . .*
Västerås: Johann Laurens
Horrn, 1759
Engraving
Conjuring Arts Research
Center, New York

CAT. 26
(see also fig. 5.15)
Knives, from *En mycket
nyttig och förbättrad
trenchier-bok . . .*
Västerås: Johann
Laurens Horrn, 1759
Engraving
Conjuring Arts
Research Center,
New York

CAT. 27 *(see also fig. 5.17)*
Magic lantern, from *En mycket nyttig
och förbättrad trenchier-bok . . .*

Västerås: Johann Laurens
Horrn, [1759?]
Engraving
Conjuring Arts Research Center,
New York

CAT. 28
Carving knife and fork
Southern Germany
19th century
Steel and buckhorn
Knife (.5) length: 12 ½ in. (31.8 cm)
Fork (.6) length: 12 ⅛ in. (30.8 cm)
The Metropolitan Museum of Art,
New York, Gift of R. Stuyvesant,
1893, 93.13.5,6

Carved into the burr or coronet
of the buckhorns, the whimsical
human faces crowning this steel
knife and fork exude a rustic charm.
The male is bearded, while the
female sports a ruff cleverly
fashioned from the natural
channels of the horn.[15] Perhaps
intended for deployment with
meats that arrived on the table
via the hunt, they clearly allude
to the pleasures of the forest.
Comparable to the fork (cat.
15) from the Cooper Hewitt,
the seemingly spontaneous
emergence of human figures
out of natural materials reflects
the fascination with transfor-
mation of matter that informed
the collection of plants, animals,
fossils, stones, and other objects
in the Kunst- und Wunder-
kammern of the early modern
period. Buckhorn remains a
popular material for cutlery.

(CAT. 28)

CAT. 29
Carving fork and knife
Netherlands, possibly Friesland
Late 17th–early 18th century
Steel, walrus ivory, and silver
Fork (.91) length: 10 in. (25.4 cm)
Knife (.92) length: 11 ⅜ in. (28.9 cm)
The Metropolitan Museum
of Art, New York, Gift of R.
Stuyvesant, 1893, 93.13.91,92

The handles on both fork and
knife feature high-relief figures
of walrus ivory representing
Faith, holding scales; Hope,
with an anchor; and Chari-
ty, with a cross and children
at her feet. Kneeling horses,
their riders broken off, crown
both implements, suggesting
chivalric themes. Both fork and
knife are forged of sturdy steel
with a silver collar marking the
transition from handle to blade.
Related pairs have different top
elements, with lions or human
heads, suggesting a common
workshop.[16]

CAT. 30 *(see fig. 2.6)*
Vincenzo Cervio
"Gallo d'India—Pavone,"
from *Il Trinciante . . . ampliato
et a perfettione ridotto dal Cava-
lier Reale Fusoritto da Narni*
Rome: Gabbia, 1593
Woodcut
8 ⅝ in. (22 cm)
Rare Books Division, The
New York Public Library, *KB
1593 (Cervio, V. Trinciante)

(CAT. 29)

CAT. 31 (*see also fig. 2.2*)
Bartolomeo Scappi
"Vettine," from *Dell arte de cvcinare*, plate 12
Venice: Combi, 1643
Engraving
8 ⅜ in. (22 cm)
Rare Books Division, The New York Public Library, *KB 1643 (Scappi, B. M. Bortolomeo [sic] Scappi dell arte del cvcinare) c.2

CAT. 32 (*see also fig. 5.18*)
Anonymous, translated from French by Giles Rose
Capon, from *A Perfect School of Instructions for the Officers of the Mouth* . . . , page 43
London: R. Bentley and M. Magnes, 1682
Woodcut
6 in. (15 cm)
The Lilly Library, Indiana University, Bloomington, TX705.R79

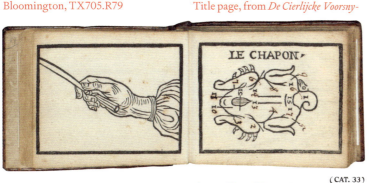

(CAT. 33)

CAT. 33
Le chapon, from *De Sectione Mensaria*
17th century
Woodcut
Closed: 4 ½ × 3 ½ in. (11.4 × 8.9 cm)
Special Collections, Regenstein Library, University of Chicago, TX635.D4 1600z c.1

CAT. 34 (*see fig. 5.7*)
[Jacques Vontet]
"Du Canard Sauvage & domestique," from *Au Lecteur Ce n'est pas sans Raison que les plus grands personnages de L'Europe se servent d'Escuyer trenchant*
Lyon or Paris, 1647–50
Iron-gall ink on paper
Closed: 9 ¼ × 7 ¼ in. (23.4 × 18.6 cm)
PY Rare Books

CAT. 35 (*see fig. 5.8*)
[Jacques Vontet]
"Du canard sauvage et domestique," from *La methode de trancher aloüetes Bequefis, et ortolans avec toute sorte d'autres petits oyseaux*
Lyon or Paris, 1647–50
Manuscript
Closed: 10 ⅜ × 7 3/16 in. (26.3 × 18.2 cm)
Ben Kinmont Bookseller

CAT. 36 (*see fig. 5.12*)
Title page, from *De Cierlijcke Voorsnydinge Aller Tafel Gerechten* . . .
Amsterdam: Hieronymous Sweerts, ca. 1660
Engraving
4 ⅜ × 5 ⅛ in. (11 × 13 cm)
Courtesy the New York Academy of Medicine Library, RB

CAT. 37 (*see fig. 2.10*)
Bartolomeo Scappi
Title page, from *Opera* . . .
Alessandro Vecchi, 1610
Woodcut
8 ¼ in. (21 cm)
Rare Books Division, The New York Public Library, *KB 1610 (Scappi, B. Opera)

CAT. 38 (*see fig. 5.2*)
Pierre Petit
Frontispiece, from *L'Art de trancher la viande, & toutes sortes de fruits / nouvellement a la françois par Pierre Petit eicuyer trenchant*
[Lyon?], [1647?]
Engraving
Closed: 7 ¼ × 10 ¼ in. (18.4 × 26 cm)
Special Collections, Regenstein Library, University of Chicago, TX885.P480 1600z c.1

CAT. 39 (*see fig. 4.14*)
Georg Philip Harsdörffer
"Anhang zu dem Andern theil, von früchten schneiden," from *Vollständiges und von neuem vermehrtes Trincir-Buch* . . .
Nuremberg: Paul Fürst, 1665
Engraving
5 ⅞ × 7 ⅛ in. (15 × 18 cm)
Rare Book & Manuscript Library, Columbia University, New York, B641 H25

CAT. 40 (*see also fig. 3.15*)
Mattia Giegher
"Melarance," from *Li Tre Trattati*, plate 24
Padua: Guaresco Guareschi al Pozzo dipinto, 1629
Engraving

The Lilly Library, Indiana University, Bloomington, Indiana

CAT. 41 (*see also fig. 4.13*)
Antonio Latini (author)
Francisco de Grado (engraver)
Fruits, from *Lo Scalco alla Moderna*
Naples: Domenico Antonio Parrino and Michele Luigi Mutti, 1694
Engraving
8 ⅞ × 6 ½ × 1 ⅝ in. (22.5 × 16.5 × 4.2 cm)
The Lilly Library, Indiana University, Bloomington, Indiana

CAT. 42 (*see fig. 3.30*)
Jacob van Ruisdael
View of the Dunes Near Bloemendael with Bleaching Fields
ca. 1670–75
Oil on canvas
13 ⅜ × 16 ⅜ in. (34 × 41.6 cm)
Wadsworth Atheneum Museum of Art, Hartford, Connecticut, The Ella Gallup Sumner and Mary Catlin Sumner Collection Fund, 1950.498

CAT. 43 (*see fig. 4.19*)
Abraham Bosse
Wives at the Table during the Absence of their Husbands
Published by Jean I Leblond, ca. 1636
Etching
Sheet (trimmed): 10 ¼ × 13 ⅜ in. (26 × 34 cm)
The Metropolitan Museum of Art, New York, Harris Brisbane Dick Fund, 1926, 26.49.63

CAT. 44
Abraham Bosse
Taste (The Five Senses)
Published by Melchior Tavernier, 1635–38
Etching
Sheet: 10 ⅜ × 13 in. (26.3 × 33.1 cm)
The Metropolitan Museum of Art, New York, Harris Brisbane Dick Fund, 1926, 26.49.25

(CAT. 44)

The theme of the five senses comes from ancient philosophy and was a popular subject in the early modern period. Bosse's allegory of taste (*Gustus/Le Goût*) presents a variety of animal and vegetable symbols: the single artichoke, reputedly a recent arrival in France via Catherine de Medici's Italian heritage and believed to be an aphrodisiac, is eaten by hand and shared between the couple, kept warm by the small chafing dish in which it is served; the melon, with its rounded form suggestive of fertility; and the small lion-trimmed dog in the foreground, avidly enjoying its repast without restraint. Inscriptions in Latin and French, likely written by Bosse himself, celebrate taste as "the king of the senses," but also recommend resistance to excess in favor of moderation.[17] The crisply starched, folded, and pressed tablecloth as well as the linen napkins—labor-intensive accoutrements—are markers of status and refinement.

CAT. 45 (*see fig. 4.27*)
Hans Mielich
Outdoor Banquet
1548
Oil on panel
23 ¼ × 27 ½ in. (59.1 × 69.9 cm)
Wadsworth Atheneum Museum of Art, Hartford, Connecticut, The Ella Gallup Sumner and Mary Caitlin Sumner Collection Fund, 1949.199

CAT. 46 (*see fig. 4.18*)
Georg Philip Harsdörffer
Title page, from *Vollständig vermehrtes Trincir-Büchlein . . .*
Nuremberg: Paul Fürst, 1652
Engraving
5 ½ in. (14 cm)
Courtesy the New York Academy of Medicine Library, RB

CAT. 47 (*see also fig. 4.11*)
Georg Philip Harsdörffer
"Rund Tafel," from *Vollständig vermehrtes Trincir-Buch*, page 325
Nuremberg: Paul Fürst, 1649
Engraving
Quarto: 6 × 7 in. (15 × 18 cm)
Courtesy the Lilly Library, Indiana University, Bloomington

CAT. 48 (*see fig. 2.8*)
Vincenzo Cervio
Table setting with fishpond, from *Il Trinciante*
Venice: The Heirs of Gioanni Varisco,

1593
Engraving
8 ⅝ in. (22 cm)
Courtesy the New York Academy of Medicine Library, RB

CAT. 49 (see also fig. 3.16)
Mattia Giegher
"Oglia putrida," from *Li Tre Trattati*, page 58
Padua: Guaresco Guareschi al Pozzo dipinto, 1629
Courtesy the Lilly Library, Indiana University, Bloomington, Indiana

CAT. 50
Tablecloth
Italy
1590
Linen
204 × 78 in. (518.2 × 198.1 cm)
The Metropolitan Museum of Art, New York, Helena Woolworth McCann Collection, Purchase, Winfield Foundation Gift, by exchange, 1975, 1975.151

(CAT. 50)

This large tablecloth is made of two lengths of plain- or tabby-weave linen joined by a panel of bobbin lace in reticella style. The ends are edged with bobbin lace inspired by punto in aria. Pattern books published in Venice and other cities from the early sixteenth century were sometimes used to provide inspiration for edging such as this.[18] The date of 1590, embroidered onto the linen in pale blue silk, together with the letters I P, possibly initials of the maker or owner of the tablecloth, suggest that it was created to mark a special event such as a wedding.

CAT. 51
Napkin with the story of Abraham and Isaac
[Haarlem?]
1663
Linen
42 × 29 ½ in. (106.7 × 74.9 cm)
The Metropolitan Museum of Art, New York, Gift of Dr. A. P. A. Vorenkamp, 1944, 44.115

Likely made in Haarlem, this napkin incorporates two inscriptions in Dutch that bear the names of Jonkheer Doecke Martena van Burmania (1627–1692), who is identified as "Lord of the manor, and keeper of the dikes, 1663" (IR.DVCO.MARTNA.VAN.NAV / BVRMANIA GRIETMAN. NAM / ENDEDIYCKGRAEF.1663), and his wife, Edwarda Lucia Van Juckema (FFVI.IVFF.EDVARDA.LVCIA / NAV.VAN VCKEMA.OP.KAM / INM.MINGHA BVRGK). A wealthy mayor in Friesland from a venerable family, Van Burmania married Van Juckema in 1647. An elaborate floral border with the Van Burmania crest in the corners frames two scenes from the story of Abraham and Isaac: Above, Abraham sits on a stool while two angels announce that he will bear a son. His wife Sarah is visible in the background. In the lower zone, Abraham kneels before an altar swinging an incense burner. The smoke rises to frame the tetragrammaton. A ram in a thicket, offered in thanks, can be seen above. The number twenty-four is embroidered in the upper-right corner, indicating that this napkin was part of a set of twenty-four. Other napkins and a tablecloth from the set, also marked twenty-four, are found today in the Abegg-Stiftung and elsewhere.[19] Speculation that this napkin was made in the workshop of the famous Haarlem linen weaver Quirijn Janzs Damast cannot be substantiated, since he died in 1650. Fine damasks continued to be produced in Haarlem for at least fifteen years, perhaps in Quirijn's workshop, which numbered sixteen weavers at his death.[20]

CAT. 52
Napkin
Netherlands or Germany
ca. 1600, with later inscriptions and labels
Linen
37 ½ × 27 ½ in. (95.3 × 69.9 cm)
The Metropolitan Museum of Art, New York, Gift of Mr. and Mrs. William A. Moore, 1923, 23.80.74a

(CAT. 51)

This damask napkin depicts a forest scene in which unicorns and peacocks gather around a fountain beneath the image of a woman on horseback holding a bird of prey on her wrist. Although it was made in Europe, the label affixed to the back bears names and dates that indicate it was passed down through several generations of the American Van Horne and Jay families, starting with Anna M. Jay; her daughter, Judith Jay, born in 1698; her son Augustus Van Horne, born in 1736; his daughter Anna Mary Van Horne, born in 1778; then Elizabeth Clarkson, 1810, and finally her daughter, Ann Mary Clarkson, 1831. It came to the Metropolitan Museum of Art as part of a bequest from a descendant, along with other objects, including a Honeycomb quilt made by Elizabeth Clarkson around 1830 (MMA 23.80.75).[21] The family would doubtless have owned hundreds of linens for the table, but this one must have had special meaning, enabling it to bear witness to the passage of time much like the flyleaf of a family Bible that records birth and death dates over many generations.

(CAT. 52)

CAT. 53

Napkin with David and Bathsheba
Netherlands
ca. 1590–1600
Linen

42 × 36 in. (106.7 × 91.4 cm)
The Metropolitan Museum of Art, New York, Purchase, Sperone Westwater Inc. and The James Parker Charitable Foundation Gifts, 2010, 2010.19

The imagery on linen damask napkins and tablecloths often drew inspiration from the Bible, as in this example. David, looking out from a turreted palace at the center of the napkin, is labeled in gothic script, "Davidt." Below, Bathsheba stands naked, bathing in a hexagonal fountain. David, having surreptitiously espied her bathing, has sent his men to bring her to him to satisfy his desire. She became pregnant as a result, and David made sure her husband was killed at war to enable him to marry the widowed Bathsheba. As a punishment for adultery and murder, this child died. After marrying David and becoming queen, Bathsheba bore Solomon, who would succeed David as king. A frequently illustrated story in this period, Bathsheba is generally represented with female attendants who try to shield her from prying eyes, emphasizing her modesty. In this more economical rendition, David's henchmen are standing by the fountain, about to carry her off, thus emphasizing David's coercion and removing any suspicion of Bathsheba's role in the seduction and her subsequent elevation as queen. The vertical repeat of the weave has left a small amount of Bathsheba's fountain visible at the top of the object. The napkin is bordered by a pattern of small checkerboard. An inscription in white drawn work, PAV 20, may indicate the

total number of napkins in the set—in this case, twenty. A similar napkin was at the Museum of Archaeology in Kortrijk, Belgium, and a fragment of a tablecloth with the same imagery is in the collection of the Abegg-Stiftung in Riggisberg, Switzerland.[22]

CAT. 54

Damask tablecloth commemorating King George I
German, possibly for the English market
ca. 1725
Linen
72 × 104 in. (182.9 × 264.2 cm)
Cora Ginsburg LLC, CG5128B

This tablecloth features imagery connected to the reign of King George I (r. 1714–28). It features repeating horizontal registers depicting George on horseback with scepter in hand, the crowned coat of arms of the City of London flanked by laurel wreaths, and two views of London from both sides of the River Thames with inscriptions "KONIG / IN ENGE / LAND" and "LON / DON." The borders are made up of ships and arabesque foliate and floral forms. There are initials embroidered in white at one corner.

CAT. 55

Damask banqueting tablecloth and eight napkins, "Konig In Engeland"
German, possibly for the English market
ca. 1725
Linen
Napkins: 32 × 36 ½ in. (81.3 × 92.7 cm) each
Tablecloth: 150 × 104 in.

(381 × 264.2 cm)
Cora Ginsburg LLC, CG5128A

The mixed English and German inscription, "GEORGE KONIG IN / ENGEL LAND" and "LON / DON" strongly suggests this set of table linens was made for English buyers. Below, the king appears on horseback, scepter in hand, followed by the crowned coat of arms of the City of London flanked by laurel wreaths. Above the words, there is a view of the River Thames. Ships decorate the border. By the eighteenth century, fine damask linen weaving had spread from Flanders and the Netherlands to Saxony and the German–speaking lands, making use of important continental flax-growing areas in Silesia and Saxony.

CAT. 56 (*see fig. 3.19*)
Mattia Giegher
Li Tre Trattati, plate 3
Padua: Paolo Frambotto, 1639
Engraving
6 ¾ × 9 in. (17 × 23 cm)
Rare Books Division, The New York Public Library, *KB 1639

CAT. 57 (*see fig. 3.25*)
Joan Sallas
"Il granciporo, e granchio di mare" (Crab, and sea crab), after Mattia Giegher, *Li Tre Trattati* (Padua: Guaresco Guareschi al Pozzo dipinto, 1629)
2010
Starched linen napkin with herringbone folds, pleated, and cut legs
The Metropolitan Museum of Art, New York

CAT. 58 (*see fig. 3.26*)
Joan Sallas
"Funff Berge" (Mountains), after Georg Philip Harsdörffer, *Vollständig vermerhtes Trincir-Buch* (Nuremberg 1652)
2010
Starched linen napkin
The Metropolitan Museum of Art, New York

CAT. 59 (*see fig. 3.27*)
Joan Sallas
"Ein Welscher Han" (Turkey), after Andreas Klett, *Neues Trenchir-und Plicatur-Büchlein* (Nuremberg: Leonhard Loschge, 1677)
2010
Two starched linen napkins
The Metropolitan Museum of Art, New York

CAT. 60 (*see fig. 3.29*)
Joan Sallas
"Fisch mit Floss-Federn" (Fish with feather-rafts, likely a pike), after Andreas Klett, *Neues Trenchir-und Plicatur-Büchlein* (Nuremberg: Leonhard Loschge, 1677)
2010
Starched linen napkin
The Metropolitan Museum of Art, New York

CAT. 61
"Alls aus diese Viere," from *Neu A la modisch Nach itziger gebräuchlichen Arth eingerichtetes Complementir-Frisier-Trenchier- und Kunst-Buch* Hamburg: Thomas von Wiering, n.d. ca. 1703
Engraving
Conjuring Arts Research Center, New York

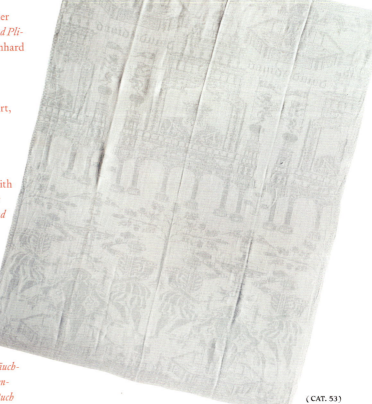

(CAT. 53)

Unless otherwise noted, all translations are my own.

1. Deborah L. Krohn, *Food and Knowledge in Renaissance Italy: Bartolomeo Scappi's Paper Kitchens* (Burlington, VT: Ashgate, 2015), 118–24.

2. Frederic J. Baumgartner, "Henry II and the Papal Conclave of 1549," *Sixteenth Century Journal* 16, no. 3 (Autumn 1985): 301–2. See also Ludwig Von Pastor, *The History of the Popes*, ed. and trans. Ralph Francis Kerr (London: Routledge & Kegan Paul, 1951), 8:1–44.

3. For related works, see Giulio Busti and Franco Cocchi, *Museo Regionale della Ceramica di Deruta* (Milan: Electa, 1999), 148–49, cat. 31, 152–53, cat. 35; and Julia E. Poole, *Italian Maiolica and Incised Slipware in the Fitzwilliam Museum, Cambridge* (Cambridge: Cambridge University Press, 1995), 183, cat. 256, 184, cat. 257.

4. William Bowyer Honey, *European Ceramic Art from the Middle Ages to about 1815* (London: Faber and Faber, 1952), 177.

5. Bruno Thomas, "The Hunting Knives of Emperor Maximilian I," in *Gesammelte Schriften zur historischen Waffenkunde* (Graz: Akademische Druck- u. Verlagsanstalt, 1977), 2:1437–46. Originally published in *The Metropolitan Museum of Art Bulletin* 13, no. 6 (1955): 201–8.

6. Bartolomeo Scappi, *Opera* (Venice, 1570), plate 13.

7. Klaus Marquardt, *Eight Centuries of European Knives, Forks and Spoons* (Stuttgart: Arnoldsche, 1997), cat. 1.

8. Victoria and Albert Museum, acc. no. 287–1867; Paul Williamson and Glyn Davies, *Medieval Ivory Carvings, 1200–1550* (London: V&A Publishing, 2014), 2:638–39, cat. 221.

9. Related objects include a set of surgical tools with similar herm figures. Barbara Grotkamp-Schepers, Georg Laue, and Virginie Spenlé, *Kostbare Bestecke für die Kunstkammern europas = Precious Cutlery for European Kunstkammer*, ed. George Laue (Munich: Kunstkammer Georg Laue, 2010), 222–23, cat. 69.

10. Hans Vredeman De Vries, Jan Van Doetecam, and Lucas Van Doetechum, *Artis Perspectiuae Plurium Generum Elegantissimae Formulae Multigenis Fontibus, Nonnullisq[ue] Hortulis Affabre Factis Exornatae, in Cõmodum Artificum, Eorumq[ue] Qui Architectura, Aedificiorumq[ue] Cõmensurata Uarietate Delectantur, Antea Nunquam Impressae, Inuentor Ioan. Fridmannus Frisius. Liber Primus* (1568), plate 9.

11. Hanspeter Lanz, Jürg A. Meier, and Matthias Senn, eds., *Barocker Luxus: Des Werk der zürcher Goldschmieds Hans Peter Oeri 1637–1692*, exh. cat. (Zurich: Swiss National Museum, 1988), 102–5, inv. nos. AG 1552, LM 10056.

12. For related works, see Jochen Amme, *Historische Bestecke: Formenwandel von der Altsteinzeit bis zur Moderne* (Stuttgart: Arnoldsche, 2002), 561, cat. 223; Jochen Amme, *Historische Bestecke: Sammlung Suermont-Ludwig-Museum, Aachen* (Aachen: Sammlung Suermont-Ludwig-Museum, 2011), 115, cat. 109, inv. no. 35, ill. 129; and Bernhard Heitmann and Carlos Boerner, *Historische Bestecke aus der Sammlung des Museums für Kunst und Gewerbe Hamburg* (Hamburg: Museum für Kunst und Gewerbe, 2007), 182, cat. 20, inv. no. 1890.264 a/b.

13. John A. Hostetler, *Hutterite Society* (Baltimore: John Hopkins University Press, 1997).

14. For related works, see Grotkamp-Schepers, Laue, and Spenlé, *Kostbare Bestecke = Precious Cutlery*, 192–93; and Amme, *Historische Bestecke: Sammlung Suermont-Ludwig-Museum*, 64, cat. 65, inv. nos. 341, 342.

15. For related works, see Amme, *Historische Bestecke: Sammlung Suermont-Ludwig-Museum*, 246–47, cats. 323–28.

16. For related objects, see Amme, *Historische Bestecke: Formenwandel*, 576, cat. 366; and Victoria and Albert Museum, acc. no. M.97&A-1923.

17. Text (left): In terris quicquid sudat, quod defluit astris / Quicquid in æquoreis velificatur aquis ; / Irrequieta mihi sine fine hæc cuncta laborant / Iure igitur sensum Rex, hominumque vocor. Text (right): Que le Goust sans l'Excez a d'honnestes appas ! / Que Nature se plaist aux choses raisonnables ! / Et qu'elle monstre bien que le luxe des tables / Nous fait mourir de fain au milieu du repas !

18. Femke Speelberg, "Putting a Name to a Lace: Fashion, Fame, and the Production of Printed Textile Pattern Books," in *Threads of Power: Lace from the Textilmuseum St. Gallen*, ed. Emma Cormack and Michele Majer (New York: Bard Graduate Center, 2022), 49–67.

19. C. A. Burgers, *White Linen Damasks: 1, Heraldic Motifs from the Sixteenth Century to circa 1830*, 2 vols. (Riggisberg: Abegg-Stiftung, 2014), 2:309–13, cat. 73.

20. G. T. Van Ysselsteyn, *White Figurated Linen Damask from the 15th to the Beginning of the 19th Century* (The Hague: Van Goor Zonen, 1962), 25–27.

21. Personal correspondence with Amelia Peck, Marica F. Vilcek Curator, American Decorative Arts, Metropolitan Museum of Art, and consulting curator, The Antonio Ratti Textile Study and Storage Center, Metropolitan Museum of Art, October 2022.

22. A. G. Pauwels, *Damast* (Kortrijk: The Netherlands Organization for the Advancement of Pure Research, 1986), 41–42, cat. 5; Burgers, *White Linen Damasks*, vol. 1, fig. 3, inv. 3828

Selected Bibliography

Abramson, Julia. "Deciphering *La vraye mettode de bien trencher les viandes* (1926)." In *Authenticity in the Kitchen: Proceedings of the Oxford Symposium on Food and Cookery 2005*, edited by Richard Hosking, 11–25. Totnes, UK: Prospect Books, 2006.

Ackerman, James. "The Conventions and Rhetoric of Architectural Drawing." In *Origins, Imitation, Convention*, 294–317. Cambridge, MA: MIT Press, 2002.

Albala, Ken. *Eating Right in the Renaissance*. Berkeley: University of California Press, 2002.

———. "Wild Food: The Call of the Domestic." In *Wild Food: Proceedings of the Oxford Symposium on Food and Cooking 2004*, edited by Richard Hosking, 9–19. Totnes, UK: Prospect Books, 2006.

Alberini, Massimo, ed. *Breve storia di Michele Savonarola: Seguita da un compendio del suo Libreto de tutte le cosse che se manzano*. Padua: Editoriale Programma, 1991.

Appelbaum, Robert. *Aguecheek's Beef, Belch's Hiccup, and Other Gastronomic Interjections: Literature, Culture, and Food among the Early Moderns*. Chicago: University of Chicago Press, 2006.

Arikha, Noga. *Passions and Tempers: A History of the Humours*. New York: HarperCollins, 2007.

Arjona, Doris King. "Enrique de Villena and the *Arte Cisoria*." *Hispania* 43, no. 2 (May 1960): 209–13.

Astarita, Tommaso. *The Italian Baroque Table: Cooking and Entertaining from the Golden Age of Naples*. Tempe: Arizona Center for Medieval and Renaissance Studies, 2014.

Baillie-Grohman, William A., and Florence Baillie-Grohman, eds. *The Master of the Game by Edward, 2nd Duke of York: The Oldest English Book of Hunting*. London: Chatto and Windus, 1909.

Balberg, Mira. *Blood for Thought: The Reinvention of Sacrifice in Early Rabbinic Literature*. Oakland: University of California Press, 2017.

Ball, Gabriele, Klaus Conermann, Andreas Herz, and Helwig Schmidt-Glintzer. *Fruchtbringende Gesellschaft (1617–1680): Hundert Jahren nach der Reformation; Forschungen der Arbeitsstelle der Sächsischen Akademie der Wissenschaften an der Herzog August Bibliothek*. Wiesbaden: Harrassowitz Verlag in Kommission, 2017.

Baron, Sabrina Alcorn, Eric N. Lindquist, and Eleanor F. Shevlin, eds. *Agent of Change: Print Culture Studies after Elizabeth L. Eisenstein*. Amherst: University of Massachusetts Press, 2007.

Battafarano, Italo Michele, ed. *Georg Philipp Harsdörffer: Ein deutscher Dichter und europäischer Gelehter*. Bern: Peter Lang, 1991.

Bell, Rudolph M. *How to Do It: Guides to Good Living for Renaissance Italians*. Chicago: University of Chicago Press, 1999.

Benker, Gertrud. *Alte Bestecke: Ein Beitrag zur Geschichte der Tischkultur*. Munich: Callwey, 1978.

Benporat, Claudio. "A Discovery at the Vatican—the First Italian Treatise on the Art of the Scalco (Head Steward)." *Petits propos culinaires* 30 (November 1988): 41–45.

Berthiaume, Guy. *Les rôles du mágeiros: Étude sur la boucherie, la cuisine et le sacrifice dans la Grèce ancienne*. Leiden: Brill, 1982.

Bertini, Giuseppe. *Le nozze di Alessandro Farnese: Feste alle corti di Lisbona e Bruxelles*. Milan: Skira, 1997.

Birnbaum, Charlotte, ed. *The Beauty of the Fold: A Conversation with Joan Sallas*. Berlin: Sternberg Press, 2012.

Bjurström, Per. *Feast and Theatre in Queen Christina's Rome*. Stockholm: Bengstons litografiska, 1966.

Blair, Ann M. *Too Much to Know: Managing Scholarly Information before the Modern Age*. New Haven, CT: Yale University Press, 2010.

- Bonneville, Françoise de. *The Book of Fine Linen*. Paris: Flammarion, 1994.
- Bonvesin della Riva. *Le cinquanta cortesie da tavola*. Edited by Mario Cantella and Donatella Magrassi. Milan: Libreria Meravigli Editrice, 1985.
- Brown, Russel V. "El 'Arte Cisoria' de Enrique de Villena: Borrador de una desconocida edición del siglo XVIII." *Romance Notes* 18, no. 3 (1978): 398–403.
- Bryson, Anna. *From Courtesy to Civility: Changing Codes of Conduct in Early Modern England*. Oxford: Clarendon Press, 1998.
- Buonarotti, Michelangelo di. *Descrizione delle Felicissime Nozze della Cristianissima Maestà di Madama Maria Medici Regina di Francia e di Navarra*. Florence: Giorgio Marescotti, 1600. Transcribed in *Dolci trionfi e finissime piegature*, exh. cat., edited by Giovanna Giusti and Riccardo Spinelli, 73–77. Florence: Palazzo Pitti Galleria Palatina; Livorno: Sillabe, 2015.
- Burgers, Cornelis A. *White Linen Damasks I: Heraldic Motifs from the Sixteenth Century to Circa 1830*. 2 vols. Riggisberg: Abegg-Stiftung, 2014.
- Cavallo, Adolfo Salvatore. *The Unicorn Tapestries at The Metropolitan Museum of Art*. New York: Harry N. Abrams; New York: Metropolitan Museum of Art, 1998.
- Celebrino, Eustachio. *Opera noua che insegna a parecchiar una mensa a vno conuito: & etiam a tagliar in tauola de ogni sorte carne & dar li cibi secondo l'ordine che vsano gli scalchi per far honore a forestieri. Intitulata Refettorio appresso aggiontoui alcuni secreti apertinenti al cucinare & etiam a conseruar carne e frutti longo tempo* [. . .]. Venice, 1526; Cesena, before 1530; Brescia, 1532.
- Cervio, Vincenzo. *Il Trinciante: Ampliato e a perfettione ridotto dal caualier Reale Fusoritto da Narni*. Rome: Ad istanza di Giulio Burchioni, nella Stampa di Gabbia, 1593.
- ———. *Il Trinciante: Ampliato et ridotto a perfettione dal caualier Reale Fusoritto da Narni*. Venice: Apresso gli heredi di Giovanni Varisco, 1593.
- ———. *Il Trinciante di M. Vincenzo Cervio; Ampliato, et ridotto a perfettione dal cavalier Reale Fusoritto de Narni, Trinciante dell'Illustrissimo e Reverendissimo Signor Cardinal Farnese*. Venice: Appresso gli heredi di Francesco Tramezini, 1581.
- Chiappini, Luciano. *La Corte Estense alla metà del Cinquecento: I compendi di Cristorforo di Messisbugo*. Ferrara: Stabilimento Artistico Tipografico Editoriale, 1984.
- Coffin, Sarah, et.al, *Feeding Desire: Design and the Tools of the Table, 1500–2005*. New York: Assouline; New York: Cooper-Hewitt, National Design Museum, 2006.
- Colle, Francisco. *Refugio de povero Gentilhuomo composto per Io. Francisco Colle a lo Illustris. et Excellentis. S. D. Alfonso Duca di Ferrara*. Ferrara: Lorenzo de Russi da Valencia, 1520.
- ———. *Refugio Ouer Ammonitorio De Gentilhuomo*. N.p., 1532.
- Collins, Brenda, and Philip Ollerenshaw, eds. *The European Linen Industry in Historical Perspective*. Oxford: Oxford University Press, 2003.
- Contini, Gianfranco. *Le opere volgari di Bonvesin della Riva*. Vol. 1, *Testi*. Rome: Società filologica romana, 1941.
- Cook, Harold J. "The History of Medicine and the Scientific Revolution" *Isis* 102, no. 1 (March 2011): 102–8.
- Cormack, Bradin, and Carla Mazzio. *Book Use, Book Theory 1500–1700*. Chicago: University of Chicago Library, 2005.
- Cox, Virginia. *The Renaissance Dialogue: Literary Dialogue in Its Social and Political Contexts, Castiglione to Galileo*. Cambridge: Cambridge University Press, 1992.
- Crépin-Leblond, Thierry. *Le dressoir du prince*. Exh. cat. Écouen: Musée national de la Renaissance; Paris: Réunion des musées nationaux, 1995.
- Cressy, David. *Literacy and the Social Order: Reading and Writing in Tudor and Stuart England*. Cambridge: Cambridge University Press, 1980.
- Cumming, Nicole Maceira. "The Relationship between Meat Consumption and Power in Late Medieval and Early Modern England." *Sloth* 5, no. 1 (2019): https://www.academia.edu/41250326/.
- Cummins, John. *The Art of Medieval Hunting: The Hound and the Hawk*. London: Weidenfeld and Nicolson, 1988.
- Dackerman, Susan, ed. *Prints and the Pursuit of Knowledge in Early Modern Europe*. Exh. cat. Cambridge, MA: Harvard Art Museums; New Haven, CT: Yale University Press, 2011.
- Dambrogio, Jana, Daniel Starza Smith, Jennifer Pellecchia, Alison Wiggins, Andrea Clarke, and Alan Bryson. "The Spiral-Locked Letters of Elizabeth I and Mary, Queen of Scots." *British Electronic*

Library Journal (2021): https://www.bl.uk/eblj/2021articles/pdf/ebljarticle112021.pdf.

Day, Ivan. "From Murrell to Jarrin: Illustrations in British Cookery Books 1621–1820." In *The English Cookery Book: Historical Essays*, edited by Eileen White, 98–150. Totnes, UK: Prospect Books, 2004.

• ———. *Royal Sugar Sculpture: 600 Years of Splendour*. Barnard Castle, UK: Bowes Museum, 2002.

• *De Cierlijcke voorsnydinge aller tafel gerechten*. Amsterdam: Hieronymous Sweerts, ca. 1660.

• Deleuze, Gilles. *The Fold: Leibniz and the Baroque*. Foreword and translation by Tom Conley. Minneapolis: University of Minnesota Press, 1993.

• ———. *Le pli: Leibniz et le Baroque*. Paris: Éditions de Minuit, 1988.

• *De Sectione Mensaria*. N.p., n.d.

• Detienne, Marcel, and Jean-Pierre Vernant. *The Cuisine of Sacrifice among the Greeks*. Translated by Paula Wissing. Chicago: University of Chicago Press, 1989.

• De Vos, Paula. "European Materia Medica in Historical Texts: Longevity of a Tradition and Implications for Future Use." *Journal of Ethnopharmacology* 132, no. 1 (2010): 28–47.

• De Zoette, Sanny. "Laying the Table." In *Class Distinctions: Dutch Painting in the Age of Rembrandt and Vermeer*, edited by Ronni Baer, Henk F. K. van Nierop, and Sanny de Zoete, 74–87. Boston: Museum of Fine Arts Publications, 2015.

• Dibbits, Hester C. "Between Society and Family Values: The Linen Cupboard in Early-Modern Households." In *Private Domain, Public Inquiry: Families and Life-Styles in the Netherlands and Europe, 1550 to the Present*, edited by Anton Schuurman and Pieter Spierenburg, 125–45. Hilversum: Verloren, 1996.

• Di Schino, June. *Arte dolciaria barocca: I segreti del credenziere di Alessandro VII; Intorno a un manoscritto inedito*. Rome: Gangemi Editore, 2015.

• ———. "The Significance and Symbolism of Sugar Sculpture at Italian Court Banquets." In *Food and Material Culture: Proceedings of the Oxford Symposium on Food and Cookery 2013*, edited by Mark McWilliams, 111–22. Totnes, UK: Prospect Books, 2014.

• Dünnhaupt, Gerhard. *Personalbibliographien zu den Drucken des Barock*. 6 vols. Stuttgart: Hiersemann, 1990–93.

• Eamon, William. *Science and the Secrets of Nature: Books of Secrets in Medieval and Early Modern Culture*. Princeton, NJ: Princeton University Press, 1994.

• Eiche, Sabine. *Presenting the Turkey: The Fabulous Story of a Flamboyant and Flavourful Bird*. Florence: Centro Di, 2004.

• Eisenstein, Elizabeth L. *The Printing Press as an Agent of Change*. Cambridge: Cambridge University Press, 1980.

• Eiximenis, Francesc. *Francesc Eiximenis: An Anthology*. Introduction and selection of texts by Xavier Renedo and David Guixeras. Translated by Robert D. Hughes. Rochester, NY: Tamesis Books, 2008.

• Elias, Norbert. *The Civilizing Process*. Cambridge, MA: Blackwell, 1994. First published 1939.

• Elsner, John, and Roger Cardinal, eds. *The Cultures of Collecting*. Cambridge, MA: Harvard University Press, 1994.

• *En mycket nyttig och förbättrad trenchier-bok, hwaruti tilfinnandes är, huruledes man, efter nu för tiden brukelig art och maner, allahanda rätter ordenteligen uppå bordet sätta, sirligen sönderskära, samt wäl och tilbörligen förelägga*. Västerås: Joh. L. Horrn, 1766.

• *L'Escole parfaite des officiers de bouche; Contenant le vray maistre-d'hostel, le grand escuyer tranchant, le sommelier royal, le confiturier royal, le cuisinier royal et le patissier royal*. Paris: chez la Vve Pierre David: J. Ribou, 1662.

• Evitascandolo, Cesare. *Dialogo del Maestro di Casa*. Rome: Apresso Giovanni Martinelli, 1598.

• ———. *Libro dello scalco: Quale insegna quest'honorato seruitio*. Rome: Carlo Vullietti, 1609.

• Febvre, Lucien, and Henri-Jean Martin. *The Coming of the Book: The Impact of Printing 1450–1800*. Edited by Geoffrey Nowell Smith and David Wooton. Translated by David Gerard. New York: Verso, 1976.

• ———. *L'apparition du livre*. Paris: Éditions Albin Michel, 1958.

• Findlen, Paula. *Possessing Nature: Museums, Collecting and Scientific Culture in Early Modern Italy*. Berkeley: University of California Press, 1994.

• Fisher, Alexander J. "Musicalische Friedens-Freud: The Westphalian Peace and Music in Protestant Nuremberg." In *Rethinking Europe: War and Peace in the Early Modern German Lands*, edited by Gerhild

Scholz Williams, Sigrun Haude, and Christian Schneider, 277–99. Leiden: Brill-Rodopi, 2019.

• Flandrin, Jean-Louis. *L'ordre des mets*. Paris: Odile Jacob, 2002.

• ———. "Structure des menus français et anglais aux XIV° et XV° siècles." In *Du manuscrit à la table: Essais sur le cuisine au Moyen Age*, edited by Carole Lambert, 173–92. Montreal: Presses de l'Université de Montréal & Champion, 1992.

• Friedman, Michael, and Lisa Rougetet. "Folding in Recreational Mathematics during the 17th–18th Centuries: Between Geometry and Entertainment." *Acta Baltica Historiae et Philosophiae Scientiarum* 5, no. 2 (Autumn 2017): 5–34.

• Frenzel, Uwe. *Deutschsprachige Tranchierbücher des Barock (1620–1724)*. Hamburg: Selbstverlag, 2012.

• Fuhse, Franz. "Trincierbücher des 17. Jahrhunderts." *Mitteilungen aus dem germanischen Nationalmuseum* (1892): 3–17.

• Furnivall, Frederick J. *Early English Meals and Manners*. London: Kegan, Paul, Trench, Trübner, 1868. Reprinted 1894.

• Gentilcore, David. *Food and Health in Early Modern Europe: Diet, Medicine, and Society, 1450–1800*. London: Bloomsbury Academic, 2016.

• Gerstl, Doris. *Georg Phillip Harsdörffer und die Künste*. Nuremberg: Hans Carl Fachverlag, 2005.

• Gertsman, Elina. *The Dance of Death in the Middle Ages: Image, Text, Performance*. Turnhout: Brepols, 2010.

• Giacomello, Alessandro. "Il 'Refettorio' di Eustachio Celebrino: Edizioni sconosciute e rare di un testo sulla tavola nel primo '500." In *Il Friuli e le cucine della memoria fra Quattro e Cinquecento: Per un contributo alla cultura dell'alimentazione*, edited by C. Corradini, 23–49. Udine: Forum, 1997.

• Giegher, Mattia. *Lo scalco di M. Mattia Giegher, Bauaro di Mosburc*. Padua: Per Guasparri Criuellari [...], 1623.

• ———. *Li Tre Trattati di Messer Mattia Gigeher Bavaro di Mosburc*. Padua: Guaresco Guareschi al Pozzo Dipinto, 1629.

• ———. *Li Tre Trattati di Messer: Mattia Giegher bavaro di Mosbvrg*. Padua: Paolo Frambotto, 1639.

• ———. *ll trinciante di Messer Mattia Gieger Bavaro di Mosburc*. Padua: Per il Martini Stampator Camerale, 1621.

• Gillingham, John. "From Civilitas to Civility: Codes of Manners in Medieval and Early Modern England." *Transactions of the Royal Historical Society* 12 (2002): 267–89.

• Ginsberg, Jane C. "Proto-property in Literary and Artistic Works: Sixteenth-Century Papal Printing Privileges." *Columbia Journal of Law and the Arts* 36 (2013): 345–458.

• Giusti, Giovanna, and Riccardo Spinelli, eds. *Dolci trionfi e finissime piegature*. Exh. cat. Florence: Palazzo Pitti Galleria Palatina; Livorno: Sillabe, 2015.

• Glaisyer, Natasha, and Sara Pennell. *Didactic Literature in England 1500–1800*. Burlington, VT: Ashgate, 2003.

• *The Good Wife's Tale: Le Ménagier de Paris*. Translated by Gina L. Greco and Christine M. Rose. Ithaca, NY: Cornell University Press, 2009.

• Grieco, Allen J. "Conviviality in a Renaissance Court: The Ordine et Officj and the Court of Urbino." In *Ordine et Officij de Casa de lo Illustrissimo Signor Duca de Urbino*, edited by Sabine Eiche, 37–44. Urbino: Accademia Rafaello, 1999.

• ———. *Food, Social Politics and the Order of Nature in Renaissance Italy*. Villa I Tatti Series 34. Cambridge, MA: Harvard University Press, 2020.

• ———. "Meals." In *At Home in Renaissance Italy*, edited by Marta Ajmar-Wollheim and Flora Dennis, 244–53. London: V&A Publications, 2006.

• Griffin, Carrie. *Instructional Writing in English 1350–1650: Materiality and Meaning*. New York: Routledge, 2019.

• Guerzoni, Guido. "Servicing the Casa." In *At Home in Renaissance Italy*, edited by Marta Ajmar-Wollheim and Flora Dennis, 146–51. London: V&A Publications, 2006.

• ———. *Le corti estensi e la devoluzione di Ferrara del 1598*. Carpi: Nuovagrafica, 2000.

• Hammond, Frederick, and Stefanie Walker, eds. *Life and the Arts in the Baroque Palaces of Rome: Ambiente Barocco*. New Haven, CT: Yale University Press; New York: Bard Graduate Center, 1999.

• Hargrave, Jocelyn Elizabeth. "Joseph Moxon: A Re-fashioned Appraisal." *Script & Print* 39, no. 3 (2015): 165–67.

• Harley, J. B., and David Woodward, eds. *The History of Cartography*. Vol. 1, *Cartography in Prehistoric, Ancient and Medieval Europe and the*

Mediterranean. Chicago: University of Chicago Press, 1987.

• Harsdörffer, Georg Philip. *Neues Trincir Büchlein. Wie man nach rechter Italienischer Art und Manir allerhand Speisen zierlich zerschneiden und höflich verlgen soll*. Nuremberg: Paulus Fürst, 1642.

• ———. *New Vermehrtes Trincier-Büchlein: Wie mann nach rechter Jtalienischer auch jtziger Art und Manier allerhand Speisen zierlich zerschneiden und höflich fürlegen soll: Alles mit zugehörigen newen Kupfferstücken gezieret*. Rinteln: Lucius, 1648.

• ———. *Trincier Büchlein Das ist Eine Anweisung, wie man nach Italienischer manier allerhand Speisen zerschneiden vnd vorlegen kan*. Danzig, 1639.

• ———. *Trincier Büchlein Das ist Eine Anweisung, wie man nach Italienischer manier allerhand Speisen Zerschneiden und vorlegen kan* [...]. Königsberg: Peter Händel, 1642.

• ———. *Trincier oder Vorleg Büchlein: Wie man allerhand Speisen, nach Italiänischer Art, anschneiden Vnd auff der Gabel Zierlich Zerlegen soll*. Leipzig: Johann Leipnitz, [1635].

• ———. *Vollständiges Trincir-Büchlein: handelnd: I, Von den Tafeldecken* [...] *II, Von Zerschneidung und Vorlegung der Speisen. III, Von rechter Zeitigung aller Mundkoste oder von dem Kuchenkalender durch das gantze Jahr; Nach Italienischer und dieser Zeit* [...]. Nuremberg: Fürst, 164[9].

• ———. *Vollständiges und von neuem vermehrtes Trincir-Buch*. Nuremberg: Paul Fürst, 1665.

• ———. *Vollständig vermehrtes Trincir-Buch*. Nuremberg: Fürst, 1652.

• ———. *Vollständing vermehrtes Trincir-Buch* [...]. Nuremberg: In Verlegung Paulus Fürsten, Kunsthändlers: Gedruckt durch Christoff Gerhard, im Jahr 1654.

• Harsdörffer, Georg Philip, and Andreas Klett. *Neues Trenchier- und Plicatur-Büchlein: darinnen begriffen wie nach jetziger Hof-art allerhand Speisen und Früchten künstlicher Weise zerschnitten, vorgeleget, aufgetragen . . . werden können*. Nuremberg: Loschge, 1677.

• Herald, Jacqueline. "Figured Linen Damasks." In *5000 Years of Textiles*, edited by Jennifer Harris, 185–87. London: British Museum Press in association with the Whitworth Art Gallery and the Victoria and Albert Museum, 1993.

• Hochstrasser, Julie Berger. *Still Life and Trade in the Dutch Golden Age*. New Haven, CT: Yale University Press, 2007.

• Imorde, Joseph. "Edible Prestige." In *The Edible Monument: The Art of Food for Festivals*, edited by Marcia Reed, 101–23. Los Angeles: Getty Research Institute, 2015.

• Impey, Oliver, and MacGregor, Arthur. *The Origins of Museums: The Cabinet of Curiosities in Sixteenth and Seventeenth Century Europe*. London: House of Stratus, 2001.

• Jaeger, C. Stephen. *The Origins of Courtliness: Civilizing Trends and the Formation of Courtly Ideals 939–1210*. Philadelphia: University of Pennsylvania Press, 2010.

• Jakob, Hans-Joachim, and Hermann Korte, eds. *Harsdörffer-Studien: Mit einer Bibliografie der Forschungsliteratur von 1847 bis 2005*. Frankfurt: Peter Lang, 2006.

• Johns, Adrian. *The Nature of the Book: Print and Knowledge in the Making*. Chicago and London: University of Chicago Press, 1998.

• Join-Lambert, Sophie, and Maxime Préaud. *Abraham Bosse, savant graveur (Tours 1604–1676 Paris)*. Exh. cat. Paris: Bibliothèque national de France; Tours: Musée de Beaux-Arts de Tours, 2004.

• Jones, Ann Rosalind, and Peter Stallybrass. *Renaissance Clothing and the Materials of Memory*. Cambridge: Cambridge University Press, 2000.

• Juvenal. *The Sixteen Satires*. Translated by Peter Green. London: Penguin Books, 2004.

• Juvenal et al. *A. Persii Flacci, D. Ivnii Ivvenalis, Svlpiciae Satvrae*. 3rd ed. Recognovit Otto Iahn. Edited by Franciscus Buecheler. Berlin: Weidmannos, 1893.

• Keppler, Stefan, and Ursula Kocher. *Georg Philipp Harsdörffers Universalität: Beiträge Zu Einem Uomo Universale Des Barock*. Berlin: De Gruyter, 2011.

• Kessel, Peter J. van. "The Denominational Pluriformity of the German Nations at Padua and the Problem of Intolerance in the 16th Century." *Archiv für Reformationsgeschichte* 75 (1984): 256–76.

• Klein, Bernhard. "Maps and Material Culture." In *The Routledge Handbook of Material Culture in Early Modern Europe*, edited by Catherine Richardson, Tara Hamling, and David Gaimster, 61–70. Abingdon: Routledge, 2017.

• Klemettilä, Hannele. *Animals and Hunters in the Late Middle Ages: Evidence from BnF MS fr. 616 of the Livre*

de Chasses by Gaston Fébus. New York: Routledge, 2015.

• Klett, Andreas. *Neü-erfundenes Trenchir-Büch*. N.p., 1665.

• ———. *Neu-Erfundenes und vollständiges Trenchir-Büchlein*. Munich: Lucas Straub, 1671.

• ———. *Neues Trenchir-Büchlein*. Jehna: Casparus Freyschmied, 1657.

• ———. *Neu Verbessertes Trenchir-Büchlein*. Wittenberg: Matthaeus Henckel, 1662.

• ———. *Ny Trencher-bog, hvorudi gives Anledning hvorledes man ret, maneerlig og som nu brugeligt er, adskillige Spise ordentlig skal paa Bordet sætte, de samme ziirligen forskiere og forelegge, ogsaa endeligen igien artelig optage, tilforne paa adskillige Stæder oplagt, nu nyligen med Fliid overseet, og med fornødne Figurer kommen til Lyset*. Copenhagen: Niels Hansen Møller, 1747.

• ———. *Wohl-informirter Tafel-Decker und Trenchant*. Nuremberg: Buggel and Seitz, 1724.

• Kluxen, Andrea M. "Harsdörffer und das Schauessen beim Nürnberger Friedensmahl." In *Georg Philipp Harsdörffer und die Künste*, edited by Doris Gerstl, 89–103. Nuremberg: Schriftenreihe der Akademie der Bildenden Künste in Nürnberg, 2005.

• Kociszewska, Ewa. "Displays of Sugar Sculpture and the Collection of Antiquities in Late Renaissance Venice." *Renaissance Quarterly* 73, no. 2 (2020): 441–88.

• Koeppe, Wolfram. *Making Marvels: Science and Splendor at the Courts of Europe*. Exh. cat. New York: Metropolitan Museum of Art, 2019.

• Koller, Aaron J. *The Semantic Field of Cutting Tools in Biblical Hebrew: The Interface of Philological, Semantic, and Archaeological Evidence*. Washington, DC: Catholic Biblical Association of America, 2012.

• Kolmer, Lothar, ed. *"Finger fertig" eine Kulturgeschichte der Serviette*. Vienna: LIT, 2008.

• Korda, Natasha. *Labors Lost: Women's Work and the Early Modern Stage*. Philadelphia: University of Pennsylvania Press, 2011.

• ———. "Much Ado about Ruffs: Laundry Time in Feminist Counter Archives." In *Early Modern Histories of Time: The Periodizations of Sixteenth- and Seventeenth-Century England*, edited by Kristen Poole and Owen Williams, 124–42. Philadelphia: University of Pennsylvania Press, 2020.

• Korda, Natasha, and Eleanor Lowe. "In Praise of Clean Linen: Laundering Humours on the Early Modern English Stage." In *The Routledge Handbook of Material Culture in Early Modern Europe*, edited by Catherine Richardson, Tara Hamling, and David Gaimster, 306–21. New York: Routledge, 2017.

• Kowalchuk, Kristine. *Preserving on Paper: Seventeenth-Century Englishwomen's Receipt Books*. Toronto: University of Toronto Press, 2017.

• Krebs, Jean Daniel. "Quand les Allemands apprenaient a trancher." *Études Germaniques* 41, no. 1 (1986): 8–23.

• Krohn, Deborah L. "Carving and Folding by the Book in Early Modern Europe." Special issue, *Journal of Early Modern History: Material Cultures of Food in Early Modern Europe* 24, no. 1 (2020): 17–40.

• ———. Food and Knowledge in Renaissance Italy: Bartolomeo Scappi's Paper Kitchens. Burlington, VT: Ashgate, 2015.

• ———. "Le livre de cuisine de la Reine: Un exemplaire de l'Opera de Scappi dans la collection de Catherine de Médicis." In *Culture de table: Échanges entre l'Italie e la France 15e-mi-17e siècle; Actes du colloque international de Blois, 13–14 Septembre 2012*, edited by Florent Quellier, 151–63. Tours: Presses Universitaires François-Rabelais; Rennes: Presses Universitaires de Rennes, 2018.

• Kusukawa, Sachiko. "*Historia piscium* (1686) and Its Sources." In *Virtuoso by Nature: The Scientific Worlds of Francis Willughby (FRS)*, edited by Tim R. Birkhead, 305–34. Leiden: Brill, 2016.

• ———. *Picturing the Book of Nature: Image, Text and Argument in Sixteenth-Century Human Anatomy and Medical Botany*. Chicago: University of Chicago Press, 2012.

• Latini, Antonio. *Lo Scalco alla Moderna*. 2 Vols. Naples: Domenico Antonio Parrino e Michele Luigi Muzzi, 1692. Reprinted 1694.

• Laue, Georg, and Virginie Splené. *Kostbare Bestecke für die Kunstkammer Europa = Precious Cutlery for European Kunstkammer*. Edited by Georg Laue. Munich: Kunstkammer Georg Laue, 2010.

• Laufhütte, Hartmut. "The Peace Celebrations of 1650 in Nuremberg." In *1648, War and Peace in Europe*, edited by Klaus Bussmann and Heinz Schilling, 2:347–57. Münster: Westfälisches Landesmuseum für Kunst und Kulturgeschichte, 1998.

- Laurioux, Bruno. "Les menus des banquets dans les livres de cuisine de la fine du Moyen Âge." In *La sociabilité à la table: Commensalité et convivialité à travers les âges; Actes du colloque de Rouen (14–17 Novembre 1990)*, edited by Martin Aurell, Olivier Dumoulin, and Françoise Thélemon, 273–82. Rouen: Publications de l'Université de Rouen, 1992.
- ———. "Le Registre de cuisine de Jean de Bockenheim, cuisinier du pape Martin V." *Mélanges de l'École française de Rome—Moyen Âge: Temps modernes* 100, no. 2 (1988): 709–60.
- Lehmann, Gilly. "The Late-Medieval Menu in England—a Reappraisal." *Food and History* 1, no. 1 (2003): 49–84.
- Leong, Elaine. *Recipes and Everyday Knowledge: Medicine, Science, and the Household in Early Modern England*. Chicago: University of Chicago Press, 2018.
- Lincoln, Evelyn. *Brilliant Discourse: Pictures and Readers in Early Modern Rome*. New Haven, CT: Yale University Press, 2014.
- ———. "Invention and Authorship in Early Modern Italian Visual Culture." *De Paul Law Review* 52 (2003): 1093–120.
- ———. "Mattia Giegher Living." In *The Renaissance: Revised, Expanded, Unexpurgated*, edited by D. Medina Lasansky, 382–401. Pittsburgh: Periscope, 2014.
- ———. "The Studio Inventory of Camillo Graffico, Engraver and Fountaineer." *Print Quarterly* 29, no. 3 (September 2012): 259–80.
- Liškevičienė, Jolita. "Conradt Götke—Engraver of the First Half of the 17th Century." *Knygotyra 55* (2010): 54–79.
- Long, Pamela O. *Openness, Secrecy, Authorship: Technical Arts and the Culture of Knowledge from Antiquity to the Renaissance*. Baltimore: Johns Hopkins University Press, 2001.
- Lotz, Arthur. *Bibliographie der Modelbücher: Beschreibendes Verzeichnis der Stick und Spitzenmusterbücher des 16. und 17. Jahrhunderts*. Stuttgart: A. Hiersemann, 1963.
- Lugli, Emanuele. *The Making of Measure and the Promise of Sameness*. Chicago: University of Chicago Press, 2019.
- Maestro Martino. *The Art of Cooking: The First Modern Cookery Book*. Edited by Luigi Ballerini. Translated by Jeremy Parzen. Berkeley: University of California Press, 2005.
- Marche, Olivier de la. *Estat de la maison du duc Charles de Bourgoingne, dit le Hardy. Published together with Memoires d'Olivier de la Marche, maître d'Hôtel et capitaine des gardes de Charles le Téméraire*, edited by Henri Beaune and Jules d'Arbaumont, 4:1–94. Paris: Société de l'histoire de France, 1883–88.
- Marquard, Klaus. *Eight Centuries of Knives, Forks, and Spoons*. Translated by Joan Clough. Stuttgart: Arnoldsche, 1997.
- Messisbugo, Christoforo di. *Banchetti, Compositioni di Vivande, et Apparecchio Generale*. Ferrara: Giovanni de Bulghat and Antonio Hucher Compagni, 1549.
- Miguel-Prendes, Sol. "Chivalric Identity in Enrique de Villena's *Arte Cisoria*." *La corónica: A Journal of Medieval Hispanic Languages, Literatures, and Cultures* 32, no. 1 (2003): 307–42.
- Milham, Mary Ella. "Apicius in the Northern Renaissance, 1518–1542." *Bibliothèque d'Humanisme et Renaissance* 32, no. 2 (1970): 433–43.
- Mintz, Sidney W. *Sweetness and Power: The Place of Sugar in Modern History*. New York: Viking, 1985.
- Mitchell, Bonner. "Notes for a History of the Printed Festival Book in Renaissance Italy." *Daphnis* 32, no. 1–2 (2003): 41–56.
- Mitchell, David. "Linen Damask Production: Technology Transfer and Design, 1580–1760." In *The European Linen Industry in Historical Perspective*, edited by Brenda Collins and Philip Ollerenshaw, 61–98. Oxford: Oxford University Press, 2003.
- Molinari, Mattio. *Il Trinciante*. Padua: Livio Pasquati, 1636. 2nd ed. 1655.
- Montague, Jennifer. *Roman Baroque Sculpture: The Industry of Art*. New Haven, CT: Yale University Press, 1989.
- Morford, Mark. "Juvenal's Fifth Satire." *American Journal of Philology* 98, no. 3 (1977): 219–45.
- Moxon, James. *The Genteel House-keepers Pastime, Or, the Mode of Carving at the Table Represented in a Pack of Playing Cards* [. . .]. Book, 52 cards, and wrapper. London: Printed for J. Moxon and sold at his shop at the Atlas in Warwick-Lane; and at the three Bells in Ludgate-Street, 1693.
- *Neu A la modisch Nach itziger gebräuchlichen Arth eingerichtetes Complementir-Frisier-Trenchier- und Kunst-Buch*. Hamburg: Thomas von Wiering, [ca. 1703].

- Normore, Christina. *A Feast for the Eyes: Art, Performance and the Late Medieval Banquet*. Chicago: University of Chicago Press, 2015.

- Notaker, Henry. *Printed Cookbooks in Europe, 1470–1700*. New Castle, DE: Oak Knoll Press; Houten: Hes & De Graaf, 2010.

- Nussdorfer, Laurie. "Managing Cardinals' Households for Dummies." In *For the Sake of Learning: Essays in Honor of Anthony Grafton*, 2 vols., edited by Ann Blair and Anja-Silvia Goeing, 173–94. Leiden: Brill, 2016.

- Pasch, Johann Georg. *Neu vermehrtes Trinchir-Büch*. Naumburg: Martin Müller, 1665.

- Park, Katharine, and Lorraine Daston, eds. *Early Modern Science*. Cambridge: Cambridge University Press, 2006.

- Past, Elena. "Una ricotta per longo e iocundo vivere: Il Libretto di tutte le cosse che se mangano." In *Michele Savonarola: Medicina e cultura di corte*, edited by Chiara Crisciani and Gabriella Zuccolin, 113–26. Florence: SISMEL, Edizioni del Galluzzo, 2011.

- Patrizot, Olivia. "En qué manera se deve servir el ofiçio del cortar: L'Arte Cisora d'Enrique de Villena (1423)." *Circé: Histoire, Savoirs, Sociétés*, no. 5 (2014): http://www.revue-circe .uvsq.fr/en-que-manera-se-deve -servir-el-oficio-del-cortar-larte -cisoria-denrique-de-villena-1423/.

- ———. "Un noble au service d'un art: L'écuyer tranchant en Espagne et en Italie à la fin du Moyen Âge." In *La table de la Renaissance: Le mythe italien*, edited by Pascal Brioist and Florent Quellier, 131–50. Rennes: Presses université de Rennes; Tours: Presses Universitaires François-Rabelais de Tours, 2018.

- Petit, Pierre. *L'art de trancher la viande, & toutes sortes de fruits / nouvellement a la françois par Pierre Petit écuyer trenchant*. N.p., n.d.

- Platina. *De Honesta Voluptate et Valetudine: On Right Pleasure and Good Health*. Translated by Mary Ella Milham. Tempe, AZ: Medieval and Renaissance Texts and Studies, 1998.

- Poole, Kristen, and Owen Williams, eds. *Early Modern Histories of Time: The Periodizations of Sixteenth- and Seventeenth-Century England*. Philadelphia: University of Pennsylvania Press with the Folger Shakespeare Library, 2019.

- Procacchi, Giacomo. *Trincier Oder Vorleg-Buch: Darinnen berichtet wird Wie man allerhand gebratene und gesottene Speisen so auff Fürstliche und andere Taffelngetragen werden mögen Nach Italienischer und vornemlich Romanischer Arth anschneiden und auff der Gabel zierlich zerlegen soll Vor dessen Von Giacomo Procacchi. In Italienischer Sprach beschrieben. An jetzo aber In das hochdeutsche trewlichen versetzet/ und mit den signirten Kupfferstichen auffs best und fleissigste gezieret [. . .]*. Leipzig: Hennig Gross the Younger, 1620. Reprinted 1621; 2nd ed. 1624.

- ———. *Voorlegh-boeck ofte maniere om verscheyden soorten van spijse Soo gesooden als Gebraden, aende Vorck voor te Snyden ende om dienen eerst uit Italiaensch beschreven*. Leyden: Jacob Roels, 1639.

- Reed, Annette Yoshiko. "From Sacrifice to the Slaughterhouse: Ancient and Modern Approaches to Meat, Animals and Civilization." *Method and Theory in the Study of Religion* 26, no. 2 (2014): 111–58.

- Reed, Marcia. "Court and Civic Festivals." In *The Edible Monument: The Art of Food for Festivals*, 27–71. Los Angeles: Getty Research Institute, 2015.

- Rickert, Edith, and L. J. Naylor. *The Babees' Book: Medieval Manners for the Young Done into Modern English from Dr. Furnivall's Texts by Edith Rickert*. London: Chatto and Windus; New York: Duffield, 1908.

- Rietz, Richard du. *Gastronomisk Spegel*. Stockholm: Thulins Antikvariat, 1953.

- Rose, Giles. *A Perfect School of Instructions for the Officers of the Mouth shewing the whole art of a master of the houshold [sic], a master carver, a master butler, a master confectioner, a master cook, a pastryman [. . .]: adorned with pictures curiously ingraven, displaying the whole arts / by Giles Rose, one of the master cooks in His Majesties kitchen*. London: Printed for R. Bentley and M. Magnes, 1682.

- Rossell, Deac. "Die Lanterna Magica." In *Ich Sehe was, was du nicht siehst! Sehmaschinen und Bilderwelten*, edited by Bodo von Dewitz and Werner Nekes, 134–45. Cologne: Steidl, 2002.

- Rundin, J. "A Politics of Eating: Feasting in Early Greek Society." *American Journal of Philology* 117, no. 2 (1996): 179–215.

- Saletnik, Jeffrey. *Josef Albers, Late Modernism, and Pedagogic Form*. Chicago: University of Chicago Press, 2022.

- Sallas, Joan. *Folded Beauty: The Art of Napkin Folding*. Translated by Edwin Corrie. Badalona: Jong Ie Nara, 2018.

. *Gefaltete Schönheit: Die Kunst des Serviettenbrechens*. Freiburg im Breisgau: self-published, 2010.

. "L'arte italiana dei trionfi piegati con tovaglioli e la *Descrizione* di Michelangelo Buonarotti il Giovane." In *Dolci trionfi e finissime piegature*, exh. cat., edited by Giovanna Giusti and Riccardo Spinelli, 39–41. Florence: Palazzo Pitti Galleria Palatina; Livorno: Sillabe, 2015.

. "Mattia Giegher and the First Work on Folded Centerpieces." *Datatèxtil* 40 (2020): 26–34.

. *Tischlein deck dich: Ursprung und Entwicklung des Serviettenbrechens; Katalog zur Ausstellung*. Salzburg: Salzburger Barockmuseum, 2008.

Sanford, Eva Matthews. "Renaissance Commentaries on Juvenal." *Transactions and Proceedings of the American Philological Association* 79 (1948): 92–112.

Sarti, Rafaella. "Who Are Servants? Defining Domestic Service in Western Europe (16th–21st Centuries)." In *Proceedings of the Servant Project*. 5 vols. Edited by S. Pasleau and I. Schopp with R. Sarti, 2:3–59. Liège: Éditions de l'Université de Liège, 2005.

Saslow, James M. *The Medici Wedding of 1589*. New Haven, CT: Yale University Press, 1996.

Savonarola, Michele. *Libreto di tute le cosse che se manzano*. Venice: Simone de Lucre, 1508.

Scappi, Bartolomeo. *Dell arte del cucinare*. Venice: Combi, 1643.

. *Opera*. Venice: Michele Tramezzino, 1570.

Schnabel, Werner Wilhelm.

"Vorschneidekunst und Tafelfreuden: Georg Philip Harsdörffer und sein 'Trincierbuch.'" In *Georg Philipp Harsdörffer und die Künste*, edited by Doris Gerstl, 158–74. Nuremberg: Schriftenreihe der Akademie der Bildenden Künste in Nürnberg, 2005.

Schorn, Stefan. "On Eating Meat and Human Sacrifice: Anthropology in Asclepiades of Cyprus and Theophrastus of Eresus." In *Studies in the History of the Eastern Mediterranean (4th Century B.C.–5th Century A.D.)*, edited by Peter Van Nuffelen, 11–48. Walpole, MA: Peeters, 2009.

Schraemli, Harry. *Von Lucullus zu Escoffier: Ein Schlemmerbuch für kluge Frauen und gescheite Männer*. Zurich: Interverlag, 1949.

Seetah, Krish. "The Middle Ages on the Block: Guilds and Meat in the Medieval Period." In *Breaking and Shaping Beastly Bodies: Animals as Material Culture in the Middle Ages*, edited by Aleksander Pluskowski, 18–31. Oxford: Oxbow Books, 2007.

Servolini, Luigi. "Eustachio Celebrino da Udine intagliatore, calligrafo, poligrafo ed editore del sec. XVI." *Gutenberg Jahrbuch* 19–24 (1944–49): 179–89.

Siraisi, Nancy G. *Medieval and Early Renaissance Medicine: An Introduction of Knowledge and Practice*. Chicago: University of Chicago Press, 1990.

Smith, Pamela H. "In the Workshop of History: Making, Writing, and Meaning." *West 86th: A Journal of Decorative Arts, Design History, and Material Culture* 19, no. 1 (2012): 4–31.

Soler, María José García. "Les professionels de la cuisine dans la Grèce ancienne: De l'abatteur au chef."

Food and History 15, nos. 1–2 (2017): 25–43.

Speelberg, Femke. "Blackwork: A New Technique in the Field of Ornament Prints (ca. 1585–1635)." In *Heilbrunn Timeline of Art History*. New York: Metropolitan Museum of Art, 2000– . http://www.metmuseum.org/toah/hd/blak/hd_blak.htm.

Stone-Ferrier, Linda. "Views of Haarlem: A Reconsideration of Ruisdael and Rembrandt." *Art Bulletin* 67, no. 3 (September 1985): 417–36.

Thomas, Bruno. "The Hunting Knives of Emperor Maximilian I." *Metropolitan Museum of Art Bulletin* 13, no. 6 (1955): 201–8.

Thornton, Peter. *The Italian Renaissance Interior, 1400–1600*. New York: H. N. Abrams, 1991.

Tilley, Roger. *A History of Playing Cards*. New York: Clarkson N. Potter, 1973.

Tomasik, Timothy J. "Translating Taste in the Vernacular Editions of Platina's *De honesta voluptate et valetudine*." In *At the Table: Metaphorical and Material Cultures of Food in Medieval and Early Modern Europe*, edited by Timothy J. Tomasik and Juliann M. Vitullo, 189–210. Turnhout: Brepols, 2007.

Unwin, Joan. "Knife Handle Making—the Subsidiary Trades in the Sheffield Cutlery Industry." *Artefact: Techniques, histoire et sciences humaines* 7 (2017): 107–20.

. "The Versatility of Bone, Ivory and Horn—Their Uses in the Sheffield Cutlery Industry." *Anthropozoologica* 49, no. 1 (2014): 121–32.

Villena, Enrique de. *Arte cisoria o tratado del arte del cortar del cuchillo / Que Escrivió Don Henrique de Aragon,*

Marques de Villena, la da a Luz [. . .] *la Biblioteca Real de San Lorenzo del Escorial*. Madrid, 1766.

• Vontet, Jacques. *L'Art de trancher la viande et toutte(s) sorte(s) de fruit(s) à la mode italienne et nouvellement à la françoise*. Lyon, 1669.

• ———. *L'art de trancher la viande et toute sorte de fruits à la mode italienne et nouvellement à la françoise* [Lyon?, ca. 1650]. Paris: École nationale supérieure des beaux-arts, 2013. Facsimile of ms. 495, Library of the École nationale supérieure des beaux-arts, Paris.

• (———). *La Methode de trancher aloüetes Bequefis, et ortolans avec toute sorte d'autres petits oyseaux*. [Lyon or Paris, ca. 1647–50].

• (———). *No. 1 Au Lecteur Ce n'est pas sans Raison que les plus grands personnages de L'Europe se servent d'Escuyer tranchant*. [Lyon or Paris, ca. 1647–50].

• Wade, Mara R. "From Reading to Writing: Women Authors and Book Collectors at the Wolfenbüttel Court—a Case Study of Georg Philip Harsörffer's *Frauenzimmer Gesprächspiele*." *German Life and Letters* 67, no. 4 (October 2014): 481–95.

• Walker, Stefanie. "Dining in Papal Rome: Un onore ideale e una fatica corporale." In *Die Offentliche Tafel: Tafelzeremoniell in Europa, 1300–1900*, edited by Hans Ottomeyer and Michaela Völkel, 72–83. Wolfratshausen: Edition Minerva Hermann Farnung, 2003.

• Wall, Wendy. *Recipes for Thought: Knowledge and Taste in the Early Modern English Kitchen*. Philadelphia: University of Pennsylvania Press, 2016.

• Watson, Katharine J. "Sugar Sculpture for Grand Ducal Weddings from the Giambologna Workshop." *Connoisseur* 199, no. 799 (September 1978): 20–26.

• Waxman, S. M. "Chapters on Magic in Spanish Literature." *Revue Hispanique* 38 (1916): 287–348.

• Wayland, Virginia, and Howard Wayland. *Of Carving, Cards & Cookery, or The Mode of Carving at the Table as Represented in a Pack of Playing Cards Originally Designed & Sold by Joseph & James Moxon, London 1676–7 together with Diverse Recipes for Excellent Dishes of Flesh, Fish, Fowl & Baked Meats Collected from 17th Century Masters at the Art of Cookery*. Arcadia, CA: Raccoon Press, 1962.

• Wheaton, Barbara Ketcham. *Savoring the Past: The French Kitchen and Table from 1300 to 1789*. Philadelphia: University of Pennsylvania Press, 1983.

• Wilson, C. Anne, *Banquetting Stuffe: The Fare and Social Background of the Tudor and Stuart Banquet*. Edinburgh: Edinburgh University Press, 1991.

• Woodward, David. "Maps and the Rationalization of Geographic Space." In *Circa 1492: Art in the Age of Exploration*, edited by Jay A. Levenson, 83–87. New Haven, CT: Yale University Press, 1991.

• Worde, Wynkyn de. *The Boke of Keruynge*. Edited by Peter Brears. Lewes: Southover Press, 2003.

• Yeomans, Lisa. "The Shifting Use of Animal Carcasses in Medieval and Post-medieval London." In *Breaking and Shaping Beastly Bodies: Animals as Material Culture in the Middle Ages*, edited by Aleksander Pluskowski, 98–115. Oxford: Oxbow Books, 2007.

Index

A

Albala, Ken, 31
Aldrovandi, Ulisse, 98
Alfonsi, Petrus, 10
animal sacrifice, 14–15
apprenticeship, 8, 12–13, 155
Aristophanes, 15

B

Bacon, Francis, 132
Bandini, Giovanni, 100
banquets, 88, 90, 99–102; Baroque, 118–19; Nuremberg Friedensmahl, 122–23
blackwork printing, 57n13
Bonvesin de la Riva, 10
Bosse, Abraham, 139–41
Bretschneider, Andreas, 67, 68, 69
Buonarotti, Michelangelo, the Younger, 92

C

Campi, Vincenzo, 4–5, 95
capons, 77, 126, 127, 160, 169, 175, 180, 182
carving *in aria*, 19, 43, 45, 52, 55, 61, 133, 144, 167; Giegher on, 74–76, 77, 174

carving manuals and carvers, 1, 8, 9, 12, 25–32, 39–56, 61–82, 106–7, 115, 126, 133, 137–39, 142–49, 155–70, 173–84; comportment of, 55–56, 72, 162; dissection and, 66, 177; historical background of, 13–19; "magic" of, 25, 169–74, 176; mathematics and, 136, 177–79. *See also écuyer tranchant*; title pages and frontispieces
Castiglione, Baldassare, 118
Caullery, Louis de, 102
Celebrino, Eustachio, 43, 45
Cervio, Vincenzo, 8, 9, 19, 48–55, 61, 62, 74, 119, 137
Cierlijcke Voorsnydinge Aller Tafel Gerechten, De, 167–68
collation, 88, 110n38
Colle, Giovanni Francesco, 19, 39–43, 44, 45, 50, 61, 119
cookbooks, 8–9, 11, 33, 43, 84, 166–67, 176
courtesy (conduct) books, 9–12
credenze, 4–7, 44, 67, 88, 89, 125
cutlery: care and cleaning of, 39, 55–56, 72, 106–7; forks, 3, 11, 26, 27, 34, 42–44, 45, 49–53, 55, 58n21, 67, 72, 139, 174, 180–81; in Giegher, 61–62, 69–73, 78; knives, 3, 11, 15, 26, 28, 29–30, 31, 32, 39–40, 42, 44, 45, 47, 49–53, 55, 72, 136, 170–71; spoons, 11, 29, 44, 100

D

David, Pierre, and widow of, 165, 167, 185n8
de Heem, Jan Davidszoon, 135
Deleuze, Gilles, 108
De Marchi, Alessandro, 6
Descartes, René, 177–78
De Sectione Mensaria, 66
Desportes, Alexandre-François, 4, 6
Detienne, Marcel, 15
Dioscurides, 31
Distichs of Cato, 10
ducks, 162–63
Dürer, Albrecht, 129, 150n7

E

écuyer tranchant, 155–57, 169
Elias, Norbert, 3, 9–11, 13–14
Erasmus, Desiderius, 10, 123
Escole parfaite des officiers de bouche, L', 164–67, 174–76
Este court, 19, 39, 41–42, 43–44, 85
Evitascandolo, Cesare, 55–56, 62

F

Facetus: Moribus et vita, 10
Farnese, Alesandro, and Maria of Portugal, 6, 7

Febvre, Lucien, and Henri-Jean Martin, 13
Fichard, Johann, 42
fish, 78, 79, 85, 126, 128, 181–82
folding manuals and practices, 1, 3, 6, 8, 9, 12, 29, 44, 100–107, 117, 139, 176; Deleuze on, 108; in Giegher, 61, 62–64, 90–99, 129–31; in Harsdörffer, 130–32; linen draping, 33; linen preparation, 106; mathematics and, 129–32. *See also* title pages and frontispieces
Frambotto, Paolo, 65
fruits, 78–79, 82, 83, 85, 88, 132–36, 174, 176, 178; lemons, 78, 88, 135, 152n35, 180; oranges, 164–65, 180
Furnivall, Frederick, Jr., 27, 29
Fürst, Paul, 119, 129, 135
Fusoritto da Narni, 48, 53

Galen, 30
Gaston de Foix, 16–18
Gentilcore, David, 31
Giambologna, 92
Giegher, Mattia, 8, 19, 29, 61–99, 106–8, 115–17, 129, 155, 183; background of, 62, 115; influence and adaptations of, 117, 120, 126, 130–33, 156, 164, 169, 174, 183; publication history of *Tre Trattati*, 62, 64–69, 82, 93, 99, 115–17, 122
Gillingham, John, 10
Glaisyer, Natasha, and Sarah Pennell, 12–13
Götke, Conradt, 117, 150n6
Götter Blumen-Mahl, Der, 121
Griffin, Carrie, 33, 36n9
Gross, Hennig, 69

H

Harsdörffer, Georg Philip, 116–37, 138–40, 142, 146, 179
Holbein, Hans, 172
Homer, 14–15
humors, 30, 162, 160, 162
hunting, 15–18
Huygens, Christiaan, 172

I

Ibn Butlan, 31, 160

J

Jamnitzer, Wenzel, 78
Juvenal, ix, 41, 42, 119–20, 138

Kircher, Athanasius, 98
Klett, Andreas, 143–47, 155, 156, 174
Kunst- und Wunderkammern, 3–4, 90, 133

L

Lancellotti, Secondo, 62
Latini, Antonio, 133–35
La Verenne, François Pierre de, 166–67
Liber Urbani, 10
Lincoln, Evelyn, 111n43, 150n7
linen. *See under* folding practices
Long, Pamela O., 11
Lonza di Vitello, 76, 126

M

magic lanterns, 172–73
"map consciousness," 2, 20n1
mathematics: in carving, 136, 177–79; in folding, 129–32
medical knowledge, 30–31
Medici family, 92, 99–100
menus, 9, 30, 34, 43, 44, 45; Giegher on, 82, 84–86, 88; of questions, 123
Messisbugo, Cristoforo di, 19, 43–45, 84–85, 119
Methode de trancher aloüetes Bequefis, La, 156
Michelangelo, 92, 144
Mielich, Hans, 148–49
Molinari, Mattio, 69, 133, 176
Moses, 179
Moxon, Joseph, 176–83
Murrell, John, 174
Mycket nyttig och förbättrad trenchier-bok, En, 169–71, 173

N

napery. *See* folding practices
Neu a la modisch Nach itziger gebräuchlichen Arth eingerichtetes Complementir-Frisier-Trenchier- und Kunst-Buch, 173–74
Neu Vermehrt Nützliches Trenchier-Buch, 174
Núñez, Francisco, 42
Ny alamodisk åg mykket nyttig trenchier-bok, 169–70

213 • INDEX

O

oglia putrida, 86, 87, 122
Olivier de la Marche, 155
origami, 90, 108

P

Palissy, Bernard, 78
Pasch, Johann Georg, 142
pattern books, 43, 99, 117
Pepys, Samuel, 172, 186n20
Petit, Pierre, 156, 157–59, 184n4
piegature, 64, 90–95, 99–102
Platina, Bartolomeo, 84
playing cards, 176–82
Polenz, Federigo di, 64
potaggi, 77
Procacchi, Giacomo, 67–68, 69, 76, 109n18, 115, 116, 120, 129, 130, 137–38

R

Rantzau, Burkhardt (Burcardo Ranzovio), 62
Ribou, Jean, 165, 167
Romano, Giulio, 4–5
Romoli, Domenico, 85
Rose, Giles, ix, 174–76
Rossell, Deac, 172
Ruisdael, Jacob van, 106, 107
Russell, John, *The Boke of Nurture*, 26–33, 37n25, 42, 44, 74, 174

S

Sallas, Joan, 62, 65, 103–5, 108n2, 112n62
salt and saltcellars, 14–15, 29, 34, 44, 49, 77, 87, 101
Sandrart, Joachim von, 123–25
Sansovino, Jacopo, 92
Savonarola, Michele, 41–42, 44, 119
Scappi, Bartolomeo, 8–9, 19, 45–48, 49, 54–55, 61, 85, 110n38, 137, 164
Schaugerichten, 122–23, 125
seasonality of foods, 18, 19, 106–7, 120–21, 162; Giegher on, 84, 85, 86; *Kuchenkalender*, 121
servants and serving, 6, 8, 28, 30
Sevin, Pierre Paul, 99, 100
Smith, Pamela H., 11, 12
stewards, 3, 8, 12, 43, 44, 49, 53, 62, 64, 66, 68, 92, 93, 95, 119, 122, 123, 137, 139, 149, 155, 162, 164, 166, 183; Giegher on, 82, 84, 85, 87
sugar, 88, 90, 122; sugar-paste sculptures, 90, 91–93, 99, 101–2, 123, 125

T

table manners, 10–11
table maps, 1–2, 86–88, 164–65
table service and settings, 66, 122–23, 129, 175–76, 184; Giegher on, 62, 88–90; with greenery, 53–54
Tacca, Pietro, 92, 100
Taiare de cortello, 56n1
Teplitsky, Joshua, 22n38
Thomasin von Zirclaere, 10
title pages and frontispieces, functions of, 137–49, 157
Tramezino, Venturino, 48–49, 54
Tramezzino, Francesco and Michele, 9
Très Riches Heures du duc de Berry, 1, 2, 18–19, 29, 155
trinciare term, 41, 44, 67, 74, 136, 180
trionfi, 90, 92, 93, 99–101, 122
Troschel, Peter, 146
Troublewit, 90

U

Unicorn Tapestries, 16–17

V

Villena, Enrique, 25–26, 27, 42
Vontet, Jacques, 66, 155–57, 160–63, 185n5
Vraye mettode de bien trencher les viandes, La, 185n5

W

wild boar, 77–78, 126, 128, 144, 181–82
wine serving, 30
Worde, Wynkyn de, 32–33, 174; *Boke of Keruynge*, 26–27, 32–35, 42, 174
Wright, Michael, 101

Photographic Credits

Photographs were taken or supplied by the lending institutions, organizations, or individuals credited in the picture captions and are protected by copyright; many names are not repeated here. Individual photographers are credited below. Permission has been sought for use of all copyrighted illustrations in this volume. In several instances, despite extensive research, it has not been possible to locate the original copyright holder. Copyright owners of these works should contact the Bard Graduate Center, 18 West 86th Street, New York, NY 10024.

Cecilia Heisser / Nationalmuseum: Fig. 3.23

© The Metropolitan Museum of Art. Image source: Art Resource, NY: Figs. 1.2, 1.3, 2.9, 3.25–27, 3.29

Allen Phillips / Wadsworth Atheneum: Fig. 3.30

Allen Phillips and Maria Porada / Wadsworth Atheneum: Fig. 4.27

RMN-Grand Palais (domaine de Chantilly) / René-Gabriel Ojéda: Figs. I.1, I.8

Scala / Art Resource, NY: Fig. I.2

© Rafael Valls Gallery, London, UK / Bridgeman Images: Fig. 3.24

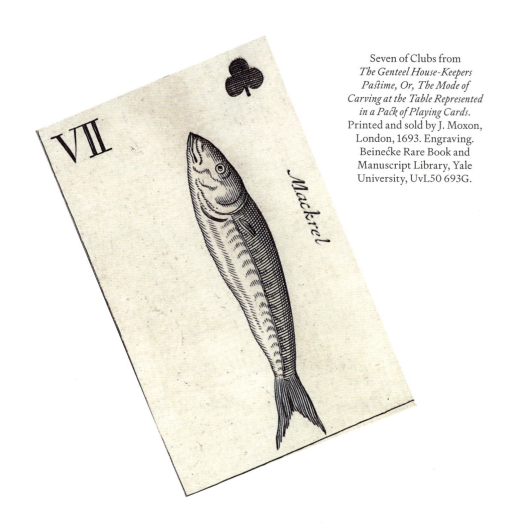

Seven of Clubs from *The Genteel House-Keepers Pastime, Or, The Mode of Carving at the Table Represented in a Pack of Playing Cards*. Printed and sold by J. Moxon, London, 1693. Engraving. Beinecke Rare Book and Manuscript Library, Yale University, UvL50 693G.